D1267284

Envisioning New Jersey

RIVERGATE REGIONALS

Rivergate Regionals is a collection of books published by Rutgers University Press focusing on New Jersey and the surrounding area. Since its founding in 1936, Rutgers University Press has been devoted to serving the people of New Jersey and this collection solidifies that tradition. The books in the Rivergate Regionals Collection explore history, politics, nature and the environment, recreation, sports, health and medicine, and the arts. By incorporating the collection within the larger Rutgers University Press editorial program, the Rivergate Regionals Collection enhances our commitment to publishing the best books about our great state and the surrounding region.

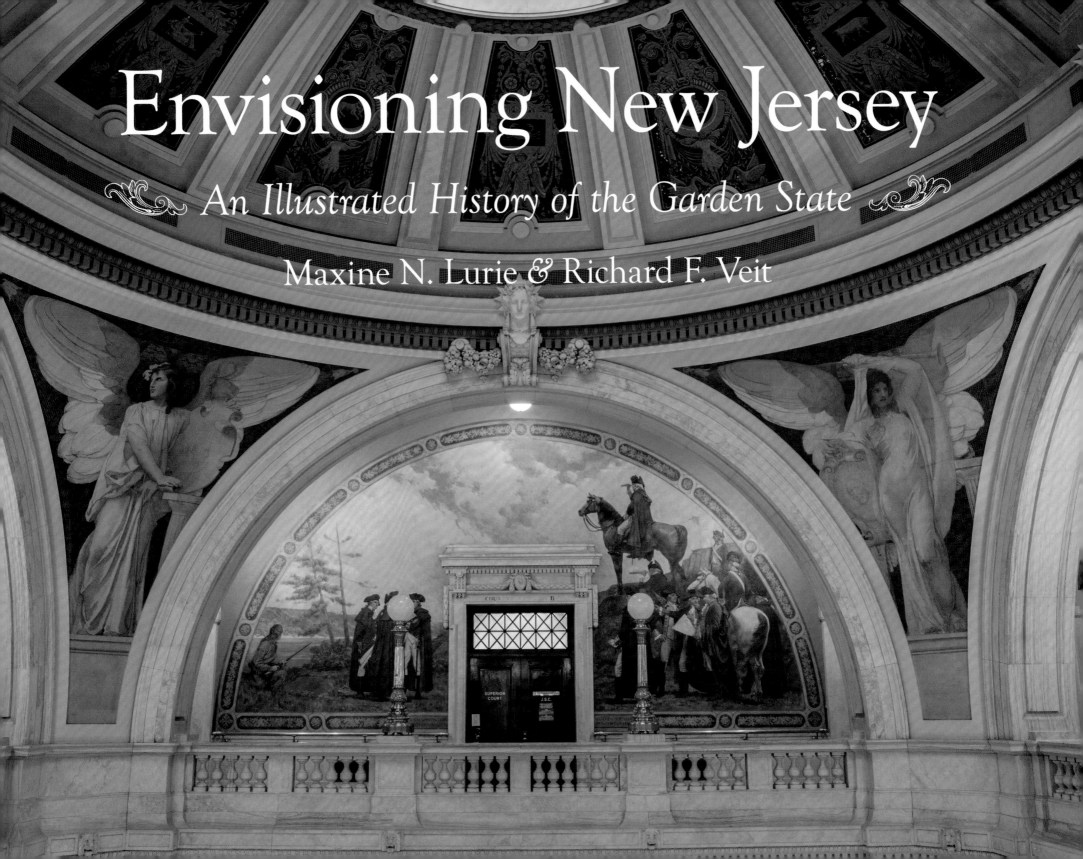

Envisioning New Jersey

An Illustrated History of the Garden State

Maxine N. Lurie & Richard F. Veit

Library of Congress Cataloging-in-Publication Data

Lurie, Maxine N., 1940– author.

Envisioning New Jersey : an illustrated history of the Garden State / Maxine N. Lurie and Richard F. Veit.

pages cm. — (Rivergate regionals)

Includes bibliographical references and index.

ISBN 978–0–8135–6957–4 (hardcover : alk. paper) — ISBN 978–0–8135–6968–0 (e-book : web pdf) — ISBN 978–0–8135–7358–8 (e-book : epub)

1. New Jersey—History. 2. New Jersey—History—Pictorial works. I. Veit, Richard Francis, 1968– author. II. Title. III. Title: Illustrated history of the Garden State.

F134.L87 2016

974.9—dc23

2015032513

A British Cataloging-in-Publication record for this book is available from the British Library.

NEW JERSEY COUNCIL
FOR THE HUMANITIES

This publication was made possible by a grant from the New Jersey Council for the Humanities, a state partner of the National Endowment for the Humanities. Any views, findings, conclusions or recommendations expressed in this publication do not necessarily represent those of the National Endowment for the Humanities or the New Jersey Council for the Humanities.

Copyright © 2016 by Maxine N. Lurie and Richard F. Veit

All rights reserved

No part of this book may be reproduced or utilized in any form or by any means, electronic or mechanical, or by any information storage and retrieval system, without written permission from the publisher. Please contact Rutgers University Press, 106 Somerset Street, New Brunswick, NJ 08901. The only exception to this prohibition is "fair use" as defined by U.S. copyright law.

Visit our website: http://rutgerspress.rutgers.edu

Designed and typeset by Bryce Schimanski

Manufactured in China

Richard F. Veit
dedicates this book to
his uncle Robert J. Veit,
whose love of books, history,
and photography has been
a lifelong inspiration.

Maxine N. Lurie
dedicates it in memory of
Susan Schrepfer,
friend and fellow historian,
for her help and encouragement
over many years.

Contents

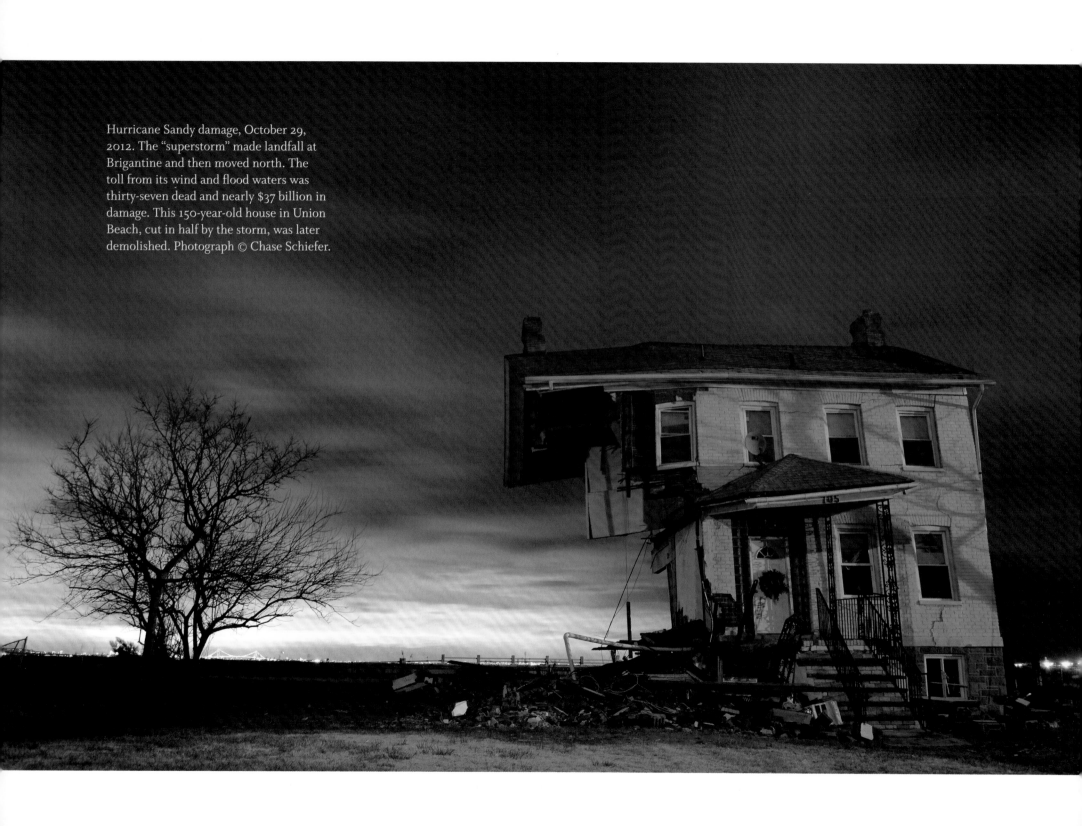

Hurricane Sandy damage, October 29, 2012. The "superstorm" made landfall at Brigantine and then moved north. The toll from its wind and flood waters was thirty-seven dead and nearly $37 billion in damage. This 150-year-old house in Union Beach, cut in half by the storm, was later demolished. Photograph © Chase Schiefer.

Preface

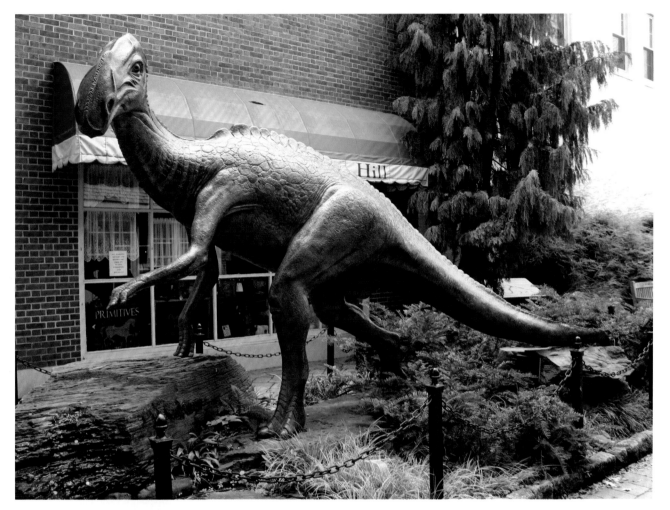

Hadrosaurus foulkii, 2003. In 1858, the Philadelphia abolitionist, prison reformer, and amateur geologist William Parker Foulke and the paleontologist Joseph Leidy unearthed the world's first nearly complete dinosaur skeleton at a site in Camden County. Measuring about thirty feet long, it created a sensation when put on display in 1868 at the Academy of Natural Sciences in Philadelphia, where the original skeleton still resides. This life-sized bronze sculpture by John Gionnatti in downtown Haddonfield is affectionately known as Haddy. Photograph by R. Veit

New Jersey is a small state in terms of area, but it has played a wide-ranging role in American history. As long-time teachers of and writers about New Jersey history, we are acutely aware of the challenges faced by individuals interested in researching and understanding New Jersey's past. Sources are scattered in disparate repositories across the state. Although many regional histories and photographic essays document particular areas and communities, there are no statewide visual histories. Our goal is to share some of the compelling stories from New Jersey's history through images in a way that will be accessible to the broadest possible audience.

The initial idea for an illustrated history came from the editorial staff at Rutgers University Press. Our research for *New Jersey: A History of the Garden State* had given us a glimpse of some of the incredible images tucked away in museums, libraries, archives, and historical societies across the state. After completing that book, we continued discussions with the Press about a visual history that would make a good companion piece. We all thought that the project would be easy to carry off. Instead, it proved far more complicated than anticipated, but also richly rewarding. We have learned more about New Jersey in the process, finding images in a wide variety of places, meeting new people, and having more than a few adventures along the way.

This book has been designed to complement the earlier history visually, and we hope that readers will use the two books together. Both follow, in ten chapters, the same chronological order. Together they show that New Jersey, sometimes seen as little more than a corridor between New York City and Philadelphia, has a long, rich, and complex history of its own.

Our co-authors in *New Jersey: A History of the Garden State* summarized the updated information about the state in each of the time periods they covered. The text in this book is deliberately more concise, and we urge readers to consult that longer work for the more detailed story. Also, in the bibliography at the end of each chapter here, we refer readers to the extensive citations there. Our thanks go to co-authors of that volume—John Fea, Graham Russell Gao Hodges, Michael Birkner, Larry Greene, Paul Israel, Brian Greenberg, G. Kurt Piehler, and Howard Gillette Jr.—for all the work they did that made this easier. That said, the words and interpretations here are our own.

This book is also part of the effort to celebrate the 350th anniversary of the creation in 1664 of the English colony called "Nova Caesera," New Jersey. Like that celebration, it begins with the geologic history of the region going back to the retreat of the glaciers, then traces occupation by early Native Americans and

Geological Map of New Jersey, 1889. New Jersey was a leader in scientific mapping in the nineteenth century. Under the direction of State Geologist George H. Cook (1818–1889), it was the first state to complete an accurate geological survey. Source: Special Collections and University Archives, Rutgers University Libraries.

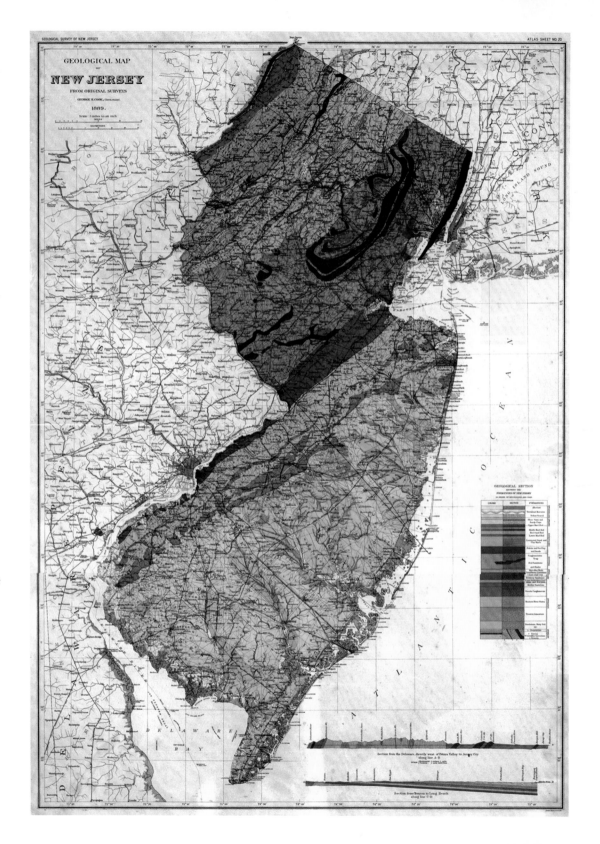

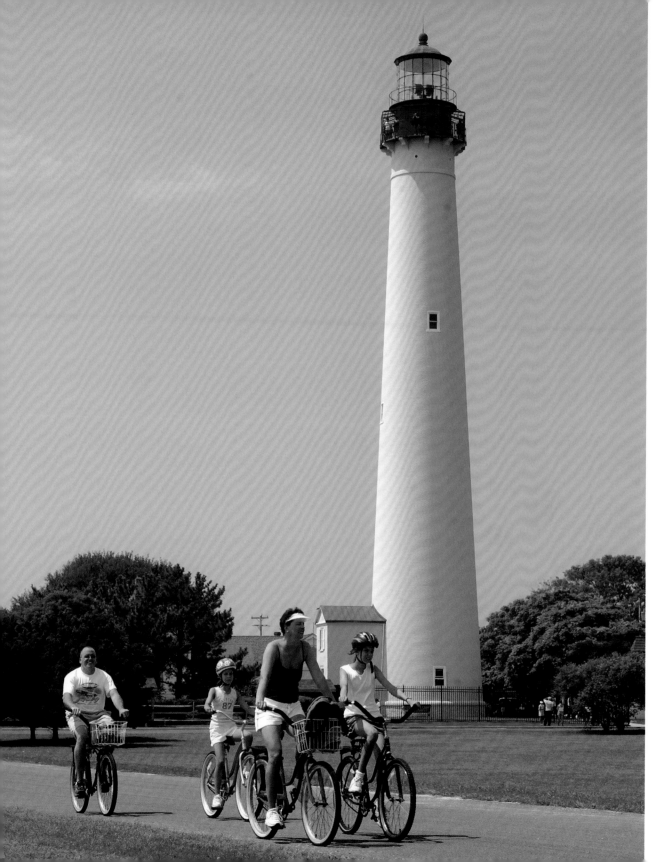

Cape May Lighthouse, built in 1859 (the third on the site) and automated in 1946, is still used to warn ships off Cape May Point, the entrance to Delaware Bay. Since 1988, it has also served as a museum and is open to the public for climbs to the top. Source: Mid-Atlantic Center for the Arts & Humanities, Cape May. Photograph by Craig Terry.

more recent settlers, and ultimately continues up to the present—ending with an image from the 350th celebration. The themes selected for the 350th—liberty, diversity, and innovation—repeatedly appear, as they are indeed woven into the state's history. While the images are here to tell a comprehensive story of the state's past, this is not an encyclopedia, and readers will surely think of many other images, and parts of the story, we could have included. The book is aimed at everyone curious to learn about New Jersey; teachers who, we hope, will use portions in their classrooms; and scholars, for whom we have included the sources of all images for further research.

Selection of these images proved to be daunting. The authors, together and separately, looked at thousands of possibilities. We picked those that helped explain the past, reproduced with reasonable clarity, illustrated the themes, and enabled us to make connections. As curators, we focused on important events in New Jersey and U.S. history, some dramatic, others reflecting gradual development, tried to be as inclusive as possible in terms of places and people, and then occasionally opted for the amusing. Some images were suggested by individuals or institutions; in other

instances we knew what we wanted to illustrate and hunted though collections, and the landscape around us, to find a particularly fitting example. The results of the wide net we cast are over 650 photographs, paintings, prints, material objects, legal and historical documents, trade cards, broadsides, postcards, maps, statutes, monuments, plaques, and more.

While looking at these pictures, the reader should think about the origins and purpose of some of the images. Often a painting presents the artist's version of an event rather than a literal depiction of what happened. Thus the famous image of *George Washington Crossing the Delaware* by Emanuel Leutze

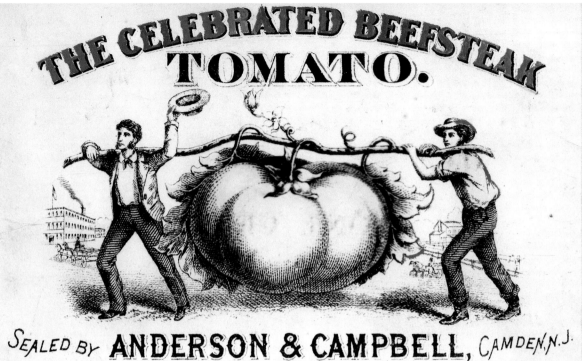

Label from a can of "The Celebrated Beefsteak Tomato," packed by Anderson and Campbell, Camden, nineteenth century. The Campbell Soup Company was started in 1869 by partners Joseph A. Campbell and Abraham Anderson, two South Jersey businessmen. Anderson left in 1876, and the company was later bought by long-time employee Arthur Dorrance, who continued to use the Campbell name. Source: Department of Agriculture, Office of the Secretary, Photograph Collection, item 4446. New Jersey State Archives, Department of State.

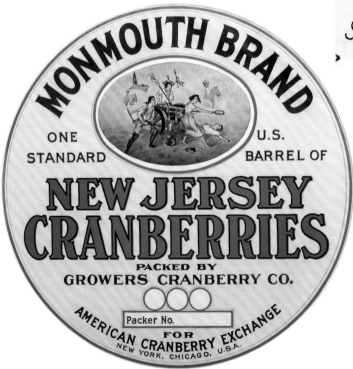

Label for "Monmouth Brand New Jersey Cranberries," packed by Growers Cranberry Company, early twentieth century. Cranberries are native to New Jersey and were used by the Indians. Commercial production started in 1840, and today the state is third in the nation in the amount produced, mostly in South Jersey bogs. Source: Chromolithograph on paper. Museum Collection, Monmouth County Historical Association, Freehold.

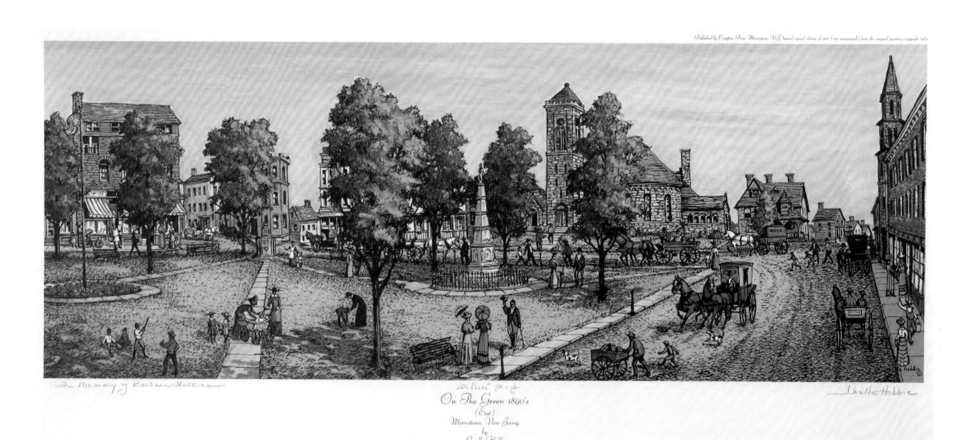

Published by Compton Press, Morristown, N.J. Issued signed edition of 900 (100 unnumbered) from the original painting, copyright 1964

In memory of Barbara Hobbie

On The Green 1890's
(East)
Morristown, New Jersey
by
Lucille Hobbie

Lucille Hobbie

On the [Morristown] Green, 1890's (East). Morristown, a small city in northern New Jersey, was the site of several encampments of the Continental Army during the American Revolution. After the Civil War, it became one of the wealthiest communities in the state as millionaires built great estates in the area. This charming painting by Lucille Hobbie (1915–2008) shows it during its heyday. Source: Courtesy of William and Frances Hobbie. From the collections of the North Jersey History & Genealogy Center, The Morristown and Morris Township Library.

was influenced by the European Revolutions of 1848. Photographers use the camera to frame a portion of what they are looking at; cartoonists simplify and use symbols that have a specific meaning that may not be apparent today. Seemingly bland documents can be very important in their wording and impact. All that said, we hope the reader will agree that seeing does help one understand history.

There is more to consider while looking at the images. Some are contemporary with the events or individuals they depict and can be considered primary sources: for example, the sword and flag of a British officer, Lieutenant Colonel Henry Monckton, who lost his life in the Battle of Monmouth. Others, created many years later, can be considered secondary sources, such as the Leutze painting mentioned above. Also, we have used photographs of historic

buildings to illustrate periods before that technology existed, black-and-white ones taken before color was widely available. Copyright restrictions sometimes made it difficult to use some modern images. On the other hand, images of New Jersey governors will be found scattered through the book. Not all have been included, but there is a larger proportion after adoption of the 1947 state constitution because that document significantly increased the role of the governor.

The illustrations included in this preface are deliberately varied and indicative of the bounty in the rest of the book. Two show the important role New Jersey played in American history in ways not usually brought to mind: the first discovery of a nearly complete dinosaur (Hadrosaurus) skeleton and the first complete scientific survey of a U.S. state's geography (1889). Garden State crops are shown with the images of cranberry and tomato products, while a 1920s song sheet pokes fun at the state's rural nature compared to Broadway. Numerous images in the rest of the book show how the state later became a major industrial center. Morristown is often and justly remembered for its role in the American Revolution, but it also was a place for the wealthy to establish weekend and summer homes in the late nineteenth century, while Long Branch in the same period welcomed presidents and then the fashionably dressed flappers of the 1920s. Towns still vary in their nature as do their inhabitants. The coast has long been dangerous, hence its string of lighthouses, while hurricanes have struck more

"When the Sun Goes Down in Jersey (Life Begins on Old Broadway)," sheet music, 1915. The lyrics by W. L. Beardsley, set to music by Ben Deely, poke fun at rural New Jersey compared to sophisticated Manhattan. Source: Courtesy of James F. Turk.

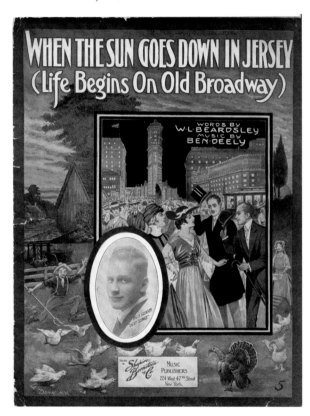

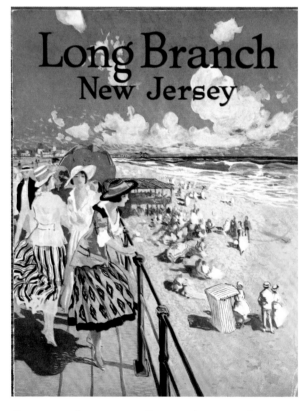

"Long Branch New Jersey," 1920. This poster featuring flappers at the Shore attests to the enduring popularity of Long Branch among New Jersey's famous seaside resorts. Source: Local History Room, Long Branch Free Public Library.

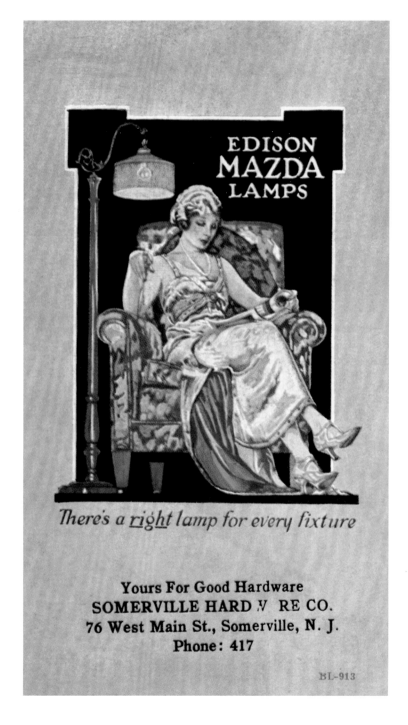

There's a <u>right</u> lamp for every fixture

Yours For Good Hardware
SOMERVILLE HARD V RE CO.
76 West Main St., Somerville, N. J.
Phone: 417

often than usually remembered, Sandy being the most recent and most devastating.

Finally, as we invite you into *Envisioning New Jersey*, we ask that you join us in thanking the many institutions and large number of individuals who helped make it possible. If you were inadvertently left off the list, we apologize, but do know that we appreciate your help. Particular thanks go to the entire staffs at the New Jersey State Archives and at Rutgers University Special Collections and University Archives, to those individuals and institutions that donated images, and to the funders without whom this volume would not be possible.

Maxine N. Lurie

Richard F. Veit

Advertisement for Edison Mazda Lamps, available from the Somerville Hardware Company. After 1909, these incandescent light bulbs were produced by General Electric in Harrison, Hudson County, the site of Thomas Edison's lamp factory. Although General Electric used a tungsten filament rather than the carbon filament patented by Edison, the inventor's name continued to appear as part of the Mazda trademark. Many of the company's advertisements were the work of Maxfield Parrish (1870–1966), a highly successful illustrator of the period, although it is not certain that he created this particular one. Source: New Jersey Trade Cards Collection, Special Collections and University Archives, Rutgers University Libraries.

Envisioning New Jersey

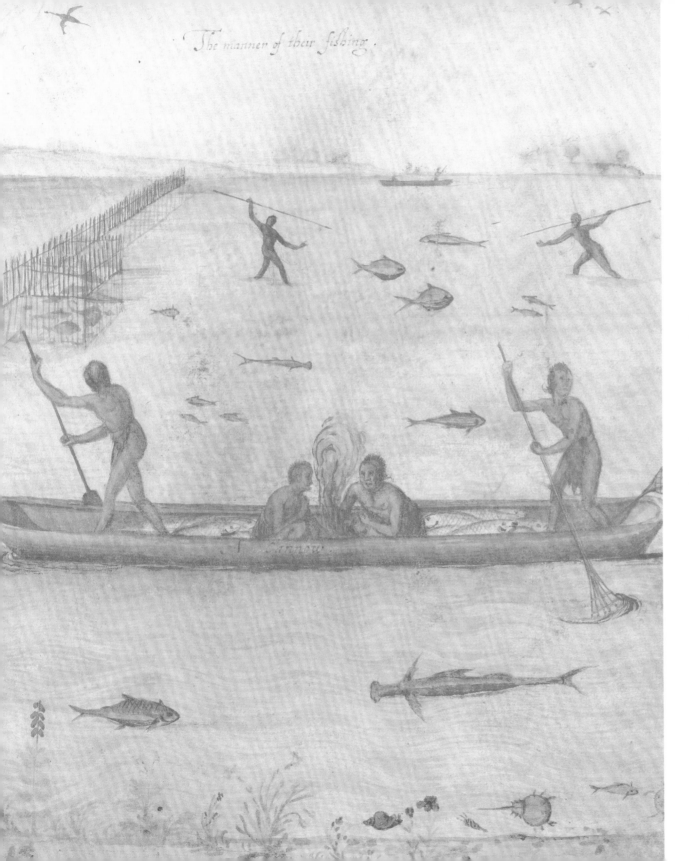

Beginnings

Archaeology and Indians, the Long Journey

Although New Jersey's written history began five centuries ago when the first explorers visited the Atlantic seaboard, its Native American heritage stretches back roughly 13,000 years. For that early period, archaeology, oral traditions, and ethno-history have revealed much about New Jersey's first inhabitants. In many ways, the story of New Jersey's Native Americans is a living story, for although many Native Americans left the state during the eighteenth and nineteenth centuries, others remained, and today their descendants continue to make important contributions to New Jersey's history and culture.

New Jersey's Native American inhabitants are generally referred to as the Lenape or Delaware Indians. The name "Lenape" means ordinary, real,

1

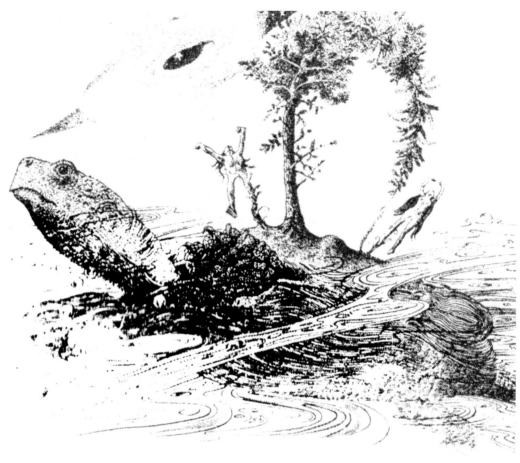

During the Pleistocene epoch, large mammals (megafauna) inhabited New Jersey. Their skeletons have been found at numerous locations across the state. This mastodon (*Mammut americanum*) was discovered in 1869 near Mannington in Salem County and is now displayed at the Rutgers Geology Museum. Photograph by R. Veit.

The Lenape Creation Myth, 1989. In this interpretation by Lenape artist William Sauts Netawuxme Bock, a woman and a man are created from a tree growing on the back of a turtle. Reproduced courtesy of the artist.

or original people. "Delaware" comes from the name of a seventeenth-century English governor of Virginia, Lord De La Warr. However, most Native Americans thought of themselves as members of particular bands, essentially extended families, of which there were several dozen, for example, Raritans, Sanhickans, and Navesinks. Here, for simplicity's sake, the terms "Delaware" and "Lenape" will be used to refer to New Jersey's Native American inhabitants during the colonial period and afterward. Earlier groups, whose names have been lost to time, will be referred to as Native Americans. The Lenape spoke Eastern Algonquian languages known to scholars as Munsee and Unami; Munsee was the dialect spoken in northern New Jersey, adjacent portions of Pennsylvania, and New York, and Unami was prevalent in southern New Jersey and adjacent parts of Pennsylvania and Delaware.

The Ice Age

Late Wisconsinian terminal and recessional ice margins
Illinoian limit
Pre-Illinoian Limit
Meltwater drainage
Glacial lakes

WALLKILL

PASSAIC

PEQUEST

BAYONNE

HACKENSACK

0 5
miles

Source: NJ Geological Survey

-N-

The Wisconsinian ice sheets may have been 2,000 feet thick above High Point, New Jersey

The ice sheets grew by withdrawing water from the oceans. As sea level dropped, the shoreline moved east

Shoreline about 20,000 years ago (sea level was about 400 feet lower)

Modern shoreline (for reference)

ATLANTIC OCEAN

Sea level has been rising since the ice sheet's retreat. If the polar ice caps were to completely melt, sea level would rise over 200 feet (the Statue of Liberty is 151 feet tall).

0 50
miles

© Rutgers University

In the 1870s, Charles Conrad Abbott, an amateur archaeologist from Hamilton Township, contradicted the then accepted wisdom that Native Americans had been present in the New World for only a few thousand years. Based on ancient stone tools he uncovered in the vicinity of Trenton, Abbott concluded that ancient human beings had once lived in the Delaware Valley. Ultimately, Abbott's finds were shown to be more recent than he had surmised, but his hypothesis that human beings had been in the Americas for more than 10,000 years has been vindicated. Since his pioneering work, many other archaeologists have expanded our knowledge of New Jersey's earliest inhabitants. In the early twentieth century, the State Geological Survey began systematically to document the locations of archaeological sites. Later, during the Great Depression, the Indian Site Survey, directed by Dorothy Cross, carried out excavations and documented private collections. More recently, federal and state laws have mandated a variety of archaeological investigations and contributed broadly to our understanding of New Jersey's past.

Today, archaeologists divide New Jersey's prehistory into three broad time periods: Paleo-Indian, Archaic, and Woodland. The Paleo-Indian period, which lasted from approximately 13,000 to 8,000 years before the present, began at the end of the last major ice age, when New Jersey's landscape was very

This map shows the extent of glaciers and the exposed continental shelf at the end of the Wisconsin Glaciation, roughly 12,000 years ago. Source: Map by Michael Siegel.

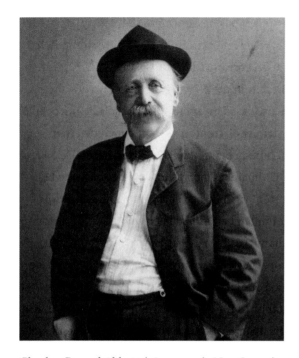

Charles Conrad Abbott (1843–1919), New Jersey's first well-known archaeologist, discovered ancient stone tools on his family's property in the vicinity of Trenton, which led him to believe that human beings had inhabited the Delaware Valley during the last Ice Age, well over 15,000 years ago. Although the artifacts he recovered were later shown to be more recent, he is important for his pioneering excavations. The property has been preserved as a national historic landmark. Source: Collection of the New Jersey State Museum. Reproduced with permission.

The Abbott Farm National Historic Landmark extends from Trenton in the north through Hamilton Township to Bordentown in the south. It has been the site of archaeological investigations since the late 1800s and has yielded some of the richest assemblages in the Delaware Valley. Source: Courtesy of Hunter Research.

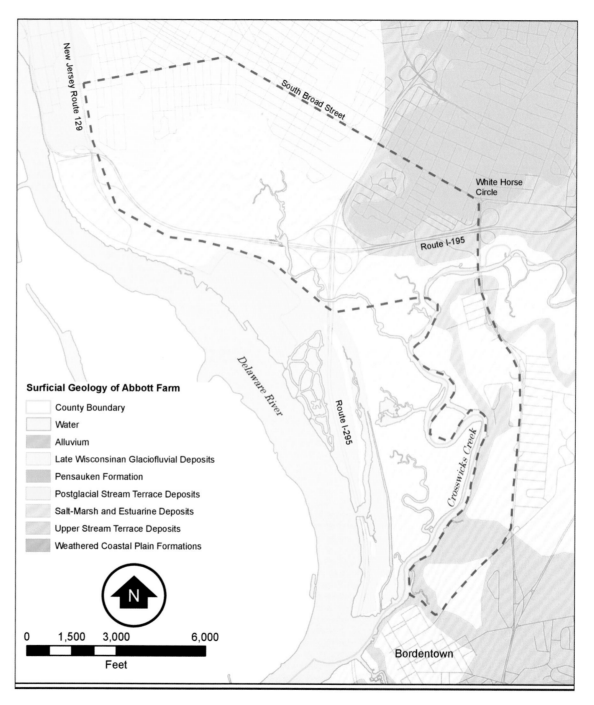

Surficial Geology of Abbott Farm

- County Boundary
- Water
- Alluvium
- Late Wisconsinan Glaciofluvial Deposits
- Pensauken Formation
- Postglacial Stream Terrace Deposits
- Salt-Marsh and Estuarine Deposits
- Upper Stream Terrace Deposits
- Weathered Coastal Plain Formations

N

| 0 | 1,500 | 3,000 | 6,000 |

Feet

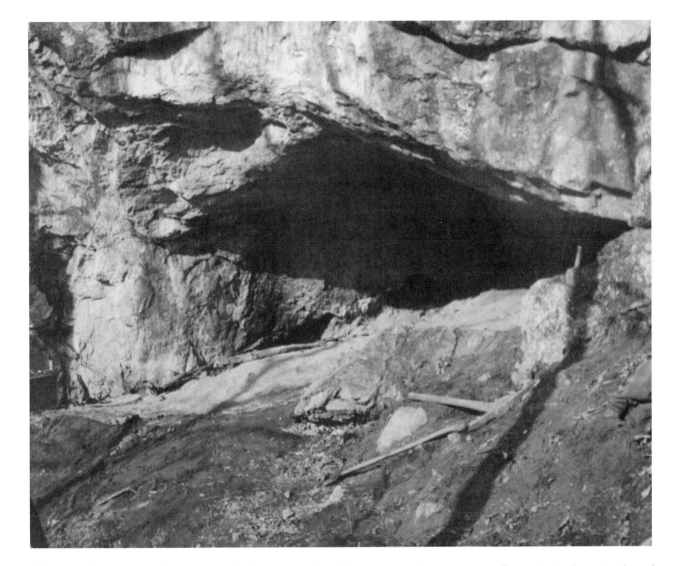

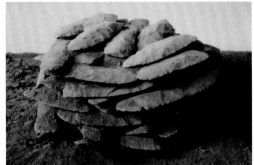

Dorothy Cross (1906–1972), New Jersey's first appointed state archaeologist, unearthed this cache of stone tools while conducting excavations at the Abbott Farm. Called Fox Creek blades by archaeologists, they were probably used to process large fish like shad, which swim up the Delaware River in the spring. Found with the blades was a long copper needle, the function of which is yet unknown. Source: Collection of the New Jersey State Museum. Reproduced with permission.

This cave near Jenny Jump Mountain, known as the Fairy Hole Rock Shelter, was used by Native Americans and has been studied by Dorothy Cross and others. Many early archaeologists were interested in rock shelters because of their similarities to the cave dwellings inhabited by prehistoric people in Europe. Source: Collection of the New Jersey State Museum. Reproduced with permission.

different. Glaciers, which once extended as far south as Metuchen and Perth Amboy, were retreating, and much of the continental shelf was dry, exposed land. The Paleo-Indians, the first Americans, probably emigrated across a land bridge from Asia. They arrived in a landscape inhabited by large mammals known as megafauna, such as mastodons and mammoths. They crafted distinctive stone tools, called fluted points, from high-quality chert or flint. Only a few Paleo-Indian sites have been carefully excavated. By 10,000 years ago, the megafauna had become extinct, the environment was warming, and new cultural adaptations were occurring.

Archaeologists label the next period in the culture history of eastern North America the Archaic period (8000–1000 B.C.). The break between this period and the Paleo-Indian was gradual and likely reflected adaptation to the

changing environment. The Archaic was character-ized by an increasing emphasis on gathering plant foods, fishing, and hunting animals. New tools came into use, such as the atlatl (spear-thrower), which allowed for more efficient hunting, as well as axes, celts, gouges, other woodworking tools, and netsink-ers. Some of the earliest human remains ever found in New Jersey are cremation burials excavated by Andrew Stanzeski at the West Creek Site in Ocean County, which date from the Early Archaic period. As time went on, larger settlements developed, often near major rivers. There is also increased evidence for the processing of seeds and nuts. New artifact types appear, such as bowls carved from soapstone, and there is considerable evidence for hunting, gathering, and fishing, as well as hot-rock cooking (stone-boiling). Shellfish also became a major food source, and shell mounds at Tuckerton and Keyport reflect the importance of this food source. Burials also become more common. At the end of the Late Archaic period, the first pottery appears in the state.

The final culture phase in New Jersey prehistory, known as the Woodland period, began roughly 3,000 years ago and ended with the beginning of European

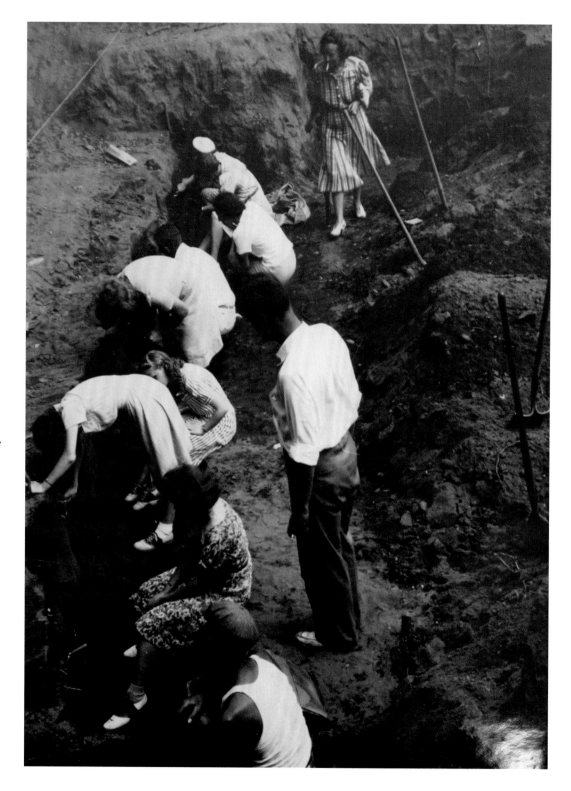

Dorothy Cross (1906–1972), upper right, leading a dig at the Abbott Farm. Cross was New Jersey's first appointed state archaeologist, a curator at the New Jersey State Museum, and a professor of anthropology at Hunter College in New York City. She led major excavations in the state for the federal Works Progress Administration. Source: Collection of the New Jersey State Museum. Reproduced with permission.

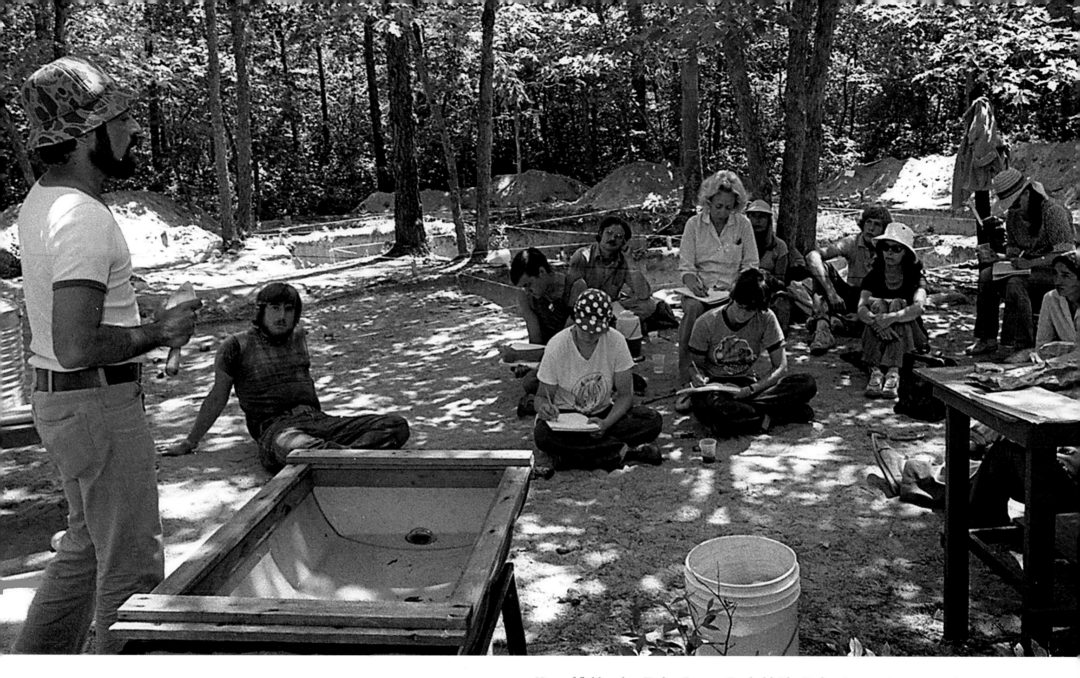

View of fieldwork at Turkey Swamp, Freehold. The Turkey Swamp site is unusual in that it contains archaeological deposits ranging from the late Paleo-Indian period to the contact period, c. 10,000 B.C.–A.D 1600. It was extensively studied by John Cavallo Sr. (left), who was associated with Monmouth and Rutgers Universities in the 1970s and 1980s. Source: Monmouth University, Department of History and Anthropology.

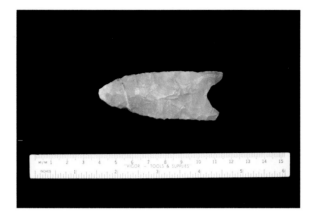

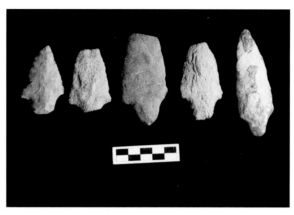

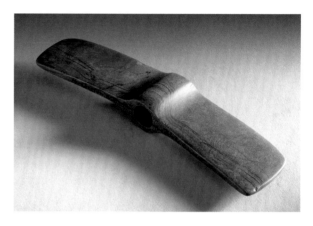

Clovis point from Beachwood, Ocean County. Archaeologists term the first well-documented ancient Native American culture the Clovis culture. Distinctive spear points made from fine stones and flaked with fluted bases are among the most important artifacts of this period. This example, which dates from roughly 12,000 years ago, is from the collection of the late Dorinda Brethwaite. Photograph by R. Veit. Reproduced courtesy of Doreen Brown.

Spear points from the Late Archaic period, c. 4000–1000 B.C. Stone tools are among the most common archaeological finds. These projectile points were likely used with darts or spears. They were found in Little Silver, Monmouth County. Source: Monmouth University, Department of History and Anthropology.

Indian atlatl weight. The atlatl is a long wooden handle that enabled a hunter to throw a dart or spear with great accuracy and force. Carved stone weights such as this one are believed to have been affixed to the atlatls. Source: Collection of the New Jersey State Museum. Reproduced with permission.

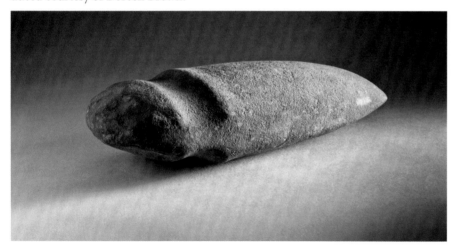

This finely wrought stone axe head from c. 8,000–1,000 B.C. was once hafted to a wooden handle. Three-quarter grooved axes such as this one were common during the Late Archaic period. Source: Collection of the New Jersey State Museum. Reproduced with permission.

Stone bowl from the Late Archaic period, c. 4000–1000 B.C. Carved from soapstone or steatite, bowls like this one are among the oldest surviving Native American containers. They were employed in food processing. Source: Collection of the New Jersey State Museum. Reproduced with permission. Photograph by R. Veit.

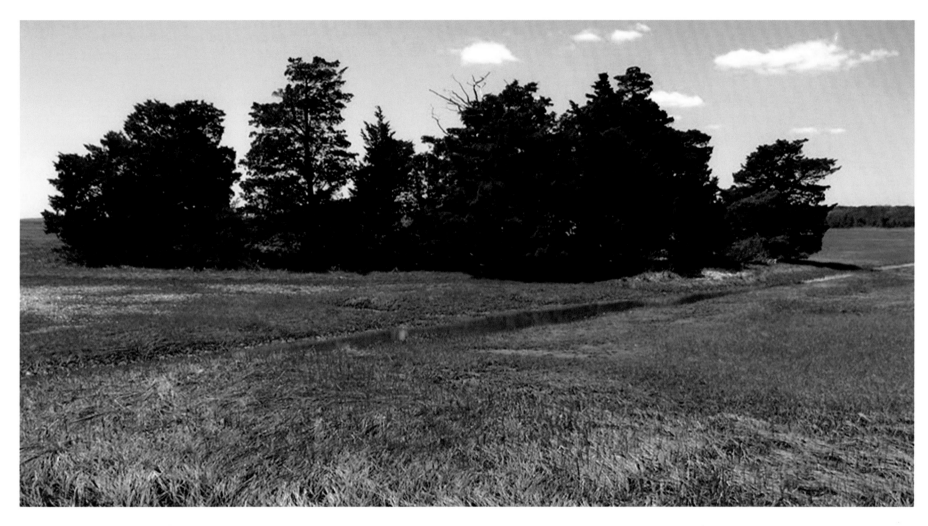

Composed almost entirely of clam and oyster shells, the Tuckerton Shell Mound represents the remains of thousands of meals eaten by Native Americans and deposited over centuries. Located in meadows south of Tuckerton in Ocean County, it has been a focus of archaeological study since the nineteenth century. Shell mounds, or middens, were once found at many locations along the coast and especially along Raritan Bay. Photograph by R. Veit.

contact 500 years ago. During this period, environmental conditions were generally similar to those today. Perhaps the most significant change at the beginning of the Woodland period was the expanded use of pottery. Ceramic vessels were an important technological innovation and made cooking and food storage much more efficient.

More elaborate burial rituals developed during the Woodland period. In Ohio and adjacent states, Native Americans were building extensive earthen mounds. Although we have no such mounds here, some burials contain exotic

grave goods, including stone pipes, copper artifacts, and large, thin, leaf-shaped stone blades.

Later, large stone blades flaked from argillite, called Fox Creek blades, became common. They may have served as knives and were associated with the processing of fish, such as shad and sturgeon, which made seasonal runs up the Delaware River and its tributaries. One of the richest sites from the Woodland period is the Abbott Farm in Hamilton Township, where a bountiful combination of natural resources was found in the Bordentown-Hamilton Marsh and associated uplands.

During, the Late Woodland period, which began roughly 1,000 years ago and continued until contact, there seems to have been an increase in population. Some of our best evidence about this period comes from excavations by the late Herbert Kraft in the Upper Delaware Valley. They revealed that families lived in small wigwams and longhouses. Small triangular projectile points, stone pendants, and clay tobacco pipes all became more common. Bodies in graves were tightly flexed or folded, and grave goods were rare.

An explorer arriving in New Jersey in A.D. 1600 would have found a land that was populated by roughly 12,000 Native Americans. They lived in relatively small groups, called bands. Their society was organized in an egalitarian manner, which emphasized flexibility and consensus over hierarchy.

The earliest surviving European report of New Jersey dates from 1524, when Giovanni Verrazano, an Italian navigator sailing for the French, explored the Atlantic coast of North America. Later, in 1609, Henry Hudson, a Dutchman sailing for the English, navigated the New England coast. Hudson and his men at first interacted peacefully with the Lenape but later came into conflict with them.

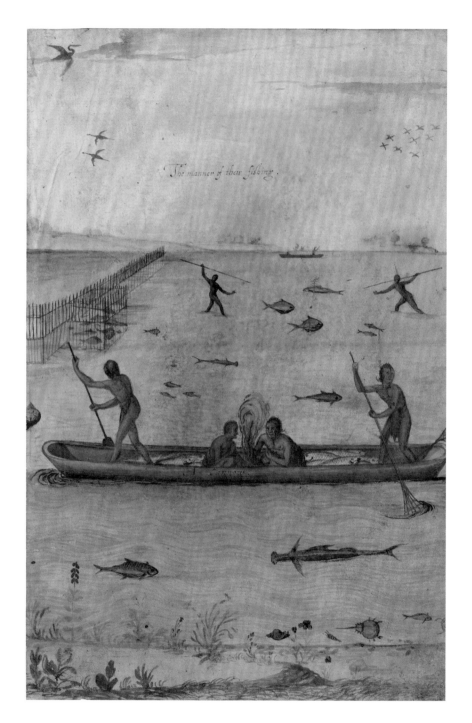

The manner of their fishing, c. 1585–1593. John White (c. 1540–1593) made studies for this watercolor when he accompanied Sir Richard Grenville's 1585 expedition to North Carolina. The scene shows fishing techniques similar to those used in New Jersey. White later served as the first governor of the Roanoke Colony. Source: 1906,0509.1.6, © The Trustees of the British Museum. All rights reserved.

This stone weir in the Passaic River between Paterson and Fair Lawn reminds us of the importance of fish as a major food source for New Jersey's Native American inhabitants. The strategically placed rocks forced the fish to locations where they could be caught easily. Photograph by Anthony DeCondo.

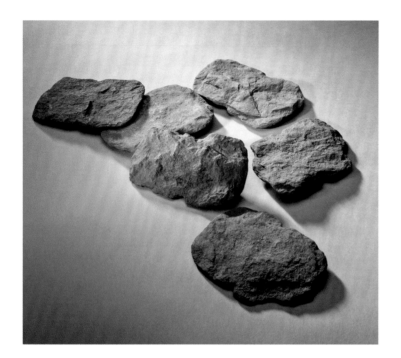

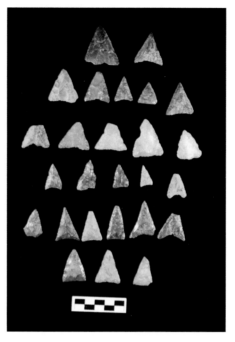

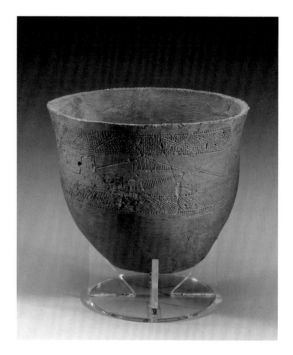

Native Americans used carefully made nets for fishing and attached netsinkers, chipped stones like these, to weigh them down. Source: Collection of the New Jersey State Museum. Reproduced with permission.

Triangular projectile points from the Late Woodland period, c. A.D. 900–1600. The bow and arrow were late introductions to North America. These stone arrow points would have been attached to fletched arrow shafts. They were found in Little Silver, Monmouth County. Source: Monmouth University, Department of History and Anthropology. Photograph by R. Veit.

Pottery vessel from the Late Woodland period, c. A.D. 900–1600. Pottery was long employed by New Jersey's Native American inhabitants, with varied forms, decorations, and manufacturing characteristics used during different time periods. Source: Collection of the New Jersey State Museum. Reproduced with permission.

In 1624, the first European settlement in New Jersey was established by Cornelius Jacobsen Mey on Burlington Island in the Delaware River. It was short-lived. The Dutch and their English contemporaries were particularly interested in furs, which were in great demand in Europe at the time. In return for the furs, the Delaware received beads, brass kettles, tools, European clothes, tobacco pipes, guns, knives, fishhooks, swords, and wampum. Thrust from a simple trading economy into a global capitalist one, the Lenape found these new European materials invaluable. Copper, which had long been precious to Native Americans, and other metals were now readily available through trade. Metal tools helped facilitate the production of shell beads, or wampum, which functioned as a currency and was valued as well for personal ornamentation, diplomacy, and symbolic communication.

At the same time, the introduction of disease and alcohol was disastrous, as they greatly reduced and debilitated the Native American population. Further

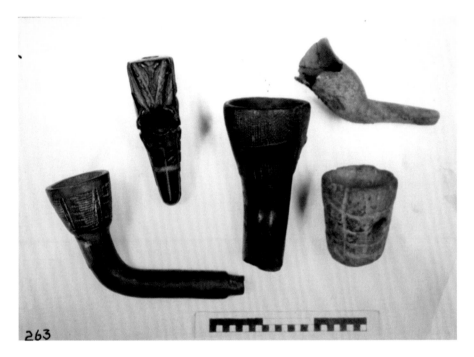

Native American pipes from the Late Woodland period, c. A.D. 900–1600. Native Americans smoked tobacco ritually. Some clay pipes were heavily ornamented and were likely treasured by their owners. Source: Collection of the New Jersey State Museum. Reproduced with permission.

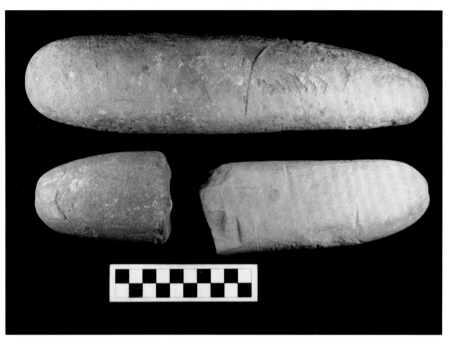

Stone pestles such as these were carefully shaped from sandstone. They were used in conjunction with wooden and stone mortars to process nuts and seeds for food. Source: Monmouth University, Department of History and Anthropology. Photograph by R. Veit.

complicating matters for the Lenape, first the Dutch and then, for a brief period, the Swedes claimed colonies within what is now New Jersey. Small Dutch settlements or patroonships were established in Hudson and Bergen Counties. Relations between the Lenape and the Dutch deteriorated after Willem Kieft became director general of New Netherland. In 1643, soldiers sent by Kieft infamously massacred a large group of Wiechquaeskeck Indians who had sought refuge at Pavonia, today's Jersey City. The survivors retaliated, decimating the Dutch settlements

in northeastern New Jersey and Staten Island. Peter Stuyvesant, a more competent governor, arrived in 1649. Even though he emphasized diplomacy rather than confrontation, fighting continued sporadically through the early 1660s.

In 1664, the English conquered New Netherland, and new settlers flooded into the colony. The eighteenth century saw New Jersey's Native American populations shrink. Many of the Munsee of northern New Jersey moved west into Pennsylvania. In 1737, the infamous Walking Purchase

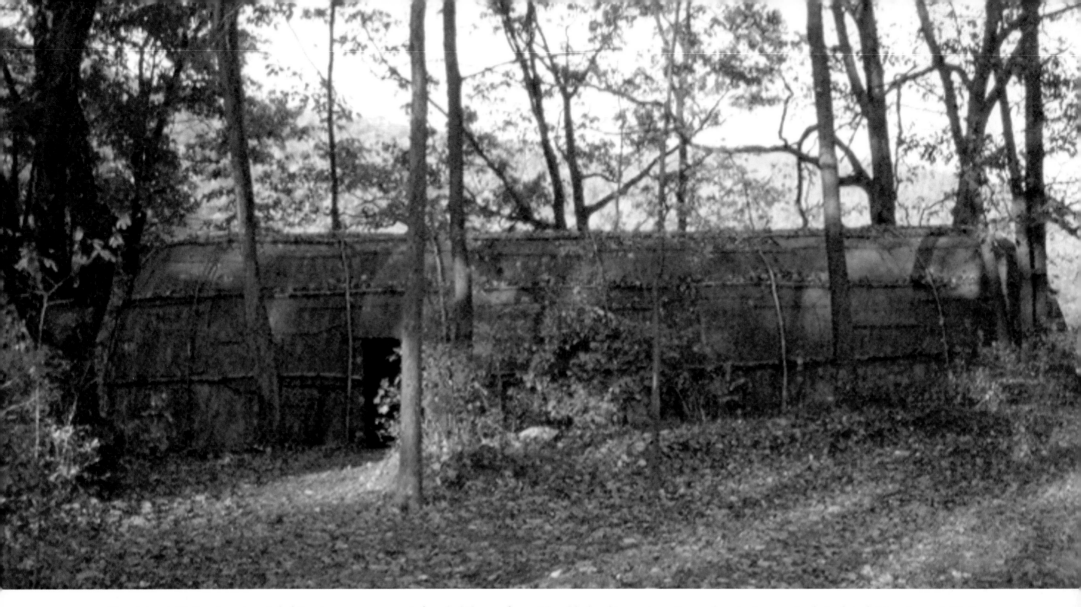

New Jersey's Native American inhabitants erected a variety of dwelling forms. At the Miller Field site in Warren County, archaeologist Herbert Kraft found traces of longhouses dating from the Late Woodland period. John Kraft constructed this reproduction of a longhouse at Winakung, the Lenape Village at Waterloo Village, Stanhope. Photograph by R. Veit.

defrauded them of considerable land in eastern Pennsylvania. Increasingly isolated, New Jersey's Native Americans worked hard to preserve their traditional lands.

For some Delaware, religion provided solace. Moravian and Presbyterian missionaries were particularly active among the Lenape. In 1746, David Brainerd, a young Presbyterian minister, began mission work among the Lenape. The next year, Brainerd established a community called Bethel in what is now Monroe Township. Brainerd hoped to teach the Delaware to farm according to the English model, with men, rather than women, working in the fields. When David Brainerd died in 1747, his brother John Brainerd succeeded him.

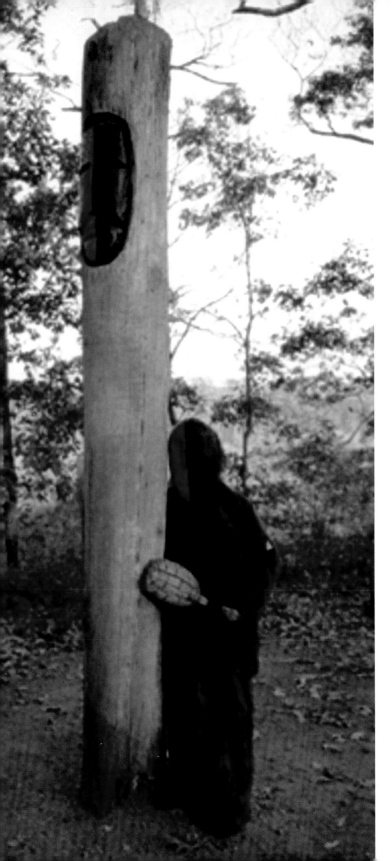

Despite initial successes, disease carried off many of the converts and led to disaffection among the survivors. In 1755, the Bethel community disbanded.

The French and Indian War (1754–1763) posed another challenge. Indians had to register as loyal subjects or they might be accused of working for the enemy; even then, some Indians were killed. In an attempt to redress the precarious situation of the Indians, three conferences were held, two in Crosswicks and one in Easton, Pennsylvania, which aimed to end the most egregious abuses of Native Americans. One byproduct of these meetings was the sale of the remaining Indian lands in northern New Jersey and the establishment of a reservation called Brotherton in today's Shamong Township. In addition to houses, the community had a store, a gristmill, a sawmill, a church, and a burying ground. A sister community, called Wepink, was located to the west of present-day Vincentown. Finally, in 1802, the Brotherton Indians sold their lands and removed to New York State, where they settled among the Stockbridge Indians.

During the eighteenth century, many other Lenape moved west to escape the settlers and live more traditional lives. Some rejected European goods and ideas, and a few participated in military campaigns against the English. In 1778, during the American Revolution, one group of Delaware signed a treaty with the United States. They were the first Indian nation to do so.

The odyssey of the Delaware Indians continued during the nineteenth century as they moved farther west to Wisconsin, Missouri, Kansas, and Oklahoma. By the early twentieth century, the remaining Delaware were living primarily in Oklahoma, Kansas, Wisconsin, and Ontario, Canada. However, some Delaware remained on the East Coast. Today, only a few individuals can speak the language fluently, but some elders have continued to pass on their traditions to their children. Native Americans in New Jersey and surrounding states, descendants of the Lenape and other Native American groups, such as the Ramapough Mountain Indians, the Sand Hill Band, the Nanticoke Lenni Lenape, and others, have worked to determine the best paths for their groups in the twenty-first century. They continue to celebrate their rich heritage and are playing an increasing role in shaping their own future by determining how their past is interpreted.

Reconstructed Mesingw at Winakung, the Lenape Village at Waterloo Village, Stanhope. The Mesingw, or Living Solid Face, is a spirit being of great importance to the Lenape. Usually depicted with a face half red and half black, Mesingw is the protector of the animals of the forest. Photograph by R. Veit.

BIBLIOGRAPHY

General books on the New Jersey's Native American heritage include: Clinton Welsager,

Portrait of Henry Hudson (d. 1611) by an unknown artist. An English sailor working for the Dutch East India Company, Hudson was looking for a passage to China. In 1609, he explored the coast of what is now New Jersey and New York, sailing up the river that bears his name. Source: Image 1266428, Print Collection, Miriam and Ira D. Wallach Division of Art, Prints and Photographs, The New York Public Library, Astor, Lenox and Tilden Foundations.

The Delaware Indians: A History (New Brunswick: Rutgers University Press, 1972); Herbert C. Kraft, *The Lenape Delaware Indian Heritage 10,000 B.C. to A.D. 2000* (Elizabeth, N.J.: Lenape Books, 2001); R. Alan Mounier, *Looking Beneath the Surface: The Story of Archaeology in New Jersey* (New Brunswick: Rutgers University Press, 2003); Robert Grumet, *The Munsee Indians: A History* (Norman: University of Oklahoma Press, 2009); Amy Schutt, *Peoples of the River Valleys: The Odyssey of the Delaware Indians* (Philadelphia: University of Pennsylvania Press, 2007); and Jean Soderlund, *Lenape Country: Delaware Society before William Penn* (Philadelphia: University of Pennsylvania Press, 2014). The *Bulletin of the Archaeological Society of New Jersey* contains numerous relevant articles. For a detailed list of the recent literature, articles as well as books, see the citations from Richard Veit, "Setting the Stage: Archaeology and the Delaware Indians, a 12,000-Year Odyssey," in *New Jersey: A History of the Garden State*, ed. Maxine N. Lurie and Richard Veit (New Brunswick: Rutgers University Press, 2012).

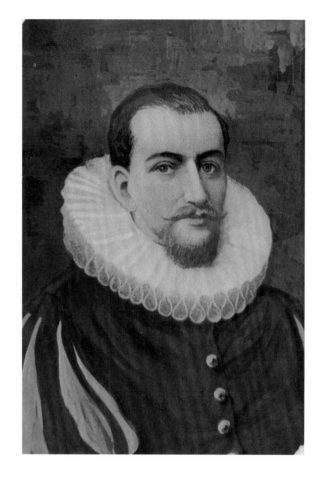

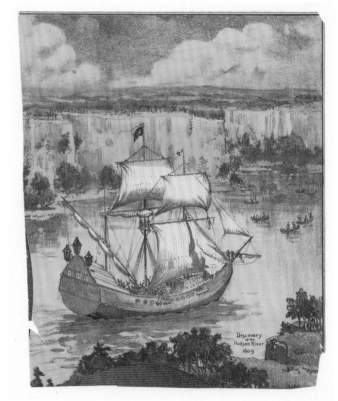

Discovery of the Hudson River, 1609, by an unknown artist. Henry Hudson's ship, the *Halve Maen/Half Moon*, sails upriver with the Palisades in the background. Source: Image 1263048, Print Collection, Miriam and Ira D. Wallach Division of Art, Prints and Photographs, The New York Public Library, Astor, Lenox and Tilden Foundations.

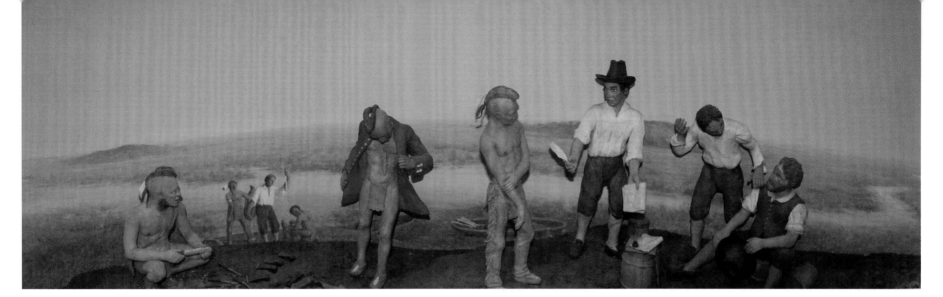

A diorama showing the English explorer Captain Thomas Young trading with Native Americans along the Delaware River in the mid-seventeenth century. This scene was created in the 1930s by artists employed by the federal Works Progress Administration. The goods depicted reflect the types of items the Lenape received from Dutch, Swedish, and English traders in return for furs, corn, and land. Source: Collection of the New Jersey State Museum. Reproduced with permission. Photograph by R. Veit.

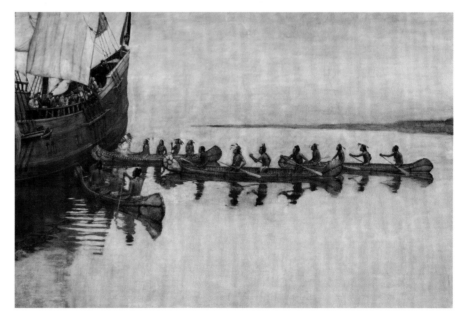

The Coming of the Dutch, c. 1910. This is one of three large murals by Howard Pyle (1853–1911) in the Freeholders' Room of Hudson County's William J. Brennan Courthouse, Jersey City. In this peaceful scene, a Dutch vessel, perhaps Henry Hudson's *Half Moon*, is greeted by a party of Native Americans in canoes. Although interactions like this did occur, the portrayal of Native Americans paddling birch bark canoes and wearing feathered headdresses has more to do with early twentieth-century views of American Indian culture than historical accuracy. At the time, Pyle was a celebrated illustrator and teacher known for using his brush to tell a story. Photograph © Mark Ludak.

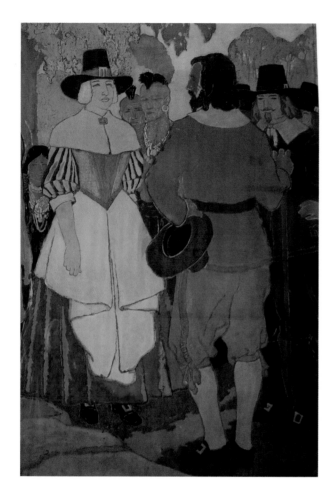

Sarah Kiersted, a Dutch settler who lived in Bergen County in the late seventeenth century, as depicted in a Works Progress Administration mural from 1936. Kiersted learned to speak the local native language and then served as a translator for many Native American land sales. A Hackensack leader, possibly Oratam, rewarded her for these services with a substantial tract of land. The mural is located in the gymnasium of the Anna C. Scott School, Leonia. Photograph by R. Veit; the left side of the image has been cropped.

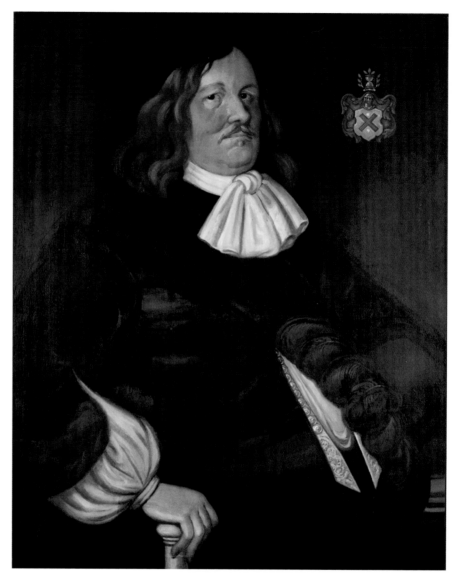

Johan Printz (1592–1663), the governor of New Sweden from 1643 to 1653, was a large man, supposedly called "Big Tub" by local Indians. Challenged by Dutch claims to the Delaware Valley and by a lack of support from home, he returned to Sweden in 1653, two years before the Dutch took over the colony. Source: Copy by Edward Berggren, 1938, after an original by an unknown artist. American Swedish Historical Museum, Philadelphia.

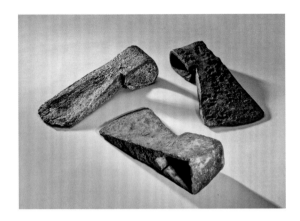

Metal tools, such as these iron trade axes recovered from archaeological sites in the Upper Delaware Valley, were invaluable to Native Americans. They facilitated felling trees and were more efficient than stone axes. Source: Collection of the New Jersey State Museum. Reproduced with permission.

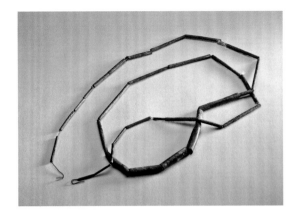

Bead necklace. Source: Collection of the New Jersey State Museum. Reproduced with permission.

Wampum beads, or sewant, made from clam shells. Wampum served as a currency, with the purple/black beads worth twice as much as the white ones. They could also be used for personal adornment, as tokens of important occasions such as treaties, and in religious rituals. Prized by the Lenape and their contemporaries, wampum was made by both Native Americans and Europeans. Source: Collection of the New Jersey State Museum. Reproduced with permission.

Seventeenth-century Dutch trade beads. Glass beads, such as these recovered from a site in Trenton, were among the goods European traders and colonists offered to Native Americans, who incorporated them into their religious and social rituals. Source: Peabody Museum of Archaeology & Ethnology, Harvard University, Cambridge, Massachusetts.

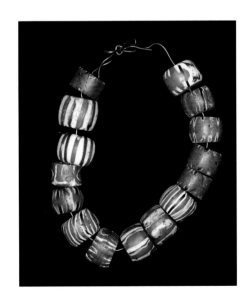

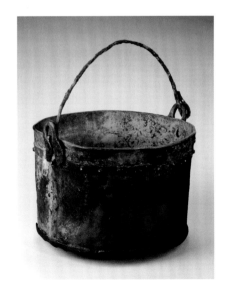

Kettles made from brass were among the most prized of trade goods. They were sturdier and traveled better than Native American pottery. They could also be cut up and reused as ornaments and projectile points, among other useful items. This example was found in the Upper Delaware Valley and likely dates from the late 1600s. Source: Collection of the New Jersey State Museum. Reproduced with permission.

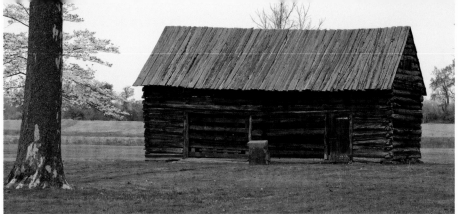

Seventeenth-century Swedish granary, Greenwich, Cumberland County. A rare architectural survivor from the state's early colonial period, this farm structure illustrates the log building techniques brought to the New World by the Swedes and Finns who settled in the Delaware Valley. The left part of the building was for animals, and the right part sheltered the family. Photograph by Janet L. Sheridan.

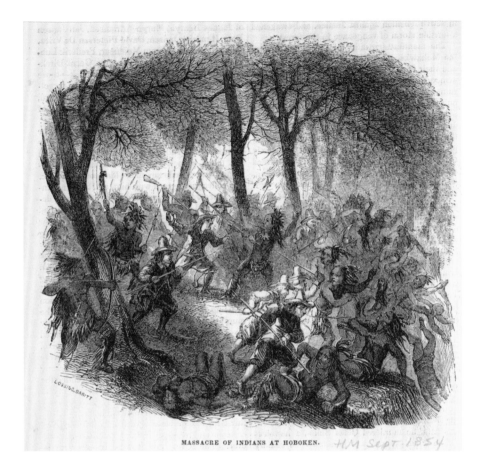

Massacre of Indians at Hoboken. This nineteenth-century image shows the 1643 massacre perpetrated by Dutch soldiers on Wappinger Indians encamped at Pavonia in what is now Jersey City. The attack was carried out at the behest of Willem Kieft (1597–1647), governor general of New Netherland, and resulted in extensive loss of life. It united local Native Americans against the Dutch and led to two years of warfare. Source: Wood engraving by Lossing & Barritt from *Harper's Magazine* (September 1854). Image 808018, Picture Collection, The New York Public Library, Astor, Lenox and Tilden Foundations.

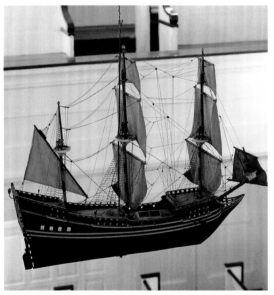

Ship Model in Gloria Dei Church, Known as "Old Swedes" Church, Dedicated in 1700 in Philadelphia, Pennsylvania, c. 1980–2006. This ship model hanging from the ceiling of Gloria Dei Church represents the *Kalmar Nyckle*, one of two ships that brought the first settlers to New Sweden in 1638. Gloria Dei, also known as "Old Swedes," is Philadelphia's oldest church building. Source: Photograph by Carol M. Highsmith (1946–). Image LC-HS503–3220, Carol M. Highsmith Archives, Library of Congress, Prints and Photographs Division, Washington, D.C.

Map of Manhattan [*Manatus Gelegen op de Noot Riuier*], 1639, copied c. 1665–1670. The earliest known portrayal of Manhattan and its environs, this manuscript map after the original by Johannes Vingboons (c. 1616–1670) shows early Dutch settlement on the west side of the Hudson River near what eventually became Jersey City and Hoboken. Source: Library of Congress, Geography and Map Division, Washington, D.C.

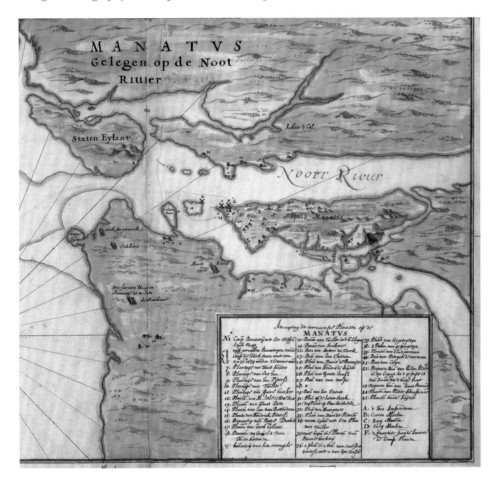

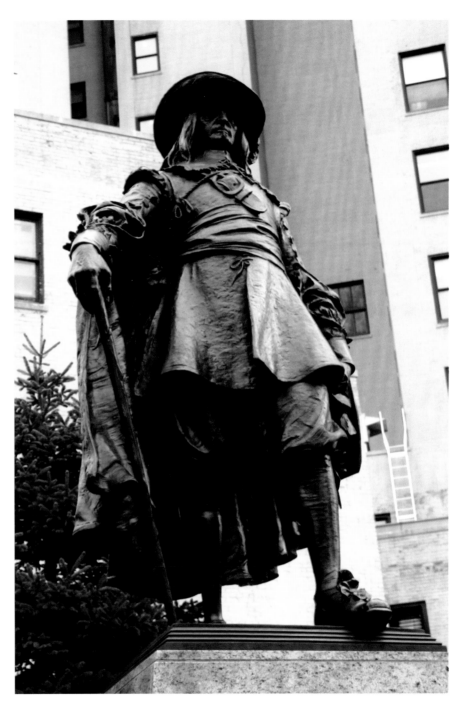

Peter Stuyvesant, 1913. Stuyvesant (1592–1672), director general of New Netherland for seventeen years, has been seen as authoritarian but effective in encouraging the growth of the colony, including portions of what became New Jersey. This statue by J. Massey Rhind (1860–1936), commissioned to commemorate the 250th anniversary of the founding of the village of Bergen in 1660, is owned by Jersey City. Photograph by R. Veit.

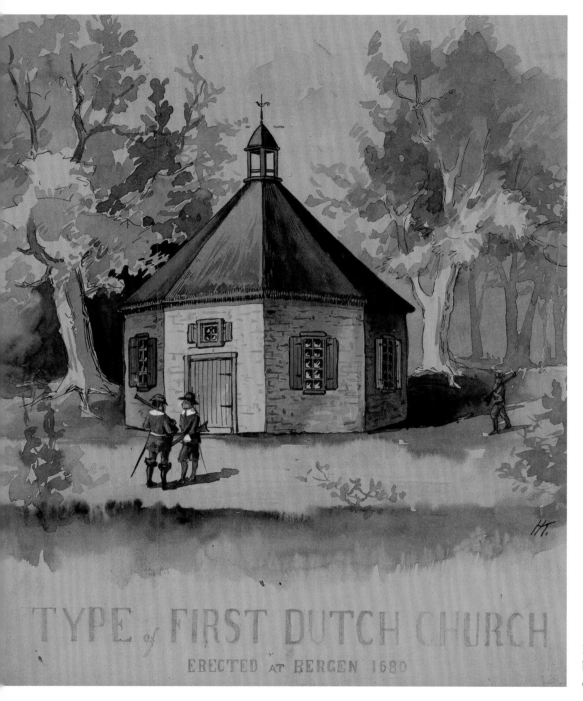

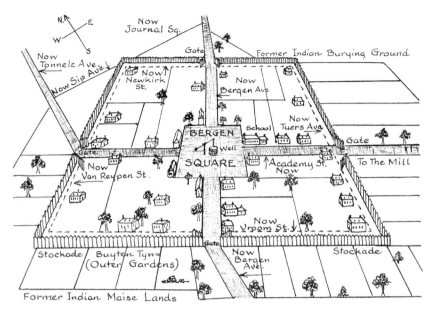

THE FORTIFIED VILLAGE OF BERGEN—SEPTEMBER 8, 1664.

The Fortified Village of Bergen—September 6, 1664. Bergen was the first permanent European settlement on the west side of the Hudson River. Today, Bergen Square is located in downtown Jersey City. Source: From Walter Francis Robinson, *The Drama of 1664: (as seen from) Old Bergen Township* (Jersey City: Hudson County Tercentenary Committee, c. 1964). Jersey City Free Public Library.

Lithograph by an unknown artist showing the Dutch Reformed church built in Bergen in 1680. Some of the first Dutch churches, including this one, had an octagonal form. Source: Jersey City Free Public Library.

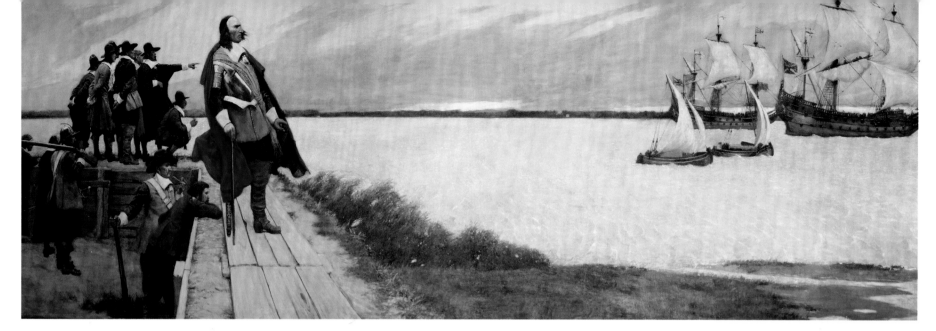

The Coming of the English, c. 1910. In this mural by Howard Pyle (1853–1911) in the Freeholders' Room of Jersey City's William J. Brennan Courthouse, Dutch residents of New Amsterdam and Peter Stuyvesant watch as the English fleet arrives in 1664. Stuyvesant wanted to resist the English invasion, but the city's leaders demurred. Photograph © Mark Ludak; image cropped to eliminate heating ducts on both sides.

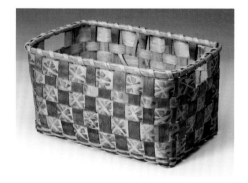

In the colonial period, basket making was a popular cottage industry among Native Americans. This locally made basket is purported to have been found in the Perth Amboy house of Lord Neill Campbell, who served as deputy governor of East Jersey in 1686. Source: Collection of the New Jersey State Museum. Reproduced with permission. Photograph by R. Veit.

Indian sale of land on the west side of the Hudson River to Baltard Hart, May 19, 1671. Some of the hundreds of surviving deeds that record the transfer of Native lands to the Dutch and English also list the items received in trade. Source: Department of State, Secretary of State's Office, Deeds, Surveys & Commissions, East Jersey: Deed Book 1, Part A (1650–1672), page 115. New Jersey State Archives, Department of State.

Signature page of an Indian sale of land on the west side of the Hudson River, May 19, 1671. Note the diversity of the signatures, some of which are clearly letters while others are symbols of now uncertain meaning. Source: Department of State, Secretary of State's Office, Deeds, Surveys & Commissions, East Jersey: Deed Book 1, Part A (1650–1672), page 116. New Jersey State Archives, Department of State.

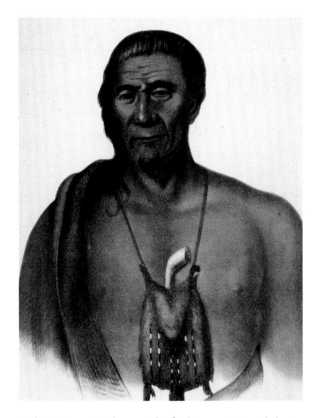

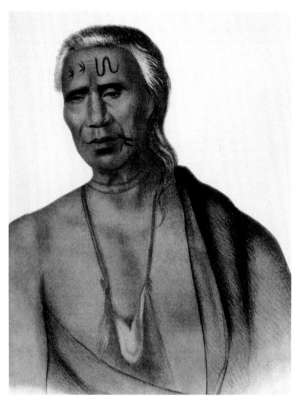

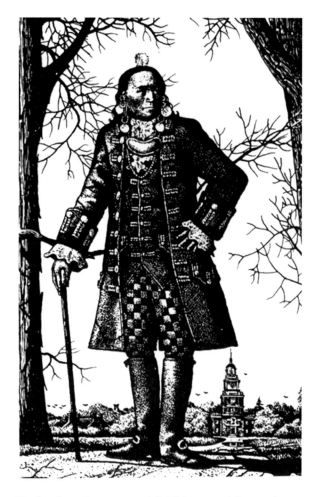

Tish-Co-Han. A Delaware Chief. This portrait and that of Lap-Pa-Win-Soe are the only surviving images of early Delaware leaders. Both lived in New Jersey and Pennsylvania, and were forced to accede to the infamous Walking Purchase of 1737, by which the Delaware lost title to much of eastern Pennsylvania. The fraud isolated the remaining Native Americans in New Jersey. Source: Hand-colored lithograph after a portrait by Gustavus Hesselius (1682–1755), 6 1/16 x 6 1/16 in. From Thomas L. McKenney and James Hall, *History of the Indian Tribes of North America*, octavo ed. (Philadelphia: J. T. Bowen, 1842–1858). Collection of the New Jersey State Museum. Museum purchase, FA1980.49.17. Reproduced with permission.

Lap-Pa-Win-Soe. A Delaware Chief. Source: Hand-colored lithograph after a portrait by Gustavus Hesselius (1682–1755), 5 7/8 x 5 5/8 in. From Thomas L. McKenney and James Hall, *History of the Indian Tribes of North America*, octavo ed. (Philadelphia: J. T. Bowen, 1842–1858). Collection of the New Jersey State Museum. Museum purchase, FA1980.49.16. Reproduced with permission.

Teedyuskung (c. 1709–1763). This portrait by modern Native American artist William Sauts Netawuxme Bock shows the Lenape leader and diplomat who played an important role in the French and Indian War. Born near Toms River, Teedyuskung lived much of his life in New Jersey and Pennsylvania. Reproduced courtesy of the artist.

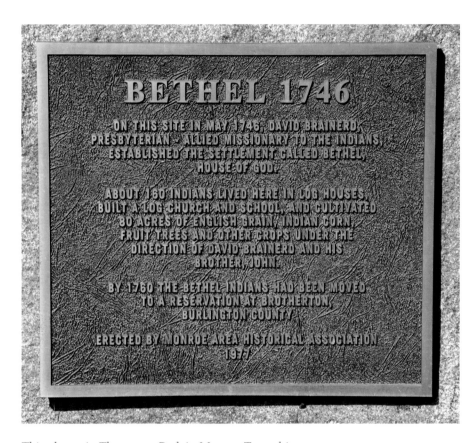

This plaque in Thompson Park in Monroe Township marks the approximate location of Bethel, a community of Christian Indians who lived in central New Jersey in the 1740s and later moved to the reservation at Brotherton. Photograph by R. Veit

First page of an Indian indenture releasing land to the Province of New Jersey, signed by sachems. Incorrectly cited as a "treaty," this document was a result of the agreement at Easton, 1758, whereby Indian signers gave up all remaining claims to much of their land in New Jersey. Source: Northampton County Historical & Genealogical Society, Easton, Pennsylvania. All rights reserved.

Gentlemen

I will transmit to England to be laid before his Majesty your petition for a Licence to raise money for his Service & will use my utmost endeavours to obtain a power for that purpose. As for the present necessity The Service you want to provide for is of so important a nature that it would give me great concern to have it defeated thro' my disability. I must therefore desire that you would, if possible, find some expedient, that, if not strictly conformable to the letter of my instruction, may be at least agreable to the Spirit & intent of it.

Fra. Bernard

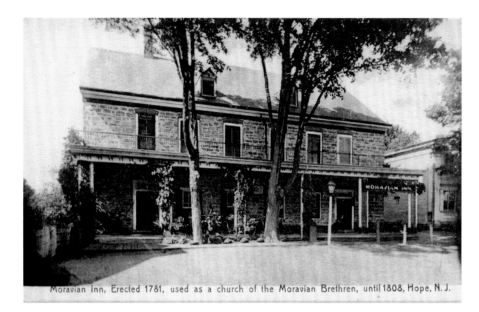

Postcard, c. 1907, showing the Moravian Inn in Hope, Warren County. Erected in 1781, the building was used as a church of the Moravian Brethren until 1808. This evangelical Protestant sect began in Europe and established settlements during the eighteenth century in Pennsylvania, North Carolina, Georgia, and New Jersey. After 1808, the building served as a school, a hotel, and, more recently, a bank. Source: New Jersey Postcards Collection, Special Collections and University Archives, Rutgers University Libraries.

Message of Governor Francis Bernard to the New Jersey General Assembly, August 10, 1758. The governor thanks the assembly of July–August 1758 for its service during the French and Indian War and prorogues it until "Thursday the Twelfth day of September next." Source: Department of Education, Bureau of Archives & History, Manuscript Collection, box 1, item 8. New Jersey State Archives, Department of State.

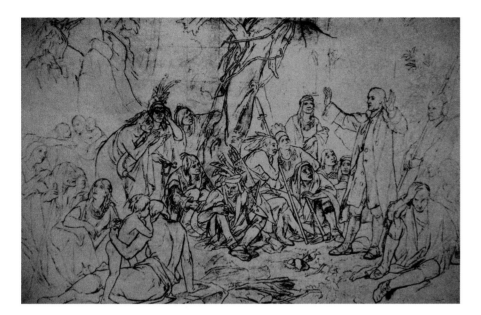

David Zeisberger (1721–1808), a Moravian missionary, spent much of his adult life preaching to Native Americans in the Northeast, including the Lenape. He was also an advocate for Native American rights. Source: Collection of the New Jersey State Museum. Reproduced with permission.

Sir Francis Bernard (1712–1779) arrived from England early in 1758, taking over as royal governor in the midst of the French and Indian War. He moved to organize New Jersey provincial forces while trying to maintain peace with the Indians. He was a signer of the agreement at Easton and other documents that ended Native American claims to much of their land in New Jersey. The first formal Indian reservation was established at Brotherton during his tenure. Then in 1760, with a large family to provide for, he became governor of wealthier Massachusetts. Source: Engraving by J. H. Daniels, 1887, after the portrait attributed to John Singleton Copley, 1765. New Jersey Portraits Collection, Special Collections and University Archives, Rutgers University Libraries.

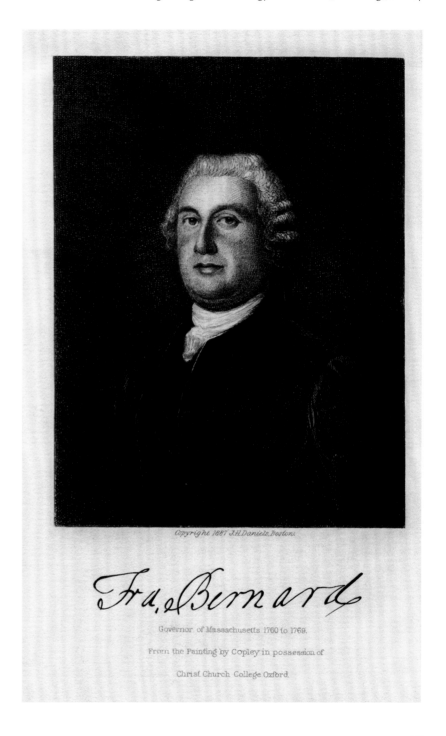

Copyright 1887 J.H.Daniels, Boston.

Fra. Bernard

Governor of Massachusetts 1760 to 1769.

From the Painting by Copley in possession of

Christ Church College Oxford.

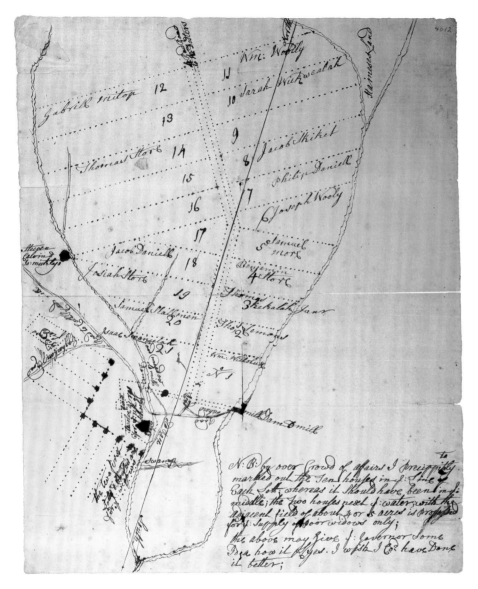

Manuscript plan of the Indian town at Edgepillock, Burlington County [Shamong Township], 1759. The area is also known as the Brotherton Tract and includes Native American names on individual plots. Brotherton was New Jersey's first and only Indian reservation. A note on the map says that it was made for the governor and that the author did his best. Source: Manuscript Map Collection, Map 4012, Special Collections and University Archives, Rutgers University Libraries.

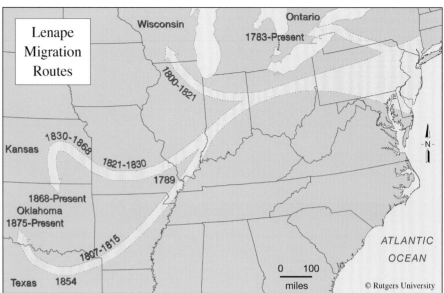

Beginning in the eighteenth century, if not earlier, many of New Jersey's Native Americans began moving west to escape European encroachment on their lands and to maintain their traditions. This map shows their migration routes. Today there are notable populations in Oklahoma, Wisconsin, and New Jersey. Source: Map by Michael Siegel.

An early twentieth-century view of "Indian Ann Roberts' House," Burlington County. Ann Roberts (1804–1894) was a descendant of the Lenape who remained in Burlington County after the Brotherton reservation closed in 1801. Her tombstone in Tabernacle says she was "The Last of the Delawares." She practiced traditional Native American crafts, such as basket and broom making. Source: Collection of the New Jersey State Museum. Reproduced with permission.

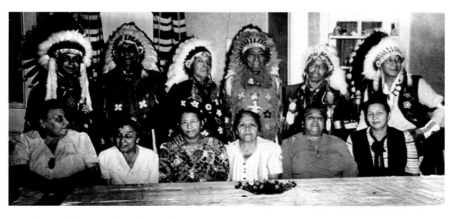

Members of the Sand Hill Band and their wives, 1948. The Sand Hill Band has historically resided in northern Monmouth County, especially Neptune Township. Its members are of Lenape and Cherokee descent. Many of the men were involved in building the first hotels in Asbury Park. Source: Archive, Neptune Public Library.

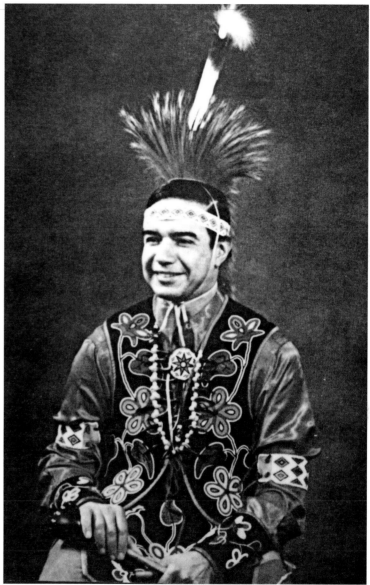

James "Lone Bear" Reevey, 1972. Reevey (1924–1998), a member of the Sand Hill Band, served on the New Jersey Indian Commission and was a well-known spokesperson on the Lenape, or Delaware, people. Source: Collection of the New Jersey State Museum. Reproduced with permission.

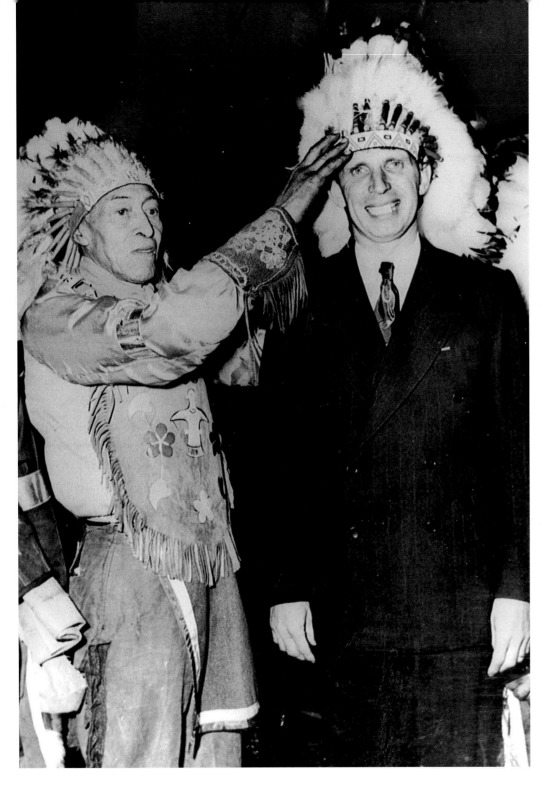

Modern Ramapo powwow, Ringwood. New Jersey's Native American groups are actively sharing their heritage and maintaining their communities and traditions. Source: Courtesy of Tom Weindl Waawaashkeshei (Little Deer).

Chief Ryers Crummel (c. 1870–1963) adopting Governor Alfred Driscoll into the Sand Hill Band at the New Jersey State Fair, 1949. Source: Joseph Bilby Collection.

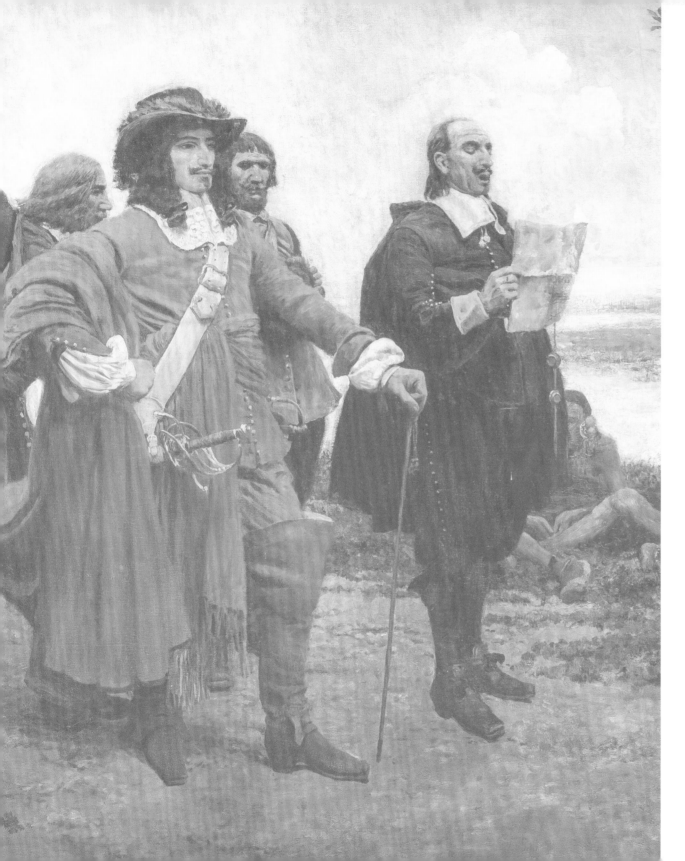

The Colonial Period

Early New Jersey

The diversity that has long characterized New Jersey's population was clearly established during the colonial period. By the time the first Europeans explored the Atlantic coast, Indians had been present for approximately 13,000 years. In the seventeenth century, settlers arrived from a variety of European countries, as first Holland, then Sweden, and finally Britain contested control of the region. Once New Jersey became an English colony, except for a brief Dutch reconquest in the 1670s, the provinces of East Jersey and West Jersey were guided by mostly absentee proprietors, who kept title to the colony's lands even after the crown took over the government in 1702. Between that date and 1776, the colony developed an economy and a political system similar to those of its mid-Atlantic neighbors, New York and Pennsylvania, although impacted by its more complex origins.

THE SEVENTEENTH CENTURY

The Spanish and the Portuguese were the first to build "New World" empires, but by the seventeenth century the French and then the English, Dutch, and Swedes had followed suit. The mid-Atlantic region became contested ground, and by the 1660s the land that became New Jersey had been part of three empires. The Dutch arrived first, following Henry Hudson's exploration in 1609 with the creation of the West Indies Company. They first briefly settled on Burlington Island, then primarily in Manhattan and up the North (Hudson) River. Their original interest in trade expanded to include farms on the west bank of the river by the early 1630s, and a fortified settlement was in place at Bergen after 1660. The New Sweden Company followed in 1638, establishing a colony along the South (Delaware) River. The Swedes claimed both sides of the lower Delaware until they were conquered by their neighbors, the Dutch, in 1655. In both New Netherland and New Sweden the colonists included Finns, French, Scandinavians, Poles, Hungarians, Italians, Germans, and Flemish. They left a legacy on the landscape in place-names (for example, Swedesboro) and building styles, such as log cabins and Dutch barns.

England, with American colonies to the north and south, and as a commercial rival of the Dutch Republic in the Atlantic trade, sent a military expedition that took over New Netherland in 1664. The colony had been promised by King Charles II to his brother, James, Duke of York, who became its proprietor and

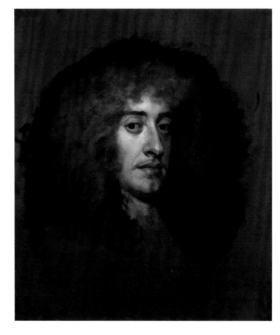

This portrait of James II (1633–1701) was made between 1665 and 1670, when James was the Duke of York. In 1664, King Charles II granted the proprietorship of New York to his brother James, the boundaries of which originally included New Jersey. Source: Oil on canvas by Sir Peter Lely (1618–1680). Portrait 5211, National Portrait Gallery, London.

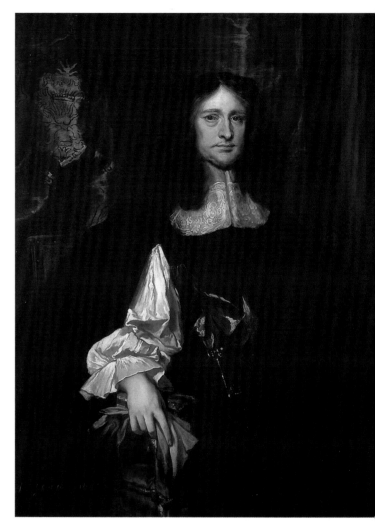

Sir George Carteret (1610–1680) remained loyal to the crown during the English civil wars. After the Restoration, he was rewarded by James, Duke of York, who gave joint property rights to Nova Caesarea (New Jersey) to him and John, Lord Berkeley. Source: Undated portrait by Sir Peter Lely (1618–1680). From the collection of Jurat Malet de Carteret, Isle of Jersey. Courtesy of Charlie Malet de Carteret, Isle of Jersey.

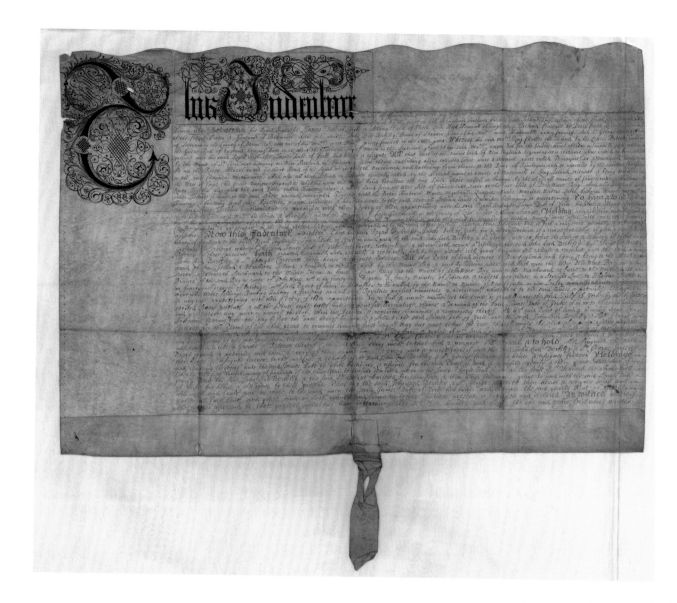

Release of James, Duke of York, to John, Lord Berkeley, and Sir George Carteret for New Jersey, June 24, 1664. Source: Council of Proprietors of West Jersey, Loose Parchments and Miscellaneous Records, c. 1664–1815, item OV-2. New Jersey State Archives, Department of State.

for whom it was renamed New York. But even as his governor Richard Nicolls took control, the duke conveyed part of his territory to Sir George Carteret and John, Lord Berkeley, two English aristocrats who had sided with the monarchy during the English civil wars. Carteret and Berkeley sent Philip Carteret as governor of their territory. By the time he arrived, New Englanders had already moved into Elizabethtown and the Monmouth patent, claiming land under titles from Richard Nicolls, which became the source of a long controversy. The Dutch briefly reappeared (1673–1674), after which Berkeley sold his half to Quakers John Fenwick and Edward Byllynge, dividing the colony into West and East Jersey. Quaker colonists settled in Salem, Burlington, and on farms along the Delaware even as the government of West Jersey changed hands several times. After Carteret's death, his widow sold East Jersey in 1682 to a consortium

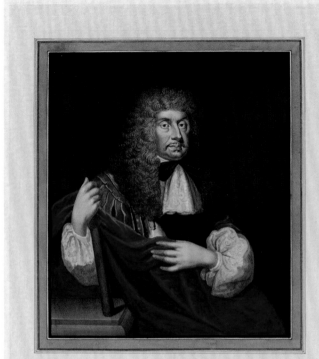

Sir John Berkeley, 1st Lord Berkeley of Stratton, c. 1825–1850.
Berkeley (1602–1678) shared the proprietorship of New Jersey
with Sir George Carteret until 1674, when he sold his half to a
group of Quakers. Source: Watercolor by George Perfect Hard-
ing (1779/80–1853) after an earlier image. Portrait D20130,
National Portrait Gallery, London.

"The Concessions and Agreement of the Lords Proprietors of the Province of New
Caesarea…," February 10, 1664/65, page 1. In effect New Jersey's first constitution,
the Concessions spelled out the proprietors' terms of settlement and included pro-
visions for religious toleration and representative government. Source: Governor
Robert Barclay, Minute Book of the East Jersey Proprietors, 1664–1686. New Jersey
State Archives, Department of State.

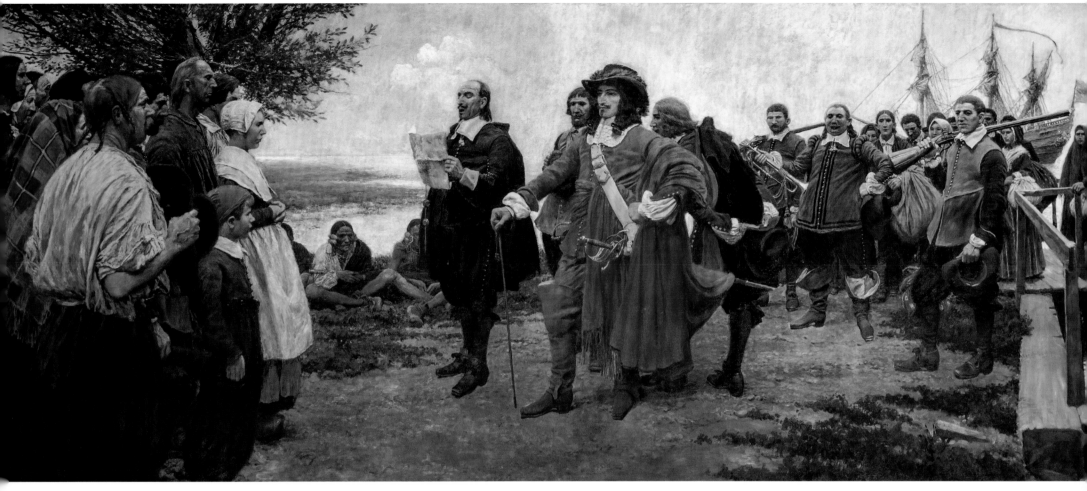

The Landing of Carteret in New Jersey, 1907. This mural by Howard Pyle (1853–1911) in a second-floor courtroom of the Essex County Courthouse in Newark depicts the arrival of Captain Philip Carteret (1639–1683) in Newark Bay in August 1665. Appointed the first governor of the colony of New Jersey by Sir George Carteret (a distant relative) and John, Lord Berkeley, he served until 1682, with several interruptions, trying to reconcile the conflicting ideas of empire held by the crown, proprietors, and settlers. Photograph © Mark Ludak.

of twenty-four men, mostly Quakers from England, Ireland, and Scotland. These proprietors attracted additional settlers, including a number of Scots who helped establish Perth Amboy. At the same time, the colony's founding documents—from the Concessions of 1664/1665 to the West Jersey Concessions of 1676/1677 and the Fundamental Constitutions of East Jersey of 1683—consistently provided for representative government and religious toleration.

New Jersey now had two capitals (Burlington and Perth Amboy), governors, and legislatures. It also had boundary disputes: first between New Jersey and New York over where one ended and the other began (the result of an inaccurate early map), and then between the West and East Jersey proprietors over the division line between their two provinces. The situation was further complicated by the efforts of the English government to consolidate its empire in the 1680s

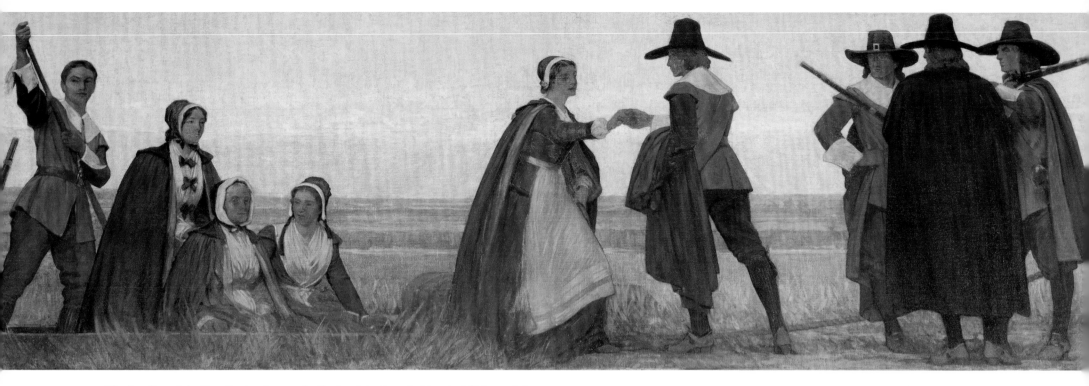

The Landing of the New Englanders on the Banks of the Passaic River in 1666, 1906. In the central portion of this forty-foot-long mural by Charles Yardley Turner (1850–1919) in a fourth-floor courtroom of the Essex County Courthouse in Newark, Josiah Ward helps Elizabeth Swaine, his future wife, from a boat onto the shore. They were among the first settlers of Newark. Not seen here, to the left, is a group of Indians who appear displeased with these intruders. Photograph © Mark Ludak.

by eliminating corporate and proprietary colonies. In 1688, New Jersey was added to the Dominion of New England, which stretched from the Delaware River to Penobscot Bay. A year later, the Glorious Revolution in England, which removed James II and replaced him with William and Mary, gave the unhappy New England colonies an opportunity to reclaim their former governing powers. In New Jersey, however, continuing land and political disputes made it impossible for the proprietors to govern effectively. In 1702, the proprietors of East and West Jersey surrendered their claims to their

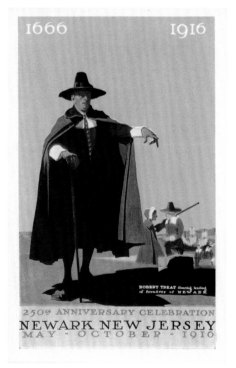

Postcard from the 250th anniversary celebration of Newark, 1666–1916. Robert Treat (1624–1710) directs the landing of the Connecticut Puritans who founded Newark. Source: New Jersey Postcards Collection, Special Collections and University Archives, Rutgers University Libraries.

William Penn (1644–1718) in middle age. A Quaker leader and founder of the Province of Pennsylvania, Penn was also involved in the settlement of both East and West Jersey. Source: Pastel portrait by Francis Place (1647–1728). Image 1957.8, Historical Society of Pennsylvania, Philadelphia.

The Friends Meeting House in Burlington, built in 1683. The Quakers were known for their plain style, shown in this early place of worship. Burlington City became a major center for the Quaker faith in the Delaware Valley. Source: Rendering by Jefferson Gauntt (1805–1864), c. 1840. Collection of the Burlington County Historical Society, Burlington. Photograph by R. Veit.

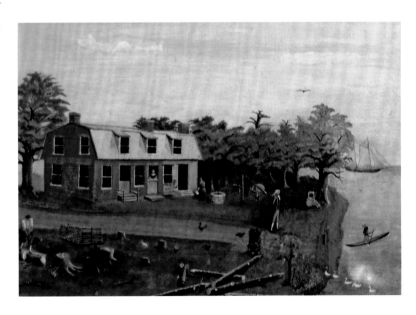

respective governments—but not their ownership of the land. New Jersey was again one colony, but now under royal control.

The later seventeenth century remains the most complicated period in New Jersey's history, and it had important consequences. Land disputes were not resolved, the provincial government shifted between the two capitals, and the population became more diverse in terms of ethnicity, religion, and race. There were now English Puritans/Congregationalists, Baptists, Quakers, Anglicans, Swedish Lutherans, Dutch Reformed, French Huguenots, and Scottish Presbyterians. Indians, though reduced in number by conflict and disease, were still present, and the first blacks, mostly slaves, had been brought in to work on farms, in homes, and at the earliest iron furnaces and forges. Settlement along the Hudson and Atlantic on the east and along the Delaware on the west began to expand through fertile river valleys from both directions into the center.

Ivy Point, the home of John Fenwick. In 1674, John, Lord Berkeley, sold his western portion of the colony of New Jersey to John Fenwick (1618–1683) and Edward Byllynge (d. 1687), both Quakers. A quarrel between them about ownership was mediated by William Penn, and Fenwick was awarded one-tenth of the original Berkeley grant. Fenwick brought colonists with him in 1675 and established the community of New Salem (today Salem) on the Delaware, where he built Ivy Point. His claims to govern the "Tenth" were disputed, and his colony was eventually reunited with the rest of West Jersey. Source: Undated painting. Salem County Historical Society, Salem.

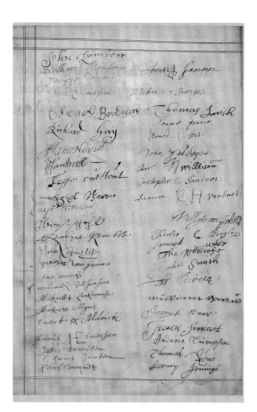

"The Concessions and Agreements of the Proprietors, Freeholders and Inhabitants of the Province of West New Jersey," 1677, page 1 (left) and page 90 signature page (right). This constitution written for the heavily Quaker colony has been seen as one of the most radical documents of the seventeenth century. It provided for religious toleration, a strong assembly, and trial by juries that could include participation by Native Americans. Source: Council of Proprietors of West New Jersey, The Concessions and Agreements.…New Jersey State Archives, Department of State.

THE EIGHTEENTH CENTURY

Until 1738, New Jersey shared a royal governor with New York. In addition to the governor, the crown approved the twelve members of the Provincial Council, while the twenty-four members of the General Assembly were elected, with twelve each from the east and west divisions of the colony. The royal governors

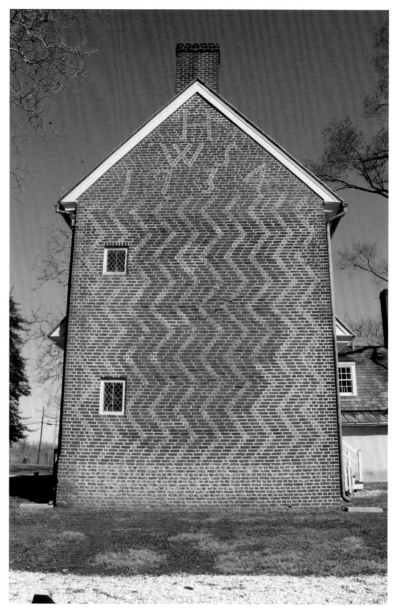

William and Sarah Hancock House, built in 1734, Salem County. This residence of South Jersey Quakers is known for its pattern brickwork, as well as a Revolutionary War massacre that took place there. Finely decorated brick houses like this one were popular in West Jersey and were often associated with successful families. The house is now a state-owned historic site. Photograph by R. Veit

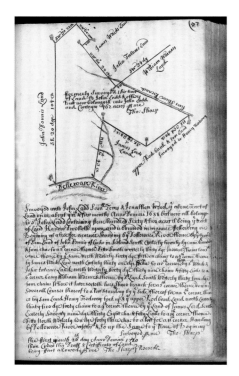

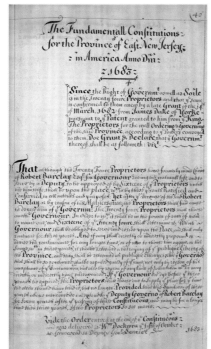

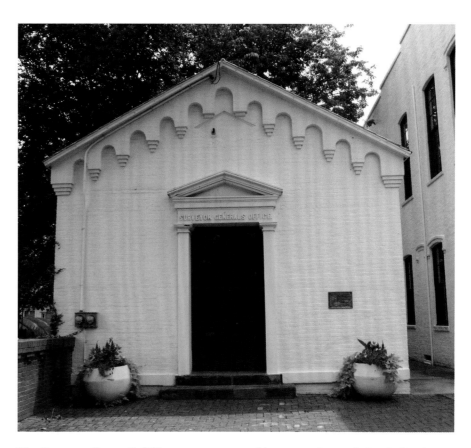

Example of an early land survey used to convey property titles, this one on the Delaware River in 1720. The surveyor, Thomas Sharp, noted the owners of neighboring lands; distances are measured in chains (each sixty-six feet). Source: Council of Proprietors of West New Jersey, Surveyor General's Calculation Book, c. 1688–1791. New Jersey State Archives; Department of State.

"The Fundamental Constitutions for the Province of East New Jersey," 1683. The twelve men (later twenty-four) who purchased East Jersey in 1682 from Elizabeth Carteret, widow of Sir George Carteret, wrote a new document under which the colony was to be governed. It was not accepted by the local inhabitants. Source: Governor Robert Barclay, Minute Book of the East Jersey Proprietors, 1664–1686, page 40. New Jersey State Archives, Department of State.

The Surveyor General's Office was constructed between 1852 and 1854 in Perth Amboy to house the records of the East Jersey Board of Proprietors. When the corporation dissolved in 1998, the documents were transferred to the New Jersey State Archives. The small brick building is currently undergoing restoration to serve as a museum. Photograph by R. Veit.

varied in their reputations, abilities, and effectiveness. The most controversial was Lord Cornbury (served 1702–1708), a cousin of Queen Anne, who abetted dubious land grants and tried to disqualify Quakers from holding office. Lewis Morris (1738–1746), the first governor appointed after New Jersey's administration was separated from New York's, was welcomed as a native son, only to die disliked because of his refusal to approve issues of paper money. The most effective were Robert Hunter (1710–1720) and William Franklin (1763–1776). The latter, a loyalist son of Benjamin Franklin, was the last royal governor of New Jersey.

Cornbury and his successors confronted a colony divided by section, religion, ethnicity, and two proprietary groups concerned to protect their lands

while settlers challenged their right to both rents and land. Yet New Jersey's political divisions in this period were more complex than a simple pro- and anti-proprietor alignment, and it was slower to develop the beginnings of a political system than its neighbors New York and Pennsylvania. Disputes over land titles fueled by the unresolved Nicolls grants, conflicting boundaries between New York and New Jersey and between West and East Jersey, claims by Newark residents that Indian titles were sufficient, inaccurate surveys, squatters, and more all contributed to a series of violent confrontations in the 1740s and 1750s. An estimated 500,000–700,000 acres were contested. In East Jersey, the proprietors filed the Elizabethtown Bill in Chancery in 1747, to which settlers responded with counterclaims. The largest legal case in the colonies in this period, it dragged into the nineteenth century without a formal resolution.

Even as local political power grew, ties to the empire drew New Jersey colonists into international conflicts in contested places. With one exception, though, these wars were not fought on New Jersey's soil, a good fortune not shared by other North American colonies. New Jersey was asked to supply material and troops for Queen Anne's War (1702–1713),

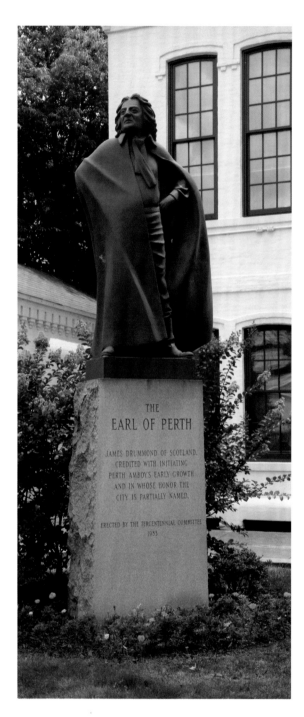

The Earl of Perth, James Drummond of Scotland, dedicated 1983. The 4th Earl of Perth was one of the twenty-four men who bought the proprietorship of East Jersey in 1682. This statue by Paul Balog stands in front of Perth Amboy's city hall and next to the East Jersey Surveyor General's Office. Photograph by R. Veit.

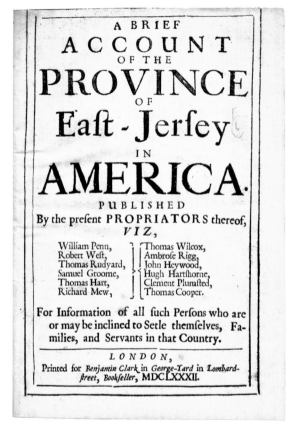

Title page of *A Brief Account of the Province of East-Jersey in America* (London: Printed for Benjamin Clark, 1682). This promotional pamphlet published by the proprietors lauds the advantages of settlement in the province and describes the region's natural features. Source: Special Collections and University Archives, Rutgers University Libraries (SNCLX F137. B85 1682).

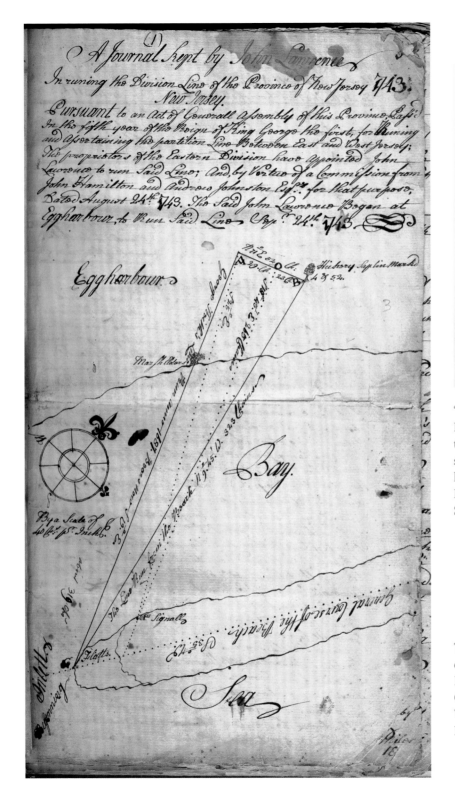

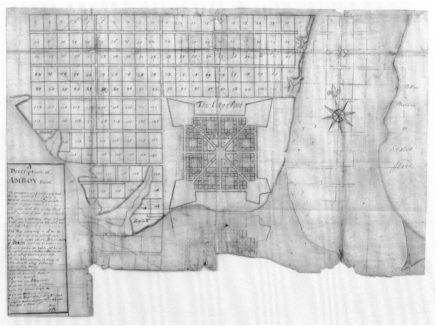

"A Description of Amboy Point," May 1684. This map from the papers of the London proprietors shows the plan for the capital of East Jersey, which became the town of Perth Amboy. The plan was never realized, and the star fortification surrounding numerous public buildings was not constructed. Early maps drawn by local inhabitants show a much more modest settlement. Source: General Board of Proprietors of the Eastern Division of New Jersey, Maps, c. 1700–1950. New Jersey State Archives, Department of State.

This map of Egg Harbor shows the survey line drawn by John Lawrence in 1743 dividing East and West Jersey. It ran from Little Egg Harbor northwest to the Delaware River and tried to resolve decades of controversy engendered by the 1676 Quintipartite Deed, which divided the colony. Source: Council of Proprietors of West New Jersey, Lawrence Division Line Journal and Notes, 1743–1751 & c. 1777. New Jersey State Archives, Department of State.

King George's War (1744–1748), and especially the French and Indian War (1754–1763). Soldiers from New Jersey served on the borders with New France, in Nova Scotia, and in the Caribbean. The colony also housed British troops in such large numbers that barracks for them were built in the 1750s in New Brunswick, Perth Amboy, Burlington, Elizabethtown, and Trenton (where some survive). At this time, a chain of blockhouses was constructed in the northwest corner of the state to protect residents from raids by Indians allied with France.

Starting in 1709, New Jersey turned to paper money to fund colonial government, and especially to finance war efforts. Also loaned out to colonists and secured by land, these issues generated interest payments (reducing the need for taxes) and facilitated local trade in an economy that lacked hard currency (gold and silver coins). This expedient had its dangers: in colonies where too much paper money circulated, its value depreciated precipitously, angering British merchants paid in the devalued currency. Royal governors were instructed not to approve paper money bills, and Lewis Morris earned the ire of the New Jersey legislature when he did not consent to such measures. (It retaliated by refusing to pay his salary.) Several later governors consented, only to be recalled to England. By 1763, New Jersey had the largest amount of outstanding paper money of any colony, some £275,000, which became problematic after 1764, when Parliament passed a Currency Act that prohibited the use of paper money for public or private debts.

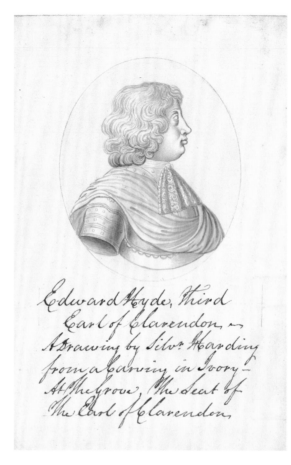

Edward Hyde (1661–1723), 3rd Earl of Clarendon, Viscount Cornbury, was the first royal governor of both New York and New Jersey. Appointed in 1702, he is sometimes described as the worst governor ever imposed on an American colony. That assessment has been challenged by the argument that he represented a new class of British administrators who clashed with colonists over efforts to enforce the rules of the empire. Source: Sketch by Silvester Harding (1745–1809) from an ivory carving. © Ashmolean Museum, Oxford University, Oxford.

Queen Anne (1665–1714; reigned 1702–1714) appointed her cousin Lord Cornbury as governor of New York and New Jersey in 1702, when East and West Jersey were combined into one royal colony. The old canard that he dressed in women's clothes to look like her has been debunked, and the supposed portrait of him in a dress at the New-York Historical Society is now labeled "unknown woman." Source: Oil on canvas by Sir Godfrey Kneller (1646–1723), c. 1690. Portrait 1616, National Portrait Gallery, London.

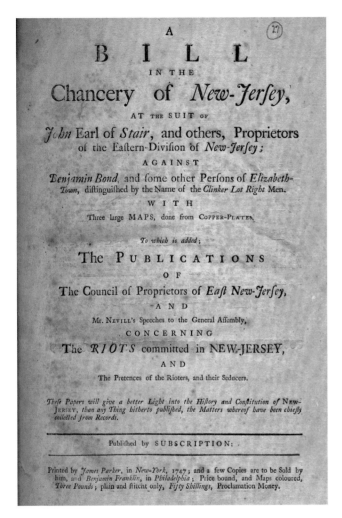

A

BILL

IN THE

Chancery of *New-Jersey*,

AT THE SUIT OF

John Earl of *Stair*, and others, Proprietors
of the Eastern-Division of *New-Jersey*;

AGAINST

Benjamin Bond, and some other Persons of *Elizabeth-
Town,* distinguished by the Name of the *Clinker Lot Right* Men.

WITH

Three large MAPS, done from COPPER-PLATES.

To which is added;

The PUBLICATIONS

OF

The Council of Proprietors of *East New-Jersey,*

AND

Mr. NEVILL's Speeches to the General Assembly,

CONCERNING

The *RIOTS* committed in NEW-JERSEY,

AND

The Pretences of the Rioters, and their Seducers.

*These Papers will give a better Light into the History and Constitution of NEW-
JERSEY, than any Thing hitherto published, the Matters whereof have been chiefly
collected from Records.*

Published by SUBSCRIPTION:

Printed by *James Parker,* in *New-York,* 1747; and a few Copies are to be Sold by
him, and *Benjamin Franklin,* in *Philadelphia;* Price bound, and Maps coloured,
Three Pounds; plain and stitcht only, *Fifty Shillings,* Proclamation Money.

Title page of *A Bill in the Chancery of New-Jersey, at the Suit of John Earl of Stair, and Others, Proprietors of the Eastern-Division of New-Jersey; Against Benjamin Bond, and Some Other Persons of Elizabeth-Town, Distinguished by the Name of Clinker Lot Right Men...*(New York: Printed by James Parker, 1747). This dispute over land titles between the East Jersey proprietors and the settlers of Elizabethtown was the largest legal case in colonial America. It was never resolved in the courts. Source: Special Collections and University Archives, Rutgers University Libraries (SNCLXF F137.B662Bi).

Political turmoil was mirrored in the religious sphere by a series of revivals, known as the Great Awakening, that swept through the colonies starting in the 1730s, encouraged by traveling ministers, the most famous being George Whitefield, and local pastors including Theodorus Jacobus Frelinghuysen among the Dutch Reform and Gilbert Tennent among the Presbyterians. Congregations split over emotional preaching, the value of education versus conversion experiences, visiting ministers, and, among the Dutch, whether services should continue in Dutch or be held in English. The desire to train New Light/New Side ministers and have them ordained in the colony led to the founding of the College of New Jersey (now Princeton University) by Presbyterians, Queens College (now Rutgers University) by the Dutch, and an academy in Hopewell by the Baptists (which relocated and became the College of Rhode Island, now Brown University). Religious divisions at times reinforced political ones, as Old Side/Old Lights opposed the chartering of these institutions and advocated strict laws to suppress land protests. Yet, despite these disagreements, the various religious sects in the colony

Governor Lewis Morris, c. 1726. From 1702 to 1738, a single royal governor presided over the colonies of New York and New Jersey. Morris (1671–1746), an important landholder and politician in both colonies, became the first separate royal governor for New Jersey in 1738. The Scottish-born artist John Watson (1685–1768) settled in Perth Amboy, where he exhibited his collection of paintings. Source: Oil on canvas, 30 1/16 x 25 in., by John Watson. Brooklyn Museum. Purchased with funds given by John Hill Morgan, Dick S. Ramsay Fund, and Museum Collection Fund, 43.196.

New Jersey, 6 pound note, dated March 25, 1776 (obverse). Because of the lack of hard currency, New Jersey and other colonies printed their own paper money, which sometimes tended to depreciate. To appease British merchants, Parliament passed the Currency Act of 1764, which prohibited the colonies from designating paper issues as legal tender for private and public debts. The act had dire consequences for the colonial economy, and Parliament amended it in 1773 to allow colonies to issue paper currency for public debts. Source: New Jersey State Archives, Paper Currency, 1759–1935. New Jersey State Archives, Department of State.

Massacre at Fort William Henry, August 9, 1757. New Jersey militiamen were among those captured and killed after the surrender of the fort to the French and their Indian allies. The fall of the fort is commemorated in James Fenimore Cooper's *Last of the Mohicans*. Source: Wood engraving by Albert Bobbett (1824–1888/9) after Felix Octavius Carr Darley (1822–1888), from Benson J. Lossing, *Our Country: A Household History for All Readers*, vol. 1 (New York: Johnson & Miles, 1876). Image 843840, Picture Collection, The New York Public Library, Astor, Lenox and Tilden Foundations.

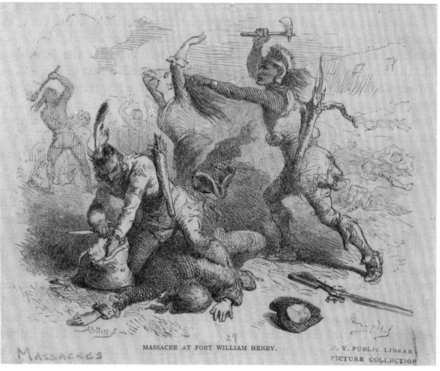

Restored colonial barracks at Trenton. Of the five barracks built in New Jersey during the French and Indian War to house British soldiers, only the Trenton Barracks survives. (The others were in Perth Amboy, New Brunswick, Burlington, and Elizabethtown.) Source: Old Barracks Museum, Trenton.

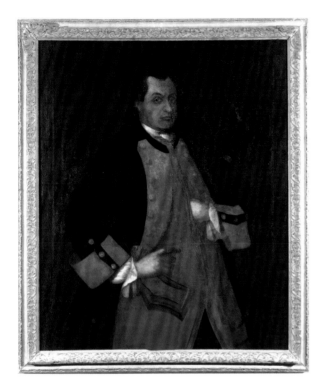

Colonel Peter Schuyler (1710–1762), the son of a wealthy copper mine owner, raised a detachment of volunteers to fight with the New Jersey militia forces, the "Jersey Blues," in the French and Indian War. Captured by the French at the surrender of Fort Oswego in 1756, then taken to Quebec, where he was paroled, Schuyler assisted in ransoming militiamen taken at Fort William Henry. Source: Portrait by an unknown artist, item 1847.1. From the collections of the New Jersey Historical Society, Newark.

Jonathan Dickinson (1688–1747), minister of the Presbyterian church in Elizabethtown, was one of the founders of the College of New Jersey (now Princeton University) in 1746 and its first president when it opened in his parsonage in 1747. The New Light/New Side founders (supporters of the Great Awakening) hoped to prepare young men for ministerial careers and public service. Source: Oil on canvas, 29 2/4 x 24 7/16 in., by Edward Ludlow Mooney (1813–1887). Princeton University Art Museum/Art Resource, New York. Gift of the artist. Photograph by Bruce M. White.

learned to accommodate one another in ways not common in less diverse places.

In this period more settlers moved into the interior of New Jersey, including Dutch from New York and Germans from Pennsylvania, as well as immigrants from England and parts of Europe. Increasing numbers of black slaves were imported; by 1776, they accounted for 8 percent of the population, or a total of 8,220 out of a population of 130,000. The number of freedmen slowly increased, particularly in West Jersey, where Quakers led by John Woolman advocated abolition.

The land along New Jersey's rivers provided fertile soil for farmers who produced wheat, corn, and other grain crops, and raised cattle, hogs, and sheep. They cultivated a wide variety of vegetables and fruits for local consumption and shipment to the growing cities of Philadelphia and New York. The colony also supplied foodstuffs to the plantations of the sugar islands in the Caribbean. Plentiful forests provided lumber for construction, shingles for roofs, and staves for barrels. Nascent industries included iron production, with ore mined in the north and scooped out of bogs in the south; sands in the south supplied the Wistarburgh/Wisterburgh Glassworks, the first successful glasshouse in the colonies.

As in other colonies, after 1750 there was an increase in the consumption of goods, particularly tea and sugar. Wealthier farmers and merchants began to build homes in the Georgian style popular in England, to dress in fancier clothes, and to drink their tea out of

fine china. Today, examples of these homes and their artifacts remain scattered across the state, such as the Trent House in Trenton, the Low House in Piscataway, and the Ford Mansion in Morristown. While New Jersey remained overwhelmingly rural, culture, education, and Enlightenment ideas spread along with the new goods. The impact of these changes on women throughout the colonial period is harder to trace, but by the end of the eighteenth century, elite women's letters show participation in intellectual discussions. Overall, New Jersey was seen as a good place for "middling" people.

BIBLIOGRAPHY

General books on the colonial period include Wesley F. Craven, *New Jersey and the English Colonization of North America* (Princeton: D. Van Nostrand, 1964); Richard P. McCormick, *New Jersey from Colony to State, 1609–1789*, rev. ed. (Newark: New Jersey Historical Society, 1981); and John Pomfret, *Colonial New Jersey: A History* (New York: Scribner, 1973). For a detailed list of the recent literature, articles as well as books, see the citations for Maxine N. Lurie, "Colonial Period: The Complex and Contradictory Beginnings of a Mid-Atlantic Province," in *New Jersey: A History of the Garden State*, ed. Maxine N. Lurie and Richard Veit (New Brunswick: Rutgers University Press, 2012).

Jonathan Edwards (1703–1758) was a leading New Light Congregational minister in Massachusetts during the First Great Awakening. His sermons on man's depravity are still read today. He served briefly as the third president of the College of New Jersey (now Princeton University) in 1758. Source: Oil on canvas, 30 x 25 in., by Henry Augustus Loop (1831–1895) after Joseph Badger (1708–1765). Princeton University Art Museum/Art Resource, New York. Gift of the great-grandsons of Jonathan Edwards. Photograph by Bruce M. White.

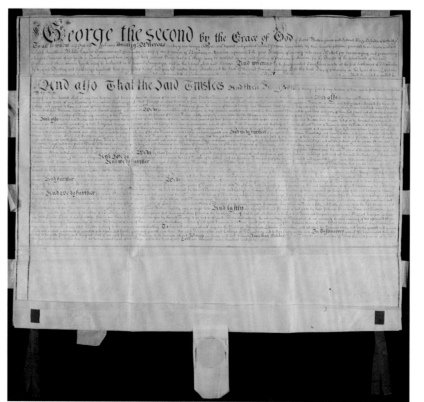

Second charter of the College of New Jersey (now Princeton University). The legality of the college's original charter of 1746 was questioned because it was issued by an acting governor. Newly appointed Governor Jonathan Belcher (1682–1757), a strong supporter of the college, issued this second charter in 1748. Source: Board of Trustees Records (AC 120), box CHARTER, folder 1, Princeton University Archives, Department of Rare Books and Special Collections, Princeton University Library.

Portrait of Aaron Burr Sr. (1716–1757) by an unknown artist, c. 1750–1760. Minister of the Presbyterian church in Newark, Burr was the youngest among the New Light founders of the College of New Jersey (now Princeton University) and became its second president. During his tenure, he devised the curriculum, enlarged the student body, and oversaw the construction of Nassau Hall. Source: Oil on canvas. Yale University Art Gallery, ac. 1968.50.2. Bequest of Oliver Burr Jennings, B.A. 1917, in memory of Miss Annie Burr Jennings.

Portrait of Esther Edwards Burr (1732–1758) by an unknown artist, c. 1750–1758. The daughter of Jonathan Edwards, wife of Aaron Burr Sr., and mother of the future U.S. vice president was well educated for the period. She kept a diary that provides insight into the obligations of a minister's wife. Source: Oil on canvas. Yale University Art Gallery, ac. 1968.50.3. Bequest of Oliver Burr Jennings, B.A. 1917, in memory of Miss Annie Burr Jennings.

"A North-West Prospect of Nassau-Hall, with a Front View of the President's House, in New Jersey." When it was completed in 1756, Nassau Hall was the largest stone building in the American colonies and housed all of the college's personnel and services. Source: Frontispiece engraved by Henry Dawkins (fl. 1753–c. 1786) after a drawing by William Tennent for *An Account of the College of New-Jersey* (Woodbridge, N.J., 1764). Department of Environmental Protection, Division of Parks & Forestry, Photographs Filed by Subject, c. 1930s–1970s, item Princeton University 002. New Jersey State Archives, Department of State.

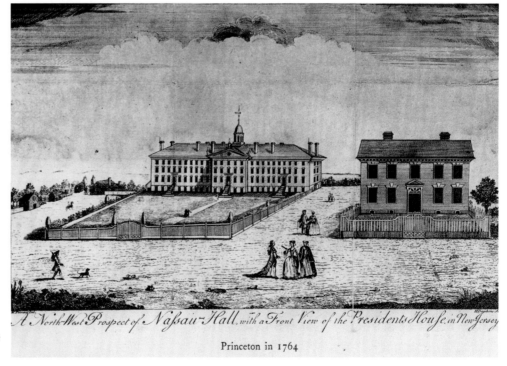

A North-West Prospect of Nassau-Hall, with a Front View of the Presidents House, in New Jersey

Princeton in 1764

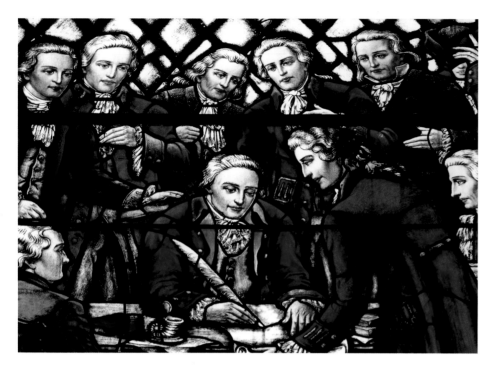

Royal Governor William Franklin signs the charter establishing Queens College (now Rutgers University), November 10, 1766, in this stained glass window at the university's Kirkpatrick Chapel. The college was started by those in the Dutch Reformed community who wanted ministers trained in the colonies who would support revival religion and could preach in English. Source: Rutgers University Archives, Special Collections and University Archives, Rutgers University Libraries.

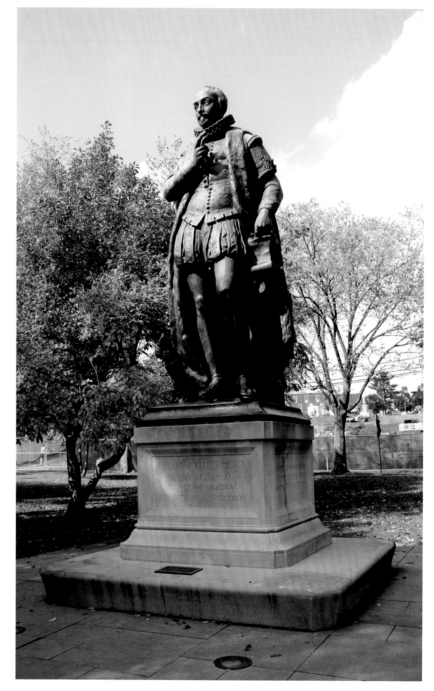

William I (1533–1584), Prince of Orange, led the resistance of the Netherlands to the Spanish crown, which eventually resulted in independence. This statue by Toon Dupuis (1877–1937), called *William the Silent*, is a copy of the one by Lodewyk Royer (1793–1868), which stands in The Hague. It was donated to Rutgers University by the Holland Society of New York and installed in Voorhees Mall on the College Avenue campus in 1928 to commemorate the Dutch origins of the university. Photograph by R. Veit.

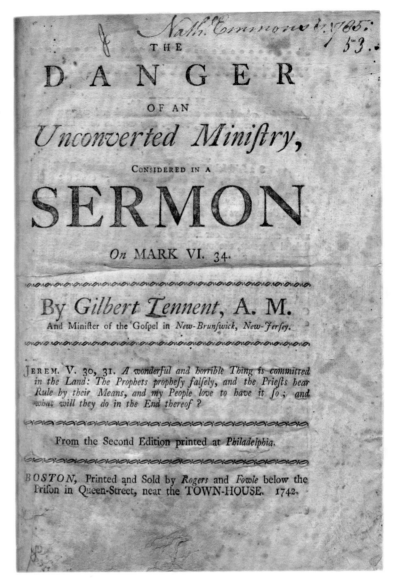

Gilbert Tennent (1703–1764), one of the leading New Light Presbyterian ministers during the First Great Awakening, preached salvation through conversion rather than predestination. He was one of the first trustees of the College of New Jersey (now Princeton University), serving from 1747 to 1764. Source: Oil on canvas, 28 13/16 x 23 5/8 in., by Jacob Eichholtz (1776–1842) after Gustavus Hesselius (1682–1755). Princeton University Art Museum/Art Resource, New York. Gift of Miss Smith. Photograph by Bruce M. White.

The Old Tennent Church on the Monmouth Battle Ground, c. 1880. Scottish Presbyterians settled in Monmouth County in the 1680s. Their first church on White Oak Hill became a center of the Great Awakening. When the members of the congregation outgrew the church, they replaced it in 1751 with this Georgian structure. It was used as a temporary hospital during the Battle of Monmouth in June 1778. Source: Oil painting on clam shell by Carrie A. Browne Swift (1844–1924). Museum Collection, Monmouth County Historical Association, Freehold. Gift of Lois Schenck, 1979.

Title page of Gilbert Tennent (1703–1754), *The Danger of an Unconverted Ministry Considered in a Sermon*, 2nd ed. (Boston: Printed and sold by Rogers and Fowle, 1742). In this strongly worded sermon, Tennent supported the need for ministers, as well as members of a congregation, to have had a conversion experience. Source: Special Collections and University Archives, Rutgers University Libraries (X BV4241.T297D).

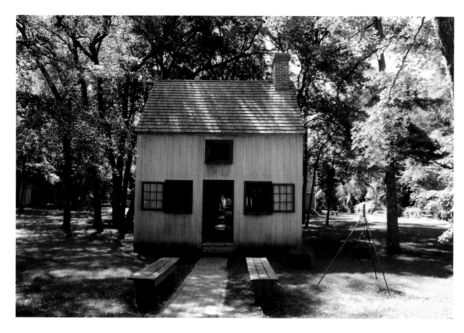

Coxe Hall Cottage at Historic Cold Spring Village is representative of seventeenth-century housing in Cape May County. This reconstructed building, originally part of a larger building, is based on one of the structures erected on the estate of West Jersey proprietor Daniel Coxe. Photograph by R. Veit.

This finely crafted wainscot armchair, with its thistle design, reflects the Scottish heritage of many East Jersey settlers. Made in 1695 of white oak and yellow pine by Robert Rhea (c. 1667–1719), a Scottish immigrant living in Freehold, it is the earliest documented piece of New Jersey furniture. Source: Museum Collection, Monmouth County Historical Association, Freehold. Gift of Mrs. J. Amory Haskell, 1941.

Re-created eighteenth-century kitchen garden at Rockingham in Kingston. Early New Jersey households grew a wide variety of vegetables, herbs, and fruit for their own consumption, but also to sell in local markets. Source: Rockingham Historic Site, Division of Parks & Forestry, New Jersey Department of Environmental Protection.

Henry Wick, a settler from Long Island, built his modest farmhouse near Morristown around 1750 in the New England style. At least four brigades of the Continental Army camped on Wick's land during the winter of 1779–1780, and the house served as the headquarters of Major General Arthur St. Clair. Source: Morristown National Historical Park.

Dutch Barn and Prize Oxen of James Anderson Perrine, c. 1856, Manalapan, Monmouth County. The Dutch brought distinctive architectural features with them, including large barns built with H-bent framing. Source: Oil on canvas by Alessandro Mario. Museum Collection, Monmouth County Historical Association, Freehold. Gift of Mrs. Fred A. C. Perrine, 1932.

This Dutch kas, or wardrobe, was crafted in Middletown, Monmouth County, around 1720 by an unknown maker from red gum, American tulip, and pine, with grisaille decoration. A kas like this would have been displayed in a prominent location in a home and was used to store linens. Source: Museum Collection, Monmouth County Historical Association, Freehold. Gift of John P. & Alfred G. Luyster, 1936.

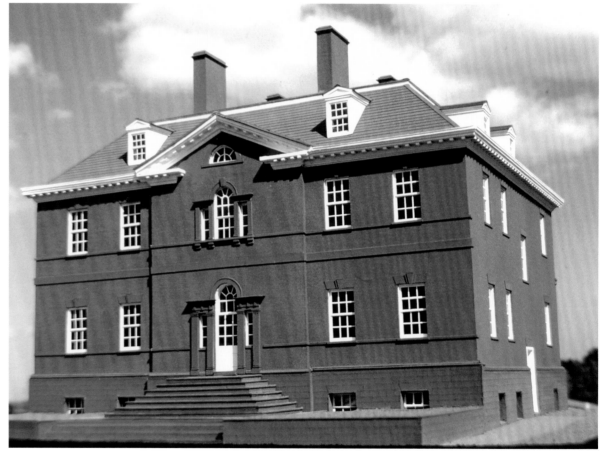

Stone dwellings like the Hopper-Goetschius House, c. 1739, in Upper Saddle River, Bergen County, were popular with Dutch settlers in northern New Jersey and New York. Photograph by R. Veit.

Modern architectural model of the original Proprietary House built in Perth Amboy between 1762 and 1764 by the East Jersey Board of Proprietors to serve as the home of royal governors. Governor William Franklin and his wife took up residence in 1774, and Franklin was placed under house arrest there at the beginning of the American Revolution. Source: Courtesy of William Pavlovsky, architect.

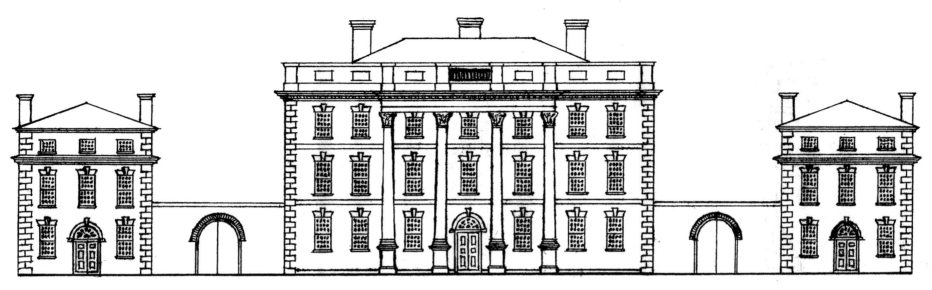

"The Buildings," the Somerset County estate of William Alexander (1726–1783), known as Lord Stirling. Begun in 1761 and still unfinished at the start of the Revolution, the estate was one of the finest in the colony. Today, only two auxiliary buildings remain. This drawing by architectural historian John Millar shows the elegant manor house where Lord Stirling entertained the elite of American society. Source: Courtesy of John Millar.

Title page of the first history of New Jersey: Samuel Smith (1720–1776), *The History of the Colony of Nova-Caesaria, or New Jersey…*(Burlington, N.J.: Printed and sold by James Parker, 1765). Source: Special Collections and University Archives, Rutgers University Libraries (X F137.S65 1765).

John Reading (1686–1767), the first native-born New Jerseyan to govern the province (1747, 1757–1758), built this classic Georgian-style mansion in 1760 along the South Branch of the Raritan River in Hunterdon County. Source: Permission to photograph courtesy of the owner. Photograph by R. Veit.

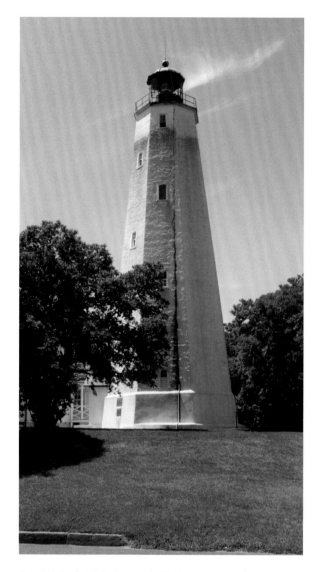

Sandy Hook Lighthouse, built in 1764 to aid ships entering New York Harbor, is the oldest operating lighthouse in the United States. It was originally called the New York Lighthouse because it was funded in part by a lottery authorized by the New York Assembly. Photograph by R. Veit.

Perth Amboy, the capital of East Jersey, was also the center for importation of slaves into the colony. This reconstructed arch and plaque mark the location of the original slave market. Photograph by R. Veit.

These eighteenth-century shackles, excavated by archaeologists at the site of the Beverwyck plantation in Parsippany–Troy Hills, Morris County, provide a grim physical reminder of the presence of slavery in colonial New Jersey. Source: Courtesy of John Milner Associates.

This modest building, c. 1700, represents the type of structure used on New Jersey farms to house enslaved African Americans. The Van der Beck slave cottage in Bergen County is one of the very few that survive. Source: Historic American Buildings Survey, HABS NJ,2-CLOST,2A (sheet 0 of 7). Library of Congress, Prints and Photographs Division, Washington, D.C.

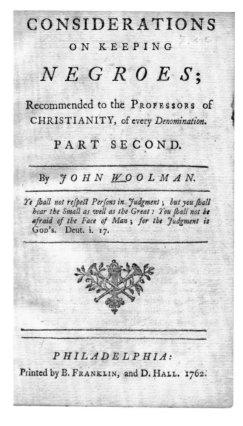

Title page of John Woolman (1720–1772), *Considerations on Keeping Negroes; Recommended to the Professors of Christianity, of Every Denomination. Part Second* (Philadelphia: Printed by B. Franklin and D. Hall, 1762). In his second antislavery tract, published at his own expense, Woolman challenged rationalizations for slaveholding. Source: Special Collections and University Archives, Rutgers University Libraries (SNCLX E446.W 1762).

John Woolman (1720–1772), a South Jersey Quaker and abolitionist, refused to use products made by slave labor. According to the editor of Woolman's journal, this portrait was "almost certainly" the work of Woolman's friend Robert Smith III of Burlington. Source: Frontispiece from *The Journal and Essays of John Woolman*, ed. Amelia Mott Gummere (New York: Macmillan, 1922). Special Collections and University Archives, Rutgers University Libraries (SNCLNJ PS891.E3WJG).

Petition of Casper Wister [Wistar] and others to the House of Representatives, January 29, 1752, asking for a waiver of taxes on his glassworks. It had been established in Alloway in 1739 and produced window glass and bottles. Source: New Jersey Legislature, Petitions, Transactions, Accounts and Miscellaneous Papers, c. 1700–1845, item 1. New Jersey State Archives, Department of State.

Blown glass bottle with the seal of Richard Wistar, c. 1745–1755. The Wistarburgh Glassworks in Alloway was the first successful glassworks in what today is the United States. Bottles with personal seals such as this one were important status symbols in colonial America. Source: Item 86.4.196 (view 1). Collection of The Corning Museum of Glass, Corning, New York. Gift of Miss Elizabeth Wistar.

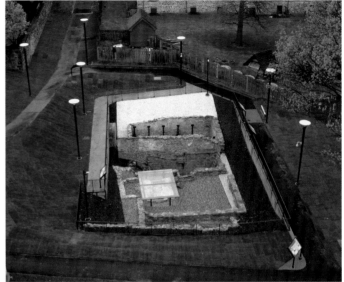

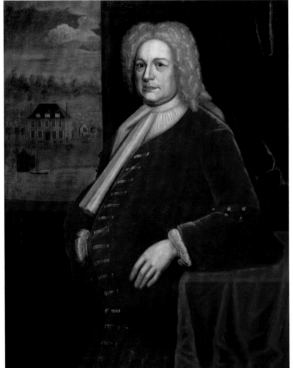

Batsto Furnace fireback, c. 1770–1780. New Jersey had a struggling, but significant iron industry in the colonial period. Batsto Furnace operated in Burlington County from 1766 to 1858, producing a variety of iron goods. Firebacks such as this one protected the bricks lining a fireplace from heat damage. Source: Iron, 26¾ x 22¼ in. Collection of the New Jersey State Museum. Museum purchase, CH1975.99.1. Reproduced with permission.

Benjamin Yard (1718–1808) established one of the first steel mills in the United States in 1745 along Petty's Run in Trenton. Archaeological investigations have shown that the location continued to be an important site for industrial endeavors well into the nineteenth century. Source: Courtesy of Hunter Research.

Arent Schuyler (1662–1730), a wealthy merchant and land speculator, opened the highly productive Schuyler Copper Mine in Bergen County in 1715. Because the mine flooded from time to time, Schuyler's son John imported one of the first steam engines seen in North America to pump out the water. Source: Oil on linen, 51 x 41 x 1 in., by John Watson, c. 1725. Accession 1979.75. Collection of the New-York Historical Society. Purchase, Thomas Jefferson Bryan Fund.

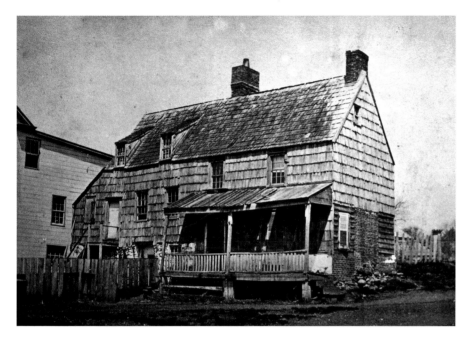

The first tavern built in Perth Amboy, c. 1685, the Long Ferry Tavern was demolished sometime before 1916. This photograph is from 1856. The ferry connected Perth Amboy and South Amboy and was part of a major transportation route across the state. Source: Courtesy of John Kerry Dyke.

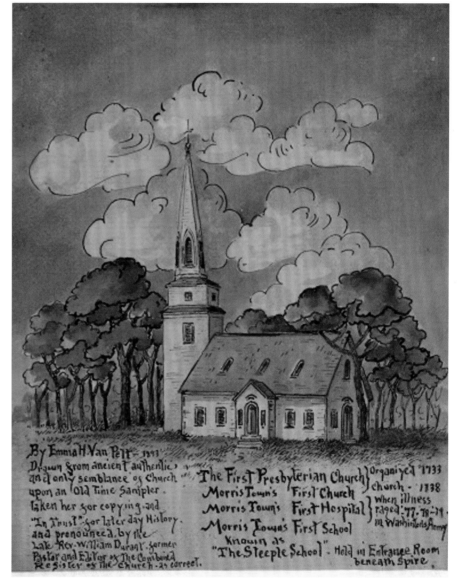

Morristown was settled predominantly by Presbyterians, many of whom were sympathetic to the goals of the American Revolution. This watercolor made by Emma H. Van Pelt in 1893 depicts the town's First Presbyterian Church, built in 1738, which served as a hospital for the Continental Army. It had been replaced by the late nineteenth century. Source: From the collections of the North Jersey History & Genealogy Center, The Morristown and Morris Township Library.

Old St. Mary's Church, Dedicated 1702 by Bishop Talbot, First Episcopal Bishop. Burlington, N. J.

Thanks. Call. again. F. E. Pugh, 127 Federal St., Burlington N. J.

Old Saint Mary's Church in Burlington, built in 1703, is the oldest standing Anglican church in the state. Divided loyalties during the American Revolution resulted in the suspension of regular services. After the war, the Burlington parish joined the Protestant Episcopal Church of the United States. Source: Twentieth-century postcard from the collection of R. Veit.

Sandstone gravestone, 1726, First Presbyterian Church, Elizabeth. Carved with a grim image of mortality, this marker is typical of gravestones erected by the descendants of the early Puritan settlers. Photograph by R. Veit.

Old Moravian Mill, in operation since 1768, Hope, N. J.

This large stone gristmill, built in 1769, was one of the economic mainstays of the Moravian community at Hope in Warren County. Today this building has been repurposed as an inn and restaurant. Source: Postcard, c. 1907. New Jersey Postcards Collection, Special Collections and University Archives, Rutgers University Libraries.

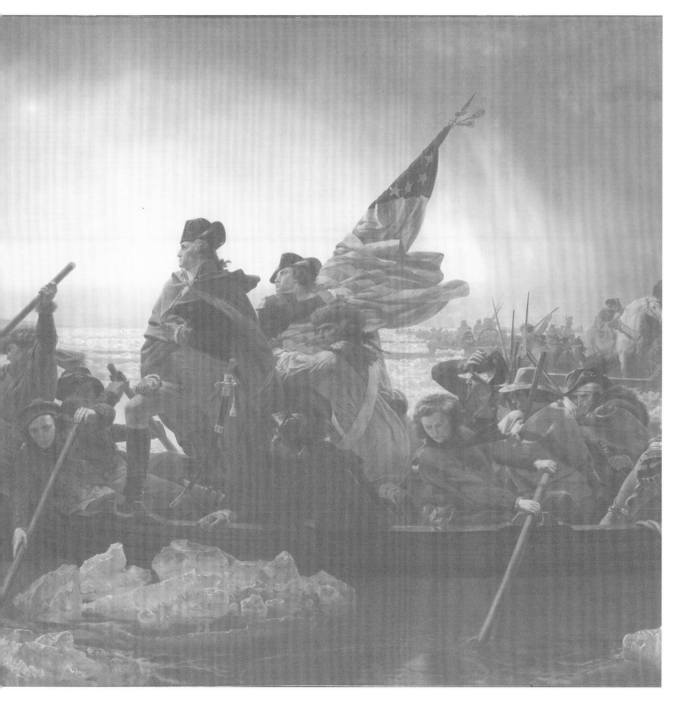

The American Revolution and Confederation Period

In 1763, New Jersey was small in territory and population (ninth among the original thirteen colonies), and overwhelmingly rural. The colony had no significant port and no newspaper, and its heterogeneous population was divided by section, religion, race, and ethnic background. Its popular new royal governor, William Franklin (the illegitimate son of Benjamin Franklin), had been raised in Pennsylvania and educated in London, though he was well schooled in colonial politics. Into this relatively peaceful scene (discounting earlier land disagreements) came changes in British policies

WILLIAM FRANKLIN, ELDER SON OF BENJAMIN FRANKLIN. AFTER A PENCIL DRAWING BY ALBERT ROSENTHAL FROM THE ORIGINAL PAINTING, THE PROPERTY OF DR. THOMAS HEWSON BACHE.

William Franklin (1730–1813), the natural son of Benjamin Franklin, was the last royal governor of colonial New Jersey and remained loyal to Britain throughout the Revolution. From New York, as president of the Associated Loyalists, he encouraged raids and reprisals against rebels in New Jersey. After the war, Franklin spent the rest of his life in exile in England. Source: Copy of an undated sketch by Albert Rosenthal (1863–1939) after an original painting. Image 1240411, Print Collection, Miriam and Ira D. Wallach Division of Art, Prints and Photographs, The New York Public Library, Astor, Lenox and Tilden Foundations.

First page of King George III's commission appointing William Franklin governor of New Jersey, September 9, 1762. Source: Department of State, Secretary of State's Office, Commission and Appointment Certificates, 1744–1917, item 11. New Jersey State Archives, Department of State.

The Greenwich Tea Burning Monument, Greenwich, Cumberland County. Created by the O. J. Hammell Co., it was erected in 1908 to commemorate the local patriots "who on the evening of December 22, 1774, burned British tea near this site." The tea had been removed from the *Greyhound*, a merchant ship on its way up the Delaware to Philadelphia. Source: Department of Environmental Protection, Division of Parks & Forestry, Photographs Filed by Subject, 1930s–1970s, item Greenwich002. New Jersey State Archives, Department of State.

that offended colonists' notions of their rights, created closer ties among the colonies, and led to revolution. Initially slow to react to imperial events, by the summer of 1776 New Jersey had joined the movement for independence, adopted a state constitution, and then found itself in the middle of the fighting, where it remained until the British withdrew from New York City in 1783. The Revolution severed ties with Britain, divided New Jerseyans into patriots, loyalists, and neutrals, and left a trail of destruction

Gen! William, Lord Stirling.
From miniature at Harvard.

William Alexander (1726–1783), known as Lord Stirling, was born into a wealthy and politically connected New York/New Jersey family. A member of the East Jersey Board of Proprietors and of the New Jersey Provincial Council, he sided with the colonists in the American Revolution and became one of George Washington's trusted generals. Source: Colored print from a miniature at Harvard University Library, artist unknown. New Jersey Portraits (Oversized) Collection, Special Collections and University Archives, Rutgers University Libraries.

A loyalist member of the New Jersey General Assembly likely drew this illustration of King George III's royal coat of arms into the legislature's minutes for January 11, 1775. The lion represents England, and the unicorn Scotland. Source: New Jersey General Assembly, Minutes [Votes and Proceedings], 1703–2010, box 9, page 110. New Jersey State Archives, Department of State.

across the state. Economic problems during and after the war meant that New Jersey was skeptical about the Articles of Confederation but quick to ratify the U.S. Constitution. In twenty-five years—one generation—much had changed.

At the end of the French and Indian War, the American colonies were proud members of the British Empire, rejoicing in the victories they had helped to win. However, the war left Britain with an enormous debt and an expanded global empire, resulting in the need for both administrative efficiency and money. As British officials looked to the colonists to contribute to past and current expenses, Parliament passed the Sugar Act in 1764 and the Stamp Act in 1765, both intended to help pay for troops stationed in North America. Opposition to the Stamp Act, an unprecedented tax imposed on newspapers and legal documents, spread throughout the colonies, leading to mob action in urban areas, particularly in Boston, where the homes of the stamp distributor and of Lieutenant Governor Thomas Hutchinson were attacked. Intimidated stamp collectors in one colony after another, including New Jersey, resigned. New Jersey had no urban areas where mobs could congregate, and William Franklin was initially proud that his colony remained calm. But then the assembly sent delegates to the Stamp Act Congress held in New York City in October, which produced a Declaration of Rights and Grievances to be sent to London. (The one New Jersey delegate who refused to sign the declaration, Robert Ogden, was later hung in effigy.) Following

the congress, the New Jersey Assembly passed resolutions insisting that as Englishmen they could be taxed only "with their own Consent, given personally or by their Representatives." Parliament repealed the Stamp Act the following year, but passed a Declaratory Act affirming its right to legislate for the colonies in "all matters whatsoever" (thus including taxes).

With the Townshend Acts of 1767, Parliament tried again to collect revenue from the colonists (duties on imported lead, paper, paint, and tea), this time to pay the salaries of royal governors and judges, thus insulating them from insubordinate assemblies. Colonists responded by boycotting British goods. In Boston, the American Customs Board, created to enforce the acts, was so unpopular that military assistance was sent to the city. On the same day in March 1770 that Parliament repealed all but the tea tax, British troops killed five civilians in the so-called Boston Massacre.

The soldiers so hated in Boston were initially welcomed to barracks in New Jersey for the money they spent, until residents were asked to cover the cost of their maintenance (seen as a tax). But without firebrand leaders like Patrick Henry and Samuel Adams, the most pressing issue became a local one. In 1768, the house of Steven Skinner, the East Jersey treasurer, was robbed, and a dispute between the assembly and Governor Franklin over who should replace the money and then the treasurer dragged on for several years, eroding the governor's influence.

Title page of Jacob Green (1722–1790), *Observations on the Reconciliation of Great-Britain, and the Colonies, in Which Are Exhibited, Arguments for, and against, That Measure. By a Friend of American Liberty* (Philadelphia: Printed by Robert Bell, 1776). Green was a Presbyterian minister in Hanover, Morris County, a supporter of the Revolution, and a member of the committee that wrote New Jersey's 1776 constitution. Source: Special Collections and University Archives, Rutgers University Libraries (SNCLX E211.G7960).

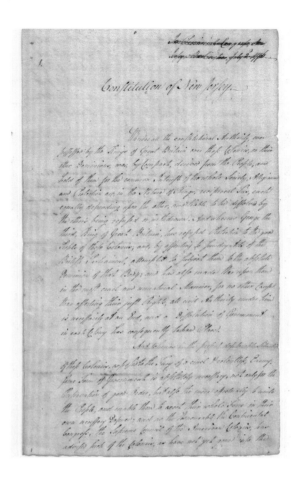

First page of the Constitution of New Jersey, 1776. Written by a committee of the New Jersey Provincial Congress, it was adopted by a vote of that body on July 2, 1776. The first paragraph is New Jersey's declaration of independence; the rest of the document provides the form of government, including a strong legislature and weak governor. It also afforded protection of basic rights: religious toleration, annual elections, and trial by jury. Source: Department of State, Secretary of State's Office, Miscellaneous Filings (Series I), c. 1681–1986, item 5. New Jersey State Archives, Department of State.

The design of New Jersey's state seal was adopted at a meeting of the legislature at the Indian King Tavern, Haddonfield, in May 1777. The horse represents speed and strength; the armor, sovereignty; the three plows, the importance of agriculture; and the two figures, liberty and prosperity. Source: Department of State, Secretary of State's Office, Original State Seal Castings, 1777–1928. New Jersey State Archives, Department of State.

Indian King Tavern, Haddonfield, built c. 1750. The New Jersey legislature met here when it adopted the great seal of the state. In 1903, the building became a state historic site, the first to become part of the park system. Photograph by R. Veit.

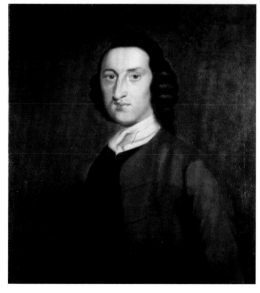

Appointed governor by the two houses of the legislature in 1776 under the state's first constitution, William Livingston (1723–1790) served continuous one-year terms until his death. The British placed a price on his head during the Revolution, and he moved frequently to avoid capture. Source: Oil on canvas, 29 5/8 x 24 ½ in., by Henry Harrison (1844–1923), 1907. New Jersey State House Portrait Collection, administered by the New Jersey State Museum (SHPC29). Reproduced with permission.

Colored postcard, 1909, showing the original section of Liberty Hall in Elizabethtown. William Livingston (1723–1790) built this home in 1772, when he moved from New York to enjoy the peace and quiet of the then country town. The Revolution quickly caught up with him. Source: Liberty Hall Museum, Kean University.

Susan Livingston Saves Governor William Livingston's Papers. According to family tradition, Livingston's daughter provided the British with insignificant legal papers rather than the governor's important correspondence when they raided his home in Elizabethtown in 1779. Source: Oil painting by Giselle Lindenfeld (1905–1986). Liberty Hall Museum, Kean University.

In 1773, Parliament passed the Tea Act, intended to solve the financial problems of the East India Tea Company and to undercut the price of smuggled tea, thereby inducing colonists to pay the Townshend duties and implicitly accept Parliament's right to tax them. The protests that followed prevented the landing of the company's tea in many colonies. Resistance in Boston culminated in the celebrated Tea Party on December 16, 1773, which infuriated King George III as well as many members of Parliament (and conservatives in the colonies) and led to passage of the Coercive/Intolerable Acts in April 1774. Meant to punish Boston

and force Massachusetts to pay for the destroyed tea, the laws closed the port, made members of the colonial council appointive, restricted local government, and more. Rather than isolate Massachusetts and divide the colonies, as British authorities expected, the acts were interpreted as a threat to the rights of all. Colonists began to unite around what they called "our common cause" over the winter of 1774/1775, collecting arms and supplies. War started when General Thomas Gage, the military governor of Massachusetts, sent soldiers through Lexington to capture the supplies at Concord and shots were exchanged.

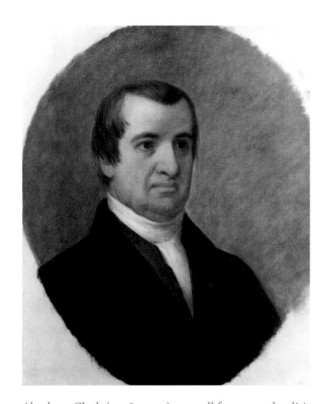

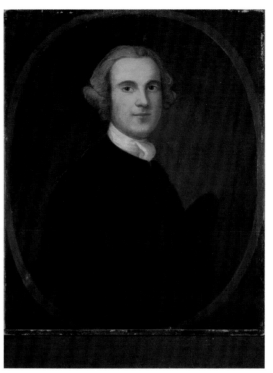

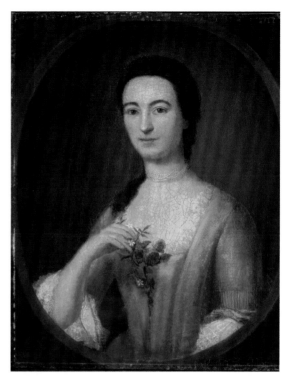

Abraham Clark (1726–1794), a small farmer and politician from Elizabethtown, was a delegate to the Second Continental Congress and a signer of the Declaration of Independence. He was sometimes referred to as "the poor man's counselor" because of his representation of individuals unable to pay for legal services. Source: Portrait by James Read Lambdin (1807–1889) after John Trumbull (1756–1843), c. 1872. New Jersey Portraits Collection, Special Collections and University Archives, Rutgers University Libraries.

Richard Stockton (1730–1781), an early graduate of the College of New Jersey (now Princeton University), a prominent lawyer, and a member of the Provincial Council, defended the rights of colonists, represented New Jersey at the Second Continental Congress, and signed the Declaration of Independence. Source: Oil on canvas, 30 9/16 x 25 9/16 in., attributed to John Wollaston (c. 1710–c. 1767). Princeton University Art Museum/Art Resource, New York. Bequest of Mrs. Alexander T. McGill. Photograph by Bruce M. White.

Annis Boudinot Stockton (1736–1801), the well-educated wife of Richard Stockton, was one of America's earliest published female poets. Her verses celebrated heroes of the American Revolution and honored George Washington. Source: Oil on canvas, 30 5/16 x 25 ½ in., attributed to John Wollaston (c. 1710–c. 1767). Princeton University Art Museum/Art Resource, New York. Bequest of Mrs. Alexander T. McGill. Photograph by Bruce M. White.

New Jersey was never in the forefront of this move toward revolution, but its residents, including a number who would later become loyalists, opposed British taxation. The assembly signed the Massachusetts Circular Letter of 1768, and residents held their own tea parties: patriots at Greenwich burned a cargo headed for Philadelphia, while students in Princeton burned the college's stores. New Jersey sent supplies to Boston when that port was closed and then chose delegates for the Continental Congresses in 1774 and 1775. It began to elect representatives to a provincial congress even as the old royal legislature

Richard and Annis Stockton built the central portion of their home, Morven, in Princeton in 1758. The Stockton family was one of the most prominent in early New Jersey, and four more generations added to the residence. From 1945 to 1981, Morven served as the state's first governor's mansion. Today the restored property is a historic house and garden museum. Photograph by R. Veit.

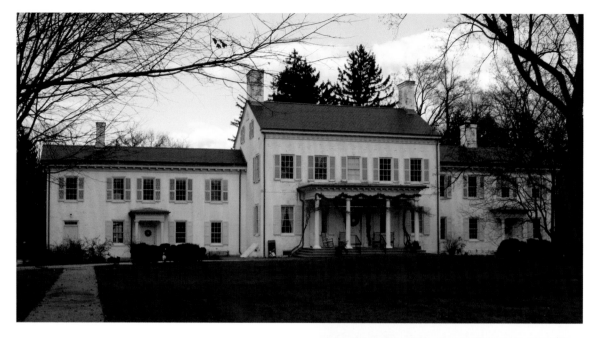

continued to meet. This new body started to collect taxes and raise troops, sending them to the army formed around Boston and then to Canada. In the spring of 1776, New Jersey moved slowly toward independence. In June, it arrested Governor Franklin and sent new delegates to Philadelphia to vote for independence (John Witherspoon, John Hart, Abraham Clark, Richard Stockton, and Francis Hopkinson). On July 2, the former colony adopted a state constitution that started with its own declaration of independence. By then, British forces had arrived in New York Harbor; invasion was just a matter of time.

New Jersey became a central battleground of the Revolution because of its location and because its agricultural economy produced food needed by both armies. Situated between New York City (held by the British for most of the war) and Philadelphia (the sometime patriot capital) and between two major rivers and with a long coast (where privateers could hide), New Jersey provided a corridor between the northern and the southern colonies, while its western mountains served as a natural fortification for the Continental Army, which spent winters in Pluckemin and Morristown (twice).

In 1768, the Scottish Presbyterian minister John Witherspoon (1723–1794) answered the call to become the sixth president of the College of New Jersey (now Princeton University). An early and strong supporter of the Revolution, he was the only college president and the only clergyman to sign the Declaration of Independence. Source: Oil on canvas, 30 x 24 7/8 in., by an unidentified artist after Charles Willson Peale (1741–1827). Princeton University Art Museum/Art Resource, New York. Gift of friends of Princeton University. Photograph by Bruce M. White.

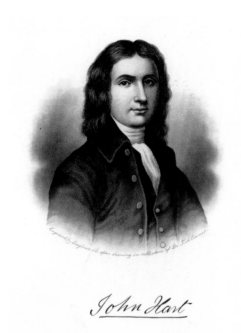

John Hart

John Hart (c. 1714–1779), a farmer and mill owner from Hunterdon County, served in the New Jersey Provincial Congress and the Second Continental Congress, where he signed the Declaration of Independence. Hart was forced into hiding during the Revolution. Source: New Jersey Portraits Collection, Special Collections and University Archives, Rutgers University Libraries.

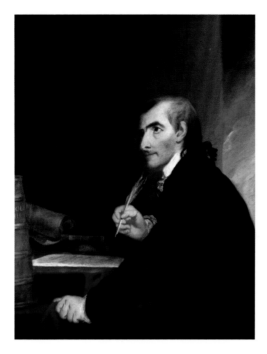

Francis Hopkinson (1737–1791) graduated in the first class of the College of Philadelphia (now the University of Pennsylvania), studied law, married Ann Borden, and moved with her to Bordentown. He served briefly on the New Jersey Provincial Council but resigned to support the Revolution. After signing the Declaration of Independence, he moved back to Pennsylvania. Source: Oil on canvas by Robert Edge Pine (1730–1788), 1785. Historical Society of Pennsylvania Collection, 1891 7. Philadelphia History Museum at the Atwater Kent. Gift of Oliver Hopkinson, 1891.

Francis Hopkinson (1737–1791), "The Battle of the Kegs," [1778]. The poem pokes fun at the British in the battle for control of the Delaware River and refers to a scheme to float gunpowder-filled barrels downriver to impede British ships supplying Philadelphia. The effort was unsuccessful, but the poem was set to music and became a popular ballad. Hopkinson was a multi-talented man, a painter and musician as well as a lawyer, politician, and judge. Source: Printed Ephemera Collection, portfolio 163, folder 3, rbpe163000300. Library of Congress, Washington, D.C.

The war moved to New Jersey in 1776, when the British pushed George Washington and his army from Long Island and Manhattan and then across the Hudson. On the night of November 20, 1776, Lord Cornwallis's army scaled the Palisades, sending the Americans on the "long retreat" that ended in Pennsylvania. New Jersey's patriot leaders scattered, hid, or, like Richard Stockton, were captured and imprisoned in New York. Many thought the war over and took an oath of allegiance to the king, but others began to regroup and fight back. Washington's victory at Trenton on December 26, 1776, and then

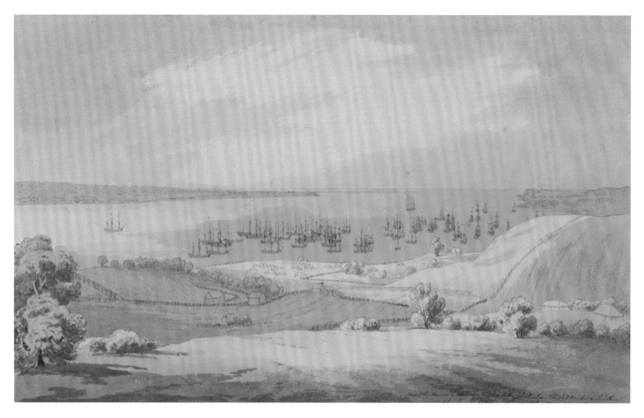

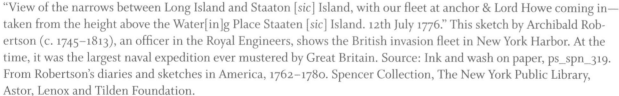

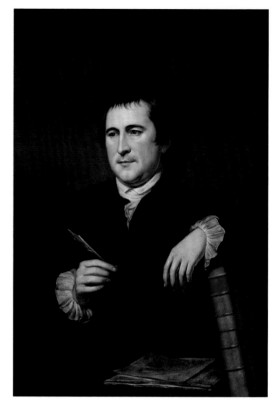

"View of the narrows between Long Island and Staaton [*sic*] Island, with our fleet at anchor & Lord Howe coming in—taken from the height above the Water[in]g Place Staaten [*sic*] Island. 12th July 1776." This sketch by Archibald Robertson (c. 1745–1813), an officer in the Royal Engineers, shows the British invasion fleet in New York Harbor. At the time, it was the largest naval expedition ever mustered by Great Britain. Source: Ink and wash on paper, ps_spn_319. From Robertson's diaries and sketches in America, 1762–1780. Spencer Collection, The New York Public Library, Astor, Lenox and Tilden Foundation.

Jonathan Dickinson Sergeant (1746–1793), a resident of Princeton, served in the Second Continental Congress and the New Jersey Provincial Congress, where he helped to write the state constitution of 1776. After British forces burned his home in Princeton, he moved to Pennsylvania. Source: Oil on canvas, 35 ½ x 26 5/8 in., by Charles Willson Peale (1741–1827), 1786. Princeton University Art Museum/Art Resource, New York. Gift of Jonathan Dickinson Sergeant III. Photograph by Bruce M. White.

his return to Trenton and Princeton in the first days of January sparked further resistance in what has been called the "foraging war." New Jersey was no longer safe for British and Hessian solders as the patriots led by Governor William Livingston regained control. The state was invaded again and again: in 1778, when British forces moved from Philadelphia to New York, resulting in the Battle of Monmouth (a draw); and in 1780, when the Battle of Springfield foiled an effort to reach Morristown. In 1781, Continental and French troops marched through on their way to Yorktown. For most of the Revolution, the state was the site of a nasty civil war that at times pitted neighbors against one another, particularly in Monmouth and Bergen

General Washington at Fort Lee, November 16, 1776, Watching the Assault Upon Fort Washington, 1911. In this mural on the fourth floor of Hudson County's William J. Brennan Courthouse in Jersey City, Charles Yardley Turner (1850–1918) portrays Washington and his officers looking across the Hudson River as British forces capture the patriot fort, a disaster for the Americans because 59 soldiers were killed and 2,837 captured. Fort Lee itself was captured by the British several days later. Photograph © Mark Ludak.

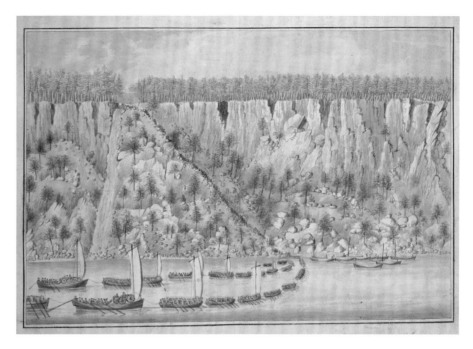

The Landing of the British Forces in the Jerseys on the 20th of November 1776, Under the Command of the Rt. Honl. Lieut. Genl. Earl Cornwallis. British soldiers, aided by a loyalist guide, scale the Palisades to attack Fort Lee. The success of this action forced Washington and his army to retreat across New Jersey. Source: Watercolor by Thomas Davies (British, c. 1737–1812), 1776. Emmet Collection, 54210, Miriam and Ira D. Wallach Division of Art, Prints and Photographs, The New York Public Library, Astor, Lenox and Tilden Foundations.

Counties. Incidents of retaliation continued to the very end and included the execution of militia captain Josiah Huddy by members of a loyalist group. Historians have estimated that more than 600 military events occurred in New Jersey, from major battles to small skirmishes.

Caught in the middle of this war, New Jersey residents chose sides or sometimes switched sides in response to which army might be on their doorstep. Family, friends, and neighbors could influence a decision, as could religion and ethnic background. With reason, British observers dubbed this a Presbyterian revolution; minister-leaders included John Witherspoon (president of

the College of New Jersey), Jacob Green of Hanover, Alexander MacWhorter of Newark, and James Caldwell of Elizabethtown. With few exceptions, Anglican ministers were loyalists; the Dutch were divided; and the pacifist Quakers largely remained neutral. Others with relatives fighting on both sides tried to avoid participation, but Committees of Safety usually insisted they take oaths of loyalty to the new government. Blacks, slave and free, fought on both sides, and some won their freedom by doing so. Most notorious was "Colonel Tye," who participated in a number of loyalist raids until he died from wounds sustained in one of them. A sizable number of New Jersey loyalists fought in British units;

This mural titled *Washington Retreating from New Brunswick* and *Howe and Cornwallis Entering New Brunswick* frames a doorway in the New Brunswick Post Office. It depicts events in late 1776. A brief artillery duel occurred at New Brunswick before the American troops withdrew. The British continued to pursue Washington's army across New Jersey, assuming that the rebellion would soon collapse. The post office was built in 1934, during the Depression, and the mural painted in 1939 by George Biddle (1885–1773) was supported by the federal Works Progress Administration. Photograph by R. Veit.

after the war, they and their families scattered to Canada, the Caribbean, and other parts of the empire. East Jersey treasurer Steven Skinner and his extended family went to Nova Scotia; William Franklin lived until 1814 as an exile in England.

It seems fitting that the war ended in New Jersey. Congress, to escape disgruntled unpaid soldiers in Philadelphia, was meeting in Princeton in 1783 when notice arrived of the signing of the Treaty of Paris. The then president of Congress under the Articles of Confederation was Elias Boudinot, who was residing with his sister, the poet Annis Boudinot Stockton. George Washington wrote his "Farewell Orders" to the Continental Army at nearby Rocky Hill.

At the war's end New Jersey remained the rural agricultural place it had been, but the former colony had changed. The state constitution of 1776 reduced the power of the governor and increased that of the legislature. Elections were annual, trial by jury was guaranteed, freedom of religion was protected, and, for a short time, suffrage was granted to "all

Thomas Paine, 1737–1809, dedicated in 1997. The author of *Common Sense* (January 1776), a pamphlet that inspired American colonists to declare and fight for independence, accompanied George Washington and his army as it retreated across New Jersey in the fall of 1776. After the war, Paine owned a house and property in Bordentown. This statue by Lawrence Holofcener, commissioned by the city, shows Paine reading from *Common Sense*. Photograph by R. Veit.

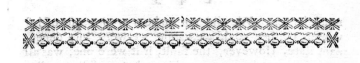

THE CRISIS.

NUMBER I.

December 23, 1776.

THESE are the times that try men's souls: The summer soldier and the sunshine patriot will, in this crisis, shrink from the service of his country; but he that stands it NOW, deserves the love and thanks of man and woman. Tyranny, like hell, is not easily conquered; yet we have this consolation with us, that the harder the conflict, the more glorious the triumph. What we obtain too cheap, we esteem too lightly: 'Tis dearness only that gives every thing its value. Heaven knows how to put a proper price upon its goods; and it would be strange indeed, if so celestial an article as FREEDOM should not be highly rated. Britain, with an army to enforce her tyranny, has declared that she has a right (*not only to* TAX) but " *to* BIND *us in* ALL CASES WHATSOEVER," and if being *bound in that manner*, is not slavery, then is there not such a thing as slavery upon earth. Even the expression is impious, for so unlimited a power can belong only to GOD.

Whether the independence of the continent was declared too soon, or delayed too long, I will not now enter into as an argument; my own simple opinion is, that had it been eight months earlier, it would have been

a 2

Thomas Paine (1737–1809), *The Crisis, Number 1*, December 23, 1776. As the patriots withdrew from New Jersey, Paine wrote a series of thirteen essays urging them to keep up the fight. This first one famously opens with the phrase, "These are the times that try men's souls." George Washington ordered his officers to read the essay to their troops before the crossing of the Delaware and the attack on Trenton. Source: From Thomas Paine, *The Crisis in Thirteen Numbers. Written During the Late War* (Albany: Printed & sold by Charles R. & George Webster, 1792). Special Collections and University Archives, Rutgers University Libraries (X PS819.C3AmW).

The Surrender of General Charles Lee at Basking Ridge to Lt. Colonel Harcourt of the British Army. Lee (1732–1782), a former British officer who joined the patriot cause, was captured on December 13, 1776, depriving the Continental Army of an experienced officer and deepening the sense of crisis. Source: Oil painting on copper, 16 ¾ x 19 ¼ in., by E. Loraine, eighteenth or nineteenth century. Collection of the New Jersey State Museum. Museum purchase, FA1972.120.2. Reproduced with permission.

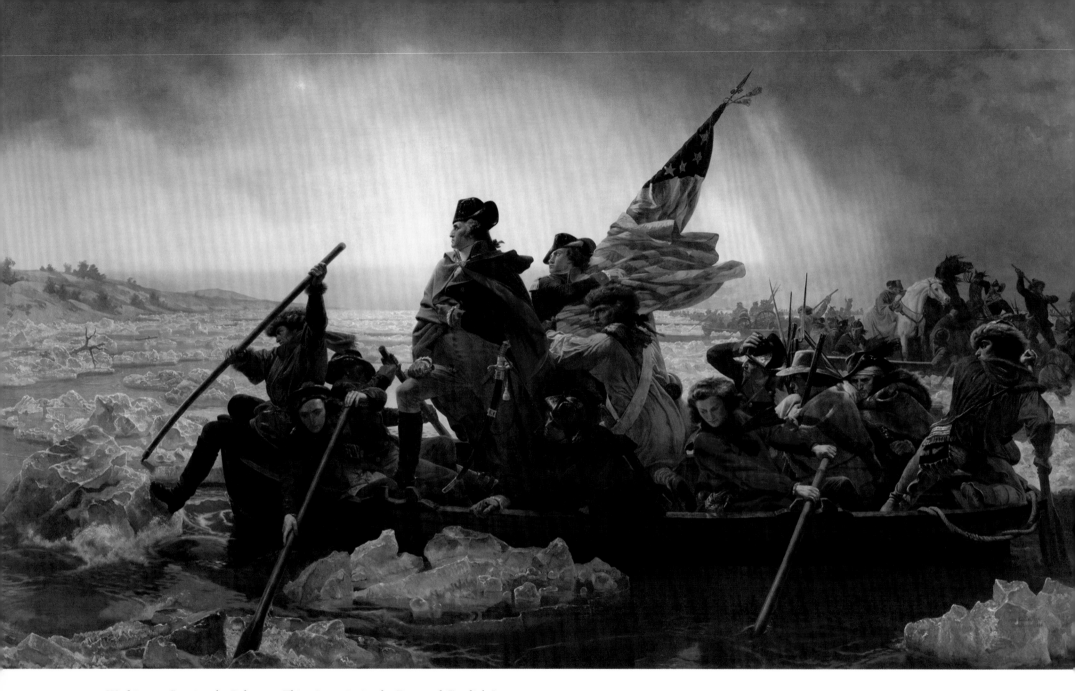

Washington Crossing the Delaware. This 1851 painting by Emanuel Gottlieb Leutze (1816–1868) captures the drama of the icy night crossing that preceded the successful attack on Trenton on the morning of December 26, 1776. Source: Oil on canvas. Ac. 97.34. Metropolitan Museum of Art, New York. Gift of John Stewart Kennedy, 1897. Open Access for Scholarly Content.

This Spanish bronze four-pounder was captured in 1762 at Havana, Cuba, by the New Jersey Provincial Regiment (the "Jersey Blues") serving the British army in the Seven Years War under Lord Albemarle and Admiral George Pocock. It is not clear whether this particular cannon was used during the Revolution, but others of its design were. Source: Old Barracks Museum, Trenton.

Reenactors portraying the Knyphausen Regiment of Hessian fusiliers drill on the parade ground of the Old Barracks Museum, Trenton. The Knyphausen Regiment was one of the three Hessian regiments captured at Trenton on December 26, 1776. Source: Old Barracks Museum, Trenton.

inhabitants" worth £50 (and Protestant), meaning that widows and free blacks could vote. Property requirements for holding office remained, but inheritance laws were made more equitable.

The Revolution also changed New Jersey in ways not always recognized. Some of the families (such as the Skinners) that had dominated colonial politics were gone; Quakers were less influential. Opposition to slavery increased even as the institution survived; suffrage for women and free blacks proved temporary. For Native Americans, the war was a disaster; few remained in the state, and most of those would soon leave.

Meanwhile, the war's end brought economic problems for New Jersey and the new nation. The new states and the central government owed money to former soldiers, those who had provided supplies, and domestic and foreign bond holders. Because so much of the war had been fought in New Jersey, it held a disproportionate share of the new nation's public debt. Adding to problems in New Jersey and elsewhere was the postwar economic depression, caused in part by excessive purchase of British goods long unavailable. Hard times and a shortage of cash led to calls for debtor relief, measures opposed by creditors. While Abraham Clark, a signer of the Declaration of Independence, insisted the suffering

Generals George Washington and Nathaniel Greene Calling on Colonel Rall at the House of Stacy Potts. Johann Rall, commander of the Hessian forces stationed in Trenton, was mortally wounded during the Battle of Trenton and died shortly afterward. This painting (c. 1850–1870), attributed to George Whiting Flagg (1816–1897), was purchased by the Old Barracks Museum from the Stitzer family, descendants of Potts. Source: Old Barracks Museum, Trenton.

was real, conservatives led by William Livingston and William Paterson instead blamed idleness and extravagant living. By the mid-1780s, the legislature moved to provide some relief and passed new paper money bills.

In addition to its economic woes in the 1780s, New Jersey had increasing doubts about the Articles of Confederation. The central government's limited powers did not allow it to tax directly or regulate commerce. Despite New Jersey's efforts to promote its ports, most of its trade still went through New York or Philadelphia, which benefited from the revenues. Nor did the state have claims to the western lands acquired by the peace treaty, and so could not benefit from their sale. Caught between its limited resources and requests for additional funds from the central government, New Jersey refused to pay its requisitions, contributing to the sense of crisis by 1786/1787. The state sent delegates to Annapolis

Johannes Reuber (b. 1759), one of the Hessians who served the British during the Revolution, kept a journal of his military activities, which he illustrated with sketches of British, American, and French ships. Captured at the Battle of Trenton in 1776, he was exchanged for American prisoners in 1778 and then served in the southern campaigns. After the war, he returned to Europe. Source: Johannes Reuber, Military Journal, 1776–1806, Special Collections and University Archives, Rutgers University Libraries.

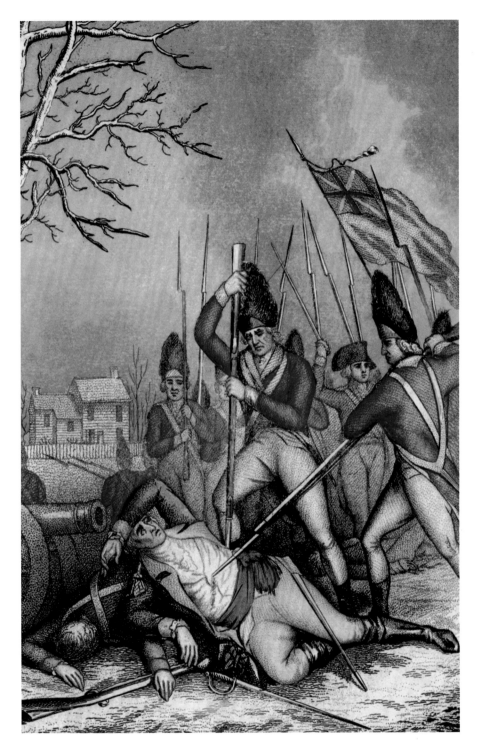

General Hugh Mercer (1726–1777) was overtaken by British forces during the Battle of Princeton on January 3, 1777, and repeatedly bayoneted. He died nine days later in the Thomas Clark house, shown in the background of this nineteenth-century engraving. Source: Frontispiece from John W. Barber and Henry Howe, *Historical Collections of the State of New Jersey* (Newark: Benjamin Olds for Justus H. Bradley, 1861). Special Collections and University Archives, Rutgers University Libraries (SNCLNJ F134.B234H 1861).

The Princeton Battle Monument was designed by sculptor Frederick MacMonnies (1863–1937) and built in Princeton between 1908 and 1922. It shows General George Washington on horseback leading his army, with Liberty in the forefront. On January 3, 1777, after the second Battle of Trenton the day before, the Continental Army successfully attacked the British forces garrisoned at Princeton. Afterward, the army continued to Morristown, where it spent the first of several winters, while the British withdrew from much of New Jersey. Source: Department of Environmental Protection, Division of Parks & Forestry, Photographs Filed by Subject, c. 1930s–1970s, item PrincetonBattleMonument001. New Jersey State Archives, Department of State.

A South-West Perspective View of the Artillery Barracks, Pluckemin N. Jersey, 1779.

A South-West Perspective View of the Artillery Barracks, Pluckemin N. Jersey, 1779. This military camp was established in 1778 by General Henry Knox (1750–1806) at a time when units of the Continental Army were scattered among sites in the Watchung Mountains. Pluckemin is significant as the first military academy for American artillery and engineering officers. Source: Sketch by Captain John Lillie, commander of the 12th Company, 3rd Regiment (Crane's Massachusetts). Morristown National Historical Park.

This brass cartridge box plate found at Pluckemin may show the first use of thirteen stars on an American flag. Source: Reprinted with permission from the Friends of the Jacobus Vanderveer House & Museum, Bedminster.

This button from the uniform of a Continental soldier, recovered during archaeological excavations at Pluckemin, is an important example of the iconography of the young United States. Source: Reprinted with permission from the Friends of the Jacobus Vanderveer House & Museum, Bedminster.

Button from the uniform of a British officer of the 35th Regiment of Foot, which was garrisoned in New Jersey in 1776. The artifact was uncovered during archaeological excavations at Raritan Landing, a port town located across the river from New Brunswick that went into decline after the Revolution. Source: Middlesex County Cultural & Heritage Commission, New Brunswick.

in 1786 to discuss changes, and then to the Constitutional Convention in Philadelphia in 1787 (William Livingston, William Paterson, Jonathan Dayton, William Churchill Houston, and David Brearley). There, William Paterson and the delegation opposed the Virginia Plan, which favored large states, and offered the New Jersey Plan, which provided for a unicameral legislature with equal representation of the states. The delegates eventually agreed to the Great Compromise, which provided for a House of Representatives apportioned by population and a Senate with equal representation of all states. New Jersey became the third state to ratify the U.S. Constitution, its convention doing so unanimously.

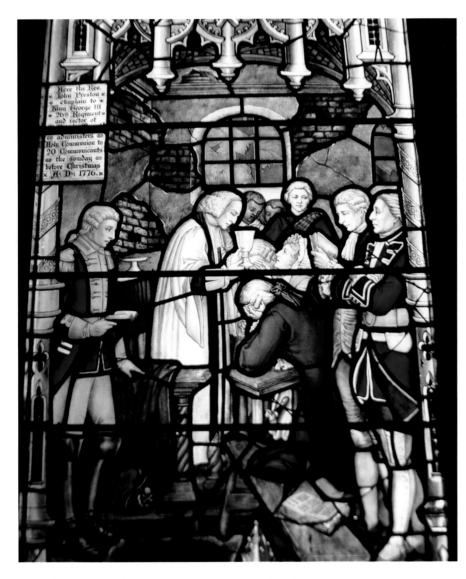

Map of the Battle of Monmouth, June 28, 1778, by John Graves Simcoe (1752–1806), with possible involvement by Adam Allen, George Spencer, and John Hills, all British officers. British forces moving from Philadelphia to New York City were attacked by the Continental Army near present-day Freehold. A military draw, the battle was a political victory for the Americans because they held the field against a large and experienced force. Source: Library & Archives, Monmouth County Historical Association, Freehold. Gift of Bertram H. Borden, 1935.

A stained glass window in Saint Peter's Church, Perth Amboy, shows British soldiers receiving communion in December 1776. The Reverend John Preston was both rector of the church and chaplain of the 26th British Regiment. Residents of Perth Amboy were divided during the Revolution, and the town and church were occupied at different times by British and American forces. Saint Peter's was first organized in 1698 as an Anglican church; today, the third church on the site is Episcopalian. Photograph by R. Veit.

New Jersey played an important role in the Constitutional Convention, as it had during the Revolutionary War. This story is complicated, and the results mixed; but it is also one full of numerous dramatic events worth remembering. British soldiers dragged cannon up the Palisades, overran Delaware River forts on their way to Philadelphia, captured General Charles Lee at Basking Ridge, and massacred sleeping patriots at Hancock's Bridge. Washington crossed the Delaware in a blizzard to attack the Hessians at Trenton, Molly Pitcher reputedly fired a cannon at the Battle of Monmouth, and the death of Hannah Caldwell, wife of the "rebel pastor" James Caldwell, during the Battle of Connecticut Farms steeled patriots to their cause. There are few places in the state untouched by events during this period.

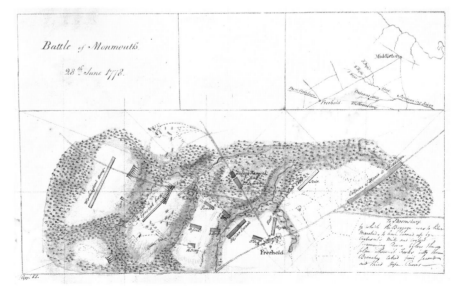

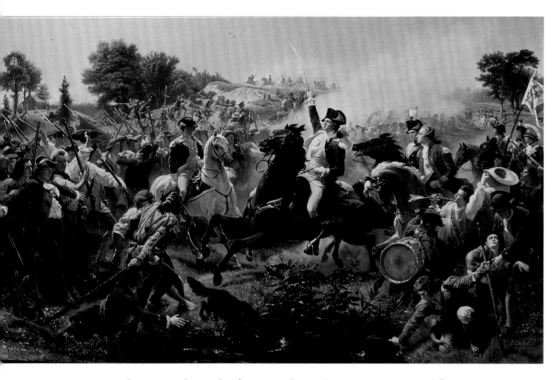

Washington at the Battle of Monmouth. Washington encountered fleeing troops at a critical point in the battle and returned them to the main American force. Source: Oil on canvas by Emanuel Gottlieb Leutze (1816–1868), 1857. Museum Collection, Monmouth County Historical Association, Freehold. Gift of the descendants of David Leavitt, 1937.

The Battle of Monmouth on June 28, 1778, one of the largest engagements in the American Revolution, is reenacted annually. Here a gun crew of reenactors that includes a woman portraying Molly Pitcher demonstrates the use of a cannon. Photograph by R. Veit.

BIBLIOGRAPHY

Many books have added to our understanding of the Revolution, the 1780s, and debate over the Constitution; for more complete references on New Jersey in this period, see John Fea, "Revolution and Confederation Period: New Jersey at the Crossroads," in *New Jersey: A History of the Garden State*, ed. Maxine N. Lurie and Richard Veit (New Brunswick: Rutgers University Press, 2012). Of particular interest on the patterns of the war is Mark Lender, "The 'Cockpit' Reconsidered: Revolutionary New Jersey as a Military Theater," in *New Jersey and the Revolution*, ed. Barbara Mitnick (New Brunswick: Rutgers University Press, 2005). On the Revolution as a civil war, see Michael Adelberg *The American Revolution in Monmouth County: The Theater of Spoil and Destruction* (Charleston, S.C.: History Press, 2010); Adrian Leiby, *The Revolutionary War in the Hackensack Valley* (New Brunswick: Rutgers University Press, 1962); and James Gigantino II, ed., *The American Revolution in New Jersey: Where the Battlefront Meets the Home Front* (New Brunswick: Rutgers University Press, 2015). For the participation of blacks, slave and free, and the slow consequences of Revolutionary ideals, see the articles in *New Jersey History* 127, no. 1 (2013). And for the loyalist worldwide dispersal, see Maya Jasanoff, *Liberty's Exiles: American Loyalists in the Revolutionary World* (New York: Alfred A. Knopf, 2011). A recent work stressing the importance of Presbyterians is S. Scott Rohrer, *Jacob Green's Revolution: Radical Religion and Reform in a Revolutionary Age* (University Park: Pennsylvania State University Press, 2014).

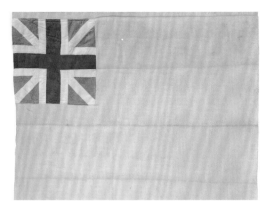

Regimental flag, c. 1775–1778, belonging to Colonel Henry Monckton, a British officer killed at the Battle of Monmouth. Source: Flag made of silk, silk brocade, cotton, and linen. Museum Collection, Monmouth County Historical Association, Freehold. Gift of Mrs. Marguerite Potter Bixler, 1943.

Colonel Henry Monckton, a British officer, was carrying this sword when he was killed at the Battle of Monmouth. Source: English sword made of steel, silver, and wood, from the second half of the eighteenth century. Museum Collection, Monmouth County Historical Association, Freehold. Gift of Mrs. Howard Brinton, 1954.

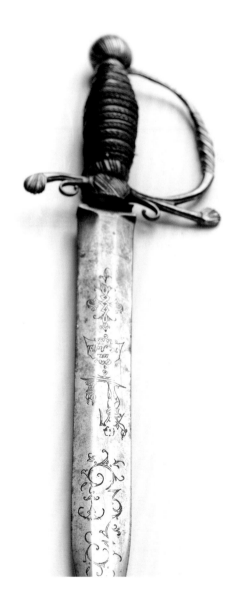

"Molly Pitcher" the Heroine of Monmouth, c. 1876. This Currier & Ives print is one of many images showing Molly Pitcher assisting with a cannon during the battle. Although this heroic action is probably a legend, a woman named Mary Ludwig Hays was present on the battlefield and may have carried water to her husband and other soldiers. Source: Image LC-USZC2–3186, Library of Congress, Prints and Photographs Division, Washington, D.C.

The Ford Mansion, George Washington's headquarters in Morristown. From December 1779 to June 1780, Washington and some of his officers stayed in this house, built by Jacob Ford Jr. and owned by his widow, Theodosia, while the Continental Army camped five miles away in Jockey Hollow. Soldiers and civilians alike struggled through the worst winter of the war. Source: Morristown National Historical Park.

The alleged murder of Hannah Ogden Caldwell (1737–1780) by a British soldier on June 7, 1780, during the Battle of Connecticut Farms inspired the design of the Union County seal, adopted in 1933. Patriot forces used her death to inflame local sentiment against the British. In fact, she was inside the house and may have been struck by a stray bullet. Source: Office of the Union County Clerk.

The National Park Service constructed several reproductions of soldier huts at Jockey Hollow, Morristown National Historical Park, using the dimensions described in historical records of the 1779–1780 encampment. Chris Cosgrove, a Monmouth University history student, participated in the reconstruction of this hut. He later entered the military and was killed in Iraq in 2006. Photograph by R. Veit.

"Give 'em Watts, Boys!" (The Battle of Springfield). James Caldwell (1734–1781) was the minister of the Presbyterian church in Elizabethtown and a passionate supporter of the Revolution. During the Battle of Springfield, June 23, 1780, just two weeks after the killing of his wife, Hannah, the "Fighting Pastor" reputedly handed out pages of hymnbooks to be used as wadding in muskets. He himself was killed a year later under suspicious circumstances by an American sentry, who was subsequently executed. Source: Painting by John Ward Dunsmore (1856–1945). From the collections of Fraunces Tavern® Museum, New York City.

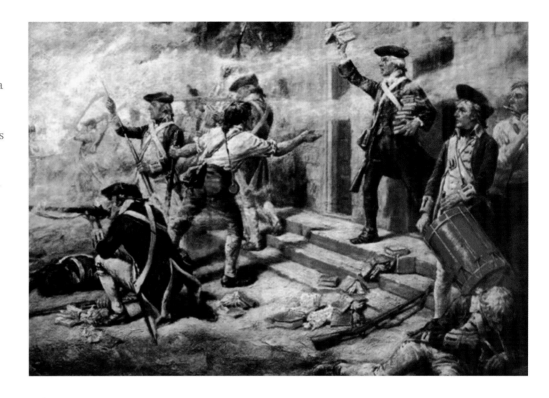

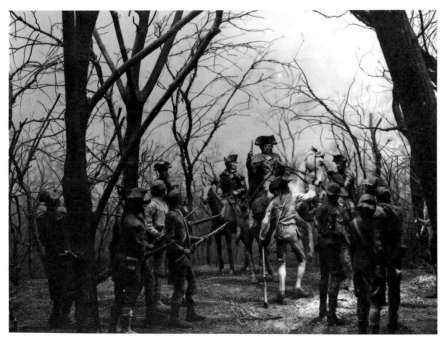

A diorama from the 1930s depicts the mutiny of General Anthony Wayne's brigade at Morristown in January 1781. The soldiers were protesting the harsh conditions in which they lived and the lack of pay. Source: Morristown National Historical Park.

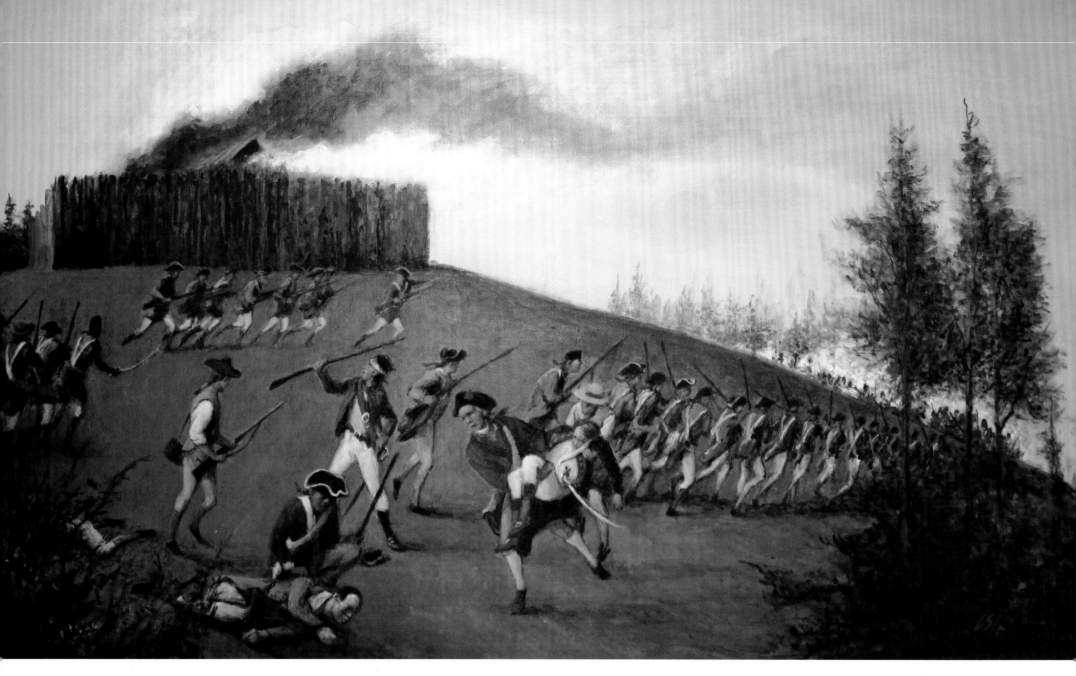

Loyalist attack on the Toms River blockhouse, March 24, 1782. During the Revolution, Toms River was a base for patriot privateers who raided British ships. Six months after the surrender of Lord Cornwallis at Yorktown, a group from the Associated Loyalists in New York City, joined by local loyalists, attacked the patriot militia commanded by Joshua Huddy at the Toms River blockhouse, killing militiamen and torching the town. Huddy was captured later that day, taken to New York, and summarily hanged two weeks later. His execution complicated the ongoing peace negotiations and led George Washington to threaten to hang a captured British officer. Source: Undated painting by an unknown artist. Ocean County Historical Society, Toms River.

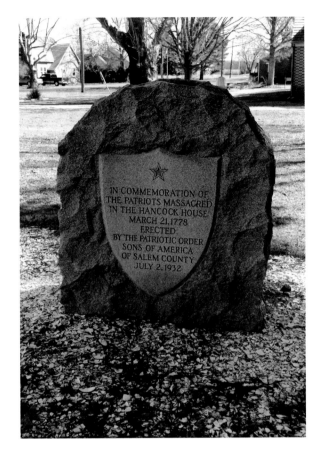

A plaque at the Hancock House, Salem County, recalls the surprise attack by British troops in the early morning of March 21, 1778. Thirty of the local militiamen stationed there were killed, wounded, or captured. Among those who died was Judge William Hancock, owner of the house, who was a loyalist but also a Quaker opposed to war. Photograph by R. Veit.

Cortland Skinner (1727–1799), a prominent lawyer, politician, and attorney general in colonial New Jersey, became the leader of the loyalist New Jersey Volunteers and served through the Revolutionary War. He and his family moved to England afterward, where he received the half-pay pension of a brigadier general. Source: New Jersey Portraits Collection, Special Collections and University Archives, Rutgers University Libraries.

Jannetje Vrelandt Drummond (c. 1740–1790) was married to Robert Drummond (1736–1789), a Bergen County merchant who joined the loyalist cause, recruited men for the New Jersey Volunteers, and served as an officer in New Jersey and then in the South through the war. Jannetje and their three children remained behind. Their property was looted by patriots and then confiscated by the state, and Jannetje herself was accused of treason. At the end of the Revolution, Robert settled in England, and the rest of the family may have joined him there. Source: Pastel on paper, 23 x 17 ¼ in., artist unknown. Item 1898.2. From the collections of the New Jersey Historical Society, Newark.

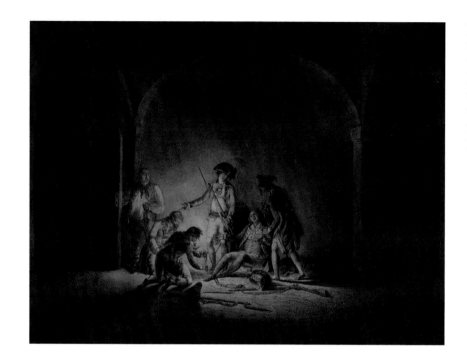

James Moody (1744–1809), a Sussex County loyalist who joined the British forces in 1777 and led raids throughout the region, settled in Nova Scotia after the war and wrote an account of his exploits. In this illustration, Lieutenant Moody rescues a British soldier from the Sussex County jail in Newton. Source: Lithograph drawn and engraved by Robert Pollard (1755/6–1839), 1785. From the exhibition at Morven Museum & Garden, Princeton, "Portrait of Place: Paintings, Drawings, and Prints of New Jersey, 1761–1898, From the Collections of Joseph J. Felcone," 2012. Image courtesy of Joseph J. Felcone. Photograph © Bruce M. White, 2011.

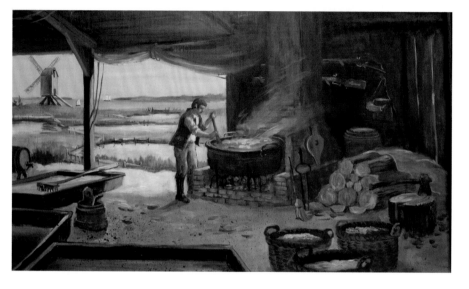

The Pennsylvania Salt Works, which operated near Toms River during the American Revolution, was one of several efforts along the Jersey Shore to produce salt by boiling off seawater. The British blockade of American ports during the Revolution brought about a shortage of the mineral, essential to preserve food. Source: Painting, c. 1975. Ocean County Historical Society, Toms River.

A notorious "Pine Robber" who terrorized the people of the Pine Barrens, Joe Mulliner was caught, tried for treason, and hanged in 1781. This modern marker commemorates his death. Source: Courtesy of Guy Thompson.

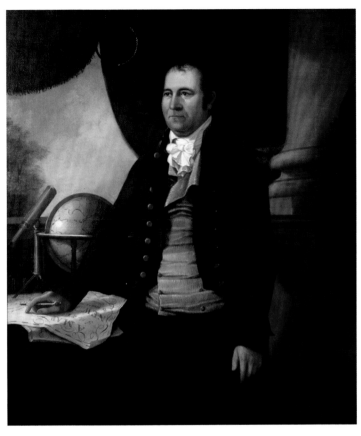

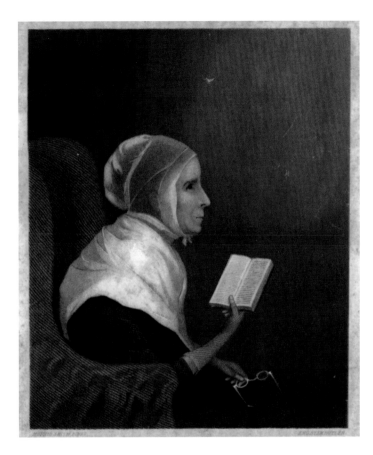

Margaret Hill Morris (1737–1816) was a Quaker widow and recognized medical practitioner who moved from Pennsylvania to Burlington in 1770. For the amusement of her sister, she kept a journal recording events as the war swirled around her. Source: Margaret Hill Morris, box 5, Portraits of American Friends (MSS 850), Special Collections, Haverford College, Haverford, Pennsylvania.

Simeon De Witt (1756–1834), a graduate of Queens College (now Rutgers University) in 1776, was one of George Washington's surveyors and map makers. He became surveyor general of the Continental Army and was stationed in New Jersey in 1780. In this portrait, he is depicted with a globe, telescope, and map, symbols of his craft. Source: Oil on canvas, 153.7 x 123.2 cm (60 ½ x 48 ½ in.), by Ezra Ames (1768–1836), c. 1804. Item 0016. Jane Voorhees Zimmerli Art Museum at Rutgers, The State University, New Brunswick. Gift of the grandchildren of Simeon De Witt. Photograph by Jack Abraham.

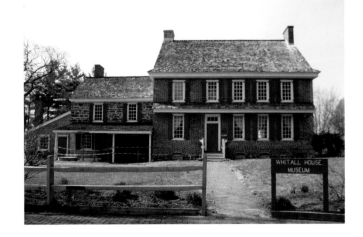

The New Jersey homestead of Quakers James and Ann Whitall, built in 1748 on the Delaware River south of Philadelphia, became caught up in the Revolutionary War when American forces constructed Fort Mercer just north of the house. During the British attempt to overwhelm the fort with Hessian troops in the Battle of Red Bank, October 22, 1777, Ann aided the wounded from both armies. The house is now preserved as part of Red Bank Battlefield, located in the town of National Park. Photograph by R. Veit.

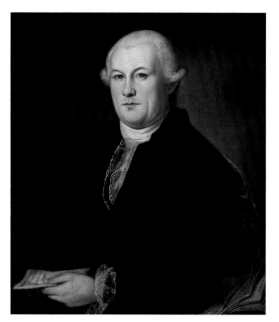

Elias Boudinot (1740–1821) was the president of Congress under the Articles of Confederation, 1782–1783. In this portrait, he holds the "Proclamation of Peace with Great Britain," which arrived while Congress was sitting in Princeton. Source: Oil on canvas, 29 15/16 x 25 in., by Charles Willson Peale (1741–1827), 1784. Princeton University Art Museum/Art Resource, New York. Gift of Mr. and Mrs. Landon K. Thorne for the Boudinot Collection.

Rockingham (Washington's headquarters), 1956. Congress rented this house in Rocky Hill for George Washington while it met in nearby Princeton. Here he wrote his "Farewell Orders" to the Continental Army, November 2, 1783. Source: Department of Environmental Protection, Division of Parks & Forestry, Photographs Filed by Subject, 1930s–1970s, item Rockingham001. New Jersey State Archives, Department of State.

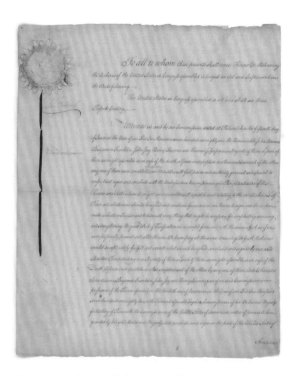

First page of exemplifications of the preliminary treaty with Great Britain, 1783, sent to New Jersey. The American representatives at the negotiations were John Adams, Benjamin Franklin, John Jay, and Henry Laurens. Source: New Jersey State Legislature, Treaty of Paris (Preliminary Articles), 1783. New Jersey State Archives, Department of State.

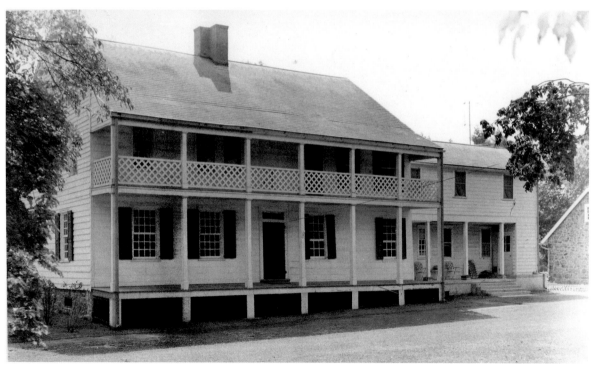

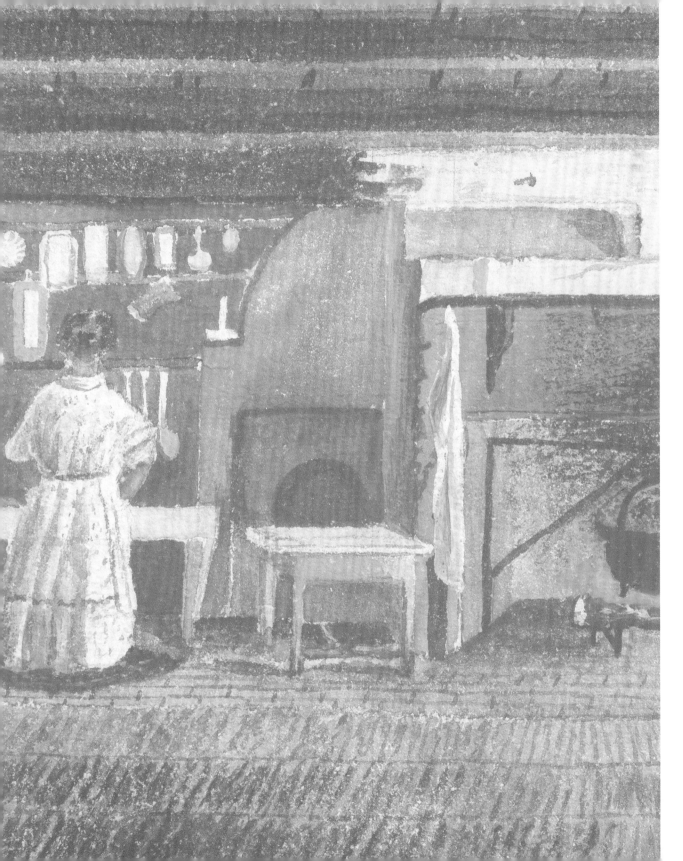

New Jersey in the Early Republic

Toward the end of June 1776, as New Jerseyans contemplated independence and a committee drafted their first constitution, Jonathan Dickinson Sergeant wrote to John Adams that the colony would soon be a "republic." The end of the Revolution ensured that this goal was achieved, but only with the ratification of the U.S. Constitution of 1787 and its implementation in the 1790s and afterward were the details worked out of what citizenship and statehood meant within a federation of states. Who would govern and who was included? Could the state and the nation prosper with an economy centered on agriculture, or were commerce and industry necessary? What about education and religion? Americans wrestled with these and other issues in the Early Republic. New

William Paterson (1745–1806) was a graduate of the College of New Jersey (now Princeton University), state attorney general during the Revolutionary War, and a member of the convention that wrote the U.S. Constitution, where he insisted that the power and influence of small states be protected. Afterward, he served as the second governor of New Jersey, 1790–1793, and as an associate justice of the U.S. Supreme Court from 1793 until his death. Source: Oil on canvas, 29 5/8 x 24 5/8 in., by Henry Harrison (1844–1923), 1905, after an undated original by James Sharples (c. 1751–1811). New Jersey State House Portrait Collection, administered by the New Jersey State Museum (SHPC109). Reproduced with permission.

Jersey, while remaining largely rural, began to change in ways that foreshadowed the period that followed—politics intensified, the pace of life increased, slavery was set on a slow path to extinction—all in a state dominated by white men.

The federal Constitution of 1787 that New Jersey's delegates to Philadelphia (William Paterson, David Brearley, William Livingston, William Churchill Houston, and Jonathan Dayton) helped design was quickly and unanimously ratified in New Jersey. Only Colonel John Stevens, whose father had chaired New Jersey's constitutional convention, participated in the war of words over ratification there and in other states; his views were strongly Federalist and published in New York papers primarily as part of the effort to influence that state to ratify as well. Locally, the new Constitution removed one divisive issue from state politics by prohibiting states from printing money. Although tensions between New Jersey's eastern and western divisions did not disappear, the two sections agreed

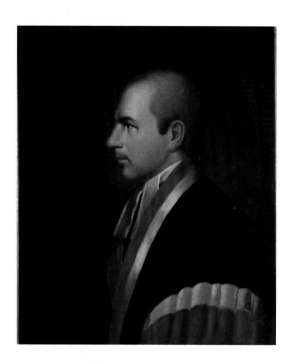

"Nova Caesarea," New Jersey copper cent, 1787. The obverse has a horse head and plow, symbols long used by the state, along with the state's Latin name. The reverse has a shield with thirteen horizontal stripes and a field with additional stripes but no stars. The rim bears the motto "*E* PLURIBUS* UNUM*," meaning "out of many, one." It was adopted for the Great Seal of the United States in 1782 and used on New Jersey coins in 1786, 1787, and 1788. This was the first use of the motto on a state coin that circulated. Source: Courtesy of Karl J. Niederer.

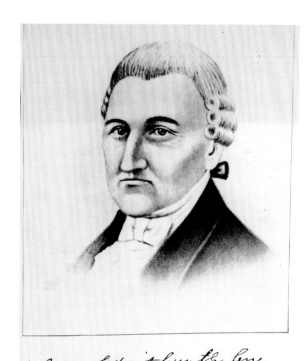

FIRST GRAND MASTER
GRAND LODGE, F. & A. M. OF NEW JERSEY

David Brearley/Brearly (1745–1790) was a lawyer and a Revolutionary War officer who served in both the militia and the Continental Army. The state legislature appointed him chief justice of the state supreme court in 1779, and he represented the state at the Constitutional Convention in 1787. Source: Undated portrait from a federal court book collected by the Federal Writers' Project in New Jersey. Works Progress Administration, New Jersey Writers' Project Photograph Collection, c. 1935–1942, item 1067NWK-19. New Jersey State Archives, Department of State.

Jonathan Dayton (1760–1824), the youngest signer of the U.S. Constitution, later represented New Jersey in both houses of Congress. His involvement in Aaron Burr's 1806 plot to detach western lands put an end to his national political career. Source: Hand-colored lithograph, date unknown. Emmet Collection, em13325, Miriam and Ira D. Wallach Division of Art, Prints and Photographs, The New York Public Library, Astor, Lenox and Tilden Foundations.

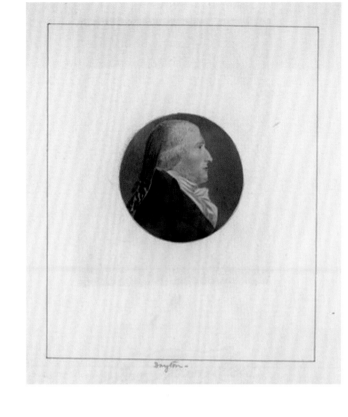

Shaving kit owned by David Brearley/ Brearly (1745–1790). Only rarely do personal items like these survive from the eighteenth century. Source: Works Progress Administration, New Jersey Writers' Project Photograph Collection, c. 1935–1942, item 1067NWK-23A. New Jersey State Archives, Department of State.

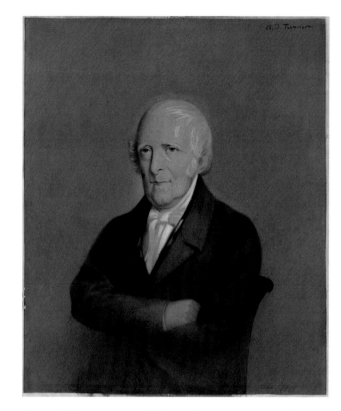

Colonel John Stevens (1749–1838) wrote a series of essays supporting adoption of the U.S. Constitution, which appeared in New York City newspapers while ratification was being debated. He also was an advocate for steam-powered transportation, especially steamships and railroads. Source: Tinted image after an oil portrait, c. 1830. Stevens Family Collection, item 589. Archives & Special Collections, Samuel C. Williams Library, Stevens Institute of Technology, Hoboken.

to tether their peripatetic government and locate the capital in Trenton. When George Washington traveled through Trenton in April 1789 on his way to inauguration in New York City as the first president of the United States, he was greeted as the hero of the battle that had occurred there in 1776 and the leader who would now unite the young country.

The political concord seen in these events did not last long, as the effort to elect representatives to the first Congress had already proved. James Madison wrote that the electoral campaign in New Jersey was "conducted in a most singular manner," because the polling places had been held open for weeks. Congress, called upon to rule on the disputed results, certified the "Junto" as winners: two men from East Jersey and two from West Jersey, all of whom would become prominent Federalists. This contentious election presaged the bitter political divisions that followed in the 1790s, as citizens joined emerging political parties as a means to express their differences over economic policy, the powers of the central government, and foreign affairs.

The acrimonious divisions that developed among nascent political parties of this period can be seen through several events in New Jersey. Its constitution of 1776 was one of eight state constitutions that defined qualified voters by age and amount of property, not gender or race. But New Jersey was the only state where widows and single women who held property in their own names voted. Historians have debated whether this unique situation was the accidental outcome of a carelessly drafted clause, the result of Quaker influence, or a deliberate effort to expand Revolutionary changes. In 1790, after the disputed election of 1789, a state law applying to southern counties specifically referred to voters as "he or she," and in 1797 the

Title page of John Stevens (1749–1838), *Documents Tending to Prove the Superior Advantages of Rail-Ways and Steam-Carriages over Canal Navigation* (New York: Printed by T. and J. Swords, 1812). Stevens advocated the building of railways as a means of tying together the increasingly extended American republic. Failing to get federal support for his proposals, he went on to experiment with steam locomotives on his estate in Hoboken. Source: Special Collections and University Archives, Rutgers University Libraries (SNCLX TF144.S844D).

"A List of the Members of the State Convention, elected pursuant to a Resolution of the Legislature of this State, passed at Trenton, October 29, 1787." The state elected thirty-nine delegates, three from each of the then thirteen counties, to a convention to consider ratification of the U.S. Constitution (one, as noted on the document, did not attend). They met at the Blazing Star Tavern in Trenton, December 11–18, but the record of what was said is sparse. After they signed their agreement to ratification, they retired to another tavern and celebrated with multiple toasts. Source: "Minutes of the Convention of the State of New Jersey, Holden at Trenton the 11th Day of December 1787," page 2. New Jersey State Archives, Department of State.

New Jersey ratification of the U.S. Constitution, December 18, 1787, page 1. The state was the third to ratify the Constitution, and its convention delegates did so unanimously. They signed two fair copies, one for the Congress of the United States and one for the state's archives. Source: Department of State, Secretary of State's Office, Miscellaneous Filings (Series I), c. 1681–1986, box 1, item 8, OV-03a. New Jersey State Archives, Department of State.

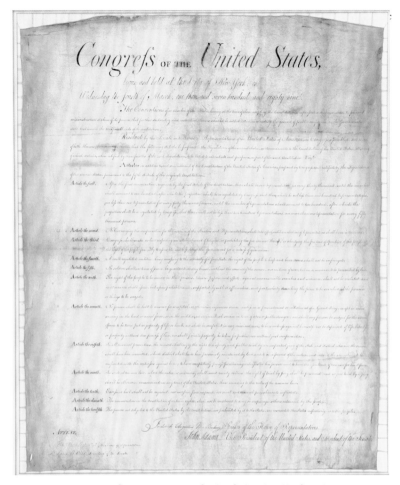

New Jersey was the first state to ratify the federal Bill of Rights, November 20, 1789. Source: Department of Education, Bureau of Archives and History, Manuscript Collection, 1680s–1970s, item 352. New Jersey State Archives, Department of State.

legislature extended the right to vote to women across the state. Both Federalists and Republicans courted women voters, and it is estimated that probably a few hundred women went to the polls in the following years. In 1807, however, women and free blacks were removed from the volatile political mix when a new election law specified that voters must be "adult white men."

The heated political atmosphere of the times also led some implacable rivals to resolve their disputes in duels, the most notorious example being the confrontation between Alexander Hamilton (Federalist and former secretary of the U.S. Treasury) and Aaron Burr (Jeffersonian Republican and then vice president) in 1804. With their seconds, they rowed across the Hudson from New

WASHINGTON'S RECEPTION BY THE LADIES, ON PASSING THE
BRIDGE AT TRENTON, N.J. APRIL 1789.
ON HIS WAY TO NEW YORK TO BE INAUGURATED FIRST PRESIDENT OF THE UNITED STATES.

View of New Brunswick from the south, c. 1795. This image of the early waterfront, with piers, sailing vessels, and probably warehouses on the Raritan River, shows the town's importance as a transportation hub. Source: Ink drawing by Archibald Robertson (1765–1835). Emmet Collection, 1253216, Miriam and Ira D. Wallach Division of Art, Prints and Photographs, The New York Public Library, Astor, Lenox and Tilden Foundations.

Washington's Reception by the Ladies, On Passing the Bridge at Trenton, April 1789. Local women organized this elaborate reception for George Washington, who was on his way to his inauguration in New York City as the first president of the United States. The triumphal arch festooned with flowers commemorates his victories at Trenton, Princeton, and Monmouth. Source: Chromolithograph, 1897. Image LC-USZC62–10808, Library of Congress, Prints and Photographs Division, Washington, D.C.

Town of Perth Amboy in the State of New Jersey, c. 1822. Although always overshadowed by New York City to its north, this small port was an important outlet for the state's products. Source: Watercolor on paper, artist unknown (initials: CGMS). Item 1958–006. From the collections of the New Jersey Historical Society, Newark.

York to Weehawken and fired at each other in a secluded location occasionally used for this purpose. Hamilton died the next day, and Burr was later indicted for murder in New Jersey.

The political competition of the period also had more permanent consequences for the state. Political parties established newspapers to support their candidates and policies, such as the Newark *Centinel of Freedom* (Jeffersonian Republican) and the *Newark Gazette* (Federalist). The parties also began to use patronage appointments, caucuses for members to reach agreement, and conventions to select candidates for office. By 1800, sooner than in most other states, New Jerseyans were using all these tools of modern political machines.

Behind the development of political parties in this period was a dispute over whether the new United States should remain primarily an agricultural society

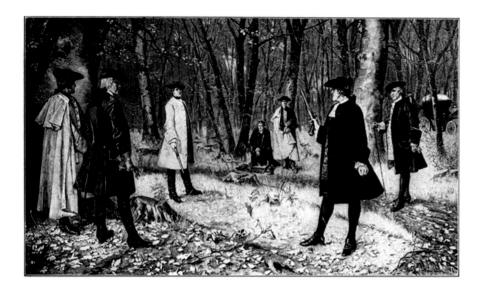

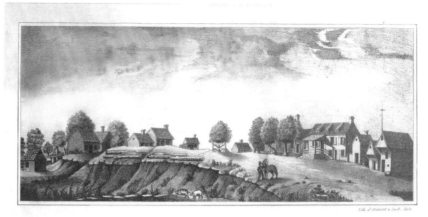

GREENWICH, N.J.
AD. 1800.

In this twentieth-century rendering of the duel between Alexander Hamilton and Aaron Burr at Weehawken, New Jersey, on July 11, 1804, the two political rivals prepare to settle an affair of honor, with fatal consequences for Hamilton, the former secretary of the U.S. Treasury. At the time of the duel, Burr was vice president of the United States; public outrage over Hamilton's death contributed to the end of his political career. Source: Illustration after a painting by J. Mund, in John Lord, *Beacon Lights of History*, vol. 11 (New York: James Clarke and Co., 1902).

Greenwich, N.J. AD 1800. The rural farming nature of this small town along the Cohansey River in western New Jersey did not change much in the Early Republic. Source: Pen and ink drawing. Cumberland County Historical Society, Greenwich.

or pursue policies favorable to industrialization. Although New Jersey's economy remained primarily agricultural, the first effort to create a planned industrial center occurred at the Great Falls of the Passaic River. For Alexander Hamilton, this site offered abundant waterpower, ample labor, and sufficient supplies of fuel and food. In 1791, Hamilton and a group of investors received a charter for the Society for Establishing Useful Manufactures (SUM) and named their selected site Paterson after the then governor (who granted the charter and a monopoly). The project sputtered in the 1790s because of local opposition and lack of a workforce, as well as the financial difficulties of its founders; but manufacturing picked up again with the War of 1812, and Paterson became an increasingly significant industrial center in the 1820s and afterward. Meanwhile, New Jersey continued to produce large

Indictment of Aaron Burr for the murder of Alexander Hamilton, Court of Oyer and Terminer, Bergen County, New Jersey, page 1. According to the document, Burr, instigated by "the Devil," shot Hamilton "wilfully maliciously and feloniously." The grand jury returned a true bill after hearing the evidence. Later, an affidavit was produced stating that Hamilton had died in New York City, and the state supreme court (on appeal) quashed the indictment because the death had occurred outside the jurisdiction of the court. Source: Case 34151, 1804–1807, vault box 2–1, Supreme Court Case Files. New Jersey State Archives, Department of State.

Aaron Burr (1756–1836) was born in Newark into a family of distinguished ministers, but his parents and grandparents died by the time he was two. Raised by relatives, he later graduated from the College of New Jersey (now Princeton University), which his father had helped found, served in the Revolution, then studied law and became involved in New York and national politics. He served as vice president of the United States from 1801 to 1805. Source: Oil on canvas by John Vanderlyn (1775–1852), c. 1802–1803. Yale University Art Gallery, ac. 1968.50.1. Bequest of Oliver Burr Jennings, B.A. 1917, in memory of Miss Annie Burr Jennings.

New Jersey State House, Trenton, c. 1791. In the colonial period, New Jersey's capital alternated between Burlington in West Jersey and Perth Amboy in East Jersey, but after the Revolution Trenton was designated as the meeting place of the government. Portions of the original state house have been incorporated into the current, much expanded building. Source: Colored lithograph. Collection of Maureen Dorment.

amounts of charcoal and other timber products, as well as some iron. Newark became a center for the leather industry, and the inventor Seth Boyden developed a process for patent leather; even more important was his process for making malleable cast iron. Thus, while the state was still largely agricultural in this period, early forms of manufacturing did take hold.

Other economic changes were important as well. Overall, the pace of commercial transactions increased in the 1790s, as banks were created and the government bonds that came out of Hamilton's plans to pay off Revolutionary War debts served as a means of investment and capital accumulation for some. At the same time, there were early efforts to improve the transportation system in New Jersey. The state began to charter private bridge and turnpike companies. Colonel John Stevens had seen the importance of transportation when he wrote his Federalist essays in 1787–1788, pointing out that the "extended republic" created by the new Constitution would need transportation projects to tie it together. He then began experimenting with

Title page of *Poems Written between the Years 1768 & 1794 by Philip Freneau of New Jersey* (Mount Pleasant, Monmouth Co., New Jersey, Year of American Independence XIX [1795]). Freneau (1752–1832), a graduate of the College of New Jersey (now Princeton University), served on privateers during the Revolution and never forgave the harsh treatment he endured on a British prison ship in New York Harbor. The "poet of the American Revolution" became a Jeffersonian Republican and newspaper editor in the 1790s, participating in the fierce political battles of the period. Source: Library & Archives, Monmouth County Historical Association, Freehold.

Plans by Robert Mills (1781–1855) for the Burlington County Jail, Mount Holly, 1808: "Elevation of the Principal Front." Mills, a student and associate of architect Benjamin Latrobe, is best known for designing the Washington Monument. His plans for the Burlington County jail were accompanied by a four-page treatise on penology, and his design incorporated principles of the "Pennsylvania system," including separation of prisoners by type of crime and individual confinement in separate cells. Source: Watercolor. The Athenaeum, Philadelphia.

Plans by Robert Mills (1781–1855) for the Burlington County Jail, Mount Holly, 1808: "General Section from East to West, thro' the Debtors' & Keeper's apartments." Mills was one of the first native-born trained architects in the United States. Source: Watercolor. The Athenaeum, Philadelphia.

Joseph Bloomfield (1753–1823) served in the Revolution and in the 1790s sided with the Jeffersonian Republicans. In 1801, he became the first Jeffersonian elected governor of the state. While in office, he pushed for the gradual abolition of slavery. Source: Oil on canvas, 25 ¼ x 21 ¼ in., by Walter H. Griffin, 1935, based on a 1798 engraving by Charles Balthazar Julien Févret de Saint-Mémin (1770–1852). New Jersey State House Portrait Collection, administered by the New Jersey State Museum (SHPC42). Reproduced with permission.

steam engines, applying the technology first to water transportation and building steamboats that crossed the Hudson. When Stevens ran up against the monopoly that New York State claimed over traffic on that river, one of his vessels (the *Phoenix*) traveled around Cape May and up the Delaware River to Philadelphia, thereby becoming the first steamboat to navigate on an ocean. The legality of the monopoly granted by New York to Aaron Ogden of Elizabethtown was challenged in court by Thomas Gibbons, Ogden's former business partner and also a resident of Elizabethtown. The case was finally resolved in 1824 by the U.S. Supreme Court in a landmark decision that interpreted the Constitution's commerce clause to mean that

Congress's right to regulate interstate commerce extended to navigable waters between states and superseded the powers of the states. Meanwhile, Stevens had proposed the creation of "rail-ways," first in an 1812 pamphlet, and by 1825 he was running a steam locomotive on an experimental track at his estate in Hoboken.

The powers of the new federal government were tested in other ways in the 1790s. Hamilton's proposal for a Bank of the United States stretched the "necessary and proper" clause of the Constitution, while the Whiskey Tax raised needed revenues for the government but provoked an uprising by western farmers. Governor Richard Howell, a Federalist, directed the

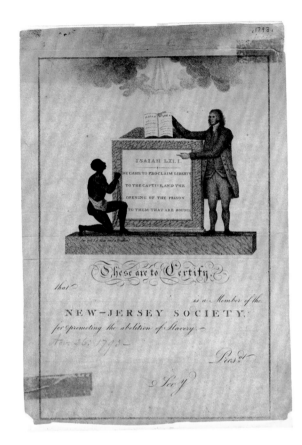

Certificate of membership in the New Jersey Society for Promoting the Abolition of Slavery, dated November 26, 1793, the year of the society's founding. New Jersey was slow to follow Pennsylvania, where Quakers established a precursor to the society in 1775 and the state assembly passed a gradual abolition law in 1780. Source: New Jersey Broadsides Collection, Special Collections and University Archives, Rutgers University Libraries.

John Bray (1750–1834), a merchant with warehouses in New Brunswick and Raritan Landing, served the New Jersey militia as an assistant commissary during the Revolution. This oil painting by an unknown artist shows him with his law books in his later career as a judge. Source: Middlesex County Cultural & Heritage Commission, New Brunswick. Photograph by R. Veit.

Women at the Polls in New Jersey in the Good Old Times. Under the terms of New Jersey's 1776 constitution, all residents worth £50 could vote. As a result, some women and freed blacks voted until the legislature specified in 1807 that voters must be white, male, and aged twenty-one or above. Source: Tinted engraving after a drawing by Howard Pyle (1853–1911), *Harper's Weekly*, November 13, 1880. Special Collections Division, The Newark Public Library.

New Jersey militia when President George Washington led a militia force into Pennsylvania to put down this first challenge to federal authority. But in the opinion of others, the government's resort to extensive military force to confront a minor protest was a dangerous precedent.

Regarding the international scene, reactions to the French Revolution and then toward England (favored by Federalists) and France (viewed with more sympathy by Jeffersonian Republicans) also influenced domestic politics. When Washington obtained and then signed the Jay Treaty in 1796, seen by some as too favorable to England, a copy was burned in Flemington. Under his successor, John Adams, Congress passed the Alien and Sedition Acts in 1798, in part to suppress French immigrant support for the Jeffersonian Republicans. The Sedition Act, in particular, was designed to silence criticism of

the government, even the comments of an inebriated Newark resident. As President Adams and his wife, Abigail, passed through Newark in July 1798, Luther Baldwin was heard to remark of the cannon salute in their honor, "There goes the President and they are firing at his a__." Baldwin was tried, convicted, and fined for sedition, whereupon a local newspaper commented on the dangers of joking in a republic.

The Federalists dominated New Jersey politics through the heated disputes of the early 1790s, but their popularity and power eroded with these events. In 1800, Jeffersonian Republican Joseph Bloomfield was elected governor, and that party held sway until the Embargo Act of 1807 cut New Jersey's trade; the War of 1812 cost the party further support. In 1812, Aaron Ogden was elected governor during a Federalist resurgence, but his party's revival was short-lived (except in some local areas). The war was followed by a surge of nationalism in the United States and peace in Europe. The so-called Era of Good Feelings was a time of ostensible one-party politics. In reality, political divisions did not disappear; they were simply reconfigured, especially after the national election of 1824.

The Early Republic was a transition period during which New Jersey residents worked out their understanding of a republic in other areas as well, including passage in 1804 of a gradual emancipation act, expansion of educational opportunities for some, and an increase in religious diversity. The Quakers were among the first American colonists to argue against slavery, and by 1776 the Philadelphia Yearly Meeting had banned all

An Act For the Gradual Abolition of Slavery (Burlington, N.J.: S. C. Ustick, 1804). By the provisions of this law, children born to slave parents after July 4, 1804, were slaves "for a term," bound to the owners of their mothers for a period of twenty-five years for males and twenty-one years for females. No provision was made for slaves born before July 4, 1804. Source: Broadside 187. From the collections of the New Jersey Historical Society, Newark.

William Vandorn's offer of a "$10 Reward" for the capture and return of a runaway slave named Elias is testimony to just how slowly gradual emancipation worked. In September 1830, twenty-six years after passage of the gradual abolition law, Elias was nineteen and would not be free for another six years. Apparently, he decided not to wait. Source: Broadsides, Legal. Library & Archives, Monmouth County Historical Association, Freehold.

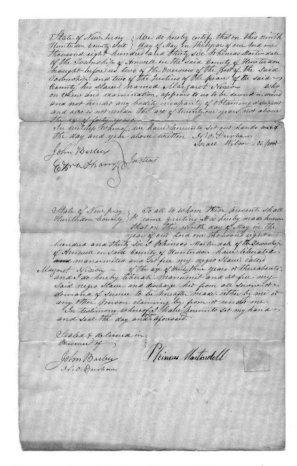

Manumission of the slave Margaret Nixon, aged thirty-three, by her owner, Phineas Martindell, Amwell Township, May 9, 1836. Because she had been born before 1804, Margaret would have had to serve for life. Source: County Records, Hunterdon County, Clerk's Office, Manumissions of Slaves, 1788–1836, item 57. New Jersey State Archives, Department of State.

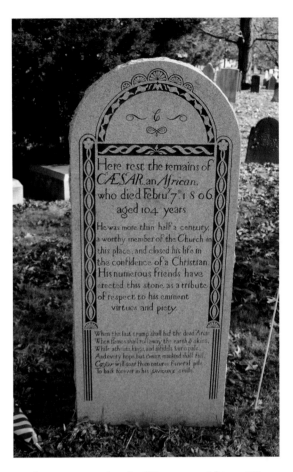

Replica grave marker for "Caesar, an African." Born into slavery, he was owned by Deacon Nathaniel Drake and served as a teamster in the American Revolution, after which he was freed. When he died at age 104, he was buried in the graveyard of the Scotch Plains Baptist Church, where he had served as a deacon. Photograph by R. Veit.

members, including those in New Jersey, from owning slaves. They were among the activists who pointed to the Declaration of Independence's statement that all men are created equal to argue for the end of the institution. Moses Bloomfield referred to the Declaration when he freed his slaves on July 4, 1783, in a public ceremony celebrating the end of the Revolution. Efforts by the legislature to abolish slavery in the mid-1780s failed, but support gathered slowly with the creation of the New Jersey Society for Promoting the Abolition of Slavery in 1793. At that time, slavery was increasingly centered in the northeastern section of the state, where small farmers, many Dutch, objected to efforts to end slavery as a violation of their property rights. New Jersey's abolition law tried to appease opponents by making the process gradual, stipulating that after July 4, 1804, the children of slaves would be freed when they came of age—twenty-one for females and twenty-five for males—after their labor had supposedly repaid their owners. Some owners connived to send young slaves south, but the law was implemented, if imperfectly. Gradually, the number of slaves declined, but so did the proportion of blacks in the population; freed blacks found more opportunity elsewhere as increasing numbers of white immigrants moved into the state.

A concern to prepare citizens to participate in a democracy led to a greater emphasis on education in the Early Republic. Although the fundamentals were not yet systematically provided to all children, the number of local schools, some of them church-supported, increased. The education of white women

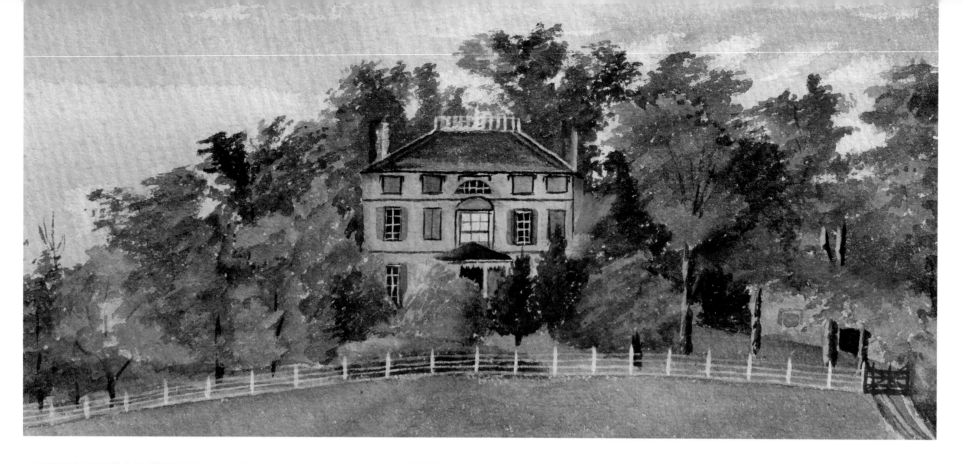

View of Merino Hill, Wrightstown, Monmouth County. This country estate was built in 1810 by Quaker abolitionist Samuel Gardiner Wright (1781–1845), a merchant, politician, and iron manufacturer. A Whig, he was elected to the U.S. Congress shortly before his death. Source: Watercolor on paper by an unknown artist, c. 1880–1900. Purchase, 2012. Museum Collection, Monmouth County Historical Association, Freehold.

Summer kitchen at Merino Hill, Wrightstown, Monmouth County. A farm girl named Martha Nixon, probably a free African American (who could have been born free or slave), is working in the kitchen at Samuel Wright's house. Source: Watercolor on paper by an unknown artist, c. 1880–1900. Purchase, 2012. Museum Collection, Monmouth County Historical Association, Freehold.

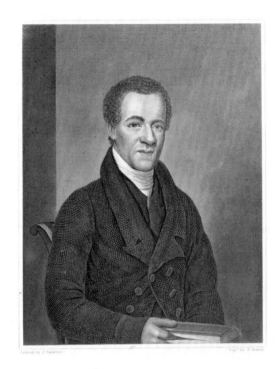

REV.ᴰ SAMUEL CORNISH

Pastor of the first African Presbyterian Church in the City of N. York

Revd. Samuel E. Cornish, Pastor of the first African Presbyterian Church in the city of N. York. Cornish (1795–1858) was born a free black in Delaware, was ordained a Presbyterian minister in 1822, and became a co-founder of the first black-owned and -operated newspaper in America in 1827. He lived in Philadelphia and New York City, as well as in Bellville and Newark, where for a time he served as a pastor. Cornish was opposed to the colonization scheme to send freed blacks to Africa, maintaining their right to live as free men and women in the United States. Source: Undated engraving by Francis Kearny (1785–1837) after a portrait by John Paradise (1783–1833). Image 485485, Photographs and Prints Division, Schomburg Center for Research in Black Culture, The New York Public Library, Astor, Lenox and Tilden Foundations.

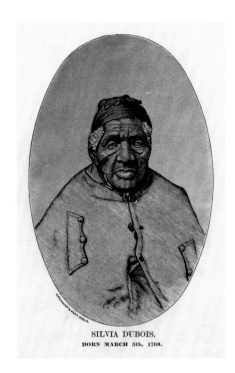

SILVIA DUBOIS,
BORN MARCH 5th, 1768.

Silvia DuBois, Born March 5th, 1768. Engraved frontispiece from an oral history of her life collected and published when she was 116 years old. Born a slave on Sourland Mountain in Somerset County, Sylvia was taken to Pennsylvania, where she obtained her freedom after returning her mistress's cruelty by beating her. She moved back to New Jersey and reputedly lived to age 122. Source: New Jersey Portraits Collection, Special Collections and University Archives, Rutgers University Libraries.

became more important because mothers were seen as the first line of instruction for children; as the number of private academies for men increased, those available for young women grew dramatically, to an estimated total of 400 nationwide in the forty years after the Revolution. Several of these institutions were located in New Jersey, including the Newark Academy and the Female Academy of New Brunswick. The music and art lessons of the early finishing schools for wealthy women gave way to a more rigorous curriculum that could include mathematics, geography, and history. The literacy rate for all, and especially for

The Reverend Richard Allen (1760–1831) was born into a slave-owning Philadelphia household and saw his family sold south, but was later allowed by his Delaware owner to buy his freedom. He became a follower of John Wesley, the founder of Methodism. Because of racial tensions at the Methodist church in Philadelphia, Allen and others formed the separate Bethel African Methodist Episcopal Church, Philadelphia (which included South Jersey). This modern stained glass window with his image is at the Mother Bethel A.M.E. Church, Philadelphia. Source: Richard Allen Archives, Mother Bethel A.M.E. Church, Philadelphia.

THE FIRST MALLEABLE IRON FOUNDRY BUILT IN THE UNITED STATES; ERECTED BY SETH BOYDEN, BETWEEN BRIDGE AND ORANGE STREETS, IN 1826; FROM AN ORIGINAL DRAWING BY THE INVENTOR.

Drawing by Seth Boyden (1788–1870) of his Malleable Iron Foundry in Newark. Source: From Peter J. Leary, *Newark, N.J., Illustrated: A Souvenir of the City and Its Numerous Industries…*(Newark: Wm. A. Baker, 1893), page 22. Special Collections and University Archives, Rutgers University Libraries (SNCNJ F144.N6L4).

Seth Boyden (1788–1870), inventor of processes to produce patent leather and malleable cast iron. He is also said to have been an early practitioner of photography. Source: Daguerreotype by an unknown photographer in gold case, 2 ¾ x 2 ¼ in., c. 1849. National Portrait Gallery, Smithsonian Institution/Art Resource New York.

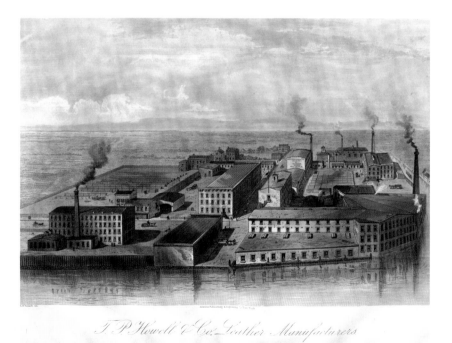

T. P. Howell & Co. Leather Manufacturers

T. P. Howell & Co. Leather Manufacturers. Newark had a long history of producing leather, and then leather products from shoes to saddles, harnesses, and other goods. Source: Colored engraving from *Industrial America: or, Manufacturers and Inventors of the United States* (New York: Atlantic Publishing and Engraving Company, 1876). Special Collections Division, The Newark Public Library.

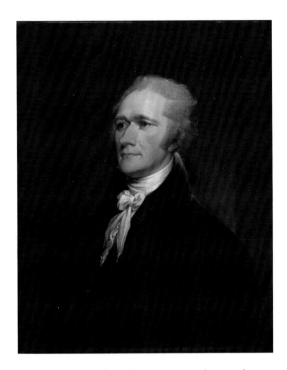

Alexander Hamilton (1755/57–1804) served as one of General George Washington's aides during the American Revolution and later as his first secretary of the Treasury. Hamilton supported the development of manufacturing in the Early Republic and thought the falls on the Passaic River could provide the power for a new industrial city. Source: Oil on canvas, 30 x 24 in., by John Trumbull (1756–1843), 1806, after a portrait by Giuseppe Ceracchi (1751–1801). National Portrait Gallery, Smithsonian Institution/Art Resource, New York. Gift of Henry Cabot Lodge.

"An Act to incorporate the contributors to the Society for establishing useful Manufactures, and for the further Encouragement of the said Society," November 22, 1791. The Society for Establishing Useful Manufactures (SUM), chartered by the state, was based on the ideas of Alexander Hamilton and Tench Coxe, who proposed building a national manufactory at a site on the Passaic River that they named Paterson, after the state's governor. Source: Department of State, Secretary of State's Office, Enrolled Laws, 1710–2012, box 11. New Jersey State Archives, Department of State.

young white women, increased. But further opportunities for educated women were limited. Suffrage for women who owned property ended in 1807, and other forms of female political participation were discouraged. Once married, women were "mere equals," caught up in managing domestic chores and raising children, and unable to make much use of their learning. The next generation began to participate in reform movements.

The two colleges chartered in the colonial era survived, though with difficulty. Queens College barely made it through the Revolution and the following decades, and was finally revived as Rutgers College in 1825. At the College of New Jersey in Princeton, young men from the plantation South did not take kindly to the strict discipline of the Presbyterian faculty. They protested, misbehaved, were expelled, or left. Enrollment slumped, but later grew again.

Both of New Jersey's colleges had been established to train ministers, and some of the challenges they faced in this period stemmed from changes in religion.

During the Revolution, almost all of New Jersey's Anglican ministers left or were silenced; services that included a prayer for the king's health were problematic. One loyalist who returned after eight years in England, the Reverend Thomas Bradbury Chandler, helped establish the separate Episcopalian Church. Methodism emerged as a separate institution and grew after 1800. The Dutch Reformed Church increasingly distanced itself from Holland and conducted services in English, though the Dutch language persisted in parts of Bergen County. Quakers divided: the few who supported the Revolution were excommunicated and became for a time "Free Quakers"; in the "Great Separation" of 1827, parallel yearly meetings were held by the more agrarian followers of Elias Hicks (the Hicksites) and the more urban "Orthodox" Quakers. Liberal Congregationalists separated and became Unitarians. African Americans, free and slave, at times felt unwelcome in existing churches, objected to segregated seating, and formed their own churches, such as the African Methodist Episcopal (AME) Church. Although

View on the Passaic River. The falls at Paterson were the second highest in the East (after Niagara) and attracted the attention of early tourists like the French artist and naturalist Jacques-Gérard Milbert (1766–1840), as well as that of developers seeking a source of waterpower. Source: Lithograph published in Paris between 1828 and 1829. From the exhibition at Morven Museum & Garden, Princeton, "Portrait of Place: Paintings, Drawings, and Prints of New Jersey, 1761–1898, From the Collections of Joseph J. Felcone," 2012. Image courtesy of Joseph J. Felcone. Photograph © Bruce M. White, 2011.

Colt revolver, version 3. Samuel Colt (1814–1862) produced early models of his revolver at the Patent Arms Manufacturing Company in Paterson, chartered in 1836, before moving to Connecticut. Source: The Paterson Museum. Photograph by R. Veit.

Lottery ticket for the Society for Establishing Useful Manufactures (SUM), printed by J. Woods, c. 1797. The New Jersey legislature authorized a lottery to help raise funds for the SUM, and tickets were sold starting in 1792. The hope was eventually to raise $100,000. Fifteen percent of each ticket's price was kept for the SUM; the rest was to be distributed in prizes. Source: Ephemera Collection (GB), Special Collections and University Archives, Rutgers University Libraries.

View of Paterson, New Jersey, from the Manchester Side. This view by Edwin White-field from across the Passaic River shows the large factories built to take advantage of waterpower from the falls. Paterson was the first planned industrial city in the United States; although initially slow to develop, by the 1820s it had become an important center for manufacturing. Source: Colored lithograph published by Isaac Prindle, Brooklyn, N.Y., 1853. The Paterson Museum. Photograph by R. Veit.

there had never been an established state church, Protestants dominated the new republic; but they splintered and worshiped in increasingly diverse ways.

In the period after the Revolution and the adoption of the Constitution, New Jerseyans worked their way through what it meant to live in a republic. It became clear that political rights—the ability to vote and to hold office—were restricted to adult white men. But women and blacks began to find some expansion of their personal freedoms with the beginning of gradual abolition and the increase of educational opportunities. New Jersey's economy became more mixed, and the state was more diversified in terms of religious affiliation. Of course, the future brought more changes.

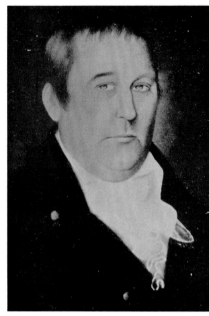

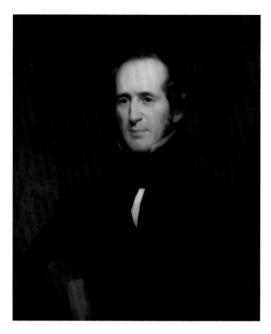

Steamboat Phoenix, 1809. John Stevens (1749–1838) launched the *Phoenix* in 1808. Not only was it the first steamship built entirely in America, but it also became the first to navigate on the open sea, sailing in 1809 from the Hudson River to the Delaware River to escape the New York steamboat monopoly. Source: Oil on canvas by Charles B. Lawrence (active 1813–1837). Image Q0582. Mariners' Museum, Norfolk, Virginia.

Thomas Gibbons (1757–1826), a lawyer, purchased a home in Elizabethtown in 1810 and then became involved in the Hudson River ferry business between New Jersey and New York. At first a partner with Aaron Ogden, he became Ogden's rival and worked to break the monopoly on ferry crossings granted to Ogden by New York State. In *Gibbons v. Ogden* (1824), the U.S. Supreme Court ruled that states cannot regulate interstate commerce, ending the long-running dispute and freeing New Jersey companies to compete. Source: Photograph of an undated portrait. Gibbons Family Papers, Special Collections and Archives, Drew University Library, Madison.

Early in his career in the ferry business, Cornelius Vanderbilt (1794–1877) worked for Thomas Gibbons as a business manager and captain of the *Bellona* (1818) and other steamboats that operated against Aaron Ogden's monopoly on ferry crossings. After the U.S. Supreme Court ruling in *Gibbons v. Ogden* (1824) opened competition on the Hudson River, "the Commodore" amassed a transportation empire on land and sea, becoming one of the wealthiest men in America. Source: Oil on canvas, 29 15/16 x 25 in., by Nathaniel Jocelyn (1796–1881), 1846. National Portrait Gallery, Smithsonian Institution/Art Resource, New York.

BIBLIOGRAPHY

Old standards for this period are: Richard P. McCormick, *Experiment in Independence: New Jersey in the Critical Period, 1781–1789* (New Brunswick: Rutgers University Press, 1950); Rudolph J. Pasler and Margaret C. Pasler, *The New Jersey Federalists* (Rutherford, N.J.: Fairleigh Dickinson University Press, 1975); and Carl Prince, *New Jersey's Jeffersonian Republicans: Genesis of an Early Party Machine* (Chapel Hill: University of North Carolina Press, 1967). Recent historians have paid particular attention to cultural, political, and gender history in

The Newark Academy was founded in 1774. After its original building was burned to the ground by the British during the Revolution, the school reopened in 1792 in the building shown in this lithograph. From 1802 to 1859, it had a division for women students. In 1964, the school relocated to Livingston, where it continues today as a private coeducational institution. Source: Archives of the Newark Academy.

Mrs. Elias Boudinot IV, 1784. After the Revolution, educated women like Hannah Stockton Boudinot (1736–1808) read a wider variety of literature. Source: Oil on canvas, 29 15/16 x 25 in., by Charles Willson Peale (1741–1827). Princeton University Art Museum/Art Resource, New York. Gift of Mr. and Mrs. Landon K. Thorne for the Boudinot Collection.

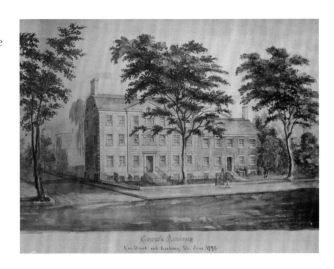

this period. See the citations in Graham Russell Gao Hodges, "New Jersey in the Early Republic," in *New Jersey: A History of the Garden State*, ed. Maxine N. Lurie and Richard Veit (New Brunswick: Rutgers University Press, 2012); Lucia McMahon, *Mere Equals: The Paradox of Educated Women in the Early American Republic* (Ithaca, N.Y.: Cornell University Press, 2012); and Jan Ellen Lewis, "Rethinking Women's Suffrage in New Jersey, 1776–1807," *Rutgers Law Review* 63, no. 3 (Spring 2011): 1017–35.

THE YOUNG LADIES OF THE NEWARK ACADEMY, NEW-JERSEY, UNDER THE CARE OF REV. MR. ALDEN.

—◄:o:►—

THIS CERTIFIES THAT

E. Boudinot, son.

has, not only, exhibited that amiable deportment, at the ACADEMY, which is ever becoming in a YOUNG LADY; but, had the honour of being at the head of the first class, of which she is a member, at the time of the subjoined date.

TIMOTHY ALDEN.

6 June 1810.

Eliza (Elizabeth) Pintard Boudinot's certificate of merit from the Newark Academy, January 6, 1810. Source: From *Key to the Quarterly Catalogues of the Names of the Young Ladies, at the Newark Academy…*(Newark: Printed by William Tuttle, 1810). Special Collections and University Archives, Rutgers University Libraries (SNCLX LD7501.N6N68).

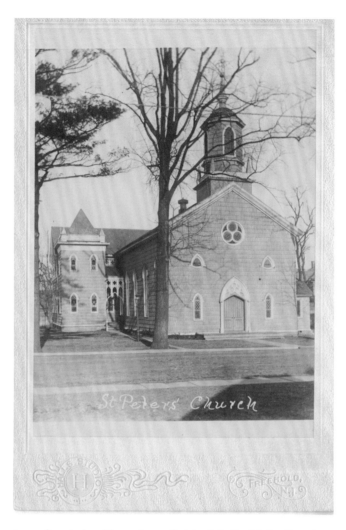

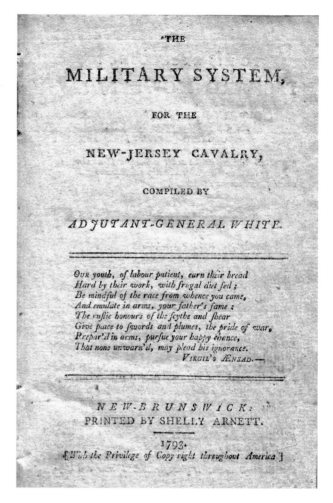

The Reverend Thomas Bradbury Chandler (1726–1790), Yale B.A. and M.A., served as an Anglican minister at Saint John's in Elizabethtown. A leading supporter of the British in the period before the Revolution and a loyalist in England during the war, Chandler returned to the United States in 1785 and helped organize the Episcopalian Church. Source: Oil on canvas by an unknown artist, eighteenth century. Yale University Art Gallery. American Paintings and Sculpture ac 1920.5. Gift of Clarence Winthrop Bowen, B.A. 1873, M.A. 1876, Ph.D. 1882.

According to local lore, the unfinished shell of Saint Peter's Church in Freehold served as a hospital during the Battle of Monmouth in 1778. Originally an Anglican church, the building was not returned until the 1790s to its by then Episcopalian congregation. Source: Undated photograph by the Hall Studio of Freehold (FR-168). Library & Archives, Monmouth County Historical Association, Freehold.

Title page from Anthony Walton White (1750–1803), *The Military System, for the New-Jersey Cavalry…*(New Brunswick: Printed by Shelley Arnett, 1793). White, a grandson of royal governor Lewis Morris, served with distinction in the Continental Army during the American Revolution and was appointed by President George Washington as a brigadier general of cavalry during the Whiskey Rebellion of 1794. He lived at Buccleuch Mansion in New Brunswick, built in 1739 by his father. Source: Special Collections and University Archives, Rutgers University Libraries (SNCLX UE154.N4W58).

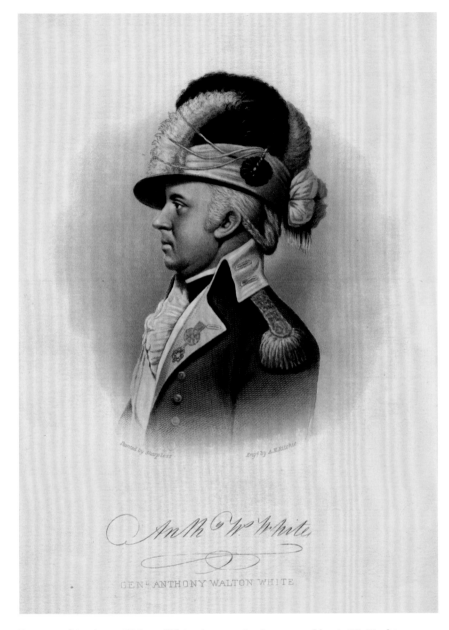

Portrait of Anthony Walton White (1750–1803) engraved by A. H. Ritchie (1822–1895) after an original sketch by James Sharples (c. 1751–1811). Source: New Jersey Portraits Collection, Special Collections and University Archives, Rutgers University Libraries.

Aaron Ogden (1756–1839), a Federalist, was elected governor in 1812 because of his party's opposition to the War of 1812; but during his one-year term he cooperated with New York and federal officials to organize against a possible British attack. Ogden also was involved in the steamboat business on the Hudson River and was the unsuccessful defendant in *Gibbons v. Ogden* (1824), which ended ferry monopolies. Source: Oil on canvas, 29 5/8 x 24 5/8 in., by Henry Harrison (1844–1923), 1903, after an 1833 painting by Asher B. Durand (1796–1886). Source: New Jersey State House Portrait Collection, administered by the New Jersey State Museum (SHPC28). Reproduced with permission.

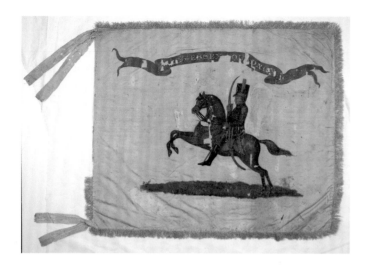

War of 1812 battle flag of the Caldwell Troop, Essex Squadron of the 2nd Regiment, New Jersey Militia. The front features a dashing cavalryman on horseback. Source: Historical Society of West Caldwell. Photograph by the Williamstown Art Conservation Center, Massachusetts.

War of 1812 battle flag of the Caldwell Troop, Essex Squadron of the 2nd Regiment, New Jersey Militia. The back shows the state seal. Source: Historical Society of West Caldwell. Photograph by the Williamstown Art Conservation Center, Massachusetts.

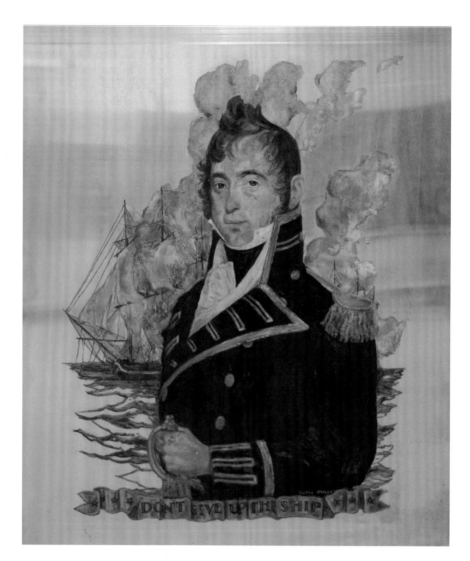

James Lawrence (1781–1813) was born in Burlington and grew up in Woodbury. As a captain in the U.S. Navy during the War of 1812, he earned everlasting fame when he urged his men on the *Chesapeake* "Don't give up the ship" during the bloody fight with the British frigate *Shannon* that cost him his life. Numerous places in the United States are named for him, including Lawrenceville, New Jersey. This painting on steel by Beulah Mullen was first displayed in the U.S.S. *New Jersey* and later in the officers' wardroom of the navy destroyer U.S.S. *Lawrence* (DDG-4). Source: From the Collection of the Burlington County Historical Society, Burlington.

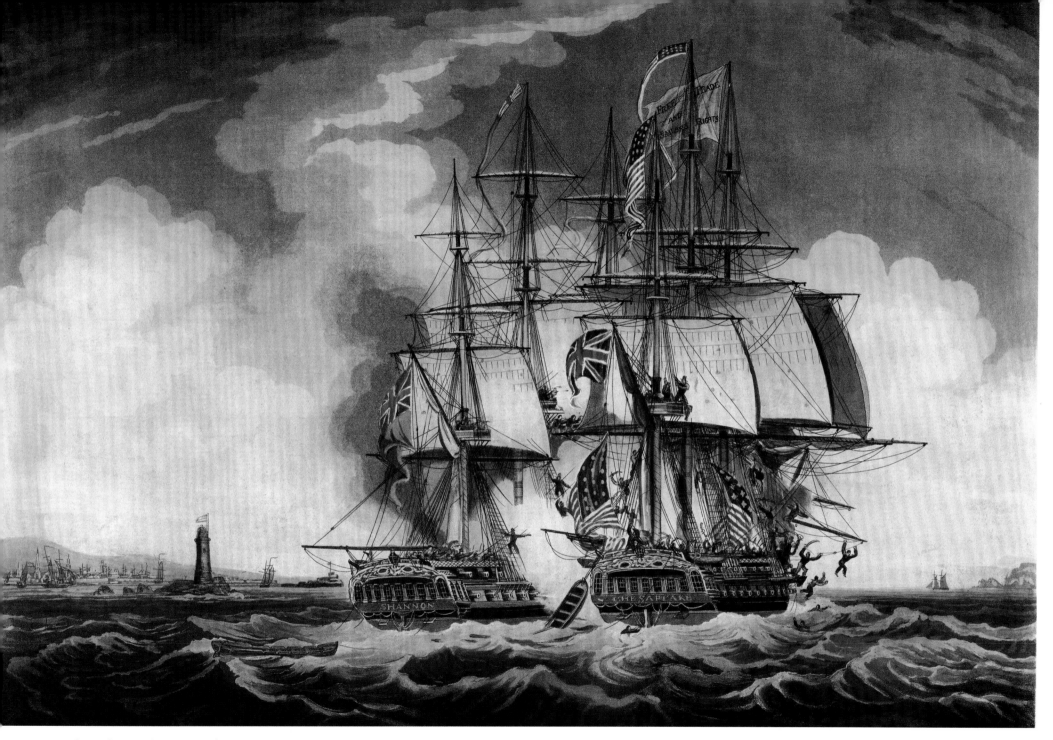

The Brilliant Achievement of the Shannon…in boarding and capturing the United States Frigate Chesapeake off Boston, June 1st 1813 in Fifteen Minutes. The title of this scene reflects the British view of the fight off Boston Harbor, here shown with the lighthouse in the distance. Source: Aquatint by William Elmes (fl. 1797–1815), August 1813. ID A 4032, © National Maritime Museum, Greenwich, London.

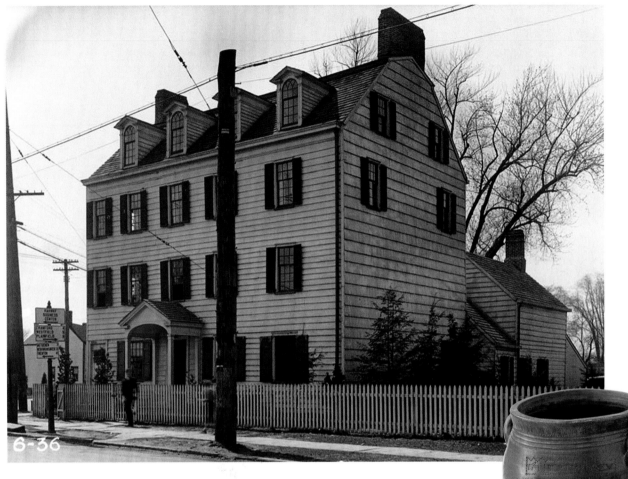

6-36

Stoneware pottery of Thomas Warne and Joshua Letts, Cheesequake, South Amboy, 1802–1813. The Raritan Valley was famous for its stoneware manufactories in the late eighteenth and nineteenth centuries. Source: Museum Collection, Monmouth County Historical Association, Freehold. Gifts of Mrs. Henry L. Post, Mrs. Lewis Waring, and Mr. Amory L. Haskell in memory of their mother, Mrs. J. Amory Haskell, 1944; and the Marshall P. Blankarn Purchasing Fund, 1979.

Merchants and Drovers Tavern, Saint Georges and Westfield Avenues, Rahway, Union County, 1936. The original two-story home and general store built at this corner c. 1795 were converted to a tavern around 1798. The building was enlarged several times to accommodate people traveling between New York and Philadelphia. Serving as a museum today, it has been restored and furnished according to its nineteenth-century appearance, when Rahway was known as Carriage City, owing to the number of carriage factories operating there. Source: Photograph by R. Merritt Lacey for the Historic American Buildings Survey (HABS NJ,20-RAH,1–2), Library of Congress, Washington, D.C.

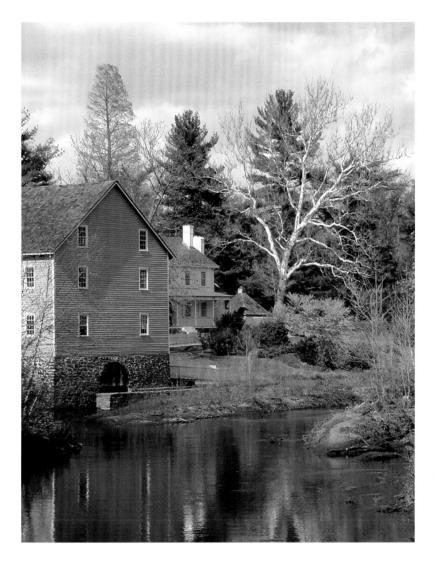

In 1773, Richard Waln, a Quaker merchant from Philadelphia, acquired the original gristmill on this site on Crosswicks Creek in Monmouth County, along with its associated hamlet, and built a fine country home. The mill processed locally grown grain using waterpower from the creek. Today, Historic Walnford is a county park. Source: Monmouth County Park Service.

After the original gristmill at Walnford was destroyed by fire in 1872, a new one was built according to the system invented by Oliver Evans (1755–1819), which allowed the milling process to be almost entirely automated. Source: Monmouth County Park Service.

The Jacksonian Era, 1820–1850

Historians have labeled the period between 1820 and 1850 the Jacksonian Era, the Age of the Common Man, and the era of the Transportation Revolution, the Market Revolution, and the Communications Revolution. The title of Daniel Walker Howe's book about this period, *What Hath God Wrought: The Transformation of America, 1815–1845*, emphasizes "transformation." All of these terms can be used to describe important developments in New Jersey in this period; and yet, at the end, as at the beginning, New Jersey had a primarily agrarian economy, and its political scene was dominated by white males who were overwhelmingly Protestant. Slavery continued to exist even as gradual abolition began to have an impact. On the national scene, war with Mexico

"New Jersey: Reduced from T. Gordon's Map by H. S. Tanner," 1846. To obtain an accurate map of the state, the legislature authorized a loan of $1,000 to Trenton surveyor Thomas Gordon (1778–1848), who produced the first large-scale New Jersey map in 1828. This later edition shows the canals and railroads that were built during the Jacksonian Era. Source: Special Collections and University Archives, Rutgers University Libraries.

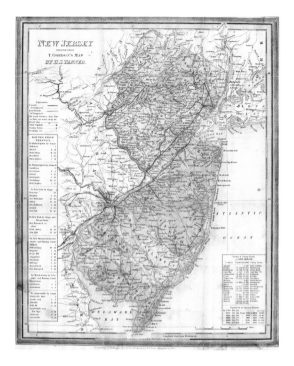

and the resulting acquisition of large new territories brought the expansion of slavery to the forefront of political debate.

By 1820, New Jersey counted 277,500 residents, but the rate of population increase was far less than in neighboring New York and Pennsylvania, which were connected to the newly settled areas of the Midwest and thus more attractive to immigrants, new businesses, and early capitalism. Natural increase through new births and some immigration masked the fact that the state lost residents who moved west and south to pursue more land and opportunity. But because of New Jersey's location between two growing metropolises, significant economic changes began to occur.

Sparking economic growth was New Jersey's leadership role in the transportation revolution. First had come toll roads and bridges built by private companies, then the development of steamboats. In the 1820s, steam technology was applied to travel on rails. Experiments by John Stevens at his estate in Hoboken led to the creation of the Camden and Amboy Railroad, which obtained a charter in 1830 that gave it a monopoly on rail transport across the narrow waist of

Styles Farm, Lumberton Township, Burlington County, c. 1860. Charles C. B. Styles (1861–1929) was fourteen when he painted his family's mid-nineteenth-century farm with house, barn, and a range of outbuildings. Source: Oil on canvas, 20 ½ x 33 ¼ in. From the exhibition at Morven Museum & Garden, Princeton, "Portrait of Place: Paintings, Drawings, and Prints of New Jersey, 1761–1898, From the Collections of Joseph J. Felcone," 2012. Image courtesy of Joseph J. Felcone. Photograph © Bruce M. White, 2011.

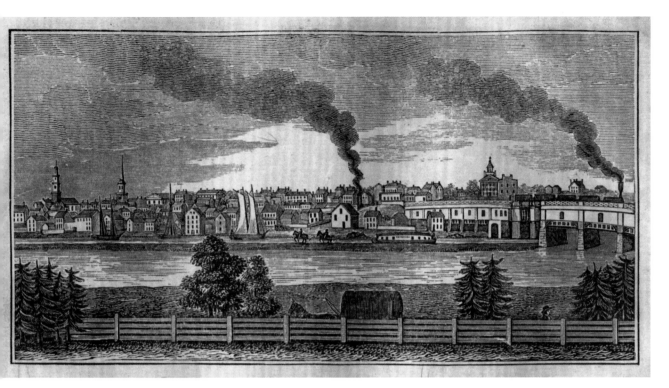

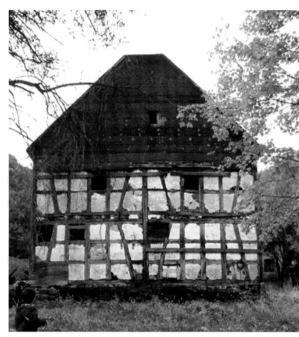

N. E. View of New Brunswick, N.J. This mid-nineteenth-century image shows the Delaware and Raritan Canal running alongside the Raritan River, with a train on a bridge crossing the river and canal. The Joint Companies (the canal and the Camden and Amboy Railroad) obtained a charter from the state that gave it a monopoly over transportation from Philadelphia to Perth Amboy, where passengers and freight could be taken by boat to New York City. Source: Engraving from John W. Barber and Henry Howe, *Historical Collections of the State of New Jersey* (New York: S. Tuttle, 1845), facing page 312. Special Collections and University Archives, Rutgers University Libraries (SNCLNJ F134.B23 1845).

Fachwerk (half-timbered) barn, 1840s, on the former Duderstadt farm located in Warren, Somerset County. This unique building, now owned by the county, represents a distinctive construction technique called fachwerk, brought to America by German immigrants. Photograph by R. Veit.

the state, connecting the two cities in its name and then, via ferry service, Philadelphia and New York City. At the same time, the state chartered a company to build a canal between the Delaware and Raritan Rivers. Within a year, the railroad and canal companies combined as the Joint Companies, which in the years that followed had extraordinary influence in state politics because of the fees it paid in exchange for monopoly privileges. Also inspired by the successful Erie Canal in New York was the Morris Canal, begun in 1825 across the mountains of northern New Jersey to connect Philipsburg and Newark (and later, Jersey City).

An engineering marvel, it featured a series of inclined planes to move the boats on rail tracks over mountains as well as locks to raise and lower them between different water levels. New Jersey's two canals carried coal and other products east from Pennsylvania to developing factories in Paterson, Newark, Jersey City, and other places, then moved people and goods westward.

The development of this transportation infrastructure supported early industrialization. The Society for Establishing Useful Manufactures (SUM) had closed its factory in Paterson in 1796 but retained its land and waterpower

Louisa Sanderson Macculloch (1785–1863) moved to Morristown with her husband and two children in 1810. There she supervised a large household, briefly helped run an academy for boys, and was active in the local Female Charitable Society, which provided aid for the poor. Source: Oil on canvas, c. 1830s, artist unknown. Collection of Macculloch Hall Historical Museum, Morristown. Photograph courtesy of Stan Freeny.

George P. Macculloch (1775–1858), a Scottish businessman, settled in Morristown in 1810 and opened the Latin School for Boys in 1814. In 1822, he proposed building a canal across northern New Jersey to connect the Delaware River with the Hudson River, and he assembled a group of investors to form the Morris Canal and Banking Company to accomplish the project. Source: Oil on canvas, c. 1830s, artist unknown. Collection of Macculloch Hall Historical Museum, Morristown. Photograph courtesy of Stan Freeny.

"An act to incorporate a Company to form an artificial Navigation between the Passaic and Delaware Rivers." The Morris Canal and Banking Company, chartered by the state on December 31, 1824, offered 20,000 shares at $100 per share to raise the capital to build the canal. When completed in 1836, it was 102 miles long and extended beyond the Passaic River through Jersey City to the Hudson River. Source: Department of State, Secretary of State's Office, Enrolled Laws, 1710–2012, box 45. New Jersey State Archives, Department of State.

rights there. Under new management in the 1820s, the SUM developed additional waterpower that attracted factories producing textiles (first cotton, later silk) and other goods, including Colt revolvers and locomotives. Newark entrepreneurs made

a variety of merchandise, but leather products (shoes, harnesses, saddles) were especially important. Inventor Seth Boyden developed a process for making patent leather and then focused on the manufacture of malleable cast iron, useful, for

"Morris Canal at Will's Basin, near Lake Hopatcong." The view of two barges at the top of Plane 1 East is looking west toward the Morris summit. The Morris Canal had an elevation change of 1,674 feet. Source: Non-Governmental Records, Commission to Investigate and Report upon the Abandonment of Navigation of the Morris Canal, Reports and Photographs, 1903, item 54. New Jersey State Archives, Department of State.

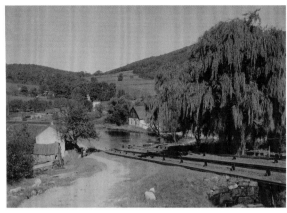

"Plane No. 7, near Port Washington," looking northwest. The Morris Canal's inclined planes were engineering marvels of their time. Canal barges were maneuvered onto cradle cars on tracks and then hauled up and over the mountains of western Jersey by means of powerful water-powered turbines. Source: Non-Governmental Records, Commission to Investigate and Report upon the Abandonment of Navigation of the Morris Canal, Reports and Photographs, 1903, item 65. New Jersey State Archives, Department of State.

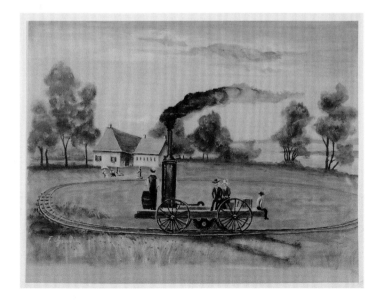

The John Stevens Circular Railroad, 1825. Colonel Stevens (1749–1838) built an experimental 16-foot-long "steam wagon" that he ran on a 630-foot track in Hoboken. It was the first effort of its kind in the United States and astonished observers by going six miles per hour. Source: Stevens Family Collection, item 576. Archives & Special Collections, Samuel C. Williams Library, Stevens Institute of Technology, Hoboken.

instance, in making buckles. The energetic Boyden continued to invent numerous products over the course of his long career; Thomas Edison regarded him as one of America's greatest inventors. A furniture factory established in Newark by David Alling illustrates the ways in which the small artisan shops of this period differed from the more mechanized and larger factories that followed in the 1850s and after the Civil War. The Alling Company made chairs by hand, using a system of specialized tasks, though not machinery, to produce at first a few and then hundreds of items, shipping them longer and longer distances, especially to New Orleans. Connected to developments in transportation and early industrialization was a communications revolution fostered by easier, faster, and less expensive travel on canals and rail lines. The number of newspapers dramatically increased, their cost decreased, and wider distribution was made possible. The canals helped to revive New Jersey's iron industry, and Speedwell Iron Works in Morristown was one of the places where iron was cast into parts for steam engines and other machines. It was there that Samuel F. B. Morse worked with Alfred Vail, son of the owner, to craft the first workable telegraph.

This first industrial revolution steadily increased the variety of available goods and began to change the nature of the economy. The need for factory workers (as well as laborers to build the canals) attracted immigrants, increasing and diversifying the population. These new residents—Irish and German plus others, Catholics among them—also contributed to turning

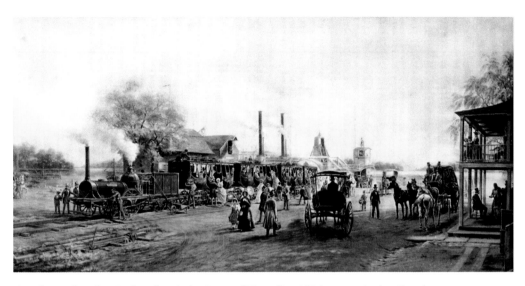

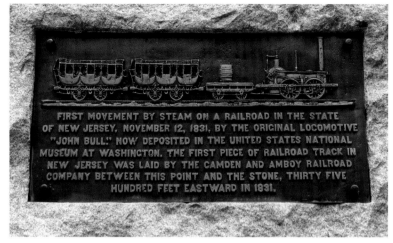

Camden and Amboy Railroad with the Engine "Planet" in 1834, 1904. At the Camden terminal, passengers board train carriages that resemble horse-drawn coaches. Source: Print from an original oil on canvas by Edward Lamson Henry (1841–1919). Special Collections and University Archives, Rutgers University Libraries.

The parts for the *John Bull* steam engine were imported from England and assembled in Bordentown. It was the first locomotive used on the Camden and Amboy Railroad when it opened in 1831 and survives today at the National Museum of American History, Smithsonian Institution. This monument and plaque erected in Bordentown in 1891 commemorate the first piece of track laid in New Jersey. Photograph by R. Veit.

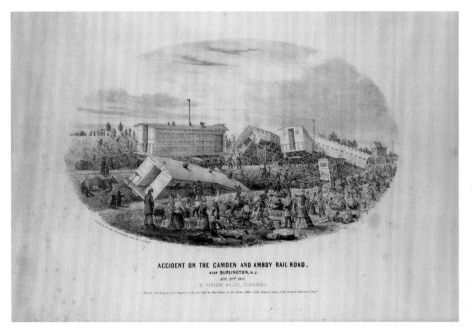

Accident on the Camden and Amboy Rail Road, near Burlington, N.J. Aug. 29th, 1855. The collision between a mail and passenger train and a horse-drawn wagon left twenty-one dead and seventy-five injured. It also produced a storm of protests against the New Jersey railroad monopoly, which had an unfortunate safety record on its single-track line. Source: Lithograph, 8 ½ x 11 ¾ in., by John Collins (1814–1902). From the exhibition at Morven Museum & Garden, Princeton, "Portrait of Place: Paintings, Drawings, and Prints of New Jersey, 1761–1898, From the Collections of Joseph J. Felcone," 2012. Image courtesy of Joseph J. Felcone. Photograph © Bruce M. White, 2011.

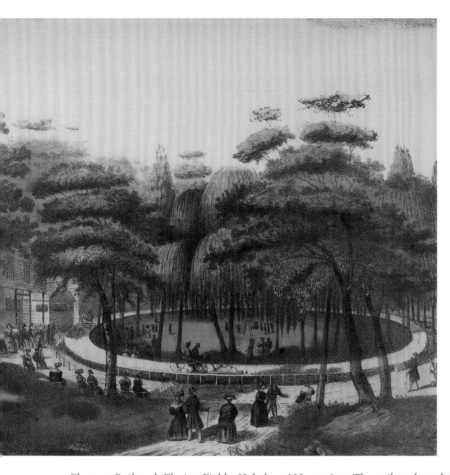

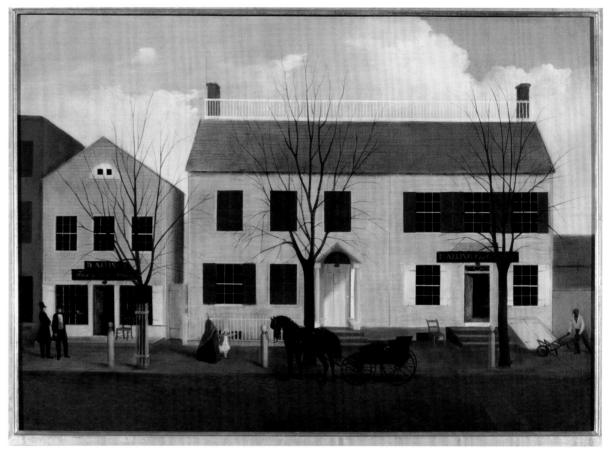

Pleasure Railroad, Elysian Fields, Hoboken, N.J., c. 1833. The railroad track built at the Stevens estate in Hoboken became part of an early amusement park meant to attract customers to the family's ferry service. Source: Lithograph. Stevens Family Collections, item 577. Archives & Special Collections, Samuel C. Williams Library, Stevens Institute of Technology, Hoboken.

The House and Shop of David Alling, c. 1840–1850. Alling (1773–1855) established a reputation as a maker of "fancy chairs." His shop was one of the numerous small manufacturing companies in Newark that began to mass-produce a wide variety of products before the Civil War during what American historians call the First Industrial Revolution. Source: Oil on canvas, image H: 20.5 in., W: 30 in., artist unknown. Purchase 1939, Thomas L. Raymond Bequest Fund 39.265. The Newark Museum.

small towns into urban centers, and by 1850 they had helped double the state's population. But the improving standard of living did not benefit everyone. In the mid-1830s, factory workers in Paterson walked out to protest low wages and changes in work rules. The employment of women and children (some as young as eight) in the mills made it clear that advancements came at a price. In addition, the nascent capitalist economy, with its ups and downs (including in this period the Depression of 1837), made more people vulnerable to sudden economic loss. New industrial centers had to cope with more poverty and mental illness.

These economic changes and the social problems that accompanied them encouraged the spread of religious evangelicalism among Protestants, known as the Second Great Awakening. Evangelical religion increased the number of Methodists and Baptists, even as it divided Quakers in New Jersey and elsewhere into Hicksites and Orthodox sects. Those moved by revival religion were more likely to participate in reform projects and to vote for the Whig Party. At revival meetings throughout the country, believers were taught that personal salvation depended not only on repenting sin but also on working toward the

David Alling chair, c. 1825–1840. This painted wooden chair is one of a few surviving examples of the Alling company's products. Source: Chair, 17 3/4 x 34 1/2 in. The Newark Museum. Gift of Madison Alling, 1923, 23.2467.

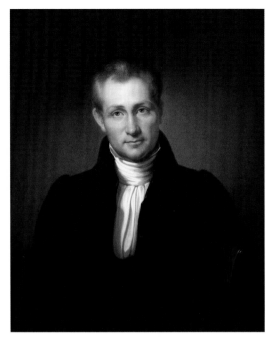

William Rankin Sr. (1785–1869) was a prominent Newark hat manufacturer at a time when hat making was one of the leading industries in the city. Source: Oil on canvas, 30.25 x 25.25 in., by Rembrandt Peale (1778–1860), 1834. The Newark Museum. Bequest of Dr. Walter M. Rankin, 1947, 47.52.

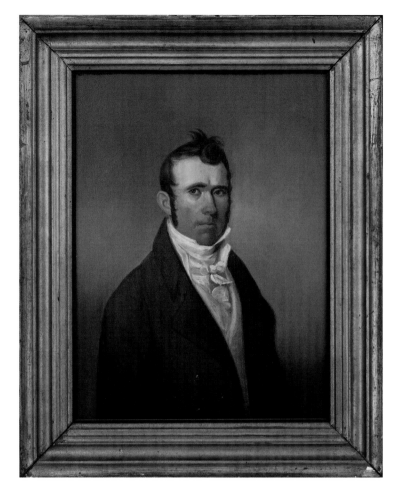

Mahlon Dickerson (1770–1853) was raised in Morristown, attended the College of New Jersey (now Princeton University), studied law, and, after his father's death, ran the family's iron mining business. As governor from 1815 to 1817, in the wake of the War of 1812, he supported improved transportation and protective tariffs. Afterward, he served as a U.S. senator and was appointed secretary of the navy by Andrew Jackson. Source: Oil painting on wood panel by J. Parker (1775–1875?), c. 1825–1830. Museum Collection, Monmouth County Historical Association, Freehold. Gift of Mrs. J. Amory Haskell, 1941.

moral perfection of society. The communications revolution contributed to the wider availability of books and other published sources that spread ideas of reform. These efforts included the creation of institutions to deal with social problems no longer solvable by families, such as prisons, hospitals, and schools, as well as utopian communities intended to provide a socialist alternative to capitalist labor organization. Women influenced by the emphasis on helping

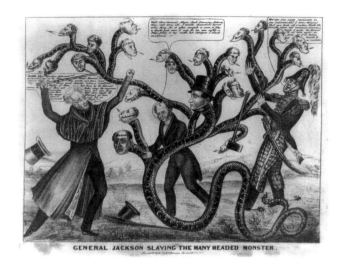

General Jackson Slaying the Many Headed Monster, 1836. President Andrew Jackson attacks a serpent with multiple heads that represent supporters of the Second Bank of the United States, which he viewed as a dangerous monopoly. Source: Lithograph published by Henry R. Robinson (d. 1850), New York. Image LC-USZ62–1575, Library of Congress, Prints and Photographs Division, Washington, D.C.

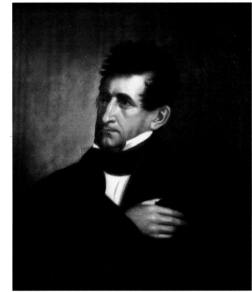

Samuel Southard (1787–1842) served briefly as governor, 1832–1833. During his time in office, he focused on the development of railroads and canals. A politician who served in numerous state and national offices from 1814 onward, Southard is interesting for how he negotiated the political changes of the antebellum period. Allying with Jeffersonian Republicans, he served Presidents James Monroe and John Quincy Adams as secretary of the navy, disliked Democratic President Andrew Jackson, and became a Whig in the new political order of the 1830s. Source: Oil on canvas, 29 5/8 x 24 ¾ in., by Henry Harrison (1844–1923), 1907, after a nineteenth-century painting by A. S. Conrad. New Jersey State House Portrait Collection, administered by the New Jersey State Museum (SHPC14). Reproduced with permission.

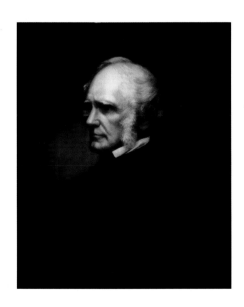

Peter D. Vroom (1791–1873) fits the national pattern of Jacksonian Democrats, who often opposed monopolies; but as governor of New Jersey (1829–1832, 1833–1836), he initially supported the creation of the company behind the Delaware and Raritan Canal and the Camden and Amboy Railroad. It became the most powerful corporation in the state. Source: Oil on canvas, 29 ¼ x 24 3/8 in., by Angelo Woodward. New Jersey State House Portrait Collection, administered by the New Jersey State Museum (SHPC110). Reproduced with permission.

others became involved in charity groups through their churches, providing aid for the elderly, ill, and poor.

The problem of an increasingly overcrowded and expensive prison system was compounded by laws that mandated imprisonment for debts. Debtors (sometimes owing as little as $5), unable to work or provide for their families, were housed with convicted criminals and, for lack of other facilities, the mentally ill. Reformers who came to regard crowded prisons as schools for crime also began to question the practice of mixing juvenile offenders and petty criminals with those who had committed more serious offenses. New Jersey replaced an aged prison building in Trenton with a new one designed on the so-called Pennsylvania system, which isolated prisoners in solitary confinement to foster reflection and penitence. The building had several wings radiating outward, allowing surveillance of prisoners while at the same time isolating them in individual cells so they would not fall prey to bad influences. In the long run, it was discovered that isolation tended to produce insanity rather than reformation, but the effort reflects the belief that change was possible.

Grand National Whig Banner, 1844. Campaign poster for presidential candidate Henry Clay (1777–1852) of Kentucky and his running mate, Theodore Frelinghuysen (1787–1862) of New Jersey. They lost to Democrats James K. Polk and George M. Dallas. Source: Lithograph published by Nathaniel Currier (1813–1888), New York. New Jersey Political Broadsides Collection, Special Collections and University Archives, Rutgers University Libraries.

Also in this period, the state built the first of several asylums for the care and treatment of the insane, based on the notion that mental problems were curable illnesses. Dorothea Dix, a widely respected advocate for the mentally ill, wrote a report for the legislature in 1844 on her investigation of the jails and almshouses in New Jersey. In her urgent appeal, she cited the case of an elderly legislator and jurist who had become insane and whom she found in the basement of a county almshouse. Although she did not name him, many legislators knew the man; authorization for an asylum in Ewing, outside of Trenton, passed in 1845.

Although New Jersey was slow to provide free education for its children, the first efforts to do so

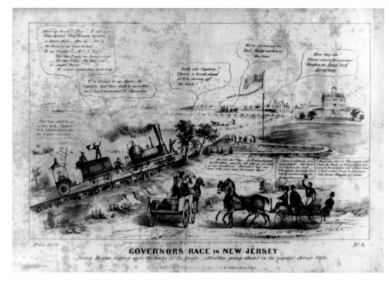

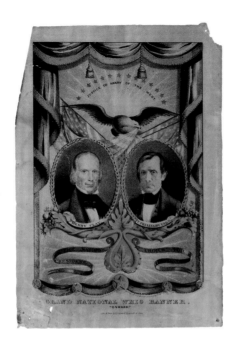

Map showing election returns by county and town, 1838. The disputed congressional election of 1838 led to the so-called Great Seal War. Governor William Pennington (1796–1852), a Whig, certified the election of all six Whig candidates for the House of Representatives with the state seal, but the secretary of state, a Democrat, issued writs of election to five of the six Democratic candidates on the basis of returns from two towns that had not been counted. After an investigation, the House of Representatives sat the five Democrats, giving that party control of the House. Source: Special Collections and University Archives, Rutgers University Libraries.

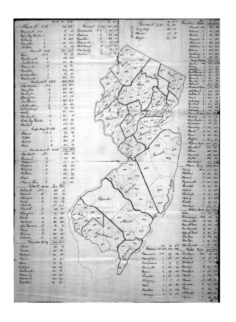

Governors Race in New Jersey, 1844. From the time of its charter in 1830 until 1870, the Joint Companies operated the Camden and Amboy Railroad and the Delaware and Raritan Canal as monopolies. The annual fee it paid to the state for this privilege covered most of the expenses of the government, giving it considerable power and making it the center of political debate. In 1844, Whig candidate Charles C. Stratton (1796–1859) campaigned on a platform opposed to the railroad interests. His rival, Democrat John R. Thomson (1800–1862), was a stockholder in the company and supported internal improvements. The cartoon shows Thomson standing atop a train traveling on tracks laid on the backs of New Jersey citizens, while Stratton arrives at a rally in a horse-drawn carriage. Source: Lithograph published by Henry R. Robinson (d. 1850), New York. Image LC-USZ62–10103, Library of Congress, Prints and Photographs Division, Washington, D.C.

As governor, Daniel Haines (1801–1877) strongly supported a revision of the state's constitution of 1776 on the grounds that it was outdated and made governing difficult in times of economic change. He was the last governor elected to a one-year term by the legislature under the old constitution in 1843 and presided over the adoption of the new constitution in 1844. He was elected to a three-year term as governor by popular vote in 1847. Source: Oil on canvas, 31 ¼ x 26 ¼ in., by Henry Harrison (1844–1923), 1895. New Jersey State House Portrait Collection, administered by the New Jersey State Museum (SHPC12). Reproduced with permission.

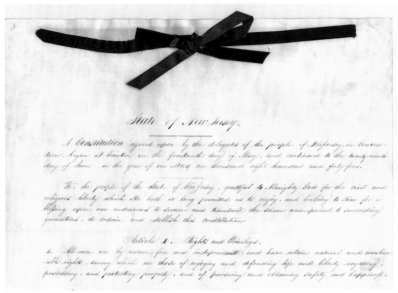

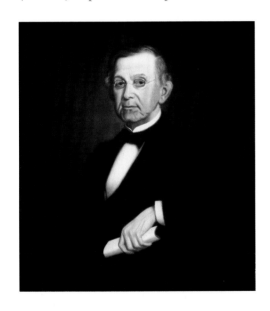

First page of the New Jersey State Constitution, 1844. This second constitution was written by a special convention called for that purpose. It provided for popular election of the governor, who then served a three-year term, and eliminated imprisonment for debt. Source: Department of State, Secretary of State's Office, Miscellaneous Filings (Series I), box 1, item 37. New Jersey State Archives, Department of State.

Charles D. Deshler (1819–1909), a New Brunswick druggist, author, and pill manufacturer, served as corresponding secretary of the anti-immigrant Know-Nothing (or American) Party from 1854 to 1856. This cartoon, c. 1855, pokes fun at his contradictory statements about immigrants, who at the time came primarily from Germany and Ireland. Source: New Jersey Political Broadsides Collection, Special Collections and University Archives, Rutgers University Libraries.

came in this period. The number of local schools and academies grew after the Revolution, including some that provided education for women. But these usually charged fees beyond the means of parents working in factories or even on small farms. The state made the first real though feeble provisions for funding free schools in 1829. Meanwhile, the number of private schools, often with religious affiliations, increased. The College of New Jersey (now Princeton University) and Rutgers College slowly admitted a larger student body (although all male for close to another 150 years). Reformers also pushed for the creation of schools to train teachers; the New Jersey State Normal School was established in Trenton in 1855 (now The College of New Jersey).

Other individuals in this age set out to create communities based on a cooperative lifestyle. Nationally, those that survived the longest had religious connections (for example, the Shaker communities in New England and the Midwest); in New Jersey, the experiments were based on the ideas of the French socialist Charles Fourier as interpreted by his American followers. The non-sectarian North American Phalanx in Red Bank tried to combine enlightened work and social practices (profit-sharing, free education and medical care) with cultural and intellectual development. Between the community's establishment in 1843 and its disbanding in 1855, the population fluctuated between 125 and 150 "associates." Several disaffected members led by Rebecca Buffum Spring and her husband, Marcus Spring, left the community in 1853 and established the Raritan Bay Union in Perth Amboy. Though short-lived, the community was notable for the coeducational and interracial Eagleswood School, which became a military academy after the start of the Civil War. Teachers included leading abolitionists of the period: Theodore Weld, his wife, Angelina Grimké Weld, and her sister Sarah Grimké.

Despite the presence of abolitionists in the state, slavery persisted under the terms of the gradual emancipation enacted in 1804. The number of individuals in bondage declined, but so did the percentage of blacks in the state's population, as some who obtained their freedom sought opportunities elsewhere and white immigrants took their place. Yet African American institutions, particularly churches, increased in this

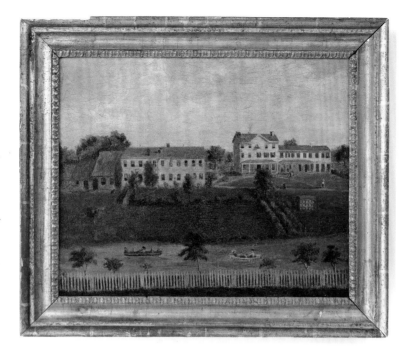

The North American Phalanx, Red Bank, c. 1847–1855. A number of experimental communities established during the Jacksonian Era emphasized cooperative living in response to the nascent capitalism in the country. Several were inspired by the writings of the French socialist Charles Fourier, including the North American Phalanx. It was organized as a joint-stock company in 1843 in Monmouth County and lasted twelve years, longer than others during this period. Source: Oil on canvas by an unknown artist. Museum Collection, Monmouth County Historical Association, Freehold. Gift of the Bucklin Family, 1936.

North American Phalanx stock certificate, dated February 1, 1854. This certificate was made out to Julia Bucklin, daughter of the Phalanx's farm manager, John Bucklin. A number of prominent reformers of the period supported the Phalanx, some by investing in it, others by visiting and writing about it. The community engaged in both farming and manufacturing, but disagreements among the settlers, as well as a fire that destroyed the main buildings in 1854, led to its dissolution. Source: Library & Archives, Monmouth County Historical Association, Freehold.

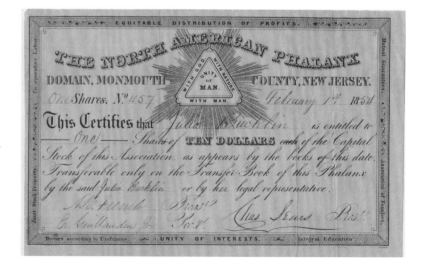

This idealized image of Monrovia, Liberia, was included in a pamphlet published by the New Jersey auxiliary of the American Colonization Society to show the beneficial effects colonization would have in Africa. The national society was organized in 1816 by the Reverend Robert Finley (1772–1817) of Basking Ridge, New Jersey, with the purpose of gradually ending slavery by financing the emigration of free blacks to Africa. Support for the organization in New Jersey waxed and waned, despite the involvement of prominent politicians. State funds in the 1850s purchased 160,000 acres in Liberia, but only twenty-four New Jerseyans moved there. Source: From *Historical Notes on Slavery and Colonization: With Particular Reference to the Efforts Which Have Been Made in Favor of African Colonization in New-Jersey* (Elizabeth-town: E. Sanderson, 1842). Special Collections and University Archives, Rutgers University Libraries (SNCLX E448.N532H).

Liberian coin dated 1833. This one-cent piece was minted in Belleville, New Jersey, for the American Colonization Society and circulated in Liberia. Source: R. Veit Collection.

period, and in several areas freedmen obtained land and created their own communities, such as Fair Haven, Marshalltown, and Timbuctoo. Churches and the land tied these residents to the state despite the support of leading politicians from all political parties for colonization schemes to send freed blacks to Africa.

American politics was also transformed in this period. The old divisions of the 1790s between Federalists and Jeffersonian Republicans dissolved after the war of 1812, but the Era of Good Feelings associated with the presidencies of James Madison and James Monroe ended with the election of 1824. Four candidates vied for the presidency: William Crawford, Henry Clay, Andrew Jackson, and John Quincy Adams. When the Electoral College votes were counted, no candidate had a majority, and the decision moved to the House of Representatives. Even though Jackson had won the plurality of popular and electoral votes, the House selected Adams. Jackson and his supporters denounced the "corrupt bargain" and immediately began to campaign for the next election in 1828. The result was a new party system of Jacksonian Democrats and National Republicans (later the Whig Party). Divisions were over personalities (especially that of Jackson), patronage, greater political participation (an end to property requirements for voting), and the concept of an agrarian society. Divisive economic issues included corporations (attacked as

monopolies) and banks (especially the powerful Second Bank of the United States), tariffs to protect manufacturing, and internal improvements (such as federally funded roads). Often the divisions are portrayed as stark: Democrats against monopolies and for the common man; Whigs for a strong central government and early industrialism. As usual, New Jersey politics were more complicated. Leaders of the Joint Companies were often Democrats, while some Whigs strongly criticized the state's premier monopoly. Farmers and immigrants tended to support the Democrats; commercial interests, evangelicals, and Quakers, the Whigs.

Despite or perhaps because of these complications, politics interested many people in this period. Parades and speeches provided entertainment, and divisions between the parties were usually quite narrow, making contests important. In 1838, contested results in New Jersey had a national impact. The governor certified six Whig candidates as winners of the general election to the U.S. House of Representatives; but owing to alleged irregularities, the House refused to seat five of the six, thereby ensuring continued Democratic control of Congress. Interest in politics led to the highest turnout of voters in the state's history—80 percent of those eligible—in the presidential election of 1840, when the Whig candidate, William Henry Harrison, won. Four years later, Democrat James K. Polk prevailed, and with his victory the issues began to change.

The number of voters increased in this period as states ended property qualifications. Governor Daniel

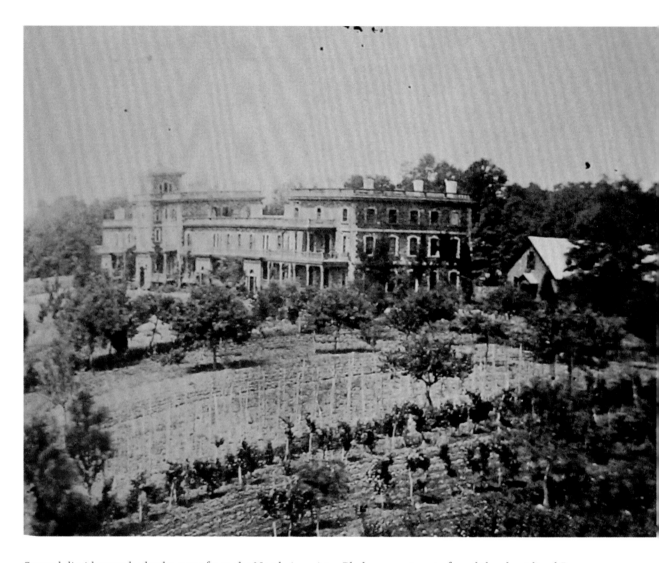

Several dissidents who broke away from the North American Phalanx went on to found the short-lived Raritan Bay Union (1853–1859) at a compound near Perth Amboy that they named Eagleswood. The associated school was coeducational, interracial, and originally run by such notable abolitionists as Theodore Weld and the Grimké sisters. The large stone community building later served in succession as a military academy, hotel, and art pottery. Source: Courtesy of John Kerry Dyke.

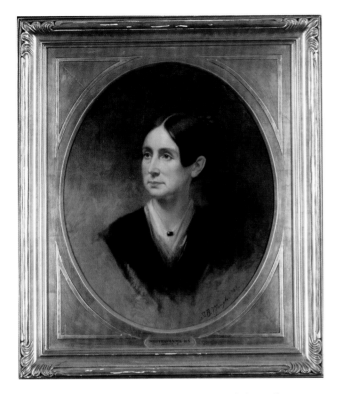

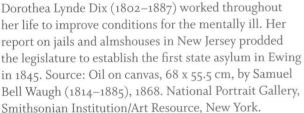

Dorothea Lynde Dix (1802–1887) worked throughout her life to improve conditions for the mentally ill. Her report on jails and almshouses in New Jersey prodded the legislature to establish the first state asylum in Ewing in 1845. Source: Oil on canvas, 68 x 55.5 cm, by Samuel Bell Waugh (1814–1885), 1868. National Portrait Gallery, Smithsonian Institution/Art Resource, New York.

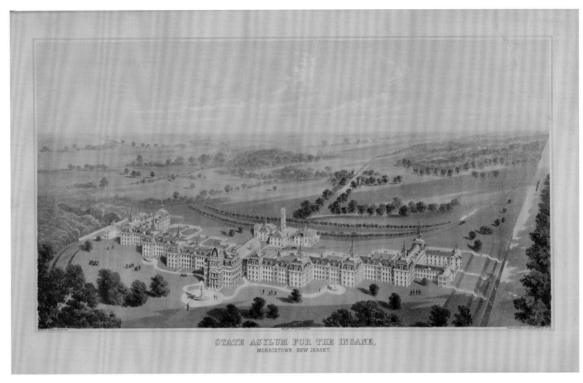

State Asylum for the Insane, Morristown, New Jersey, 1875. Built to relieve overcrowding at the Ewing facility, the psychiatric hospital known as Greystone opened in 1877. In time, ideas about treatment of the mentally ill changed, and the underused complex deteriorated. In 2015, the state demolished what was left of the main building. Source: Lithograph, 5 ½ x 26 1/8 in., by the architect Samuel Sloan (1815–1884). From the exhibition at Morven Museum & Garden, Princeton, "Portrait of Place: Paintings, Drawings, and Prints of New Jersey, 1761–1898, From the Collections of Joseph J. Felcone," 2012. Image courtesy of Joseph J. Felcone. Photograph © Bruce M. White, 2011.

Haines advocated for this provision when New Jersey replaced its original constitution in 1844. Other significant changes included election of the governor by popular vote to serve for three years (rather than being selected annually by the legislature); he could not succeed himself but could run again later. He was also given a veto, although it could be overridden by the legislature. The three branches were more clearly separated, and the governor no longer had a judicial role. Assemblymen were still elected annually, but senators every three years. Imprisonment for debt was ended, as were individual divorce bills. A bill of rights was added at the front of the document; property and religious qualifications for voting and holding office were eliminated, but the new constitution incorporated provisions of the 1807 law that limited the vote to adult white males. In the years that followed, women like Lucy Stone began to protest this

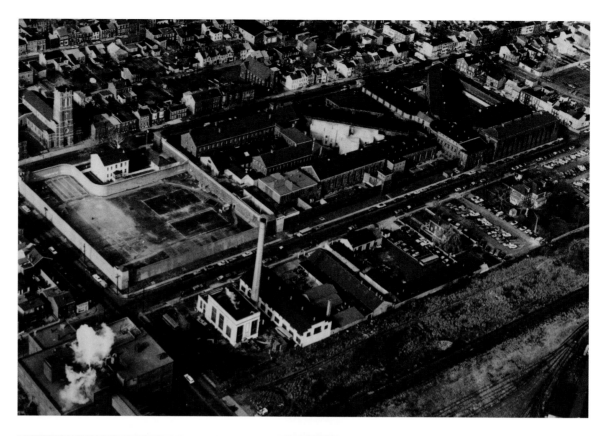

Aerial view of Trenton State Prison, c. 1931. The original prison, built in 1797, quickly became overcrowded. In the early 1830s, a committee of the legislature recommended a new building modeled on the so-called Pennsylvania system, which confined prisoners to individual cells to promote reflection and reform. A third wing was added between the original two radiating wings in the 1860s. Source: Civil Works Administration/Emergency Relief Administration, Works Progress Administration (WPA) Photographs of Work Projects, c. 1931–1936. New Jersey State Archives, Department of State.

restriction, remembering that some women had voted in New Jersey under the constitution of 1776.

The election of James K. Polk to the presidency in 1844 and the following war with Mexico marked the end of the Jacksonian Era in several ways. The United States acquired California (with the aid of a naval commander from Princeton named Robert Field Stockton) and a vast southwestern territory. This territorial expansion led to an increasingly bitter debate over the spread of slavery and the balance of power in Congress between slave and free states, which in the 1850s splintered the political system.

BIBLIOGRAPHY

For a national overview of this period, see Daniel Walker Howe, *What Hath God Wrought: The Transformation of America, 1815–1845* (New York: Oxford University Press, 2007). In addition to the numerous citations in Michael Birkner, "New Jersey in the Jacksonian Era, 1820–1850," in *New Jersey: A History of the Garden State*, ed. Maxine N. Lurie

Clara Barton School, built c. 1853. In 1852, Massachusetts-born Clara Barton (1821–1912) moved to Bordentown, New Jersey, where she started and ran a small private school. Her campaign to establish a free public school gained wide support, and the local school committee built a larger schoolhouse to accommodate the growing number of students. But the town then hired a male principal, and Barton left in 1854 for better-paid employment in Washington, D.C. Source: Department of Environmental Protection, Division of Parks & Forestry, Photographs Filed by Subject, c. 1930s–1970s, item ClaraBarton001. New Jersey State Archives, Department of State.

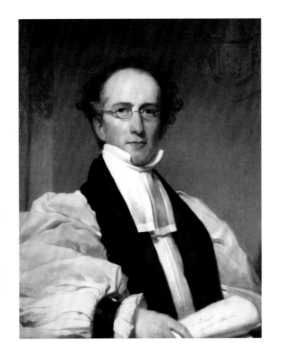

The Reverend George Washington Doane (1799–1859), second bishop of the Episcopal Diocese of New Jersey, was born in Trenton, ordained as a priest, and then served in New York City and Boston before returning to New Jersey in 1832. He was rector of Saint Mary's Church in Burlington, where he also organized a school for women and a college for men. Source: Courtesy of Doane Academy, Burlington.

and Richard Veit (New Brunswick: Rutgers University Press, 2012), see Michael Birkner, Donald Linky, and Peter Mickulas, eds., *The Governors of New Jersey*, rev. ed. (New Brunswick: Rutgers University Press, 2014), and James J. Gigantino II, *The Ragged Road to Abolition: Slavery and Freedom in New Jersey, 1775–1865* (Philadelphia: University of Pennsylvania Press, 2015).

State Normal Schools, Trenton, N. J.

New Jersey Normal and Model Schools, Trenton, late nineteenth or early twentieth century. The New Jersey legislature established the state's first school for teacher training by an act of 1855, which also authorized a "model school" where students of the normal school could practice their teaching methods. Both institutions, originally located on Clinton Avenue in Trenton, were part of the effort by reformers to confront the problems of a changing economy and the resulting need for educated workers. Source: New Jersey State Archives, New Jersey Postcards, 1900–1970. New Jersey State Archives, Department of State.

ST MARY'S HALL, GREEN BANK, BURLINGTON,

UNDER THE SUPERVISION OF THE BISHOP OF NEW JERSEY.

St. Mary's Hall, Green Bank, Burlington, c. 1837–1845. Bishop George Washington Doane (1799–1859) purchased what had briefly been a Quaker school on the banks of the Delaware River in Burlington and opened it as a school for girls in 1837. Two daughters of Ulysses S. and Julia Grant attended the school during the Civil War. Source: Lithograph drawn by W. Mason and engraved by F. Kearney. Courtesy of Doane Academy, Burlington.

In 1853, Bishop James Roosevelt Bayley (1814–1877) became the first Roman Catholic bishop of the Diocese of Newark. He founded Seton Hall University in 1856 in South Orange and named it after his aunt, Elizabeth Ann Bayley Seton. In response to rapid immigration in the second half of the nineteenth century, he also expanded the number of area churches and schools for children. Source: Monsignor William Noé Field Archives & Special Collections Center, Seton Hall University, South Orange. Courtesy of the New Jersey Catholic Historical Commission.

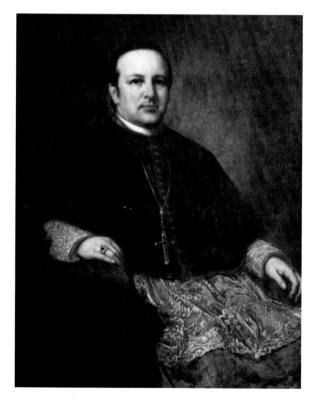

Mother Mary Xavier Mehegan, S.C. (1825–1915), founder of the Sisters of Charity of Saint Elizabeth, headquartered in Convent Station, near Morristown, after 1860. Born Catherine Josephine Mehegan in County Cork, Ireland, she emigrated to the United States at seventeen and served as mother superior of her order from 1859 until her death. Under her leadership, these Catholic nuns established hospitals, orphanages, and other institutions to aid the immigrants pouring into New Jersey and elsewhere. In 1899, they opened the College of Saint Elizabeth, the first four-year institution for women in the state. This image shows Sister Mary Xavier as a young woman. Source: Sisters of Charity of Saint Elizabeth Archives.

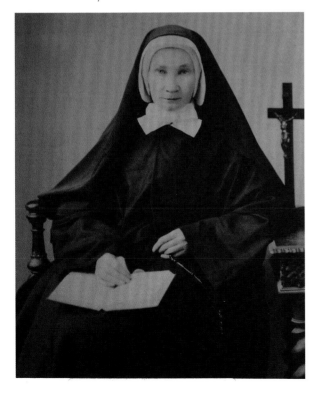

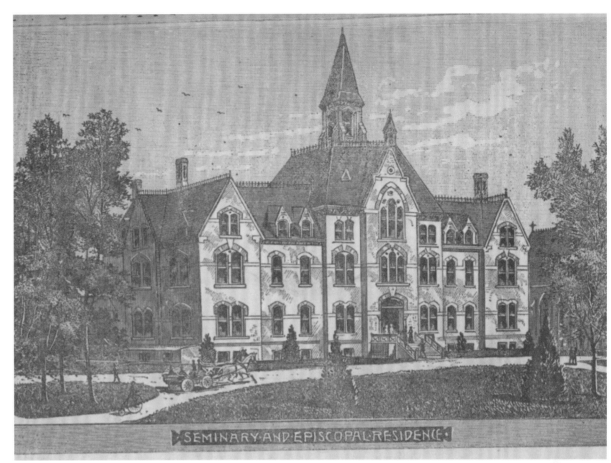

Seminary and Episcopal Residence, Seton Hall, c. 1863. One of the earliest buildings on the campus, Presidents Hall now houses the university's main administrative offices. Source: Monsignor William Noé Field Archives & Special Collections Center, Seton Hall University, South Orange. Courtesy of the New Jersey Catholic Historical Commission.

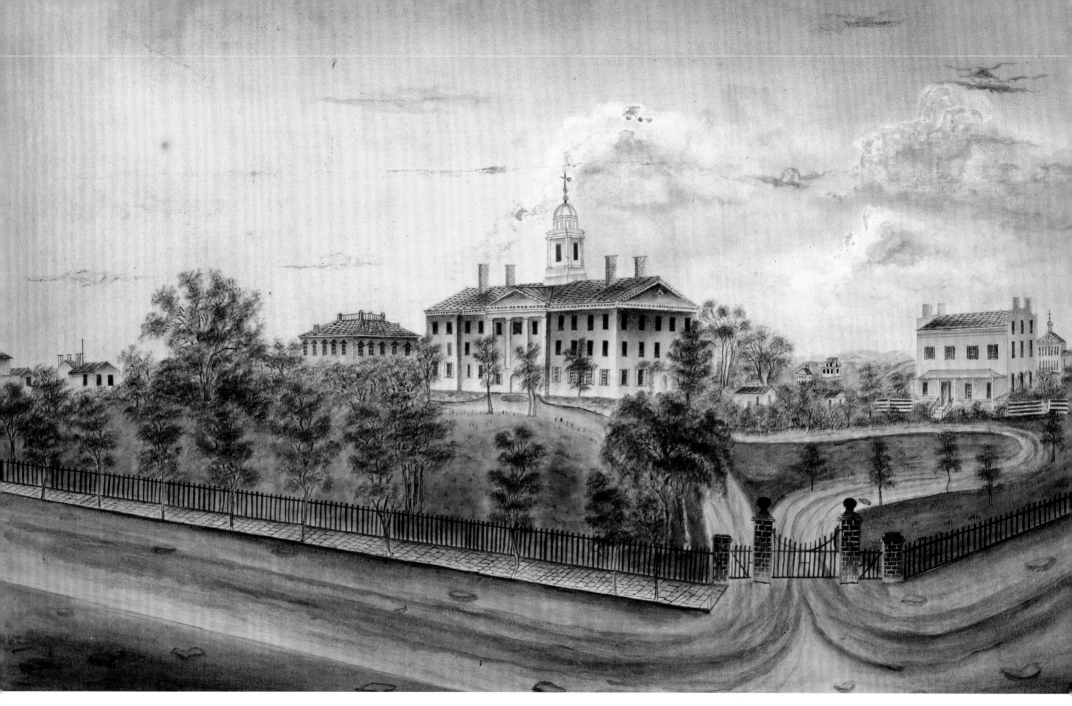

Rutgers College, New Brunswick, c. 1857. T. [Theodore] Stanford Doolittle, who graduated from Rutgers in 1859, made this watercolor of the campus while a student. Although Rutgers struggled in the period after the American Revolution, it was a small but growing institution by the mid-nineteenth century. Source: Special Collections and University Archives, Rutgers University Libraries.

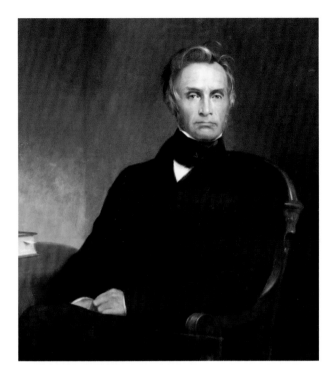

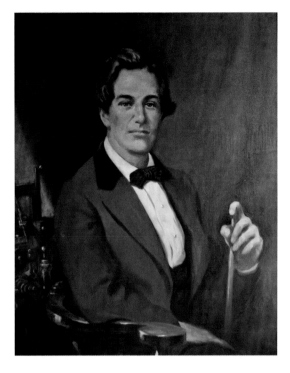

Alfred Vail. Vail (1807–1859) worked with Samuel F. B. Morse (1791–1872) to develop the telegraph. They used the Speedwell Iron Works of Vail's father Stephen in Morristown to build the early instruments. Source: Portrait by John LaValle (1896–1971), 1956. From the collections of the Morris County Park Commission.

This portrait of Theodore Frelinghuysen (1787–1862), a U.S. senator from New Jersey (1829–1835), vice presidential candidate on the Whig ticket (1844), and president of Rutgers College (1850–1862), hangs in Kirkpatrick Chapel on the Rutgers campus. Source: Oil on canvas by Thomas Sully (1783–1872), 1865. Special Collections and University Archives, Rutgers University Libraries.

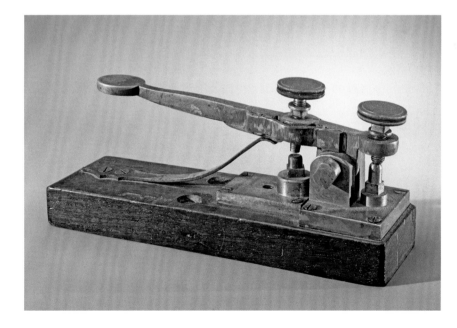

Morse-Vail telegraph key, 1844. The telegraph was developed at Speedwell Iron Works in Morristown. Source: Classified as National Treasure, CA–W&I 74–2491. Western Union Telegraph Company Records, Archives Center, National Museum of American History, Smithsonian Institution, Washington, D.C.

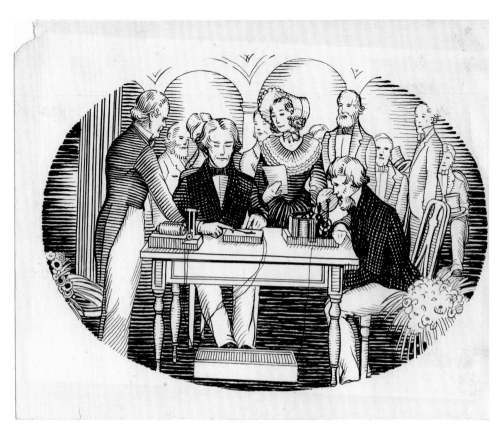

Samuel F. B. Morse at the U.S. Capitol opening the first commercial telegraph circuit between Washington and Baltimore, May 24, 1844. The message consisted of a biblical quote, "What hath God wrought." Source: Undated woodcut. Item AC 0205–0000008. Western Union Telegraph Company Records, Archives Center, National Museum of American History, Smithsonian Institution. Washington, D.C.

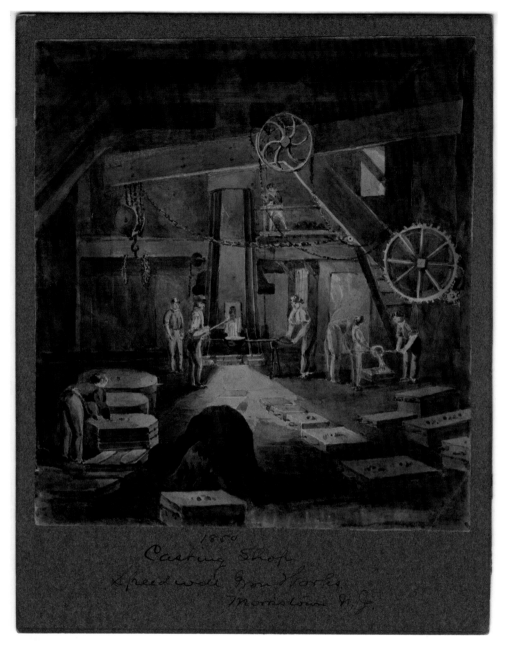

Casting shop, Speedwell Iron Works, Morristown. Owned by Stephen Vail (1780–1864), the ironworks manufactured products from nails to engine parts, including the engine for the *Savannah*, which became the first steamboat to cross the Atlantic. Source: From the collections of the Morris County Park Commission.

Map of the Howell Works, 1853. In 1822, James P. Allaire (1785–1858) purchased land in Monmouth County that contained bog iron deposits and a small ironworks. He established a model manufacturing center that included mills, a blast furnace, and housing for his workers. Today it is part of Allaire State Park. Source: Lithograph. Special Collections and University Archives, Rutgers University Libraries.

Oxford Furnace was part of a complex that produced iron from ore mined in the northwestern area of New Jersey. Manufacturing took place at the site from 1741 to 1884, and it was one of the first places to make use of the hot blast process, which removed iron from ore more efficiently. However, rich beds of ore discovered in the Midwest ended production in the late nineteenth century. Photograph by R. Veit.

Raking the pit. African American men produced charcoal in the Pine Barrens during the 1930s using the same methods as in earlier times. Charcoal was used in iron manufacturing and many other processes. Source: New Jersey Division of Parks and Forestry, Bass River State Forest.

Whitney Glassworks, Glassboro N.J., Established 1775, c. 1850. Casper Wister/Wistar pioneered the production of glass using South Jersey sands in the mid-1700s. In the mid-nineteenth century, the Whitney Glassworks was a large producer of bottle glass. Source: Colored engraving by J. N. Allan. Special Collections Division, The Newark Public Library.

Portrait of the Sisters Zénaïde and Charlotte Bonaparte, 1821. These daughters of Joseph Bonaparte, older brother of Napoleon, visited him while he lived in exile at Point Breeze in New Jersey. In exile themselves in Belgium, the sisters (Zénaïde on the right) read a letter from their father. Source: Oil on canvas, 51 x 39 3/8 in., by Jacques-Louis David (1748–1825). Item 86.PA.740. © J. Paul Getty Museum, Los Angeles.

View of Point Breeze, c. 1820. Joseph Bonaparte (1768–1844), who had been king of Naples and Spain while his younger brother ruled France, spent seventeen years as an exile in the United States. He built an elaborate estate in the picturesque style along the Delaware River near Bordentown. Source: Oil on canvas, 26 ¾ x 36 ¼ in., by Charles B. Lawrence (1790–1864). Collection of the New Jersey State Museum. Gift of Mr. and Mrs. Harry L. Jones, FA (1962) 306.1. Reproduced with permission.

Sarah Conover Schenk Smock and Baby Elenor, Freehold, Monmouth County, c. 1819. Sarah (1786–1825) was married to farmer Aaron Smock; the couple had ten children. Elenor (1818–1819), the seventh, died shortly after this portrait was made, and the mother died six years later, several months after the birth of her last child. The Smocks' farm produced sheep and fruit, including the peach held by the baby. Source: Pastel on paper by Micah Williams (c. 1782–1837). Item 1982.417. Museum Collection, Monmouth County Historical Association, Freehold. Gift of Sarena V. Roome, 1957.

Micah Williams (c. 1782–1837) produced hundreds of portraits of upper- and middle-class New Jersey and New York residents. Source: Oil on wood panel by an unknown artist, c. 1830–1832. Purchase, 1980. Museum Collection, Monmouth County Historical Association, Freehold.

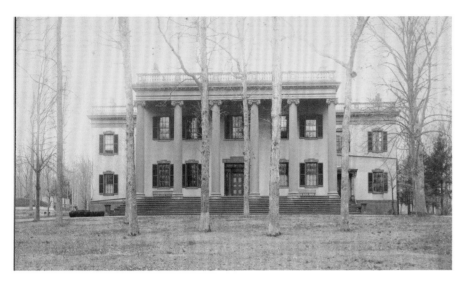

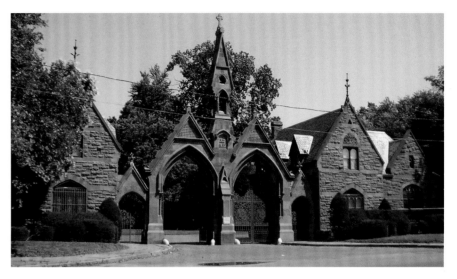

Mead Hall, c. 1885. This important example of Greek revival architecture was built from 1833 to 1836 by William Gibbons, the wealthy son of steamboat operator Thomas Gibbons. After the Civil War, the estate was purchased by the financier Daniel Drew for use by the Methodist theological seminary (now Drew University) he helped establish. Today the building, restored after a fire in 1989, is used for university functions. Source: Buildings and Campus Features, Photograph Collection. Special Collections and Archives, Drew University Library, Madison.

The Gothic gate of Mount Pleasant Cemetery, Newark, separates the cemetery from the city. Mount Pleasant, which opened in 1844, is a fine example of the rural cemetery movement, which advocated carefully landscaped grounds on the peripheries of cities, which in the Victorian period were also used as parks. Photograph by R. Veit.

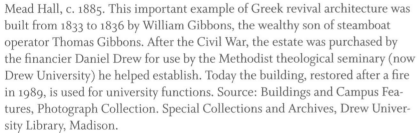

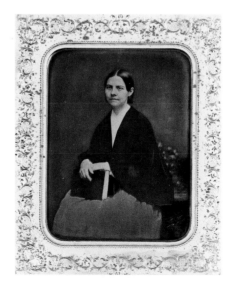

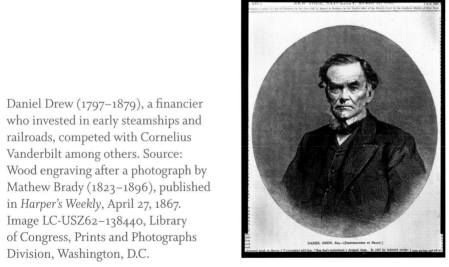

Daniel Drew (1797–1879), a financier who invested in early steamships and railroads, competed with Cornelius Vanderbilt among others. Source: Wood engraving after a photograph by Mathew Brady (1823–1896), published in *Harper's Weekly*, April 27, 1867. Image LC-USZ62–138440, Library of Congress, Prints and Photographs Division, Washington, D.C.

Lucy Stone (1818–1893), reformer and early advocate for women's right to vote. She lived in Orange, New Jersey, where she refused to pay taxes on the grounds that she could not vote and therefore was not represented. Source: Daguerreotype, c. 1855, in gold frame. National Portrait Gallery, Smithsonian Institution/Art Resource, New York.

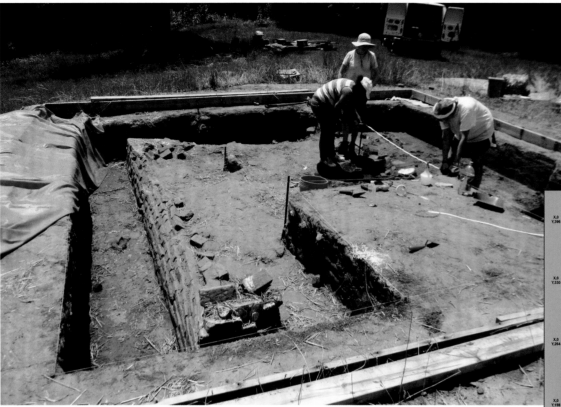

Archaeological dig at Timbuctoo, an early African American community in Burlington County. It was one of several sites in the state where freedmen and escaped slaves established their own separate communities. Source: Courtesy of Chris Barton.

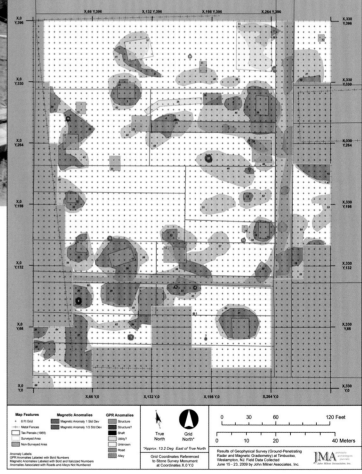

This ground-penetrating radar image shows where houses were located in Timbuctoo. They seem to form a circular pattern, resembling the form of traditional African communities. Source: Courtesy of Chris Barton.

Mrs. Elizabeth Stewart, One of the Organizing Members of Gouldtown Church.

Commodore Robert Field Stockton, c. 1821. A member of the prominent Princeton family, Stockton (1795–1866) was a career naval officer who served in the War of 1812 and was later known for his actions leading to the acquisition of California during the war with Mexico. After resigning from the navy in 1850, he briefly represented New Jersey in the U.S. Senate and was involved in Democratic Party politics. Source: Pastel on paper by Micah Williams (c. 1782–1837). Morven Museum & Garden, Princeton.

Mrs. Elizabeth Stewart, one of the organizing members of the Gouldtown A.M.E. Church, Cumberland County. Source: From William Steward and Rev. Theophilus G. Steward, *Gouldtown: A Very Remarkable Settlement of Ancient Date* (Philadelphia: J. B. Lippincott Company, 1913), opposite page 126. Print 1229351, Manuscripts, Archives and Rare Books Division, Schomburg Center for Research in Black Culture, The New York Public Library, Astor, Lenox and Tilden Foundations.

Gouldtown A.M.E. Church, Cumberland County. Gouldtown was established by African American, Native American, and white settlers who intermarried and built a community despite considerable prejudice. Source: From William Steward and Rev. Theophilus G. Steward, *Gouldtown: A Very Remarkable Settlement of Ancient Date* (Philadelphia: J. B. Lippincott Company, 1913), opposite page 146. Print 1229353, Manuscripts, Archives and Rare Books Division, Schomburg Center for Research in Black Culture, The New York Public Library, Astor, Lenox and Tilden Foundations.

Gouldtown A. M. E. Church.

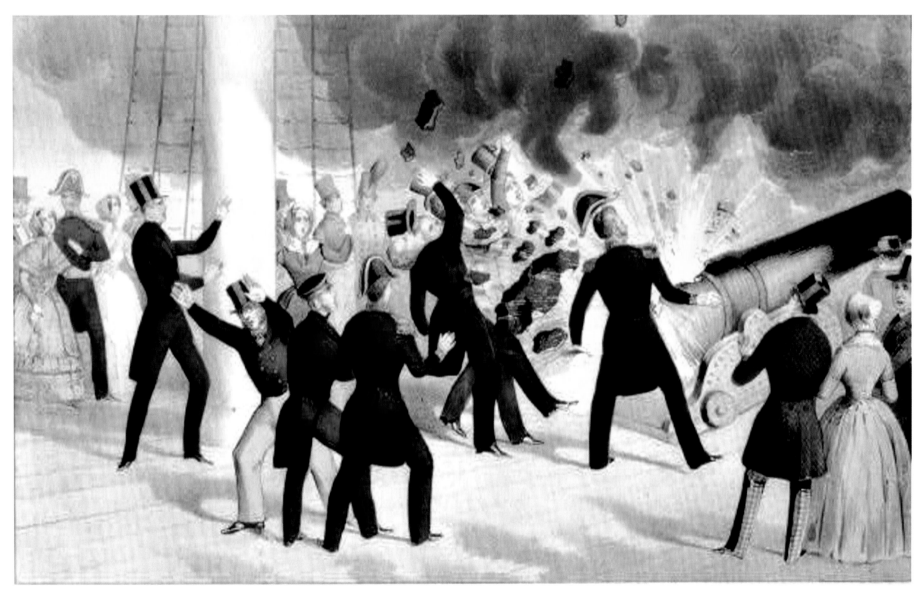

Awful Explosion of the "Peace Maker" on board the U.S. Steam Frigate, Princeton, on Wednesday, 28th. Feby. 1844. The state-of-the-art U.S.S. *Princeton*, built under the supervision of then Captain Robert Field Stockton, was sailing under his command on the Potomac River with a large crowd of dignitaries when, during a demonstration of its two massive cannons, one exploded. President John Tyler was unhurt, but two members of his cabinet were killed. Source: Hand-colored lithograph published by Nathaniel Currier (1813–1888). Image LC-USZC2–3201, Library of Congress, Prints and Photographs Division, Washington, D.C.

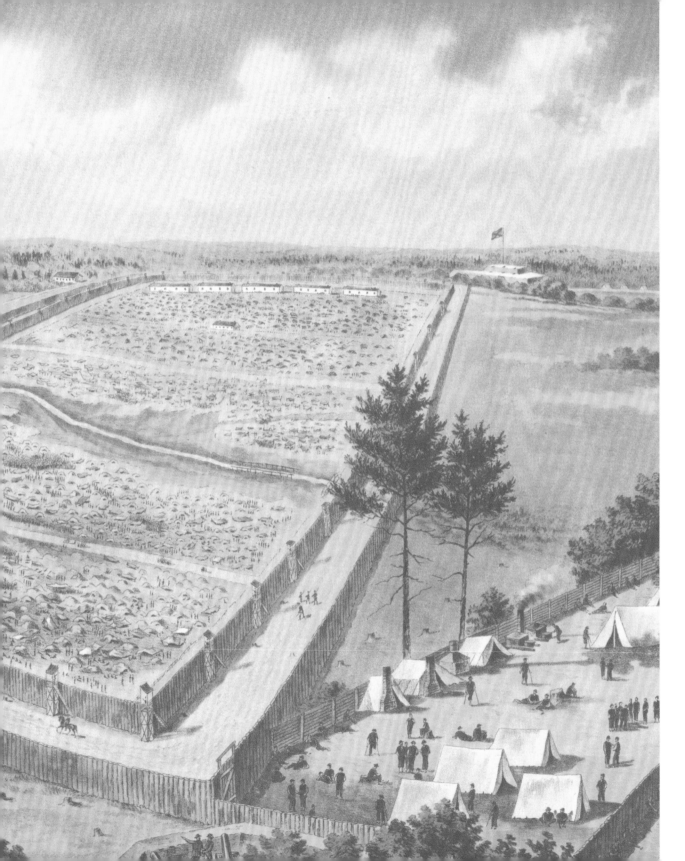

Civil War and Reconstruction

The two fundamental events in U.S. history are the American Revolution, which established the nation, and the Civil War, which preserved it. New Jersey was a battleground in the first, but avoided the physical ravages of war during the second. It did not, however, escape the divisive political debates over slavery and the war, and its citizens served on numerous battlefields as well as on the home front. The war and its aftermath ended slavery, including its remnants in New Jersey, and broadened the definition of citizenship to include blacks. But new constitutional amendments did not result in a fully equal society.

Three national issues divided New Jerseyans over the course of this period: whether to limit the expansion of slavery in the West or abolish it

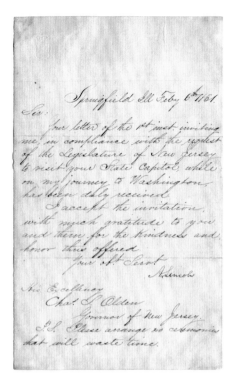

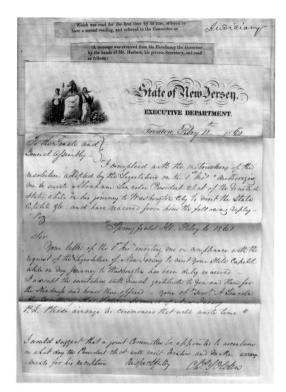

Abraham Lincoln (1809–1865), an Illinois lawyer and politician, was selected as the Republican candidate for president in 1860 because he was seen as a moderate. He won with less than 40 percent of the popular vote because the Democratic ticket was divided. South Carolina responded by seceding from the Union on December 20, 1860, without waiting to see what actions he would take. Source: Undated lithograph, Governor Charles Smith Olden, Lincoln Letter, 1861. New Jersey State Archives, Department of State.

Letter from Abraham Lincoln (1809–1865) to Governor Charles S. Olden (1799–1876), February 6, 1861. Even though Lincoln lost the popular vote in New Jersey in the presidential election of 1860, he accepted an invitation to speak to the New Jersey legislature on his way to his inauguration in Washington, D.C. Source: Governor Charles Smith Olden, Lincoln Letter, 1861. New Jersey State Archives, Department of State.

On February 11, 1861, Governor Charles S. Olden (1799–1876) notified legislators that President-elect Lincoln had accepted their invitation to speak and asked them to make the necessary arrangements to welcome him. Source: New Jersey Legislature, Senate Journals [Minutes], 1845–2011, volume 5, February 5–11, 1861. New Jersey State Archives, Department of State.

everywhere (including in the South); whether to preserve the Union or allow the South to secede; and whether to approve the Thirteenth, Fourteenth, and Fifteenth Amendments. New Jersey has sometimes been described as a "southern" or "border" state, not quite a northern one. But the divisions here were typical of those in other mid-Atlantic states (New York and Pennsylvania), the lower Midwest, and the Shenandoah Valley. New Jersey's partisan attitudes can be explained by the pervasive racism at the time, the emergence of a third set of political parties, and the fact that the margin of votes between them was quite narrow, meaning that political control regularly shifted from one party to the other. Newspapers reflected these divisions, supporting a variety of positions.

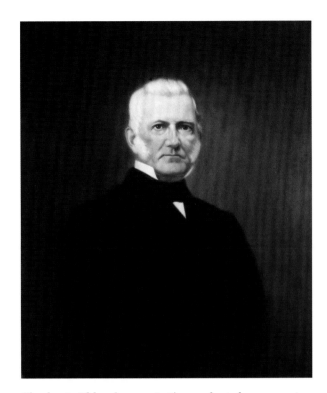

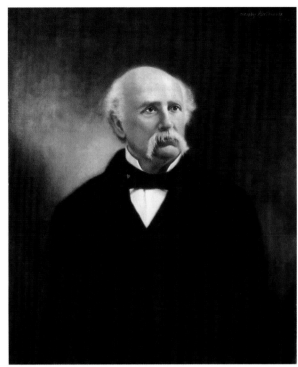

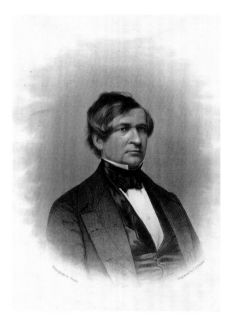

Charles S. Olden (1799–1876) was elected governor in 1859 as the Opposition coalition candidate. A conservative on the issue of slavery, he viewed the institution as a matter for state regulation. Olden opposed secession while unsuccessfully working for a compromise to avoid it. Once war came, he mobilized the state's forces to keep the Union together. Source: Oil on canvas, 35 ½ x 29 5/8 in., by Henry Harrison (1844–1923), 1896. New Jersey State House Portrait Collection, administered by the New Jersey State Museum (SHPC45) Reproduced with permission.

Rodman M. Price (1816–1894), a naval officer whose service included time in California during its acquisition, became a Democratic politician and was elected governor of New Jersey in 1853. Taking a conservative stance on most issues, he was sympathetic to the South. In 1861, he urged New Jerseyans to refrain from taking up arms. Source: Oil on canvas, 35 ½ x 29 ½ in., by Henry Harrison (1844–1923), 1904. New Jersey State House Portrait Collection, administered by the New Jersey State Museum (SHPC38). Reproduced with permission.

William Lewis Dayton (1807–1864) was a New Jersey state senator, judge, U.S. senator, state attorney general, and diplomat. An antislavery Whig who opposed the Compromise of 1850, Dayton ran for vice president on the Republican ticket in 1856 and supported Lincoln in 1860. Appointed U.S. minister to France during the Civil War, he played an important role by keeping the French from recognizing the Confederate States of America. Source: Engraving by J. C. Buttre (1821–1893) after a photograph by Mathew Brady (1822–1896). New Jersey Portraits Collection, Special Collections and University Archives, Rutgers University Libraries.

Economic factors and family ties further complicated the picture. In the end, New Jerseyans fought bravely and died on far-flung battlefields outside the state's boundaries. Ultimately, the state legislature ratified the Reconstruction amendments.

Although New Jersey sided with the Union, it had been the last northern state to abolish slavery. As the gradual abolition act of 1804 went into effect, the number of free blacks rose in the state, and the number of slaves declined; according to the census of 1860, only eighteen slaves remained. Yet, slavery

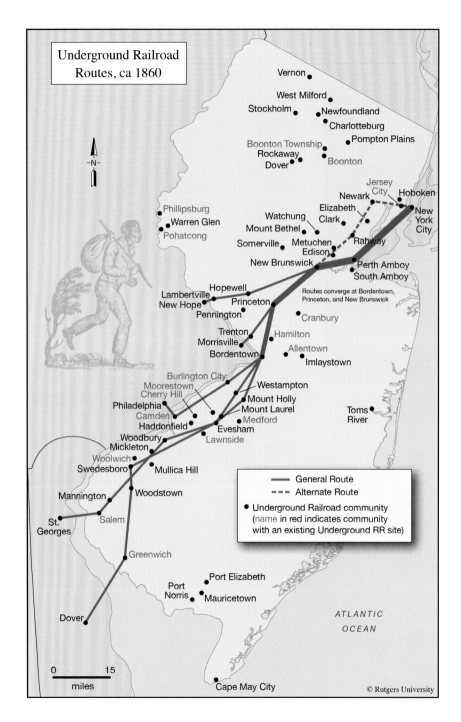

Underground Railroad
Routes, ca 1860

Routes converge at Bordentown,
Princeton, and New Brunswick

General Route
Alternate Route
● Underground Railroad community
(name in red indicates community
with an existing Underground RR site)

ATLANTIC
OCEAN

0 15
miles

© Rutgers University

The New Jersey Freeman, volume 1, number 1 (June 1844). From Boonton in Morris County, Dr. John Grimes published fifty-two numbers of the *Freeman* (June 1844–March 1850). The first issue begins with a statement of purpose: to end slavery by "immediate, universal emancipation." The *Freeman* was New Jersey's first abolitionist newspaper, and Rutgers University has one of only two known complete sets. Source: Special Collections and University Archives, Rutgers University Libraries (SNCLXF F144.B66N39).

The Peter Mott House (c. 1845), an Underground Railroad station. Mott (c. 1807–1881), an African American, was a minister at the Snow Hill Church in what is now Lawnside, Camden County, a community of free blacks and escaped slaves. Source: Photograph by Margaret Westfield.

This map of the Underground Railroad illustrates the most likely routes taken through New Jersey by blacks escaping from slavery. Source: Map by Michael Siegel.

Dr. James Still (1812–1885) was the son of slaves and the brother of abolitionists. The self-taught homeopathic "Black Doctor of the Pines" served black and white patients from South Jersey and Philadelphia. Source: Folk image at the Medford Historical Society. Photograph by R. Veit.

Dr. James Still's office, Medford Historical Society. Photograph by R. Veit.

Harriet Arminta Tubman (1820–1913), c. 1885. Born in Maryland, this escaped slave was called the "Black Moses" for her repeated trips south to lead others to freedom. For several summers she worked in Cape May to earn money to support her efforts, and during the Civil War she served the Union army as a nurse and spy. Source: Paper photograph, 5 ½ x 3 7/8 in., by H. Seymour Squyer (1848–1905). National Portrait Gallery, Smithsonian Institution/Art Resource, New York.

had become more rather than less important. The abolitionists of the 1830s and thereafter dismissed gradualism. Influenced by the Second Great Awakening, they saw slavery as a sin that must be expunged immediately. Southerners increasingly defended slavery as a system better than northern wage capitalism and argued that it should be permitted everywhere. For some New Jerseyans, sending blacks to Africa, the agenda of the American Colonization Society, was seen as one solution to national divisions over slavery and economic competition from freed blacks.

As the free black population increased, it was easier for runaway slaves to obtain help. They were aided by Quakers and other sympathetic whites, as well as by black abolitionists, some of whom were escaped slaves themselves (the best known in New Jersey are Harriet Tubman and members of the Still family). Runaways passed through the state via several Underground Railroad routes or hid in existing communities of free blacks (for example, Gouldtown in Cumberland County and Lawnside near Camden). By 1860, New Jersey had a total population of 646,699, of whom 25,336 were black, the highest percentage (nearly 4 percent) of any free state. New Jersey was not a center of radical abolitionism, although some of the foremost abolitionists lived in the state, including Theodore D. Weld and his wife, Angelina Grimké, and Lucy Stone and her husband, Henry Blackwell. When John Brown was

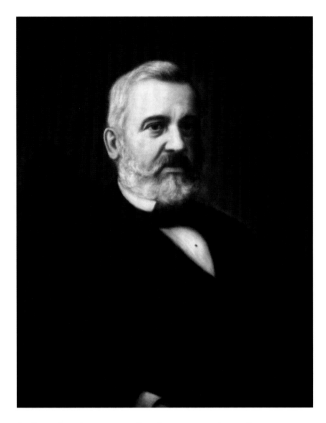

Joel Parker (1816–1888), a Democrat elected governor in 1862, supported the war to maintain the Union, but opposed emancipation, Lincoln's use of presidential powers, and voting rights for blacks. Elected to a second term in 1871, he called for the end of Reconstruction. Source: Oil on canvas, 29 ½ x 24 5/8 in., by Charles W. Wright (1824–1869), 1888. New Jersey State House Portrait Collection, administered by the New Jersey State Museum (SHPC49). Reproduced with permission.

Governor Joel Parker's proclamation, June 22, 1863, discharging the troops raised earlier in response to "the appeal of the Governor of Pennsylvania for aid in repelling the threatened invasion of that State." The companies should stand ready, however, "as their services may be needed again at any moment." The Battle of Gettysburg began just nine days later. Source: Department of Defense, Adjutant General's Office (Civil War), Governors' Proclamations, 1861–1865. New Jersey State Archives, Department of State.

Major Genl. McClellan, c. 1862. As general-in-chief of all Union armies from November 1861 to March 1862, McClellan (1826–1885) was better at organizing than at fighting. Source: Colored lithograph. Image LC-USZC2–3791, Library of Congress, Prints and Photographs Division, Washington, D.C.

convicted of treason for the raid on the federal arsenal at Harpers Ferry, which was part of his plan to lead a rebellion of southern slaves, the Quaker reformer and abolitionist Rebecca Buffum Spring visited him before his execution. Two of Brown's executed companions were buried on the property of the Raritan Bay Union, where she lived. And she supported the war when it came; for her, abolition trumped pacifism.

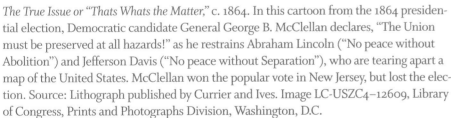

THE TRUE ISSUE OR "THATS WHATS THE MATTER".

The True Issue or "Thats Whats the Matter," c. 1864. In this cartoon from the 1864 presidential election, Democratic candidate General George B. McClellan declares, "The Union must be preserved at all hazards!" as he restrains Abraham Lincoln ("No peace without Abolition") and Jefferson Davis ("No peace without Separation"), who are tearing apart a map of the United States. McClellan won the popular vote in New Jersey, but lost the election. Source: Lithograph published by Currier and Ives. Image LC-USZC4–12609, Library of Congress, Prints and Photographs Division, Washington, D.C.

Political banner for George B. McClellan and George H. Pendleton, c. 1863–1864. For the election of 1864, a divided Democratic Party nominated pro-war General McClellan (1826–1885) of New Jersey for president and anti-war U.S. Representative Pendleton (1825–1889) of Ohio for vice president. Source: Black ink over graphite on woven cotton. Museum Collection, Monmouth County Historical Association, Freehold.

Despite the active abolitionist community, New Jersey could be a dangerous place for escaping slaves. The state did not enact personal liberty laws used in other parts of the North to try to protect officials and citizens who refused to abide by the federal Fugitive Slave Act of 1850, which required them to aid in the seizure of alleged runaways. New Brunswick, an important transportation hub, was the headquarters of slave catchers. Although state law required that slave hunters provide proof before returning their captives and that the cases be tried by a jury, these provisions apparently were rarely used. Many residents thought that each state had a right to deal with slavery by itself and that the South and its "peculiar institution" should be left alone. Rodman Price,

NEWARK DAILY JOURNAL.

MONDAY, APRIL 17, 1865.

Proclamation by the Governor.

TRENTON, April 17, 1865.

The President of the United States is dead.—He was murdered by an assassin. The crime has no parallel in our history. Its enormity has astounded and almost paralyzed the nation. At this crisis the death of the Chief Magistrate in such a manner, and through such means, is peculiarly a national calamity.

After four years of terrible war, the sunlight of peace began to glimmer through the dark clouds, and while a joyful people hailed the brightening prospect, the blow fell. The ways of God are above our comprehension, yet in Him will we put our trust. The Lord is high above all nations.

In view of the sad and appalling event which engrosses the public mind, it is right and in consonance with the feelings of all good citizens that some general manifestation of sorrow should be made.

Therefore, I, JOEL PARKER, Governor of the State of New Jersey, do hereby recommend the people of this State to observe the day appointed for the obsequies of the late President of the United States, to wit: WEDNESDAY, the 19th day of April instant, by closing all places of business, by draping all public buildings in mourning, by assembling at the hour of twelve (12) o'clock noon in their usual places of worship and by such other demonstrations of grief and respect as are fitting to the occasion.

Given under my hand and privy seal at
[L. s] Trenton this seventeenth (17th) day of April, A. D. eighteen hundred and sixty five (1865.)

(Signed,) JOEL PARKER.

Attest: S. M. DICKINSON, Private Sec'y.

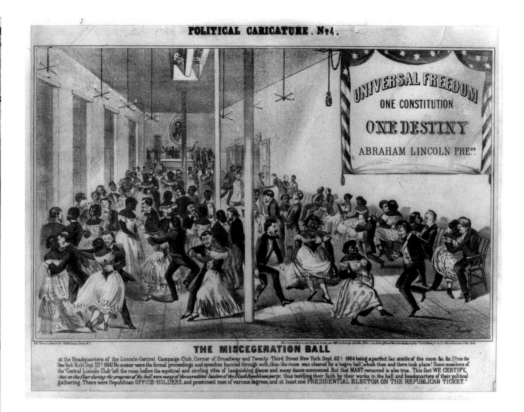

The Miscegenation Ball, 1864. One of a series of anti-Republican attacks, the cartoon played on northern fears that Abraham Lincoln's reelection would lead to racial mixing and worse. New Jersey Democrats, opposed to the Emancipation Proclamation, shared these fears. Source: Lithograph by Kimmel & Foster, published by Bromley & Co. Image LC-USZ62–14828, Library of Congress, Prints and Photographs Division, Washington, D.C.

Proclamation of a day of mourning by Governor Joel Parker after the assassination of President Abraham Lincoln, April 14, 1865. Source: *Newark Daily Journal*, April 17, 1865. Loose Newspaper Collection, Special Collections and University Archives, Rutgers University Libraries.

governor of New Jersey in the mid-1850s, stated that slavery was "no sin," and few ministers in the state actively opposed the institution.

Political changes were also important in the slavery debate. Sectional differences were part of the new nation from its start, symbolized by compromises in the Constitution of 1787, even as its authors avoided the word "slavery." Such distinctions became increasingly important with westward expansion: the Louisiana Purchase in 1804 led to the Missouri Compromise of 1820, which established a boundary between North and South at 36° 30´; the Mexican-American

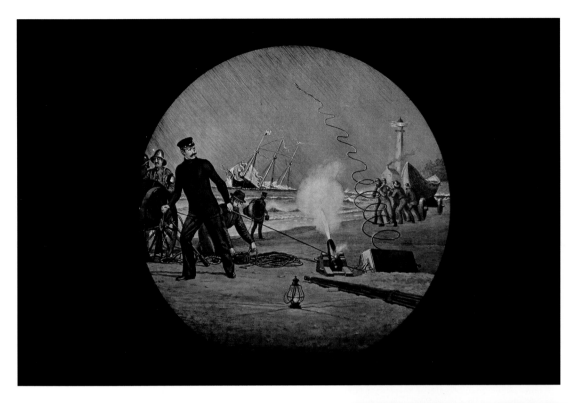

Members of the U.S. Life-Saving Service fire a shot line to a distressed ship, the first step in the rescue procedure. The image on glass was painted by the renowned magic lantern slide artist Joseph Boggs Beale (1841–1926). It was used to illustrate the hymn "Throw Out the Lifeline." Source: From the collection of the American Magic-Lantern Theater, East Haddam, Connecticut.

War (1846–1848) again raised the issue of slavery in newly acquired territories, which was resolved with the contentious Compromise of 1850. Political agreement did not hold for long. The Kansas-Nebraska Act of 1854 effectively repealed the Missouri Compromise by allowing white male settlers in those territories to determine whether to allow slavery. The idea of popular sovereignty died with the Dred Scott decision of 1857, when the U.S. Supreme Court ruled that blacks, both free and slave, were not citizens and that slavery could not be restricted. In the midst of these developments the existing political parties fractured. The Whigs disintegrated into the American (Know-Nothing) Party, opposed to immigrants, the Free Soil Party, which desired to keep the West a white man's country, and the Radical Abolitionist Party. In the North, ex-Whigs tended to merge into the Republican Party. In 1860, the Democrats divided into northern, southern, and Constitutional Union segments.

A doctor and a Whig politician, William A. Newell (1817–1901) is best known for his role in helping found the U.S. Life-Saving Service (1848), a predecessor of the U.S. Coast Guard. Though opposed to the extension of slavery, he did not support abolition where slavery already existed. Elected governor in 1856 as an "Opposition" Party candidate, he became a Republican after 1860 and supported Lincoln, the war, and Reconstruction. Source: Oil on canvas, 31 ½ x 25 ½ in., by Frederick H. Clark (1861–1948), 1901. New Jersey State House Portrait Collection, administered by the New Jersey State Museum (SHPC40). Reproduced with permission.

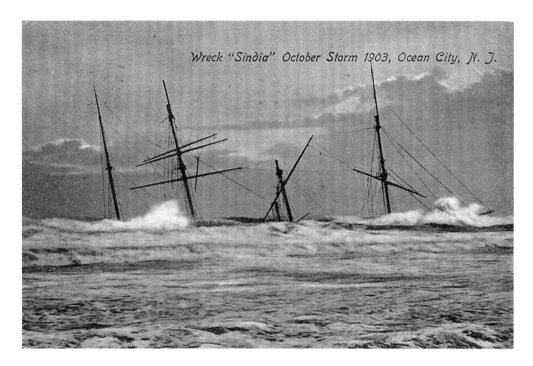

Wreck of the *Sindia*, 1903. This postcard vividly illustrates the long history of dangerous conditions along the New Jersey coast that led to the creation of the U.S. Life-Saving Service in 1848. The *Sindia* sank just over a decade before the Life-Saving Service was merged with the Revenue Cutter Service to create the U.S. Coast Guard. Source: R. Veit Collection.

Highlands of the Navesink and the Twin Lights Lighthouse at the entrance to New York Harbor, 1872. The first lighthouse on this location, built in 1828, was replaced in 1862 with the one shown here. Decommissioned in 1962, today it is a museum. Source: Oil on canvas by an unknown artist. Purchase, 1985. Museum Collection, Monmouth County Historical Association, Freehold.

Politics in New Jersey reflected these shifts. Whigs were replaced by what initially was simply called the "Opposition," then the "Union" party, and finally the "Republican" party. In 1860, the state's Electoral College votes were split, with four going to Republican Abraham Lincoln and three to northern Democrat Stephen A. Douglas. On his way to Washington, D.C., for his inauguration,

yours truly
James W. Wall

James W. Wall (1820–1872), a former mayor of Burlington, was one of the anti-war Democrats known as Copperheads. He was arrested and briefly held in 1861, charged with "secession proclivities." In 1863, the state legislature elected him to the seat in the U.S. Senate vacated by the death of John R. Thomson. He served for six weeks. Source: New Jersey Portraits Collection, Special Collections and University Archives, Rutgers University Libraries.

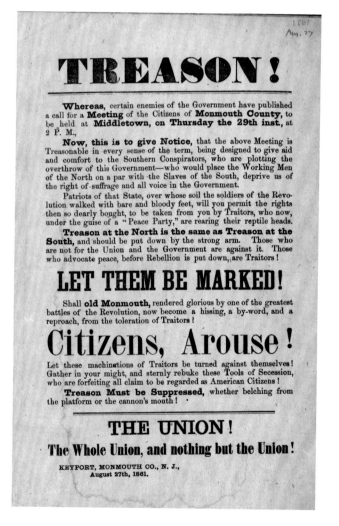

TREASON !

Whereas, certain enemies of the Government have published a call for a **Meeting** of the Citizens of **Monmouth County,** to be held at **Middletown, on Thursday the 29th inst,** at 2 P. M.,

Now, this is to give Notice, that the above Meeting is Treasonable in every sense of the term, being designed to give aid and comfort to the Southern Conspirators, who are plotting the overthrow of this Government—who would place the Working Men of the North on a par with the Slaves of the South, deprive us of the right of suffrage and all voice in the Government.

Patriots of that State, over whose soil the soldiers of the Revolution walked with bare and bloody feet, will you permit the rights then so dearly bought, to be taken from you by Traitors, who now, under the guise of a "Peace Party," are rearing their reptile heads.

Treason at the North is the same as Treason at the South, and should be put down by the strong arm. Those who are not for the Union and the Government are against it. Those who advocate peace, before Rebellion is put down, are Traitors !

LET THEM BE MARKED!

Shall **old Monmouth,** rendered glorious by one of the greatest battles of the Revolution, now become a hissing, a by-word, and a reproach, from the toleration of Traitors ?

Citizens, Arouse !

Let these machinations of Traitors be turned against themselves ! Gather in your might, and sternly rebuke these Tools of Secession, who are forfeiting all claim to be regarded as American Citizens !

Treason Must be Suppressed, whether belching from the platform or the cannon's mouth !

THE UNION !
The Whole Union, and nothing but the Union !

KEYPORT, MONMOUTH CO., N. J.,
August 27th, 1861.

Lincoln spoke briefly in Jersey City, Newark, Elizabeth, Rahway, New Brunswick, and Princeton Junction; in Trenton, he addressed both houses of the legislature, trying to reassure the concerned citizens even as southern states voted to secede. A number of New Jersey politicians supported peace efforts in early 1861, but these came to naught. As military action began with the firing on Fort Sumter, Democratic politicians divided into "war" and "peace" factions, with some so-called Copperheads clearly sympathetic to the South (the most extreme stating that New Jersey should join the Confederacy). Northern defeats and war fatigue produced more dissatisfaction. In 1863, the legislature passed peace resolutions and selected Democrat James W. Wall (a notorious Copperhead) to fill a vacant seat in the U.S. Senate, although only six weeks remained to the term.

Just before the presidential election of 1864, the war was going badly for the North, and the death toll was enormous. The state voted for a native son, Democrat George McClellan, then living in West Orange (in 1877 he would be elected governor of the state). The former general-in-chief of the Union army criticized the administration but thought the Union should be preserved. Some Democrats played on the

A warning to the citizens of Monmouth County that a meeting of the "Peace Party" in Middletown represents treason: "Those who advocate peace, before Rebellion is put down, are Traitors!" Source: Broadside, Keyport, August 27, 1861. New Jersey Political Broadsides Collection, Special Collections and University Archives, Rutgers University Libraries.

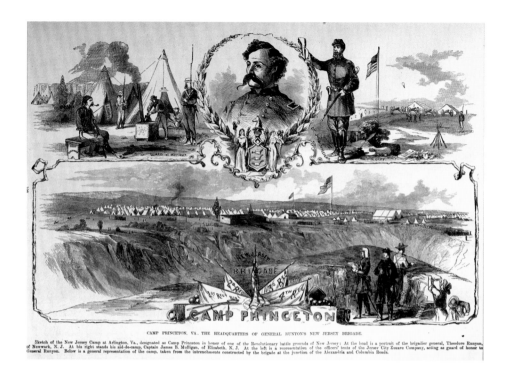

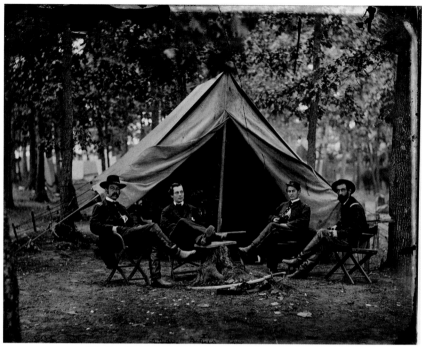

Camp Princeton, Va., The Headquarters of General Runyon's New Jersey Brigade. Above a sketch of the encampment in Arlington named for the site of one of George Washington's Revolutionary War victories, scenes depict the officers' tents of the Jersey City Zouave Company (left), serving as the guard of honor to Brigadier General Theodore Runyon of Newark (center), and the general's aide-de-camp, Captain James B. Mulligan of Elizabeth (right). Source: Colored engraving from *Frank Leslie's Illustrated History of the Civil War* (Washington, D.C., 1895), originally published July 18, 1861. Historical Views 1, US: Pre-Revolution to Civil War. Special Collections and University Archives, Rutgers University Libraries.

Secret Service officers at Army of the Potomac headquarters, Brandy Station, Virginia, February 1864. From left to right: Colonel George H. Sharpe, John C. Babcock, unidentified soldier, Lieutenant Colonel John McEntee. George Henry Sharpe (1828–1900) graduated from Rutgers College in 1847, worked briefly for U.S. legations in Vienna and Rome, and practiced law until the start of the Civil War. In 1861, he began as commander of Company B of the 20th New York State Militia, then was colonel of the 120th New York Volunteers. Responding to an order from General Joseph Hooker, Sharpe established the Bureau of Military Information to gather and coordinate army intelligence. After the war, he was sent to Europe as a special agent of the U.S. State Department to search for Americans who might have been involved in the assassination of President Lincoln. Source: Digital file from an original glass plate negative. Image LC-DIG-cwpb-03861, Library of Congress, Prints and Photographs Division, Washington, D.C.

fears of a prejudiced population, predicting that a victory for Lincoln and his Radical Republican allies would lead to racial mixing and an inundation of emancipated black slaves who would take white jobs. New Jersey did not have an absentee ballot, meaning that soldiers in the field (believed to favor Lincoln) were disenfranchised. Lincoln lost New Jersey's seven Electoral College votes, but won in the rest of the North, helped as the tide of the war turned in the

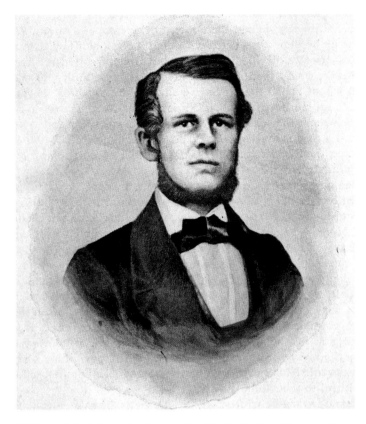

William Salt (1837–1890) was raised in Bath, New York, and was teaching school in Arkansas when the Civil War started. He was drafted into the Confederate army and served for three years. After the war, Salt returned north, converted to Catholicism, became a priest, and then taught at Seton Hall for many years. Source: Monsignor William Noé Field Archives & Special Collections Center, Seton Hall University, South Orange. Courtesy of the New Jersey Catholic Historical Commission.

A stone plaque in the Memorial Atrium in Nassau Hall lists the names of Princeton students who died in the Civil War without indicating their affiliation with the Union or Confederacy. The numbers here are approximately equal, but more served the South. Source: Historical Photograph Collection (AC111), Grounds and Buildings Series, Digital Additions. Princeton University Archives, Department of Rare Books and Special Collections, Princeton University Library.

Union's favor with the capture of Mobile and Atlanta and victories in the Shenandoah Valley.

Despite the political divisions, New Jerseyans volunteered in large numbers to fight for the Union, although enthusiasm waned as the war continued, and in the end a draft proved necessary. A total of 77,346 New Jersey men served the Union army and navy, most with the Army of the Potomac, and an estimated 6,300 died. An estimated 2,872 African Americans also served, of whom 469 died; because the state did not field black units, they joined those of Pennsylvania and other states (their numbers were credited to New Jersey). Some New Jerseyans fought for the Confederacy, the place of their birth or residence or because of family ties. The College of New Jersey (now Princeton University), which had from its founding attracted a substantial number of southern students, was unusual in providing a nearly equal number of recruits to both sides.

Those who fought wrote home about their experiences, including the tedium of marches, the horror of battle, and the loss of relatives, friends, and companions. A number achieved distinction signified by the Congressional Medal of Honor and other awards. The sacrifice of General Philip Kearny was remembered by a town named after him. The lucky survived injuries and disease, though they lived with physical and mental wounds.

Many soldiers captured in battle died in prisons. Fort Delaware, located on Pea Patch Island in the Delaware River, housed an estimated 33,000 Confederate prisoners of war, of whom 2,700 (7.6 percent)

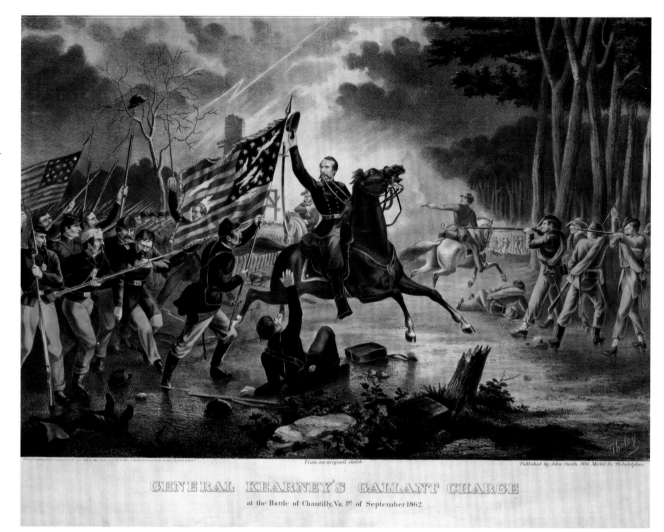

General Kearny's Gallant Charge at the Battle of Chantilly, Va. 1st of September 1862. Philip Kearny (1815–1862) lost an arm in battle during the Mexican-American War but went on to fight as a cavalry officer in the Civil War. He is shown here in the action that cost him his life. Source: Color lithograph by Augustus Tholey (d. 1898), 1867. Image LC-USZC4–12604, Library of Congress, Prints and Photographs Division, Washington, D.C.

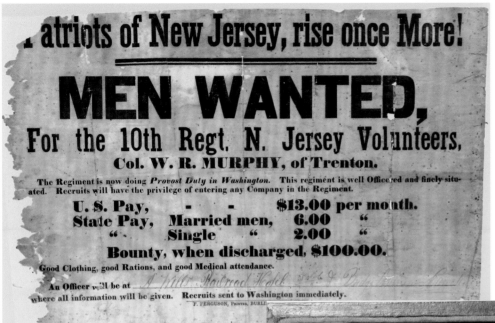

Patriots of New Jersey, rise once More!

MEN WANTED,

For the 10th Regt. N. Jersey Volunteers,

Col. W. R. MURPHY, of Trenton.

The Regiment is now doing *Provost Duty in Washington.* This regiment is well Officered and finely situated. Recruits will have the privilege of entering any Company in the Regiment.

U. S. Pay, - - $13.00 per month.
State Pay, Married men, 6.00 "
" Single " 2.00 "
Bounty, when discharged, $100.00.

Good Clothing, good Rations, and good Medical attendance.

An Officer will be at *A Mills Railroad Hotel*
where all information will be given. Recruits sent to Washington immediately.

F. FERGUSON, Printer, BURLI.

Recruiting poster for the 10th Regiment, New Jersey Volunteers. Organized in Beverly on October 1, 1861, the 10th did guard service around Washington, D.C., and in Pennsylvania, and later fought in the battles of the Virginia campaign. Source: Collection of C. Paul Loane.

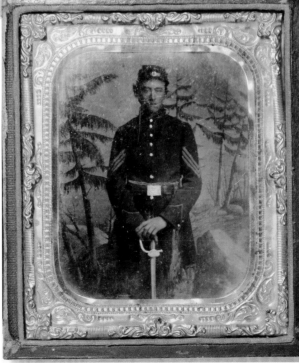

died, along with about 140 Union guards, most from disease. Many are buried in the national cemetery at Finn's Point in Salem County. The most notorious prison of the war was Andersonville, located in Georgia, where an estimated 13,000 out of 45,000 men died, including a number from New Jersey.

Like men, women in New Jersey had different views on the war. Some had connections to family fighting for the Confederacy: Varina Howell, a daughter of Federalist Governor Richard Howell, was Jefferson Davis's wife, and Mary Todd Lincoln, who vacationed at the Jersey Shore during the war, had relatives in the Confederate army. Despite the gender restrictions of the times, women participated in the war effort. Dorothea Dix served as superintendent of Union nurses; Cornelia Hancock and Clara Barton cared for the wounded in hospitals in New Jersey, Washington D.C., and on the front lines. Women also traveled to help injured and ill relatives, as did Arabella Wharton Griffith, married to twice-wounded Union general Francis Channing Barlow; she died of typhus while her husband was fighting in Virginia. Hospitals for the wounded were also established in the state, including one in Newark supported by Marcus L. Ward, the Republican who was elected governor at the end of the war. As mothers, sisters, and wives, women wrote to loved ones, mourned when they died, and helped where they could.

Sergeant Charles Sheppard, Company D, 10th New Jersey Volunteer Infantry. Source: Tinted tintype. Collection of C. Paul Loane.

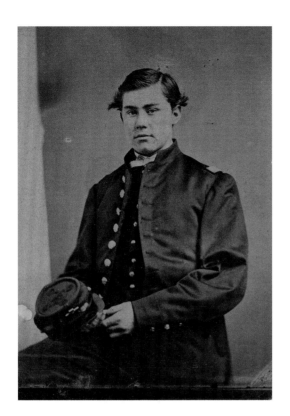

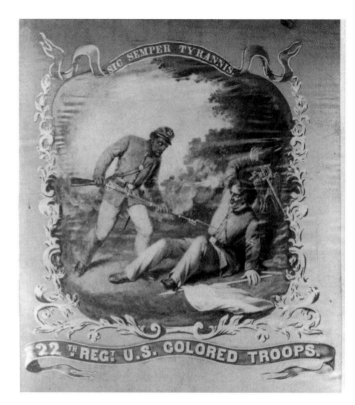

Ellis Hamilton (1845–1864) from Camden enlisted in 1862 and served with the 15th Regiment New Jersey Volunteers. Made a captain at age seventeen, he died in 1864 from wounds suffered at the Battle of the Wilderness. Source: Department of Defense, Adjutant General's Office (Civil War), Photographs of Soldiers (Cartes de Visite), item 153. New Jersey State Archives, Department of State.

Letter from M. R. Hamilton about his deceased son, Captain Ellis Hamilton, March 25, 1874, page 1. Addressed to Adjutant General William Stryker, the letter responded to a request for information for what became the *Record of Officers and Men of New Jersey in the Civil War 1861–1865* (1876). Source: Department of Defense, Adjutant General's Office (Civil War), Memorials of Officers, c. 1869–1907, item 71. New Jersey State Archives, Department of State.

Regimental flag of the 22nd U.S. Colored Infantry, c. 1860–1870. After the Emancipation Proclamation, the Union army actively recruited African Americans into colored units commanded by white officers. The 22nd was organized in Pennsylvania, but many of the men who served in it were from New Jersey. Source: Photograph of a painting by David Bustill Bowser (1820–1900); albumen print on carte de visite mount. Image LC-USZ62–23096, Library of Congress, Prints and Photographs Division, Washington, D.C.

The twists and turns of political and military affairs during the Civil War are reflected in the governors New Jersey elected during this period: in 1857, William A. Newall, who ran as an "Opposition" candidate; in 1860, Charles S. Olden, a conservative "Unionist" from a Quaker family; in 1863 (and again in 1872), Joel Parker, a Democrat. Despite their different party labels, none agreed with the Emancipation Proclamation, but neither did they approve of secession, and all supported the war effort. Parker, like most Democrats, was for "the Constitution as it is, the Union as it was," indicating the desire to preserve

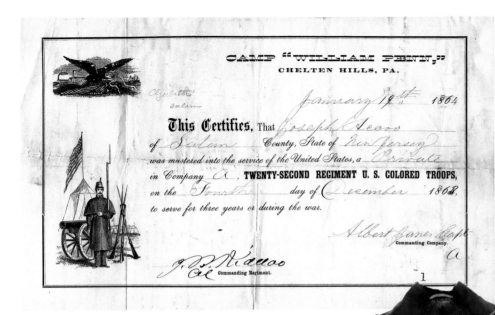

Muster certificate of Private Joseph Accoo, 22nd U.S. Colored Infantry, January 19, 1864. Source: Department of Defense, Adjutant General's Office (Civil War), United States Colored Troops, Service Files, c. 1862–1870. New Jersey State Archives, Department of State.

Uniform of 1st Lieutenant James S. Stratton, Company K, 12th Regiment New Jersey Volunteers. Stratton (1843–1864), from Mullica Hill, Gloucester County, was killed in action in Virginia. Source: Collection of C. Paul Loane.

the Union with slavery, if need be. But for Lincoln, an increasing number of northern Republicans, and Union soldiers, too much blood had been spilled to go back to the status quo. Rather, they expanded the purpose of the war to include emancipation. Republican Marcus L. Ward, elected governor in 1866, pushed the state to recognize this new reality by ratifying the Thirteenth Amendment, which abolished slavery, even though the amendment had already gone into effect. He argued that, to protect its honor, the state should give its "endorsement to the extinguishment forever of human slavery in our land." Only by keeping in mind the general conservatism of the state, the hesitancy of Republicans initially even to call themselves by that label, the close margin of votes between the parties, and the persistent racism does what followed during Reconstruction make sense.

Once the war was over, the nation had to decide how to return the former Confederate states to the Union and how to define the status of four million freed people. The process was complicated by the contests for power between President Andrew Johnson and the U.S. Congress, and between northern Radical Republicans and southern Democrats. Congress passed and sent to the states the Thirteenth Amendment abolishing slavery, the Fourteenth Amendment providing equal protection to all and including blacks as citizens, and the Fifteenth Amendment extending the vote to black males. The New Jersey legislature first rejected and then passed each one, as first one and then the other party held sway. After ratifying the Fourteenth

Amendment, the legislature voted to rescind its approval—and was told by Congress that it could not do so. Ironically, the first black man to cast a vote in the United States after the Fifteenth Amendment went into effect was Thomas Mundy Peterson, a respected resident of Perth Amboy. In 1875, the state got around to amending its 1844 constitution, finally removing the "white" requirement for voting.

At this point, persistent and vicious southern resistance had brought an end to Reconstruction. The finale came in the aftermath of a contested presidential election, a dispute over the votes from four states. When a special election commission ruled for Republican Rutherford B. Hayes, the tie-breaking vote came from Supreme Court Justice Joseph Bradley, a conservative Republican from New Jersey. Once Hayes took office, all military forces were withdrawn from the South; no longer would the Republicans force political and social change. Southern states then moved to disenfranchise and segregate blacks, replacing slavery with discriminatory Jim Crow laws. In New Jersey, African Americans could vote, but decent jobs were hard to come by. Genuine equality remains an issue today.

When the war was over, former soldiers from New Jersey joined the Grand Army of the Republic (GAR), maintaining ties with other veterans. Monuments to their wartime efforts were scattered across many battlefields, including eleven at Gettysburg alone, where more than 4,000 had served. Numerous towns in New Jersey created memorials

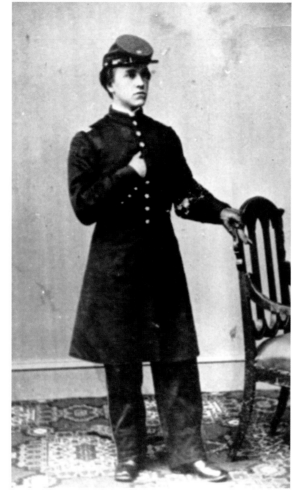

1st Lieutenant James S. Stratton, 12th Regiment New Jersey Volunteers. Source: Photograph by Mathew Brady. New Jersey Portraits Collection, Special Collections and University Archives, Rutgers University Libraries.

Hat worn by Captain Edward Stratton with the insignia of the Union army's Third Division, Second Corps. Source: Collection of C. Paul Loane.

Purse that stored the bullet extracted from the leg of Captain Edward Stratton, Union army, Third Division, Second Corps. Source: Collection of C. Paul Loane.

SLOAN, SPARKS & CO.,
No. 10 MARKET STREET, CAMDEN, N. J.
WILL FURNISH UPON THE SHORTEST NOTICE
SUBSTITUTES AND VOLUNTEERS,
FOR THE ARMY OR NAVY,
FOR ANY DISTRICT IN THE STATE,
On the most Favorable Terms.
APPLICATION CAN BE MADE EITHER IN PERSON OR BY LETTER.
CHEW, PR, CAMDEN.

as well; some mounted decommissioned artillery pieces while others erected statues of soldiers and Abraham Lincoln. These are local reminders of a war that affected every citizen, even though the military campaigns took place elsewhere.

BIBLIOGRAPHY

For a general overview of this period, see Larry Greene, "Civil War and Reconstruction: State and Nation Divided," in *New Jersey: A History of the Garden State*, ed. Maxine N. Lurie and Richard Veit (New Brunswick: Rutgers University Press, 2012). The most comprehensive look at politics is still William Gillette, *Jersey Blue: Civil War Politics in New Jersey, 1845–1865* (New Brunswick: Rutgers University Press, 1995); also useful is the revised edition of Michael Birkner, Donald Linky, and Peter Mickulas, eds., *The Governors of New Jersey* (New Brunswick: Rutgers University Press, 2014). There are a number of books on individual military units from New Jersey that fought in the Civil War and on specific battles (such as Gettysburg). For more general information, see

Advertisement for "Substitutes and Volunteers for the Army and Navy." Men called up by the draft could pay others to serve for them, a legal provision that clearly helped the wealthy more than the poor. Placed by a Camden company, this undated advertisement promised to find such substitutes. Source: Peter Voorhees Papers (Ac. 1065), box 4. Special Collections and University Archives, Rutgers University Libraries.

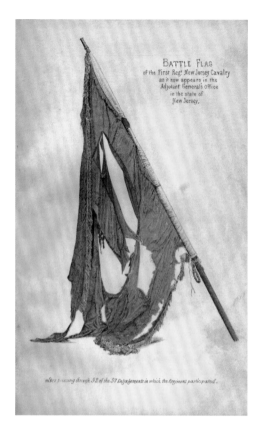

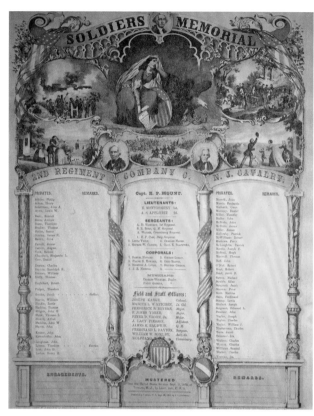

"Battle Flag of the First Regt. New Jersey Cavalry as it now appears in the Adjutant General's Office.…" Source: Colored frontispiece from Henry R. Pyne, *The History of the First New Jersey Cavalry, (Sixteenth Regiment, New Jersey Volunteers)* (Trenton: J. A. Beecher, 1871). Special Collections and University Archives, Rutgers University Libraries (SNCLX E521.6 1st).

List of officers and privates of the 2nd Regiment, Company C, New Jersey Cavalry (Trenton: J. L. Anderson, September 28, 1863). Source: Lithograph by A. Hoen and Co., Baltimore. New Jersey Broadsides (Oversized) Collection, Special Collections and University Archives, Rutgers University Libraries.

The Union Monument at Finn's Point National Cemetery, Pennsville, was dedicated in 1879 in memory of the 135 Union guards who died at the Fort Delaware prison for Confederate soldiers. Disease was a problem for both guards and prisoners. Source: Department of Environmental Protection, Division of Parks & Forestry, Photographs Filed by Subject, c. 1930s–1970s, item FinnsPoint002. New Jersey State Archives, Department of State.

The Confederate Monument at Finn's Point National Cemetery was erected by the U.S. government in 1910 to memorialize the 2,436 Confederate prisoners of war who died at Fort Delaware and were buried on the eastern shore of the river. Source: Department of Environmental Protection, Division of Parks & Forestry, Photographs Filed by Subject, c. 1930s–1970s, item FinnsPoint001. New Jersey State Archives, Department of State.

William J. Jackson, *New Jerseyans in the Civil War: For Union and Liberty* (New Brunswick: Rutgers University Press, 2000), and several books by Joseph G. Bilby, including: *"Remember You Are Jerseymen": A Military History of New Jersey's Troops in the Civil War* (Hightstown, N.J.: Longstreet House, 1998), *New Jersey Goes to War: Biographies of 150 New Jerseyans* (Hightstown, N.J.: Longstreet House, 2010), and *Forgotten Warriors: New Jersey's African American Soldiers in the Civil War* (Hightstown, N.J.: Longstreet House, 1993).

National Color with Battle Honors, 3rd Regiment New Jersey Volunteer Infantry (c. 1861). Source: Horstmann Brothers, silk, 74 ½ x 71 in. Collection of the New Jersey State Museum. Museum Purchase, State Flag 20. Reproduced with permission.

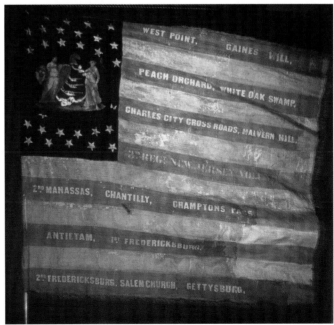

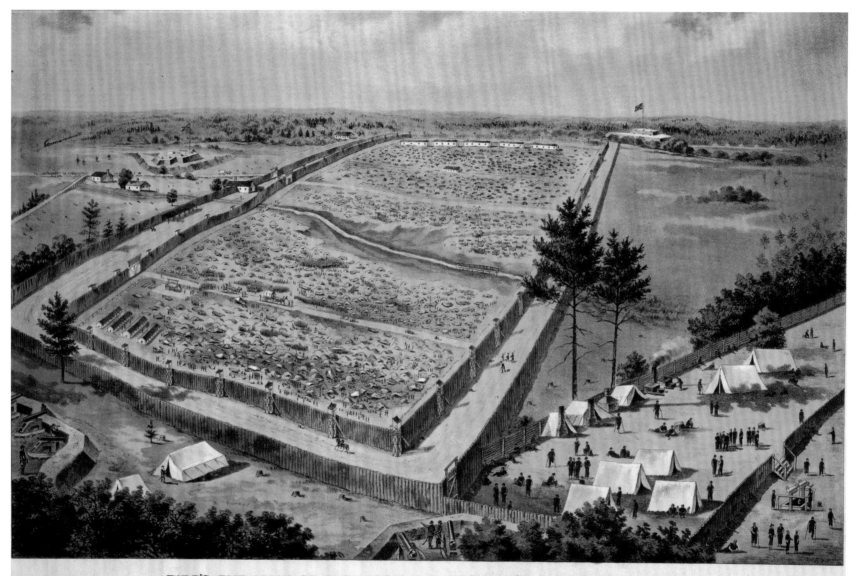

BIRD'S-EYE VIEW OF ANDERSONVILLE PRISON FROM THE SOUTH-EAST.

Bird's-Eye View of Andersonville Prison from the South-East, ca. 1890. This Confederate prison in Georgia held approximately 45,000 Union prisoners of war, of whom more than 13,000 died from malnutrition and diseases caused by unsanitary conditions. Source: Lithograph. Image LC-USZ4–10808, Library of Congress, Prints and Photographs Division, Washington, D.C.

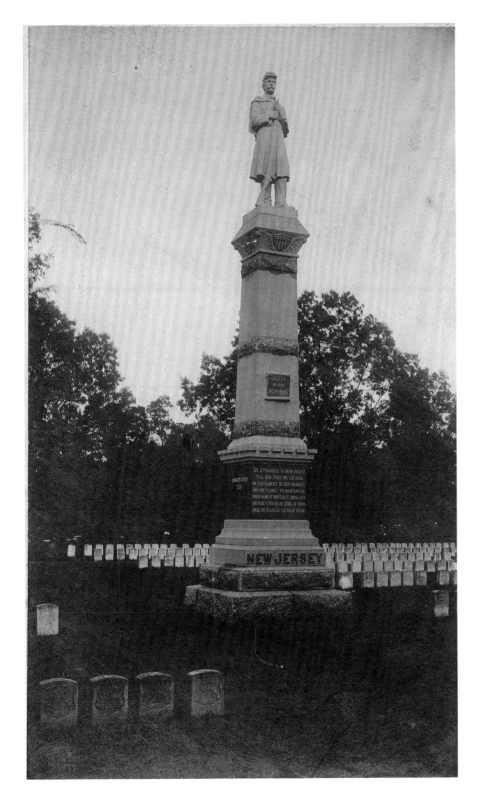

The War Spirit at Home, 1866. Children celebrate the Union victory at Vicksburg in 1863. Source: Oil on canvas, 30 x 32.75 in., by Lilly Martin Spencer (1822–1902). Source: Purchase 1944, Wallace M. Scudder Bequest Fund 44.177. The Newark Museum.

Memorial to the Union soldiers from New Jersey who died at the infamous Andersonville prison during the Civil War. Source: Department of Defense, Adjutant General's Office, Photographs of Monuments, 1888–1908, item 13. New Jersey State Archives, Department of State.

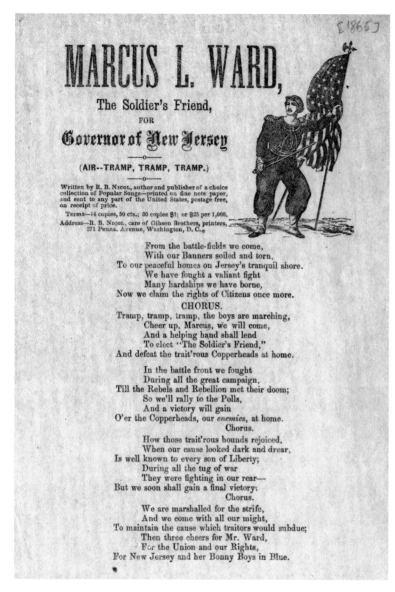

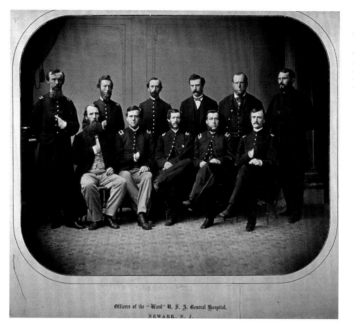

Staff physicians at the Ward General Hospital in Newark. Source: Item B029584, National Library of Medicine, Bethesda, Maryland.

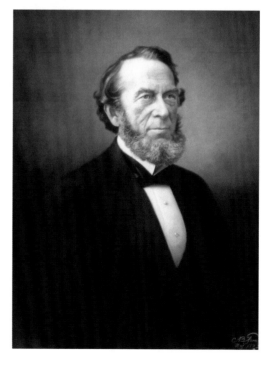

"Marcus L. Ward, The Soldier's Friend, for Governor of New Jersey," by R. B. Nicol (Washington, D.C.: Gilson Brothers, 1865). The song sheet was used to raise support for Ward in the gubernatorial election of 1865. Source: New Jersey Political Broadsides Collection, Special Collections and University Archives, Rutgers University Libraries.

Marcus Ward (1812–1884), a businessman, philanthropist, and antislavery Republican, began his single term as governor in 1866. He worked to support soldiers' financial and medical needs and to gain New Jersey's ratification of the Thirteenth and Fourteenth Amendments. Source: Oil on canvas, 35 ¼ x 28 ⅝ in., by C. B. Templeman, 1892. New Jersey State House Portrait Collection, administered by the New Jersey State Museum (SHPC46). Reproduced with permission.

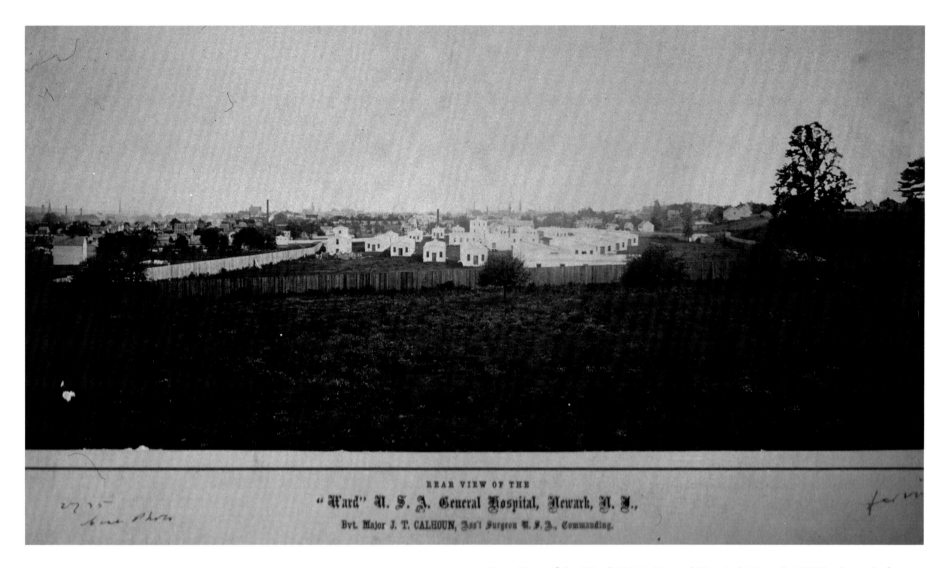

REAR VIEW OF THE

"Ward" U. S. A. General Hospital, Newark, N. J.,

Bvt. Major J. T. CALHOUN, Ass't Surgeon U. S. A., Commanding.

"Rear View of the 'Ward' U.S.A. General Hospital, Newark, N.J." By the end of the Civil War, 192 military hospitals had been built on the home front to care for wounded and ill soldiers. Among the three in New Jersey, the one in Newark, founded in 1862 by businessman Marcus L. Ward, had treated 80,000 military patients by the time it was decommissioned in 1865. Source: Item A02315, National Library of Medicine, Bethesda, Maryland.

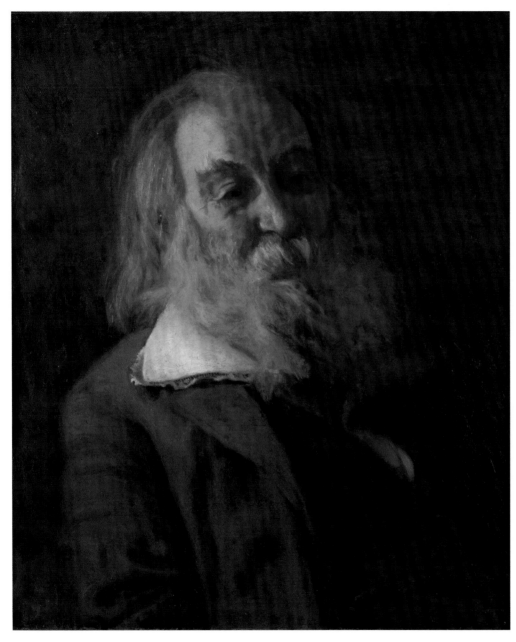

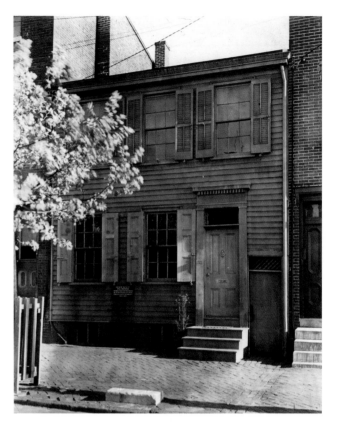

Walt Whitman House (1848), Camden, c. 1930s. Whitman (1819–1892) became acquainted with military hospitals during the Civil War while looking for his wounded brother. He spent the next three years visiting hospital wards around Washington, D.C., doing what he could for patients. The celebrated poet moved to Camden in 1884 and lived at 330 Mickle Street until his death in 1892. Today the house is a state historic site. Source: Photograph by Charles W. Benson. Works Progress Administration, New Jersey Writers' Project Photograph Collection, c. 1935–1942, item 757A. New Jersey State Archives, Department of State.

Walt Whitman, 1887–1888. Source: Oil on canvas, 30 1/8 x 24 ¼ in., by Thomas Eakins (1844–1916). Acc. No. 1917.1, General Fund. Pennsylvania Academy of the Fine Arts, Philadelphia.

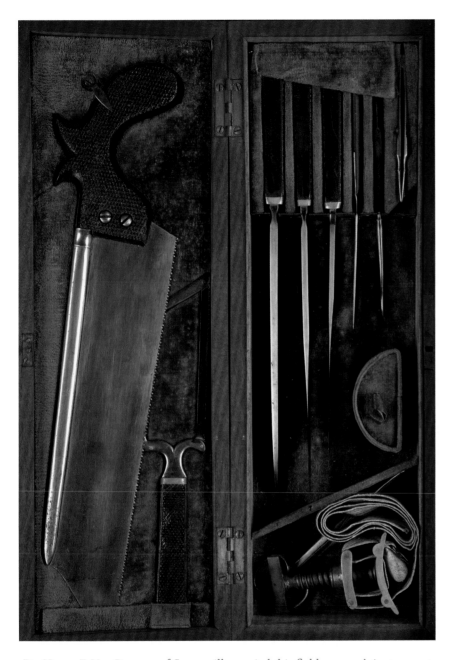

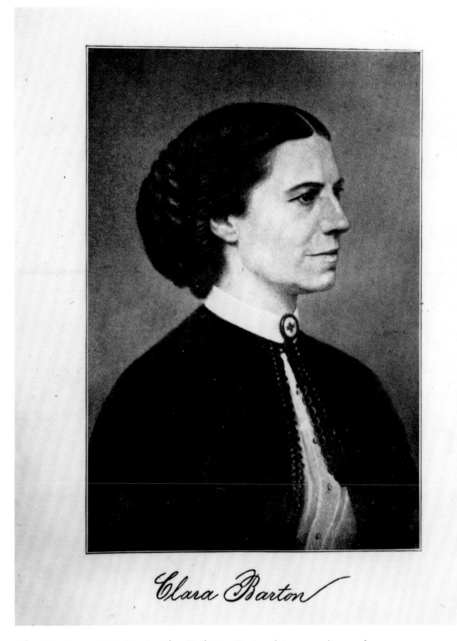

Dr. Henry F. Van Derveer of Somerville carried this field surgeon's instrument kit while serving with the Fifth New Jersey Volunteers. He used it at the Battle of Gettysburg. Source: Museum Objects Collection, Lot 1. Special Collections and University Archives, Rutgers University Libraries.

Clara Barton, c. 1865. During the Civil War, Barton (1821–1912) served as a nurse, at times in battlefield hospitals. After the war, she went on to found the American Red Cross and led humanitarian missions abroad. Source: Department of Environmental Protection, Division of Parks & Forestry, Photographs Filed by Subject, c. 1930s–1970s, item ClaraBarton003. New Jersey State Archives, Department of State.

The *Aereon* over the Raritan River, 1863. This early airship was invented by Solomon Andrews (1806–1872) of Perth Amboy and flew in the 1860s to much acclaim because, unlike other balloons of that period, it could be steered. Apparently, Andrews flew it from Perth Amboy to Manhattan, but he was unable to get a military contract in time for its use in the Civil War. Source: Courtesy of John Kerry Dyke.

The *Intelligent Whale*, an experimental, hand-cranked submarine designed by Scovel S. Merriman in 1863 for use in the Civil War, later inspired submarine pioneer John Holland. Pictured in a playground at the Brooklyn Naval Yard, today it is on display at the National Guard Militia Museum of New Jersey in Sea Girt. Source: U.S. Navy.

Gettysburg memorial honoring the 13th New Jersey Volunteers, 3rd Brigade, 1st Division, c. June 1888. This is one of twelve monuments erected on the battlefield to commemorate the New Jersey soldiers who fought there. Source: Department of Defense, Adjutant General's Office, Records Relating to the New Jersey Monuments at Gettysburg Battlefield, c. 1885–1888. New Jersey State Archives, Department of State.

Meeting of the Grand Army of the Republic (GAR), veterans of the Seventh Regiment, June 16, 1870, Long Branch. Union soldiers who had served in the Civil War held reunions for many years afterward. Source: Photograph by C. D. Frederick and Company. New Jersey Group Portraits, Oversized, Monmouth County, Long Branch. Special Collections and University Archives, Rutgers University Libraries.

Civil War military record of Israel Ward, prepared by Conrad Ward and published for the Army and Navy Record Co., 1883, by Pettibone Brothers Manufacturing Company. A note on the bottom states that it was "Presented by Conrad Ward to his wife Catherine, son John H., and three grandchildren" and dedicated to the memory of another son who died in May 1911. Source: Israel Ward Papers (Ac. 2035), Special Collections and University Archives, Rutgers University Libraries.

Joint resolution of the New Jersey legislature ratifying the Fifteenth Amendment to the U.S. Constitution, February 1871. The amendment stated that the right of a citizen to vote could not be denied because of "race, color, or previous condition of servitude," making it possible for black males to vote. It was ratified by the necessary three-fourths of the states on February 3, 1870, and therefore in effect when the legislature gave its approval. Source: Department of State, Secretary of State's Office, Enrolled Laws, 1710–2012, box 235. New Jersey State Archives, Department of State.

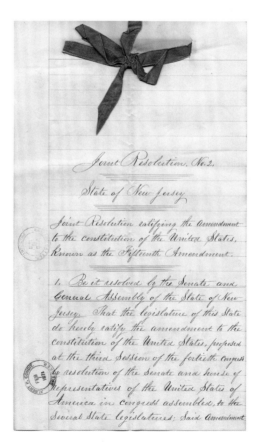

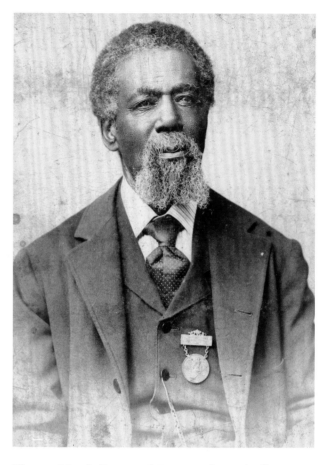

Thomas Mundy Peterson (1824–1904) was the first African American to vote in the United States under the authority of the Fifteenth Amendment. He voted one day after certification of the amendment, on March 31, 1870, in a special election in Perth Amboy, where he lived. In this undated photograph, he wears a medal commissioned by citizens of Perth Amboy in 1884 to commemorate the occasion. Source: Perth Amboy Free Public Library.

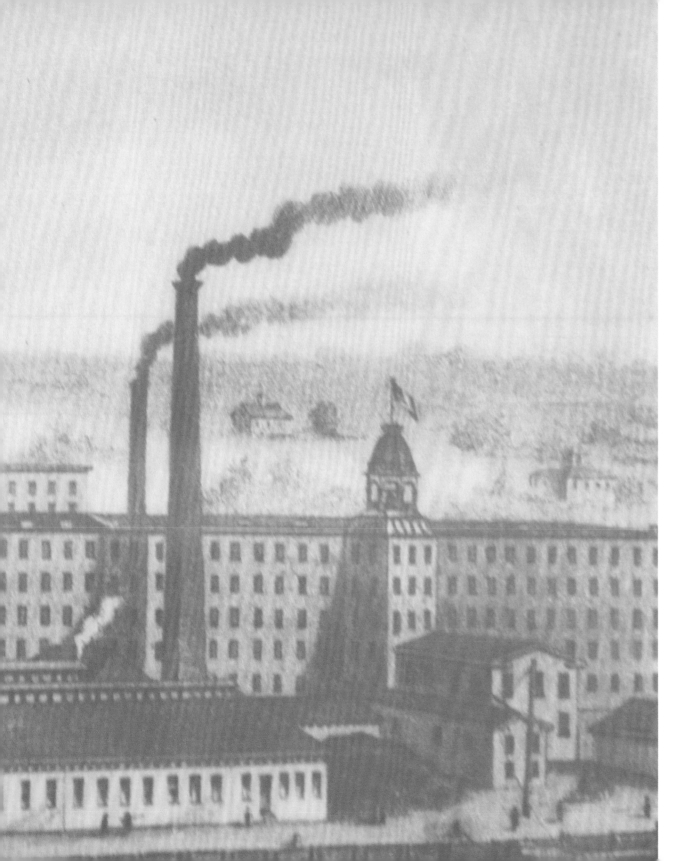

Industrialization, Immigration, and Urbanization
The Post–Civil War Years

The Civil War, which some believed would lead to the collapse of New Jersey's industries, had the opposite effect. Cities, particularly Newark, Jersey City, Paterson, Passaic, and Camden, grew in importance, and manufactories, especially those producing war materials, thrived. Highly significant were the iron industry and the manufacture of locomotives, textiles, ceramics, and leather goods. In the postwar period, the state's industrial might continued to grow. Straddling the main transportation corridor from New England to the South, New Jersey was a nexus of commerce. Railroad networks expanded and proved to be a

catalyst for the growth of industries and suburbs. At the same time, new immigrants enriched and transformed the state's culture, revitalized its cities, and provided the workforce for burgeoning industries. Inventors and industrialists, including most famously Thomas Edison, found New Jersey, with its proximity to major cities, a skilled workforce, and outstanding transportation networks, to be an excellent location for factories and laboratories. The railroads also facilitated the growth of seaside resorts, which provided the growing middle class with an escape from the workaday world of city life.

The Republican Party, which had been divided during the war, carried the governorship and both houses of the legislature in the elections of 1865. Marcus Ward, who served as governor from 1866 to 1869, had earned an enviable reputation as a supporter of Union soldiers during the war, and their return to the voting ranks likely aided his cause. Ward may also have been helped by the Democratic legislature's rejection of the Thirteenth Amendment (abolition of slavery). The legislature went back and forth between Democrats and Republicans in the postwar years, while a small group of Democratic politicians, known as the Statehouse Ring, also dominated state politics during this period. Although some governors, such as Joel Parker (1872–1875), were excellent, others were lackluster, including General George B. McClellan, former commander of the Army of the Potomac, who served from 1878 to 1881. This period also saw the rise of political bosses; Leon Abbett, governor from 1884 to 1887 and

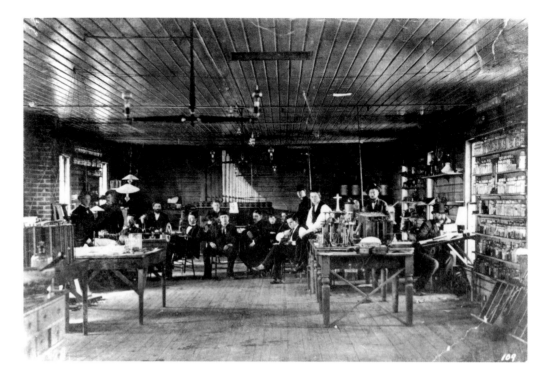

Thomas Edison (seated in the back at the organ) and his staff at Menlo Park, 1880. Edison (1847–1931) built several laboratories in New Jersey while working on his various inventions, running his "invention factory" in Menlo Park primarily from 1876 to 1881. In 1887, he opened a new and larger facility in West Orange. Source: Item 14.710.3, U.S. Department of the Interior, National Park Service, Thomas Edison National Historical Park.

Thomas Edison (1847–1931) built the original Black Maria movie production studio in West Orange in 1893. It had a removable roof and sat on a turntable, to take advantage of natural light during filming. The original was demolished in 1903; this full-scale reconstruction is from 1954. Source: Item 12.440.409, U.S. Department of the Interior, National Park Service, Thomas Edison National Historical Park.

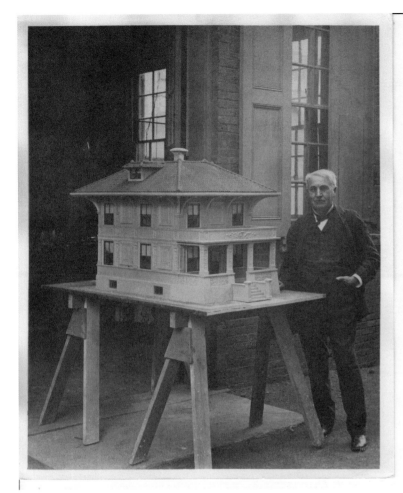

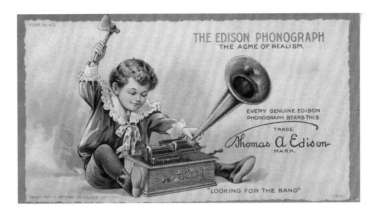

One of Thomas Edison's major inventions was the phonograph, and he also produced records that could be played on his machines. He was hard of hearing and not a good judge of popular taste in music, which meant that competing companies were ultimately more successful. Source: Trade card, img091(2), U.S. Department of the Interior, National Park Service, Thomas Edison National Historical Park.

Colgate Palmolive building, 1954. The Colgate Company was an important presence in Jersey City from 1820 to 1985, and this building on the waterfront with its clock was a landmark. Source: Jersey City Free Public Library.

Thomas Edison (1847–1931) and a model of his concrete house. Edison used equipment he developed for iron mining to produce cement in northwestern New Jersey. He then designed a system for building cement houses; a few were built in New Jersey, but they never became as popular as he hoped. Source: Item 14.610.13, U.S. Department of the Interior, National Park Service, Thomas Edison National Historical Park.

1890 to 1893, was especially influential. Many politicians during this period were in essence the representatives of business interests, particularly the railroads.

Since the 1830s, the Joint Companies had dominated state politics and held a legal monopoly on railroad and canal travel across one of the most important transportation corridors in the nation. With its charter set to expire in 1869, and dogged by a poor reputation and increased competition, the company attempted to maintain its dominance by creating the United New Jersey Railroad and Canal Company, an alliance of the Camden and Amboy Railroad, the Delaware and Raritan Canal, and the New Jersey Railroad and Transportation Company. In 1871, the Pennsylvania Railroad acquired a long-term lease on the properties of the United Company, and

BIRD'S EYE VIEW OF THE GREAT SINGER FACTORY.

Bird's Eye View of the Great Singer Factory, Elizabethport, c. 1880. Isaac Singer (1811–1875) developed his first sewing machine in 1851 and used mass-production techniques to make his machines affordable to middle-class families. His large factory, started in 1873, employed 6,000 workers and produced thousands of machines annually. It closed in 1982. Source: Engraving from John Scott, *Genius Rewarded; or, The Story of the Sewing Machine* (New York: John Caulon, 1880), 13. Special Collections and University Archives, Rutgers University Libraries (SNCLY TJ 1507.G33).

the monopoly ended. The 1870s and 1880s saw significant increases in trackage across the state, facilitating the transportation of both freight and passengers. Indeed, by the 1880s, railroads had connected most New Jersey towns and transformed formerly rural areas into hives of industry. Jersey City in Hudson County was particularly important as the terminus of seven main-line railroads. From there, passengers and freight were ferried across the Hudson to New York.

Following the railroads, early suburbs sprang up in northern New Jersey and close to Philadelphia. Captains of industry built lavish estates in Morris

Trade card for the Singer Sewing Machine, 1893 (front). Isaac Singer (1811–1875) specifically marketed to housewives. Source: New Jersey Trade Cards Collection, Special Collections and University Archives, Rutgers University Libraries.

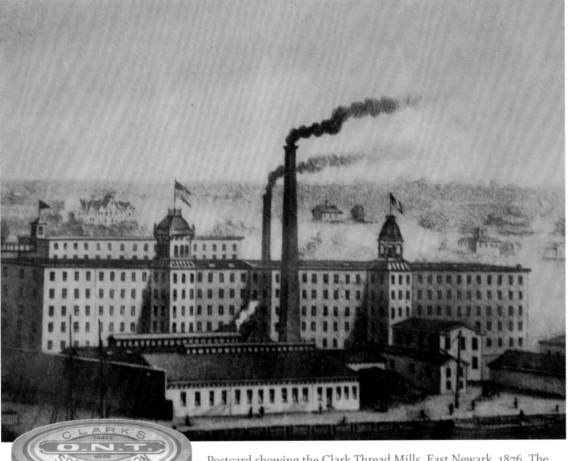

Postcard showing the Clark Thread Mills, East Newark, 1876. The company produced thread on spools, which could be used on sewing machines. Source: The Newark Public Library.

Clark's O.N.T. [Our New Thread] Spool Cotton trade card, c. 1890s (front). The card is shaped like a spool and shows a mother holding up her child with a thread, illustrating its strength. Source: New Jersey Trade Cards Collection, Special Collections and University Archives, Rutgers University Libraries.

and Somerset Counties, while tourists flocked to new Shore resorts like Ocean Grove and Asbury Park. Industries also followed the railroads, freed from water-powered sites by the development of steam and then electric power. Northern New Jersey's ironworks thrived in the postwar period. Newark and surrounding communities were home to hundreds of manufacturers, including the Clark Thread Company, numerous breweries, and a flourishing jewelry industry. In nearby Elizabeth, Isaac Singer constructed a gargantuan sewing machine factory, and Jersey City's extensive stockyards provided fresh meat for the New York City market. Paterson, long a center of industry as a leading supplier of textiles, particularly silk, was also a major producer of railroad locomotives. Rubber manufacture was important locally, with factories in New Brunswick, Milltown, and elsewhere. Trenton was home to John August Roebling's wire rope factory, which produced the cables for the Brooklyn Bridge. The Roebling business continued to grow in the late nineteenth century, and in 1905, the company built its own factory town on the Delaware River.

Small-scale stoneware and earthenware potteries had been scattered across New Jersey since the colonial period; after the Civil War, the state's growing ceramics industry soon vied with East Liverpool, Ohio, to be the national leader. Trenton grew into a major ceramics manufacturing hub. The city's potteries produced everything from toilets to art pieces, though it was especially well known for its production of tableware. Two of the best-known manufacturers were

Thomas Maddock and Walter Scott Lenox. Initially, Lenox had to contend with the perception that his wares were not up to the standards of European manufacturers. His hard work and perseverance proved the detractors wrong. Indeed, Lenox's fine wares would ultimately grace tables in the White House.

Though more mundane, brick manufacturing was also a major local industry. Rich clay banks in the Hackensack and Raritan Valleys had been worked since colonial times. Soon brick manufacturers in Sayreville, Woodbridge, and South Amboy were supplying construction materials to architects, builders, and masons up and down the East Coast. Sayreville owed its existence to the brick-making industry. There, the company founded by James R. Sayre and Peter Fisher produced millions of bricks each year. Nearby, Perth Amboy became the center of the American terra cotta industry, producing colorful glazed and sculpted ceramic blocks used to clad the steel frame construction of the first modern skyscrapers.

Although manufacturing was concentrated in the northern portion of the state, South Jersey also experienced industrial development. The larger and more efficient coal-fired ironworks in the Midwest put an end to the Pine Barrens blast furnaces dependent on bog iron and charcoal. However, factories producing bottle glass and window glass thrived in Bridgeton, Salem, Glassboro, and Vineland. Burlington City on the Delaware River became an important center of shoe manufacture and was home as well to the John H. Birch Company, a major carriage producer that also

NATIONAL FIRST AID WEEK
May 17 thru May 26

Johnson & Johnson Company trade card, c. 1920 (front). Johnson & Johnson was founded in 1886 in New Brunswick and produced sterile sutures and other medical products. Band-Aid adhesive bandages were marketed beginning in 1920. Source: New Jersey Trade Cards Collection, New Brunswick. Special Collections and University Archives, Rutgers University Libraries.

John A. Roebling (1806–1869), a German-born engineer, founded the Roebling Company, which produced the wire rope used in suspension bridges. He designed and supervised a number of bridges and died as a result of an accident while working on the Brooklyn Bridge. Source: Engraving from a photograph, c. 1865. Roebling Family Papers (MC 654), photo box 1.b, folder 2, image no. 3.b. Special Collections and University Archives, Rutgers University Libraries.

Works of John A. Roebling's Sons Company, Trenton, New Jersey, 1898. Roebling's sons continued his work and produced wire rope in Trenton and the company town of Roebling to its south. Source: Ink and wash with white gouache on paper mounted on board, 18 13/16 x 42 ¾ in., by H. B. Longacre. Collection of the New Jersey State Museum. Museum Purchase, FA1983.27.1. Reproduced with permission.

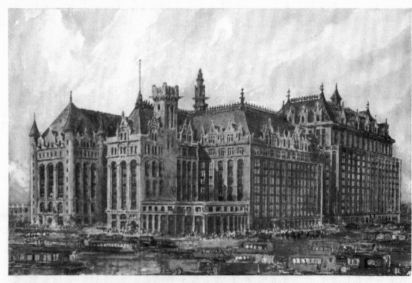

AT HOME IN THE HEART OF NEWARK

 THE PRUDENTIAL
INSURANCE COMPANY OF AMERICA
EDWARD D. DUFFIELD, President

John Fairfield Dryden (1839–1911) founded the forerunner of the Prudential Insurance Company in Newark in 1875 and initially sold inexpensive life insurance policies to working-class families. Business expanded rapidly, as can be seen by this representation of its enormous and ornate late nineteenth-century headquarters. The image of the Rock of Gibraltar was used in advertisements to represent the company's reliability and stability. Source: Prudential Buildings Comm., 1890–1939 folder. The Newark Public Library.

made rickshaws for the Asian market. In Camden, Joseph Campbell and Abraham Anderson opened their cannery in 1869; the Campbell Soup Company would long be one of the economic mainstays of the area.

A visitor today traversing the New Jersey Turnpike in the vicinity of Linden might be surprised to learn that the state has no naturally occurring fossil fuels. Nevertheless, it has a long history of refining. Bayonne was one of the first centers of refining in the United States; both John D. Rockefeller's Standard Oil Company and Tidewater Refinery established refineries in there.

As early as the eighteenth century, New Jersey had been a center of industrial innovation. John Fitch experimented with steam-powered watercraft, and in the early nineteenth century John Stevens invested in steamboats and built his own small model railroad in Hoboken as a way of interesting investors

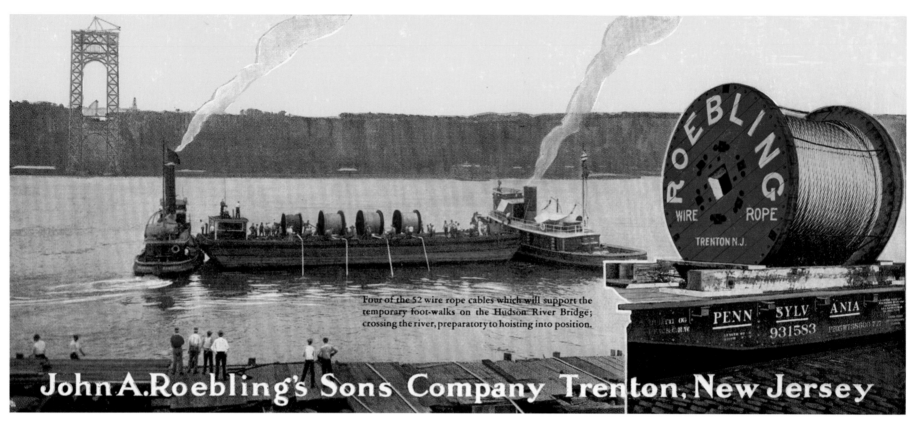

Four of the 52 wire rope cables which will support the temporary foot-walks on the Hudson River Bridge; crossing the river, preparatory to hoisting into position.

John A. Roebling's Sons Company Trenton, New Jersey

Colored advertisement showing spools of Roebling wire rope being ferried to a tower of the Hudson River (George Washington) Bridge, 1930. Source: Courtesy of Clifford Zink.

in the possibilities of steam-powered transportation. Somewhat later, Seth Boyden, sometimes dubbed the "Uncommercial Inventor," settled in Newark, where he invented processes for making patent leather and malleable cast iron, made improvements to steam engines, and experimented with photography. Alfred Vail, working with Samuel F. B. Morse, invented the telegraph at Speedwell Village near Morristown, revolutionizing communication. These early experimenters foreshadowed New Jersey's most famous inventor, Thomas Edison, and his contemporary and competitor George Westinghouse. The combination of excellent transportation networks, a highly skilled population, and proximity to investor capital in New York City and Philadelphia made late nineteenth-century New Jersey a fruitful location for inventors.

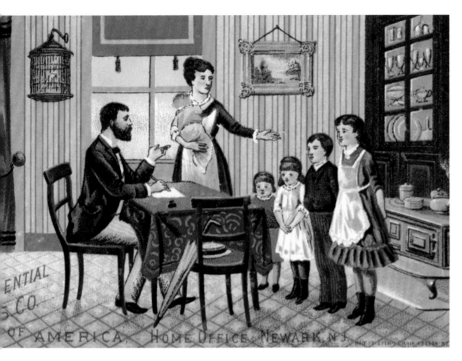

Prudential Insurance Company trade card, date unknown (front). An agent explains insurance benefits to a widow and her young family. Source: New Jersey Trade Cards Collection, Special Collections and University Archives, Rutgers University Libraries.

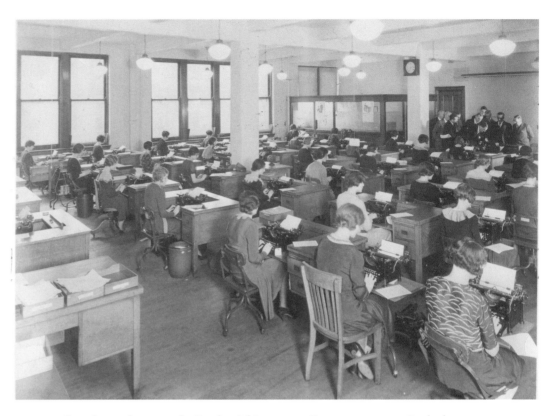

Female employees at the Prudential Insurance Company, c. 1900. In the late nineteenth and early twentieth century, clerical jobs opened new opportunities for women. Source: Newark Buildings Comm., Prudential Interiors folder. The Newark Public Library.

Today, Edison is best known for inventing the practical incandescent light bulb and the motion picture. However, he is equally important for pioneering the concept of the research laboratory. Edison's first inventions were improvements to the telegraph system. His income from these patents allowed him to expand his laboratory in Newark and to hire assistants such as Charles Batchelor. In 1875, Edison left Newark for Menlo Park, a failed real estate development located on the main line of the Pennsylvania Railroad. Its distance from major centers of population offered some protection from industrial espionage, while the railroad provided easy access to urban centers. At Menlo Park, Edison created a research and development laboratory, bankrolled by Western Union and other investors. The concept was a success: Edison and his team registered more than three hundred patents, earning him the moniker "The Wizard of Menlo Park." Edison outgrew his Menlo Park quarters and in 1887 relocated to West Orange, where he built an extensive industrial and research complex. There he worked on the Edison battery, improvements to the phonograph, large-scale cement production, and motion pictures.

New Jersey was also home to other inventors. Edward Weston focused on electricity, particularly electroplating, as well as generators, fuses, and devices

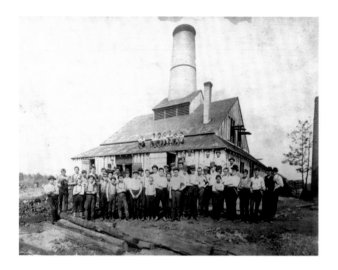

Among the workers at the Wheaton glassworks, c. 1888, were a number of children. Source: Museum of American Glass, Wheaton Arts and Cultural Center, Millville.

to measure current. John Wesley Hyatt of Newark pioneered the use of celluloid as a substitute for ivory; he would later make improvements to water filtration systems, work on refining sugar cane, and develop roller bearings or ball bearings. His celluloid was also used for photographic film by the Reverend Hannibal Goodwin of Newark, facilitating popular photography.

Americans had been experimenting with submarines ever since David Bushnell of Connecticut built the *Turtle* to attack (unsuccessfully) British ships during the Revolution. Near the end of the Civil War, the *Intelligent Whale* was built in Newark. More famous and more successful were the submarines of John Holland, an Irish immigrant and Paterson schoolteacher, who built several in the late nineteenth

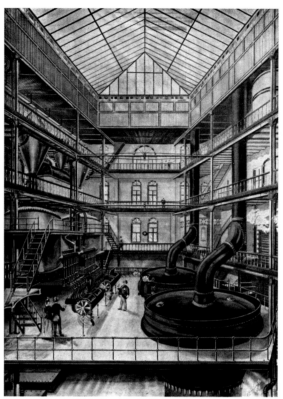

Interior of the Christian Feigenspan Brewery, Newark. Along with Ballantine in Newark and Kuser in Trenton, Feigenspan was a major producer of beer in this period. All three families were originally German. Source: Engraving from Peter J. Leary, *Newark, N.J., Illustrated: A Souvenir of the City and Its Numerous Industries* (Newark: Wm. A. Baker, 1893), 247. Special Collections and University Archives, Rutgers University Libraries (SNCLNJ F144.N6L4).

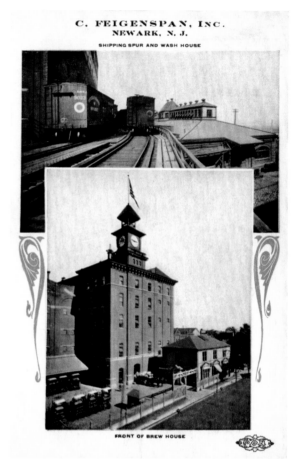

Postcard, c. 1909, showing the brew house, shipping spur, and wash house of the Christian Feigenspan Brewery, Newark. The brewery was established in 1875 by the German immigrant for whom it was named. Its logo, "P.O.N.," stood for Pride of Newark. The company was bought by Ballantine in 1943. Source: New Jersey Postcards Collection, Essex County, Newark. Special Collections and University Archives, Rutgers University Libraries.

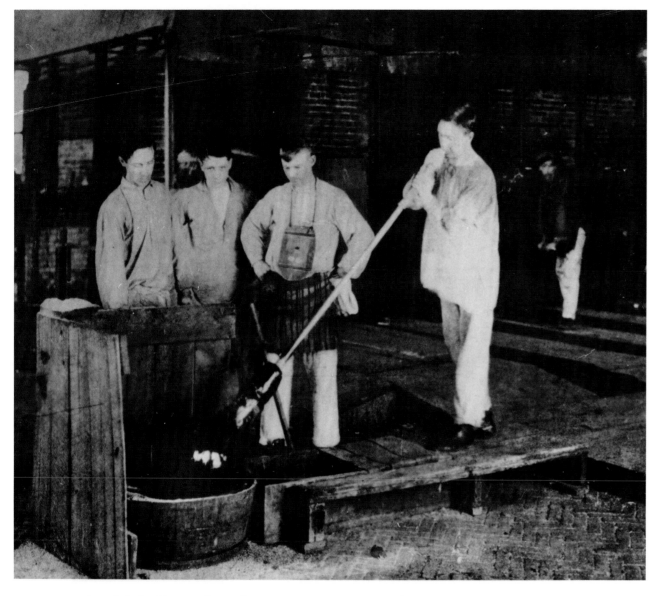

Unidentified glassblowers, date unknown. Source: Department of Environmental Protection, Division of Parks & Forestry, Photographs Filed by Subject, c. 1930s–1970s, item Glassworks004. New Jersey State Archives, Department of State.

century, including the *Fenian Ram*. Holland's initial financing was provided by the Fenian Brotherhood, which hoped to wage war on Great Britain. The submarines Holland built proved successful, and several were acquired by the U.S. government.

Two other iconic American companies were established during this period: Johnson & Johnson and Prudential Insurance Company. Johnson & Johnson, founded in 1886 in New Brunswick by the brothers Robert W., James W., and E. W. Johnson, made ready-to-use sterile bandages, a revolutionary idea that helped transform first aid. The company grew into one of the largest suppliers of health care products in the world. John Dryden's innovation was financial, not technological, but equally radical. Dryden pioneered the idea of selling life insurance policies to working-class customers. His company, the Prudential, grew to be a world leader in financial services. Dryden was also a major employer of women, many of whom held clerical posts.

The development of the state's railroad network, which led to industrial growth, also facilitated tourism and the expansion of summer resorts, especially at the Shore. Cape May and Long Branch had long dominated the summer trade, but railroads made possible the founding of the Methodist seaside resort of Ocean Grove, famous for its camp meeting, its Great Auditorium, and its religiously influenced municipal legislation. James Bradley established Asbury Park, just north of Ocean Grove, in an attempt to protect that godly community from the moral iniquities of

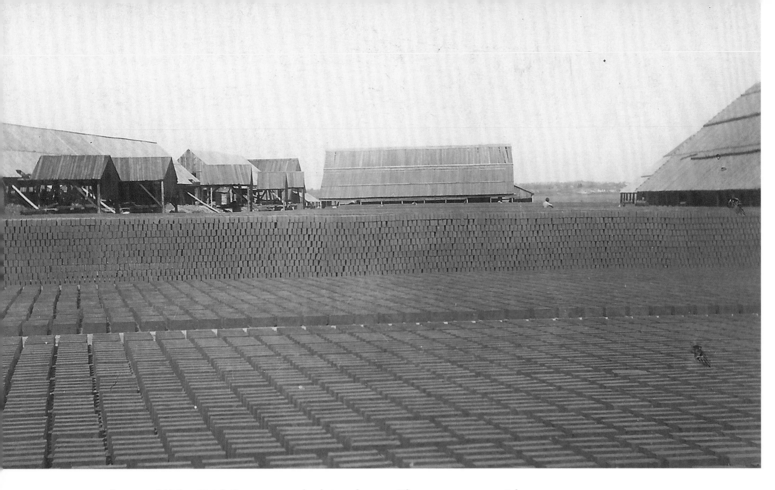

Sayre and Fisher Brick Company yards, date unknown. The company was established in 1850 in an area rich in clay deposits. At the height of production in 1912, the company made 62 million bricks. Sayre and Fisher survived until 1970. Source: Sayreville Historical Society.

Terra cotta Statue of Liberty with a flag on what was the Carpatho-Russian Benevolent Institution in Perth Amboy. New Jersey clay was used to produce more than plain building bricks, as this decorative sculpture illustrates. Photograph by R. Veit.

Long Branch, which offered gambling and horse racing along with sun and sand. Artists, thespians, and the well-heeled all flocked to the bluffs at Long Branch. In the late nineteenth and early twentieth centuries, the resort played host to seven presidents, a fact now commemorated in a Monmouth County park and in the Church of the Presidents, the former Saint James Chapel, where many of them worshiped. Perhaps the most famous visitor was President James A. Garfield, who in 1881 was brought to Long Branch in the hope that the healthful climate would help him recover from wounds inflicted during an assassination attempt in Washington, D.C. Sadly, the salubrious salt air was unable to undo the damage done by the assassin and the well-meaning but unhygienic physicians. Elsewhere on the Shore, Cape May remained an important destination in the post–Civil War era, and a massive new resort community, Atlantic City, serviced by the purpose-built Camden and Atlantic Railroad, grew at a breakneck pace, becoming famous for its boardwalk (the first in the nation), salt water taffy, and beautiful beaches.

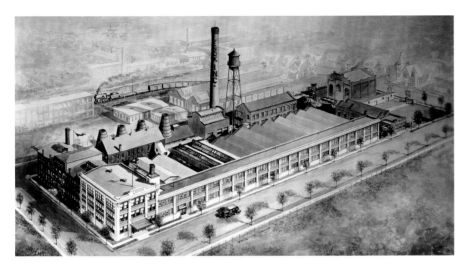

The mural commissioned by the federal Works Progress Administration for the Clarkson S. Fisher Federal Building and Courthouse in Trenton illustrates the pottery industry in the city and wire rope making at the Roebling mills. It was completed c. 1935 by artist Charles Wells. Source: "'New Deal' WPA Art." Photograph by Carol M. Highsmith (1946–), 2010. Image LC-DIG-Highsm-10898, Carol M. Highsmith Archive, Library of Congress, Prints and Photographs Division, Washington, D.C.

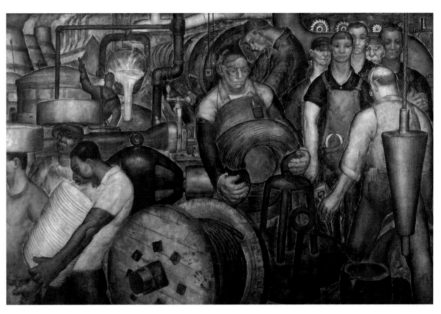

Trenton plant of the Lenox Company, c. 1920. Walter Scott Lenox (1859–1920) started the American Ceramic Company in Trenton in 1889 to make porcelain artware and then went on to produce dinnerware. The company has produced special sets for the White House, but its china is no longer made in New Jersey. Source: Rendering by E. Mott. Lenox, Incorporated, Records, 1889–2005 (MC 1390), box 371, folder 12. Special Collections and University Archives, Rutgers University Libraries.

The southern part of the state attracted Jewish and Italian immigrants. Vineland, established in 1861 by Charles Landis, was a planned community with a central business and industrial district. Landis envisioned the center of town being settled by New Englanders and surrounded by an outer ring of farms, which would be home to immigrants from southern Italy. New Jersey's Jewish immigrants included many from Germany and eastern Europe. The former were important in the economic development of the state and included prominent families like the Guggenheims and Bambergers. Louis Bamberger

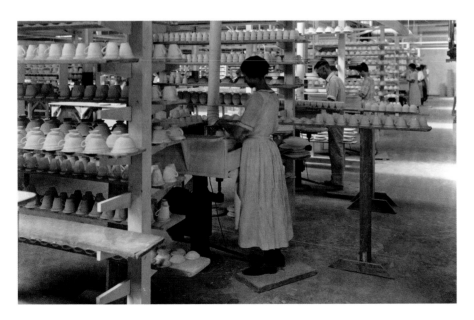

Mold line removal by a woman worker at the Lenox Company, c. 1922. Source: Lenox, Incorporated, Records, 1889–2005 (MC 1390), box 373, folder 52. Special Collections and University Archives, Rutgers University Libraries.

Joseph Campbell Preserve Company, Canners and Preservers, Camden, date unknown. Campbell Soup began in 1869 as the Campbell Preserve Company; after 1897, it developed the condensed soups (especially tomato) that became its best-known products. Originally, the company's main production facility was in Camden and used South Jersey farm products; that plant closed in March 1990 and was demolished the following year. Source: Department of Agriculture, Office of the Secretary, Photograph Collection, item 4480. New Jersey State Archives, Department of State.

founded one of the most successful department stores in the state, with headquarters in Newark and branches in Morristown, Plainfield, and Princeton. Russian Jewish immigrants, assisted by funding from Baron de Hirsch and the Hebrew Immigrant Society, established agricultural communities in southern New Jersey: Alliance, Norma, Brotmanville, Rosenhayn, and Carmel. One of the most famous was Woodbine in Cape May County, home to the Woodbine Agricultural School. The school graduated many individuals who went on to have impressive careers, including Jacob Lipman, dean of the Rutgers Agricultural School, and Dr. Jacob Pincus, developer of the birth control pill.

In summary, in the decades after the Civil War, New Jersey became an increasingly industrialized and urbanized state, dominated by Democratic governors until the mid-1890s. Although it was clearly a northern state, New Jersey remained a state divided, and one that had a less than enviable reputation in terms of its treatment of African Americans. At the same time, a large number of inventors called the state home. Growing industries provided ample

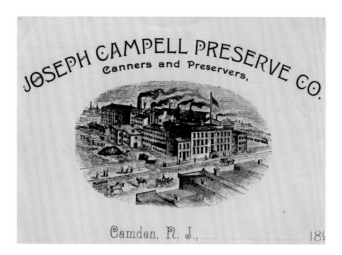

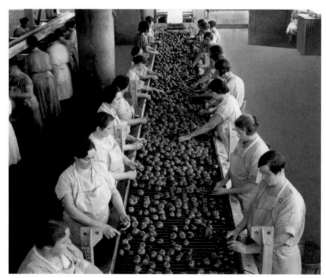

Final inspection of raw tomatoes at a cannery in Camden, c. 1930s–1940s. The tomatoes were delivered by area farmers. Source: Department of Agriculture, Office of the Secretary, Photograph Collection, item 7196. New Jersey State Archives, Department of State.

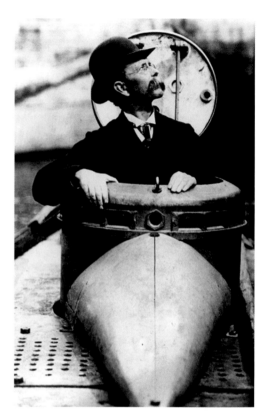

John Holland (1841–1914) standing in the hatch of a submarine in Perth Amboy, 1895. Born in Ireland, he moved to New Jersey, where he became a teacher in Paterson. He tested his first submarines there before winning a competition to design a submarine for the U.S. Navy. The early submarines are now in the Paterson Museum. Source: U.S. Navy.

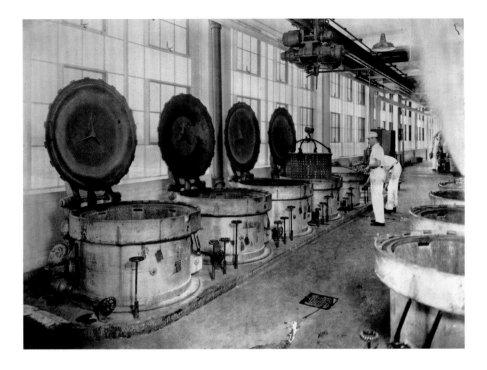

Pressure cookers inside the Campbell Soup factory, c. 1930s. Source: Department of Agriculture, Office of the Secretary, Photograph Collection, item 4494. New Jersey State Archives, Department of State.

employment opportunities, which were often filled by new immigrants from southern and eastern Europe, who began to arrive in the state in ever larger numbers. Italians worked on estates in Morris County, and many settled in cities like Elizabeth, Newark, and Trenton. Hungarians and Poles came to work in the silk industry and in the ironworks. A small cadre of Danes came to dominate the terra cotta industry. All the while, political bosses expanded their power. An improving transportation network enabled the growth of suburbs and Shore resorts. New Jersey's industrial skeleton developed in the decades after the Civil War and provided a framework for later growth.

BIBLIOGRAPHY

The growth of industrial New Jersey is examined in Paul Israel, "The Garden State Becomes an Industrial Power: New Jersey in the Late Nineteenth Century," in *New Jersey: A History of the Garden State*, ed.

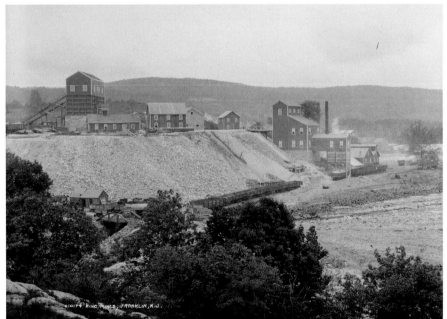

Zinc mines and slag pile, Franklin, c. 1890–1901. Zinc mining started along the Wallkill River in the mid-nineteenth century. In 1897, area companies consolidated into the New Jersey Zinc Company, the largest producer in the United States until the 1960s. Source: Image LC-D4–10174, Library of Congress, Prints and Photographs Division, Washington, D.C.

Japanese students at Rutgers, date unknown. Dutch Reformed missionaries in Fukui, Japan, encouraged students there to attend Rutgers Elementary School and Rutgers College. The first Japanese student arrived at the college in 1867, but died of tuberculosis shortly before the 1870 graduation ceremony. Others who followed were more fortunate. Source: William Elliot Griffis Collection, Special Collections and University Archives, Rutgers University Libraries.

Maxine N. Lurie and Richard Veit (New Brunswick: Rutgers University Press, 2012). Thomas Edison's career has had many chroniclers. Two important studies are Paul Israel, *Edison, a Life of Invention* (New York: John Wiley, 1998), and Leonard De Graaf, *Edison and the Rise of Innovation* (New York: Sterling Signature, 2013). An excellent discussion of the Roeblings is provided by Clifford Zink in *The Roebling Legacy* (Princeton: Princeton Landmark Publications, 2011). Jason Slesinksi's *A Cultural History of Sayreville* (Ultramedia Publications, 2011) provides a strong introduction to this brick-making community. The relationship of Camden and the Campbell Soup Company is examined in Daniel Sidorick, *Condensed Capitalism: Campbell Soup and the Pursuit of Cheap Production in the Twentieth Century* (Ithaca, N.Y.: Cornell University Press, 2009). There are numerous histories of individual Shore towns, especially Long Branch, Asbury Park, Ocean Grove, and Atlantic City. Joseph Bilby and Harry Ziegler's *Asbury Park: A Brief History* (Charleston, S.C.: History Press, 2009) is particularly interesting.

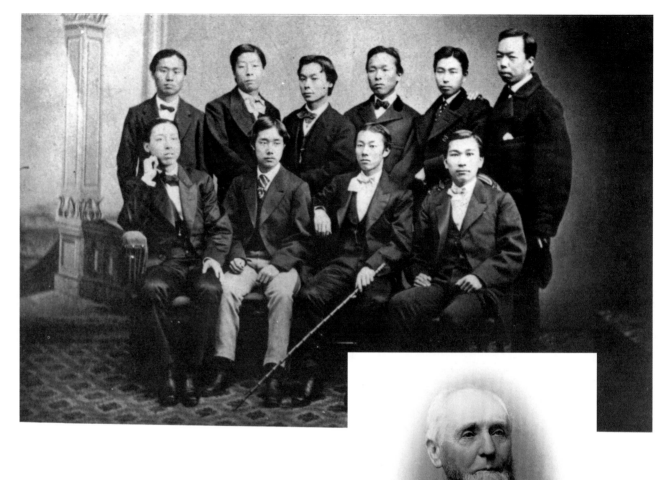

George H. Cook (1818–1889) was a professor of chemistry and natural sciences at Rutgers College when he was appointed state geologist in 1864. He helped produce detailed maps of New Jersey and was instrumental in the creation of the Agricultural Experiment Station at Rutgers. Source: Photograph by E. Bierstadt, New York. New Jersey Portraits Collection, Special Collections and University Archives, Rutgers University Libraries.

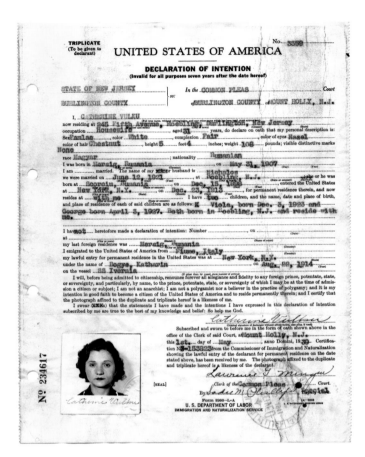

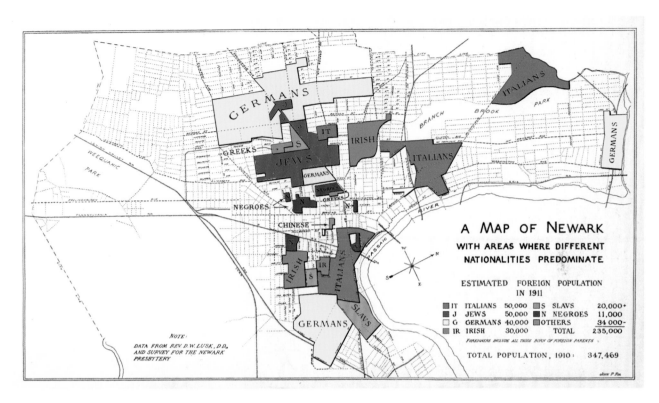

In May 1930, Catherine Vulku, an immigrant from Romania then living in Burlington County, declared her intention to become a citizen of the United States. Source: Burlington County, Court of Common Pleas, Naturalization Records, 1790–1956, box 47, volume 14, item 3359. New Jersey State Archives, Department of State.

"Map of Newark with Areas Where Different Nationalities Predominate," 1911. This map was based on data collected by the Presbyterian Church and clearly shows the diversity of the city, as well as neighborhoods that were divided according to race, religion, and ethnic backgrounds. Source: Frontispiece (color added) from A. W. MacDougall, *The Resources for Social Service…Newark, New Jersey* (New York: G. P. Putnam's Sons, 1912). Special Collections and University Archives, Rutgers University Libraries (HV99.N533B).

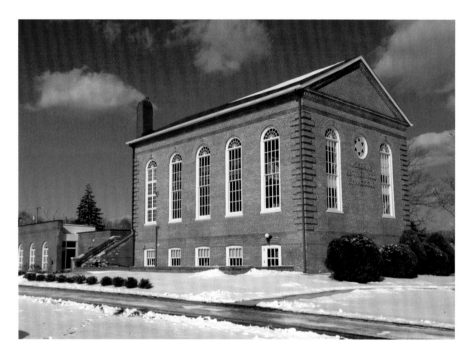

Woodbine Brotherhood Synagogue, 2015. The Baron de Hirsch Fund purchased land in Cape May County for an agricultural community of Russian Jews. The Woodbine Agricultural School, which opened there in October 1894, was the first secondary school specializing in agriculture. Over the years, some residents turned to manufacturing. Today the synagogue, built in 1896, is used for religious services and also houses a museum dedicated to the history of the community. Source: Sam Azeez Museum of Woodbine Heritage. Courtesy of Stockton University, Galloway.

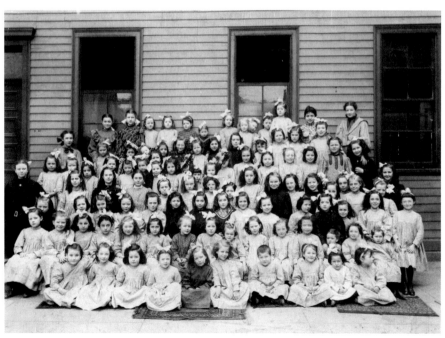

Young female orphans at the asylum attached to Saint Mary's Catholic Church in Jersey City, c. 1900. It was one of many Catholic institutions established in New Jersey's industrial cities in the late nineteenth century to help immigrants and their children. Source: Monsignor William Noé Field Archives & Special Collections Center, Seton Hall University, South Orange. Courtesy of the New Jersey Catholic Historical Commission.

The Jewish Farmer was a monthly Yiddish- and English-language newsletter published by the Jewish Agricultural and Industrial Aid Society from 1908 to 1959. The society helped Jewish immigrants settle in rural areas and provided training and loans so they could purchase land, seeds, and equipment. The July 1926 issue of the newsletter featured a story about Nathan Koenig, a teenager from Freehold who had won numerous awards, most of them for the chickens he raised. Source: Rutgers University Libraries.

Leon Abbett (1836–1894), a Democrat elected governor in 1883 and 1889, was an urban machine politician who sought to restrain railroad and business interests and to improve conditions for working men and women. Source: Oil on canvas, 29 ½ x 24 ½ in., by Charles H. Sherman (1852–1934), 1896. New Jersey State House Portrait Collection, administered by the New Jersey State Museum (SHPC17). Reproduced with permission.

Geo: M. Patchen, 1857. The famous Monmouth County trotting horse (b. 1849) raced before the sport became controversial in the 1890s because of gambling. Supported by some Democratic politicians and opposed by Protestant ministers and Republicans, the placing of bets became a political issue. Source: Oil on canvas by Charles Spencer Humphreys (1818–1880). Museum Collection, Monmouth County Historical Association, Freehold.

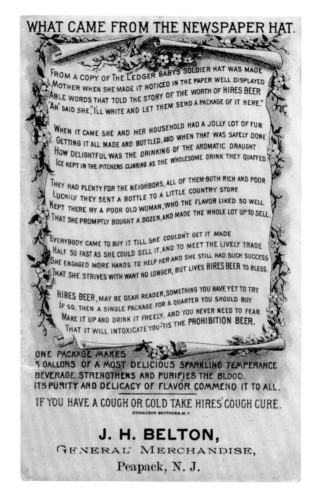

Pennsylvania Railroad Company, *Summer Excursion Routes*, 1892 (cover). Railroads increased tourism to Shore destinations by making them accessible to the middle and lower classes. From the 1870s onward, the Pennsylvania Railroad issued an annual excursion route pamphlet. Source: Special Collections and University Archives, Rutgers University Libraries (SNCLNJ TF25.P4S86 1892).

The front of this trade card for the Charles E. Hires Company, maker of root beer, shows a young girl wearing a hat made from a newspaper. The article at the peak explains the medicinal benefits of the concoction invented by Hires (1851–1937), a Philadelphia pharmacist. The reverse of the card informs customers that the product is available from J. H. Belton, a merchant in Peapack, New Jersey. Source: New Jersey Trade Cards Collection, Special Collections and University Archives, Rutgers University Libraries.

The back of the Hires Company trade card features a poem about root beer that concludes with an affirmation of its non-alcoholic content. Temperance was an important issue in the late nineteenth century and played a significant role when divisions between Republicans and Democrats were narrow. Source: New Jersey Trade Cards Collection, Special Collections and University Archives, Rutgers University Libraries.

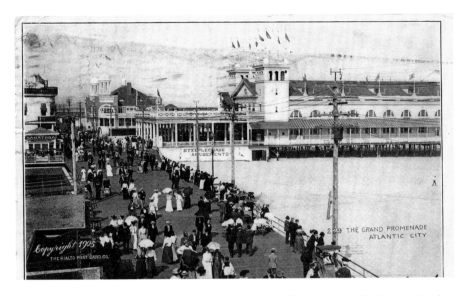

The Grand Promenade on the Atlantic City Boardwalk was a popular Easter Sunday event that brought visitors to the city before the summer season. Source: Rialto Post Card Company, 1905. New Jersey Postcards Collection, Atlantic County, Atlantic City. Special Collections and University Archives, Rutgers University Libraries.

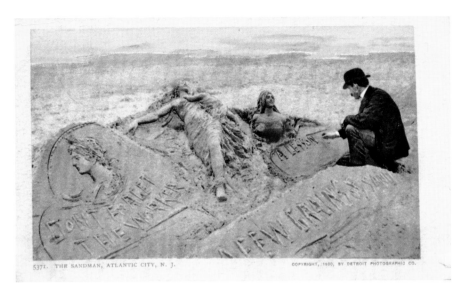

Making sand sculptures has always been a popular pastime at the Shore. This elaborate one at Atlantic City seems to have a political message. Source: Postcard by the Detroit Photographic Co., 1900. New Jersey Postcards Collection, Atlantic County, Atlantic City. Special Collections and University Archives, Rutgers University Libraries.

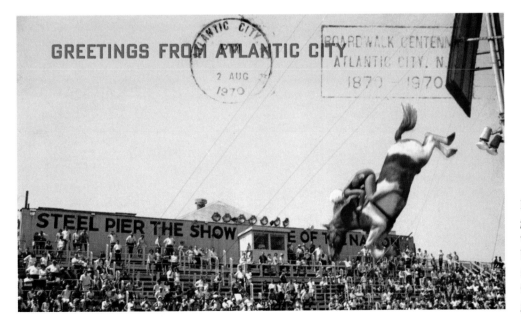

Long part of the entertainment at the Steel Pier, Atlantic City, the diving girl and horse attracted fewer crowds and more objections from animal welfare activists in the post–World War II era. Source: Original postcard by H. S. Crocker Co., Inc., Philadelphia, 1914; republished and postmarked 1970. New Jersey Postcards Collection, Atlantic County, Atlantic City, Entertainment. Special Collections and University Archives, Rutgers University Libraries.

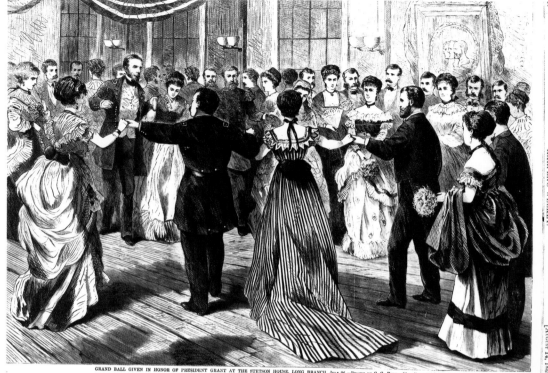

GRAND BALL GIVEN IN HONOR OF PRESIDENT GRANT AT THE STETSON HOUSE, LONG BRANCH, JULY 26.—DRAWN BY C. G. BUSH.—[SEE PAGE 519.]

Grand Ball Given in Honor of President Grant at the Stetson House, Long Branch, July 26, 1869. Starting with Ulysses S. Grant (1822–1885), a series of late nineteenth-century presidents spent time at the Jersey Shore. Source: Illustration by C. G. Bush (1842–1909), *Harper's Weekly*, August 14, 1869. Works Progress Administration, New Jersey Writers' Project Photograph Collection, c. 1935–1942, item 1641A. New Jersey State Archives, Department of State.

Our Modern Canute at Long Branch, 1873. After his reelection in 1872, there was speculation that President Ulysses S. Grant (1822–1885) would run for an unprecedented third term. In this cartoon by Thomas Nast (1840–1902), he declares that he cannot proclaim himself an emperor (Caesar) any more than he can stop the ocean waves. As a political cartoonist, Nast attacked Boss Tweed and political corruption; he was a friend of Grant and supporter of Reconstruction policies that tried to change the South following the Civil War. After 1872, Nast and his family lived in Morristown. Source: *Harper's Weekly*, October 11, 1873. Local History Room, Long Branch Free Public Library.

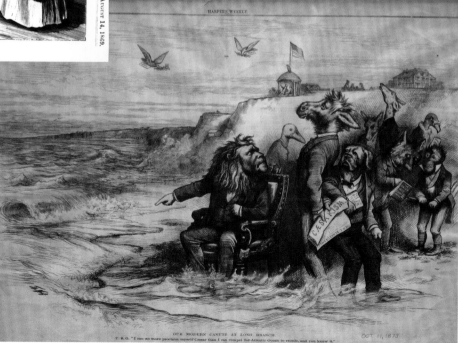

OUR MODERN CANUTE AT LONG BRANCH.

On July 2, 1881, President James A. Garfield was shot by an assassin at the train station in Washington, D.C. Transported to Long Branch in the hope that the climate would help him recover, he died there on September 19, his condition made worse by doctors probing for the bullet. Source: Wood engraving from James D. McCabe, *Our Martyred President* (Philadelphia: National Publishing Company, 1881). Works Progress Administration, New Jersey Writers' Project Photograph Collection, c. 1935–1942, item 1634A. New Jersey State Archives, Department of State.

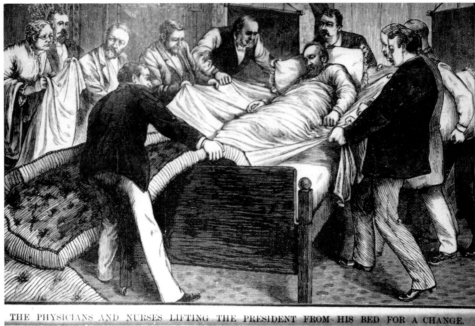

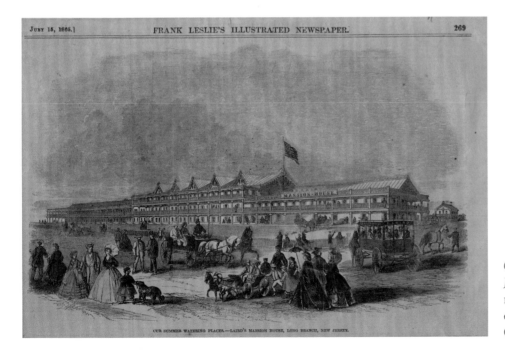

Our Summer Watering Place—Laird's Mansion House, Long Branch, New Jersey. In the late nineteenth century this Shore community with its many large hotels attracted the rich and famous. Source: Colored engraving from *Frank Leslie's Illustrated Newspaper*, July 15, 1865. Special Collections Division, The Newark Public Library.

The Emlen Physick House, built in 1879, is an example of an upper-class Victorian home in Cape May. Today the house is maintained as a museum showcasing the architecture and lifestyle of the late nineteenth century. Source: Photograph, c. 2003. Mid-Atlantic Center for the Arts & Humanities, Cape May.

Houses on the 600 block of Columbia Avenue, Cape May. Victorian houses in Cape May, with their gingerbread trim, are today often maintained as bed-and-breakfast inns and/or restaurants that draw tourists. Source: Mid-Atlantic Center for the Arts & Humanities, Cape May.

Avenue of Tents, Ocean Grove, N. J.

Ocean Grove was established in 1869 as a Methodist camp meeting that combined worship and enjoyment of the ocean air. The tent community continues to exist in part of the town. Source: Postcard, 1909. New Jersey Postcards Collection, Monmouth County, Ocean Grove. Special Collections and University Archives, Rutgers University Libraries.

A statue of the Reverend Ellwood Stokes, first president of the Ocean Grove Camp Meeting Association, stands in front of the Great Auditorium. Completed in 1894, this large wooden building is still used today for worship and concerts. Source: Photograph, 2014. Joseph Bilby Collection.

INTERIOR OF AUDITORIUM, SHOWING THE LARGEST ORGAN IN THE WORLD, OCEAN GROVE, N.J.

Originally, the Great Auditorium at Ocean Grove could seat up to 10,000 people; updates to the interior have reduced that number to about 6,000. Source: Postcard published by Samuel Strauss, 1916; postmarked 1918. New Jersey Postcards Collection, Monmouth County, Ocean Grove. Special Collections and University Archives, Rutgers University Libraries.

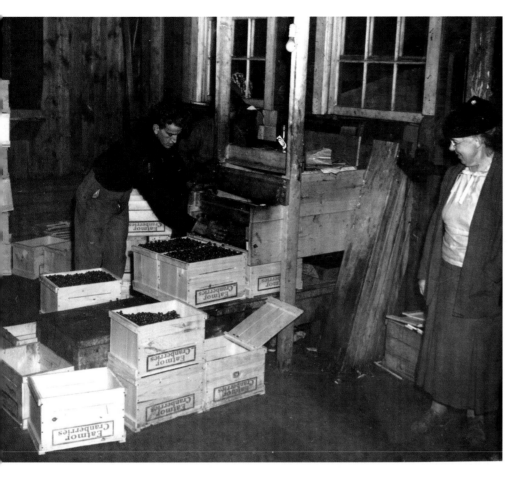

Elizabeth Coleman White (1871–1954) observing a cranberry sorting machine, c. 1930s–1950s. White took over her father's cranberry farm, Whitesbog, and worked with others to develop the commercial blueberry bushes afterward cultivated across the United States. Source: Department of Agriculture, Office of the Secretary, Photograph Collection, item 1905. New Jersey State Archives, Department of State.

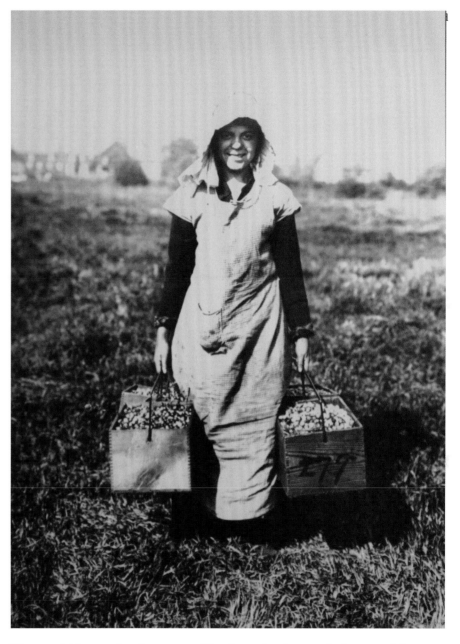

Woman picking cranberries c. 1900. New Jersey has long ranked as one of the top five producers of cranberries in the nation. Source: Ocean County Historical Society, Toms River.

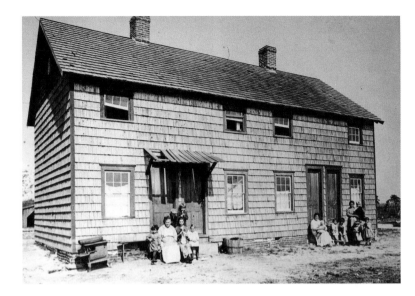

One of the houses at Whitesbog where migrant cranberry pickers and their families stayed during the picking season, c. 1930s–1940s. Improving the lives of migrant workers became a long-term goal of owner Elizabeth Coleman White (1871–1954). Source: Department of Agriculture, Office of the Secretary, Photograph Collection, item 1929. New Jersey State Archives, Department of State.

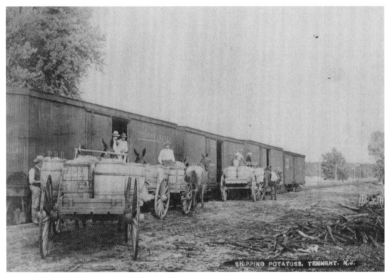

Farmers shipping potatoes to market from Tennent Station, c. 1900. Horse-drawn wagons carried produce to the train. Source: Item T-7. Library & Archives, Monmouth County Historical Association, Freehold. Gift of James C. McCabe.

Hackensack Water Works, interior of the 1892 pump house and Old No. 7. The New Milford plant of the Hackensack Water Company was built between 1882 and 1911 in Oradell to provide safe water for the growing community. It operated until 1990. Source: By permission of The Water Works Conservancy from its publication *The History of the Hackensack Water Works* (2004) by Clifford W. Zink.

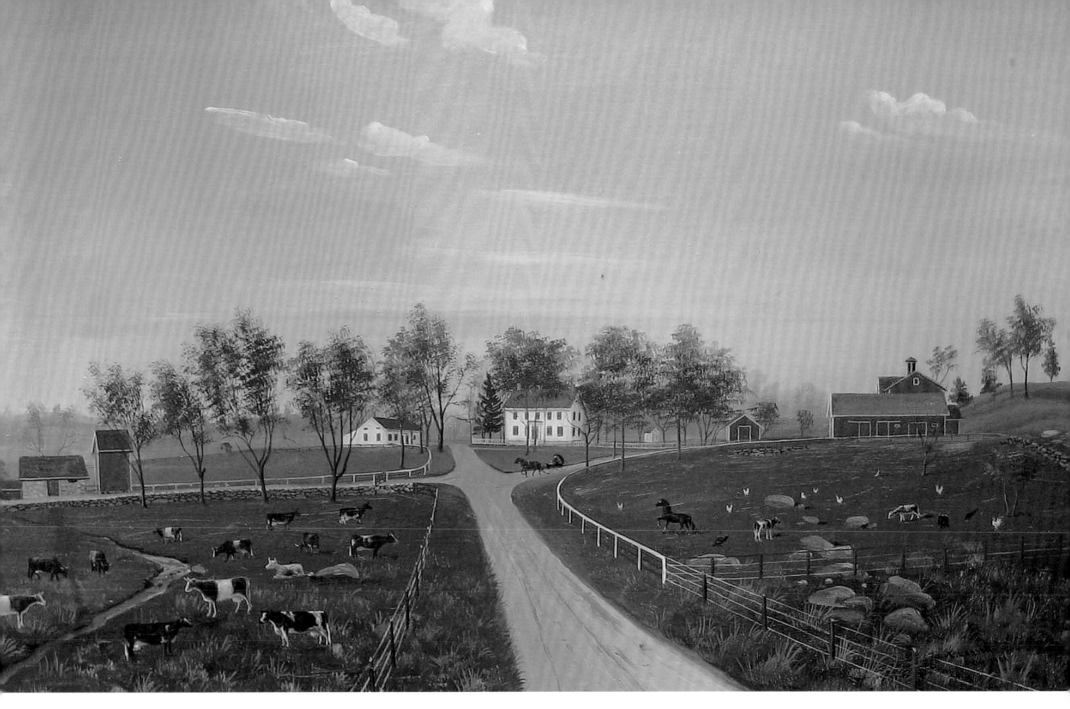

The Sussex County farm of Sam Vandruff, late nineteenth century, painted by Louis Larsen (c. 1863–1932), a Norwegian immigrant house painter and folk artist. Source: Reproduced from William R Truran, *Country Lanes: Portrait of a Century Past, Featuring the Complete Works of Louis Larsen* (2010). This image is from the collection of Minny Holbert Haas.

"Plan of Sewerage for the City of Trenton, N.J.," by Rudolph Hering, 1890. As cities expanded in the late nineteenth century, they built sewer systems to protect the health of residents. Source: *New Jersey Health Report* (1890). Document Collection, Library of Science and Medicine, Rutgers University Libraries.

Clara Maass (1876–1901), a nurse trained at the Newark German Hospital School, served in the Spanish-American War and in the Philippines. She then went to Cuba, where a U.S. Army commission was working to develop an inoculation against yellow fever. Maass volunteered to be bitten by infected mosquitoes, contracted a severe case of the disease, and died. Her body was returned to New Jersey and buried with military honors. Source: New Jersey Portraits Collection, Special Collections and University Archives, Rutgers University Libraries.

Soldiers stand on a large cannon installed at the Sandy Hook Proving Ground, c. 1902. Sandy Hook, at the entrance to New York Harbor, was the location of a series of military installations from the American Revolution until 1974, when it was turned over to the National Park Service. Source: Postcard. R. Veit Collection

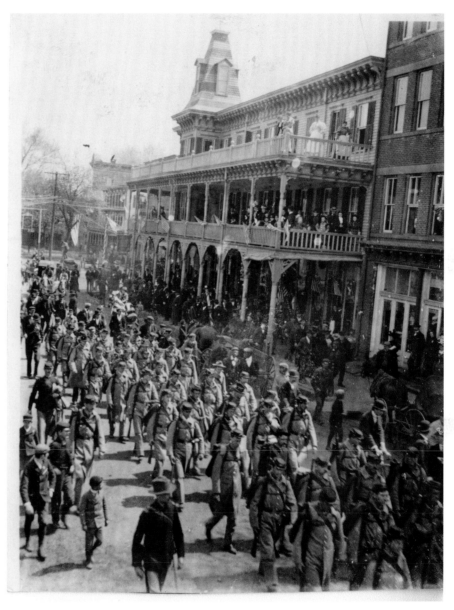

Members of the Vredenberg Rifles Company E, which participated in the Spanish-American War, parade down Main Street in Freehold, 1898. Source: Photo images Book 3, FR 389. Library & Archives, Monmouth County Historical Association, Freehold.

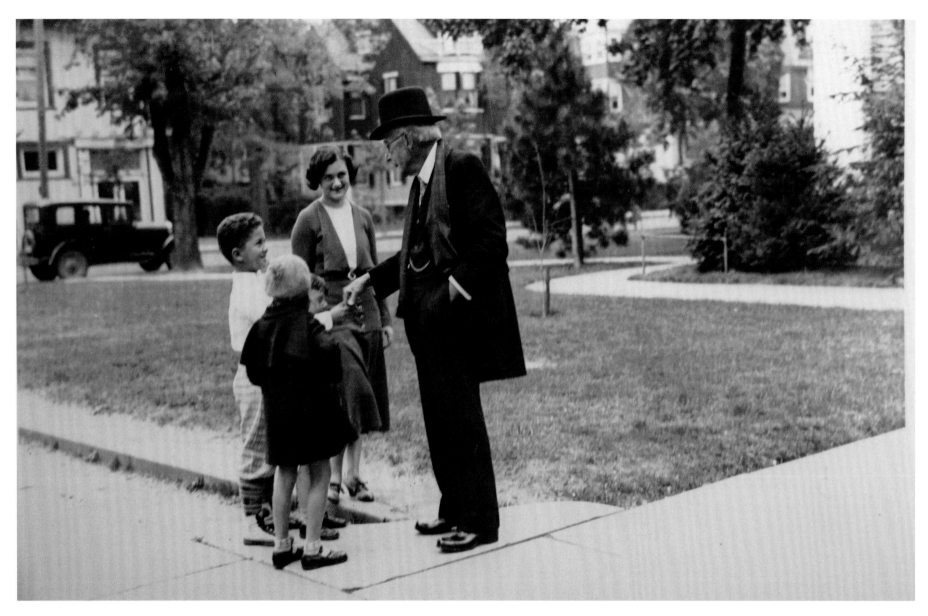

John D. Rockefeller (1839–1937) became the wealthiest man in America through his monopolistic business practices. His Standard Oil Trust was incorporated in New Jersey in 1899. Once retired, he devoted his wealth to philanthropy, becoming a benefactor of public health, educational, and Baptist Church causes. He was known for handing out nickels and dimes to children, as here in Lakewood, where he maintained an estate (now Ocean County Park). Source: Photograph, date unknown. Ocean County Historical Society, Toms River.

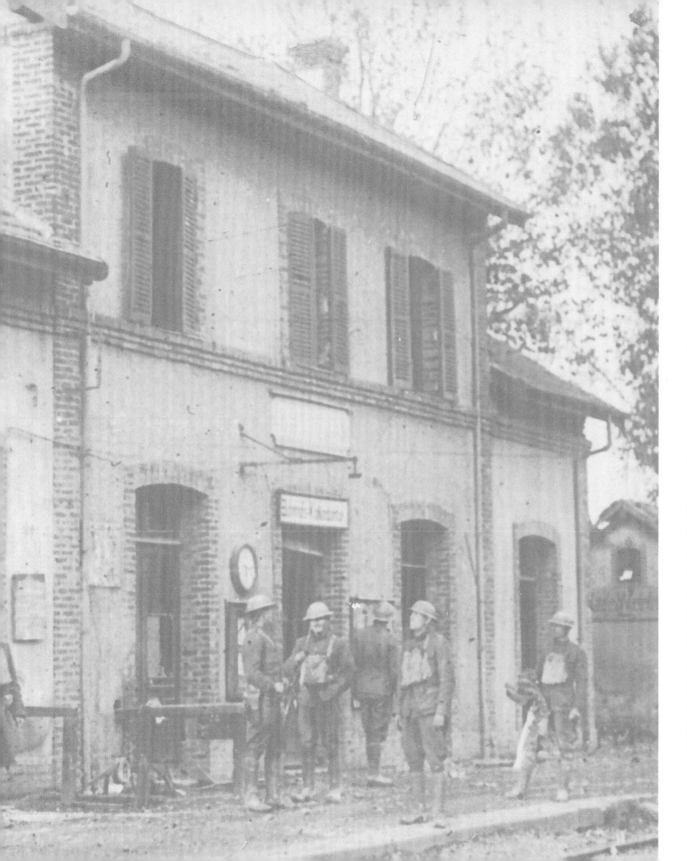

Immigration, the Progressive Era, and World War I

The Statue of Liberty was dedicated on October 26, 1886. Though New Jersey and New York have sparred over its ownership, the symbolism is clear. It is an icon of freedom, liberty personified, welcoming new immigrants from abroad. And in the late nineteenth century, there were multitudes to welcome. These new arrivals found ready work in the factories of northern New Jersey, especially in Newark, Elizabeth, Passaic, and Paterson, while others moved to farms, especially in the southern part of the state. By 1900, over half of the state's residents were first- or second-generation immigrants, a stunning number. Indeed, only in the late twentieth and early twenty-first century have

similar numbers of new arrivals been counted. Paid miserly wages and concentrated in urban tenements, many of these first-generation New Jerseyans struggled to survive. They built churches, social clubs, and beer halls, and created communities of support. Some struck for higher wages, shorter workdays, and better conditions, while others engaged in political action, even anarchism. Many New Jersey politicians during this era were beholden to large corporations; their willingness to offer a tax haven to railroad and oil trusts led the muckraking journalist Lincoln Steffens to refer to New Jersey as the "Traitor State."

For much of this period Republicans were ascendant in state politics. However, a political and social reform movement was beginning to focus on the stark economic inequalities visible across the state and the nation. Although these progressives included both Democrats and Republicans, it was the election of Woodrow Wilson, a Democrat, as governor in 1910 that marked the success of the movement in New Jersey. Wilson went on to serve as president of the United States and in 1917 brought America into World War I on the side of the Allies. Thousands of troops were trained in New Jersey or left for the front from local ports. At the war's end, returning troops brought back the Spanish influenza, costing even more lives than the conflict itself. Following the war, significant legislative changes, including suffrage for women and Prohibition, reshaped New Jersey in the 1920s.

The underpinnings of the state's twentieth-century demographics derive from the waves of

Franklin Murphy (1846–1920) served in the Civil War and afterward started a varnish company in Newark that expanded to several other cities. A Republican, he became interested in city and then state politics. As governor (1902–1905), he pushed for reforms to make state government more efficient. While favoring corporations, he supported child labor restrictions and tenement housing inspection laws. Source: Oil on canvas by Frederick M. Vermorcken (1858–1920), 1905. New Jersey State House Portrait Collection, administered by the New Jersey State Museum (SHPC68). Reproduced with permission.

Started by an Armenian family, the Karagheusian Rug Mill manufactured rugs in Freehold from 1904 to 1964; at its height, it employed 1,700 people. Source: Hall Studio, Freehold (FR-443, Coll. 51). Library & Archives, Monmouth County Historical Association, Freehold. Gift of Mrs. Samuel Hanson, 1967.

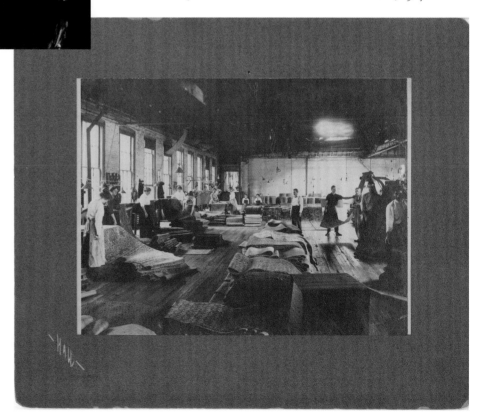

Trade card (front) for Hahne and Co., a downtown Newark business (1858–1987) that became a large full-service department store. Source: New Jersey Trade Cards Collection, Special Collections and University Archives, Rutgers University Libraries.

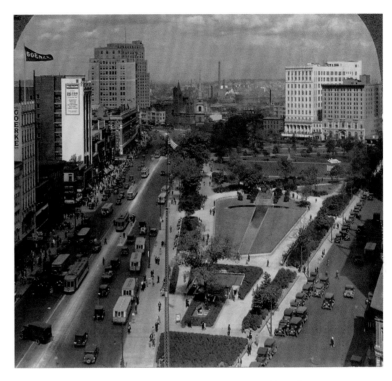

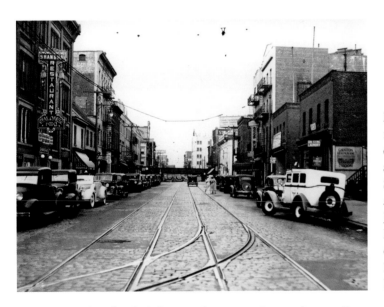

Mulberry Arcade, c. 1930s. In the early twentieth century, Newark had a thriving Chinatown. Source: Works Progress Administration, New Jersey Writers' Project Photograph Collection, c. 1935–1942, item 710A. New Jersey State Archives, Department of State.

The bustling businesses surrounding Military Park in downtown Newark, including the Hahne's department store, drew many shoppers until the opening of suburban malls. Source: Photograph, 1930s. Joseph Bilby Collection.

immigrants that flooded the state between 1890 and 1920. German and Irish immigrants had been present in the state since the colonial period, and their numbers swelled in the mid-nineteenth century. Still more German, Irish, and English arrivals in the late nineteenth century were joined by immigrants from Holland, France, Austria, Hungary, and Italy. Particularly in the period after 1900, large numbers of southern and eastern European immigrants came to the state. Many of the Italians were from southern Italy, especially Naples and Sicily, while Poles, Russians, Slovaks, Czechs, and Hungarians also came in significant numbers. Many hoped for better economic opportunities, while others, especially Jewish immigrants, came to escape religious persecution. They often settled in ethnic enclaves, in part because they faced prejudice due to their faiths and their customs, dress, and foods. Newark even had a significant

Part II of "New Jersey: A Traitor State" appeared in the May 1905 issue of *McClure's Magazine*. (Part I was in the April 1905 issue.) Lincoln Steffens, Ida Tarbell, and others writing for *McClure's* in the Progressive period attacked aggressive monopolies, wealthy business barons, and misguided public policy. Steffens described New Jersey as the "Traitor State" because it alone among states allowed the incorporation of monopolistic trusts. Source: Cover of *McClure's Magazine* 24 (May 1905).

Muckraking journalist Lincoln Steffens (1866–1936), author of the two-part article "New Jersey: A Traitor State" (1905), at a speaking engagement in New York City, April 1914. Source: Photograph by Bains News Service. Image LC-B2–3044–4, Library of Congress, Prints and Photographs Division, Washington, D.C.

Preliminary plan, c. 1923, for Warinanco Park, Elizabeth, Union County, by the renowned landscape architectural firm of Olmsted Brothers. Providing recreation spaces for urban workers was one of the causes supported by Progressive reformers. Source: From *Report of the Union County Park Commission, New Jersey: Report from the Period from October, 1925, to July, 1928*, after page 40. Special Collections and University Archives, Rutgers University Libraries (SNCLY SB482.N5U55 yr.1926/28).

Chinatown. Although Catholics and Jews had long been present in the state, they now arrived in large numbers and built churches, synagogues, schools, and recreation halls. Fraternal organizations that provided social benefits to members became very common. Often, immigrants hoped to earn enough money to return to their homelands as wealthy individuals. Some, like the Italian anarchists living in Paterson, dreamed of reforming their home country's political system. Indeed, Gaetano Bresci, an Italian American resident of Paterson, returned to Italy and assassinated King Umberto in 1900, much to the consternation of local officials.

In scenes reminiscent of Upton Sinclair's *The Jungle*, new immigrants learned that they were easy prey for unscrupulous con artists and often found themselves consigned to long, dangerous hours working for meager wages with

A BULL MOOSE RALLY

Will be held by

The Keyport National Progressive Club,

In Keough's Hall,

Cor. Front and Church Sts., Keyport, N. J.

Friday Evening,

October 18,

At 8 o'clock.

The Brilliant and Polished Speaker,

Hon. Adrain Lyon,

Of Perth Amboy, Progressive Candidate for
State Senator, will be the
Orator of the Evening.

Other Prominent Speakers will be Present.

The Public is Cordially Invited

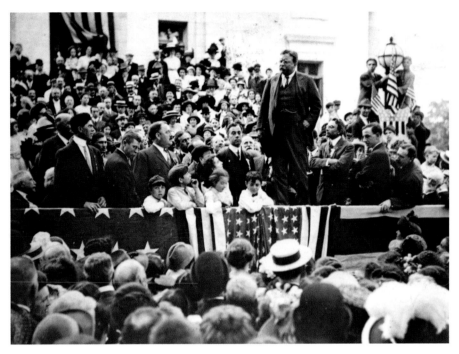

Theodore Roosevelt (1858–1919) campaigning in Somerville, 1912. He ran for president as the Progressive (Bull Moose) Party candidate. Source: Somerset County Historical Society, Bridgewater.

Notice of a rally for Adrian Lyon, Progressive Party candidate for state senator, 1912. Lyon was a New Jersey delegate to the Progressive Party convention that nominated Theodore Roosevelt for president. Source: New Jersey Political Broadsides Collection, Special Collections and University Archives, Rutgers University Libraries.

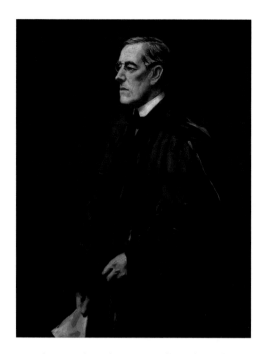

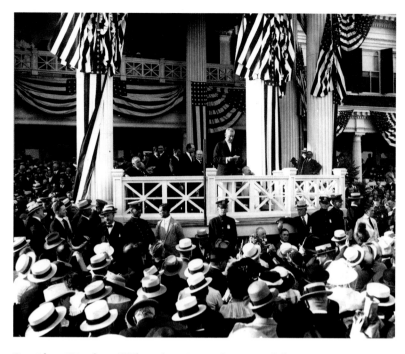

Woodrow Wilson (1856–1924) graduated from the College of New Jersey in 1879, returned as a professor, and served as president of the renamed Princeton University from 1902 to 1910. He went on to be elected governor of New Jersey (1910–1912) and president of the United States (1913–1921). Source: Oil on canvas, 59 ¼ x 39 3/8 in., by Sidney Edward Dickinson (1890–1980), 1929. Princeton University Art Museum/ Art Resource, New York. Gift of William Church Osborn, Class of 1883, and friends. Photograph by Bruce M. White.

In a three-way presidential race that pitted Woodrow Wilson and his running mate, Thomas Marshall, against Republican William Howard Taft and Progressive Theodore Roosevelt, the Democratic ticket won by a plurality of votes. Because all the presidential candidates (including Socialist Eugene V. Debs) supported some measure of reform, 1912 is seen as the high point of progressivism. Source: Cover of *Puck Magazine*, October 23, 1912. Image LC-DIG-ppmsca-27886, Library of Congress, Prints and Photographs Division, Washington, D.C.

President Woodrow Wilson (1856–1924) accepted the Democratic Party's nomination to run for a second term at Shadow Lawn, Long Branch, September 19, 1916. Source: International News Photos, New York. Works Progress Administration, New Jersey Writers' Project Photograph Collection, c. 1935–1942, item 1595A. New Jersey State Archives, Department of State.

little hope of advancement. Some struck in response. The most famous of these strikes was the 1913 Paterson Silk Strike: 23,000 silk workers walked off their jobs to protest a wage cut and a doubling of the number of looms worked by broad-silk weavers. The striking workers also sought an eight-hour day. During a strike that was both democratic and relatively nonviolent, they shut down 300 mills for months. Representatives from the Industrial Workers of the World (IWW), including Carlo Tresca, Bill Haywood, and Elizabeth Gurley Flynn, served as spokespersons. The strike brought together workers from many different crafts, both men and women, as well as individuals of different nationalities in an attempt to build a more equitable system of work. In an imaginative

Cornelia Bradford (1847–1935), an associate of activist-reformer Jane Addams, established New Jersey's first settlement house in Jersey City in 1893. Whittier House provided free education, legal service, and other aid to immigrants and poor residents. Source: From Joseph A. Dear, ed., *The Book of New Jersey: Records of Outstanding Men and Women…*(Jersey City: Jersey City Print Co., 1929), 197. Special Collections and University Archives, Rutgers University Libraries (SNCNJF F133.B66 1929).

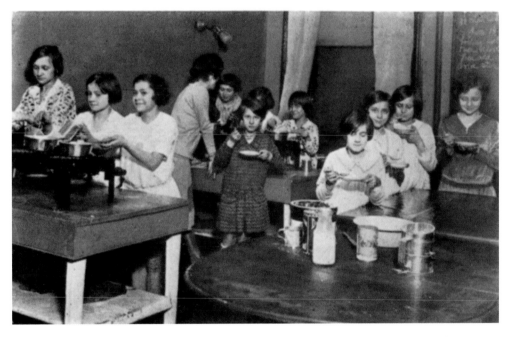

Whittier House provided a wide variety of services to local residents, including cooking classes that introduced immigrant women and/or their daughters to American food. Source: Photograph, c. 1929. Jersey City Free Public Library.

Mary Philbrook (1872–1958) was the first woman admitted to the New Jersey bar and an active supporter of suffrage and women's rights. She studied law in Hoboken, practiced in Jersey City and Newark, served the Red Cross in France during World War I, and in 1947 lobbied the state constitutional convention to include an equal rights provision. Source: Item MG 1363–28–02–01. From the collections of the New Jersey Historical Society, Newark.

Logo of the Women's Political Union of New Jersey. Founded by Mina C. Van Winkle (1875–1932) in 1908, the Equality League for Self-Supporting Women of New Jersey changed its name in 1912 to the Women's Political Union and became an affiliate of the larger New Jersey Woman Suffrage Association. Source: Item MG 1051–01–06. From the collections of the New Jersey Historical Society, Newark.

move, strikers performed "The Pageant of the Paterson Strike" at Madison Square Garden to draw attention to their plight. The strikers eventually returned to work, having achieved the continuation of the two-loom system. It would take several more years for the eight-hour workday to be adopted.

Silk mills were not the only industries to take advantage of workers. Newark was infamous for its poorly paid Greek shoeshine boys, and employees in southern New Jersey glasshouses often worked in miserable conditions. Housed in company towns and paid in scrip, workers often found that after paying for rent and groceries at the company store, they had very little money left. Glassblowing was a skilled trade that was shattered in the early

Suffragist Mina C. Van Winkle (1875–1932) of Newark holds a torch for the Women's Political Union in the bow of a decorated tugboat off of Jersey City, c. 1912–1915. Source: Photograph by Bain News Service. Image LC-B2–3362–9, Library of Congress, Prints and Photographs Division, Washington, D.C.

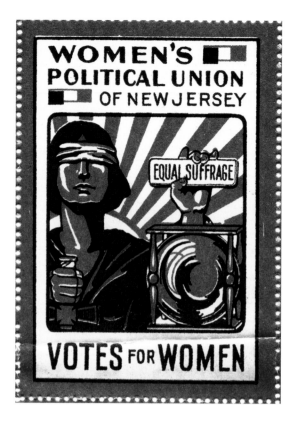

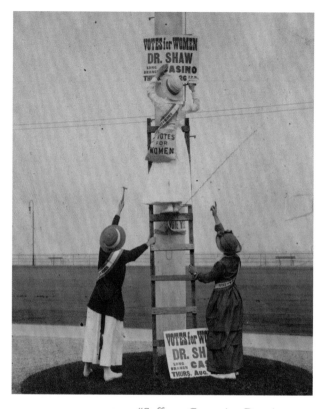

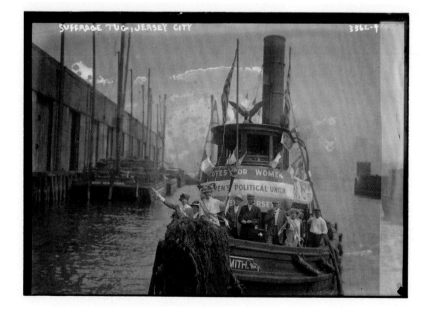

"Suffrage Campaign Days in New Jersey," 1915. Women place a placard advertising a talk at Long Branch in August by women's suffrage leader Dr. Anna Howard Shaw. A proposed amendment to the state constitution giving women the right to vote was defeated in October in a referendum in which only men could vote. Source: Image LC-DIG-ds-00609, Library of Congress, Prints and Photographs Division, Washington, D.C.

Mary T. Norton (1875–1959) with other female members of Congress, c. 1932–1933. From left to right: Virginia E. Jenckes (Indiana), Caroline O'Day (New York), Norton (New Jersey), Edith N. Rogers (Massachusetts), and Florence Kahn (California). With the support of boss Frank Hague of Jersey City, Norton became the first female Democrat elected to the House of Representatives without having been preceded by her husband. She served thirteen consecutive terms (1924–1950) and supported labor legislation and laws protecting women. Source: Mary T. Norton Papers (MC 1201), box 9, folder 7. Special Collections and University Archives, Rutgers University Libraries.

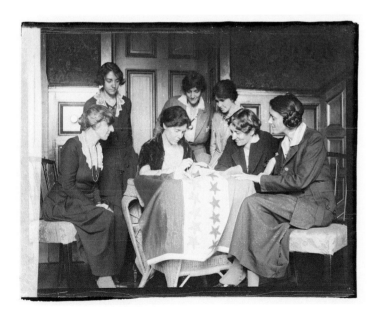

Alice Paul (third from left) and other suffragists sew a new star onto a flag to signify ratification of the Nineteenth Amendment, c. 1920. Born into a Moorestown Quaker family, Paul (1885–1977) attended Swarthmore College and later earned advanced degrees in social work, economics, and law. She was a leader of the National Women's Party and a supporter of an equal rights amendment. Arrested, jailed, and force-fed, she was one of the activists pushing for women's right to vote during World War I. Source: Photograph by the National Photo Company. Image LC-DIG-npcc-01204, Prints and Photographs Division, Library of Congress, Washington, D.C.

twentieth century by the invention of automated glassblowing machines.

The terrible working and living conditions faced by new immigrants did not go unnoticed, and reformers, often known as social progressives, strove to ameliorate their situation. A leader in this fight was Cornelia Bradford, who established Whittier House in Jersey City, a settlement house that provided otherwise unavailable services to new immigrants, such as a mother's club, a free kindergarten, a lending library, legal aid, and cooking classes. Public health reforms were also part of the progressive agenda. Dr. Henry Leber Coit of Newark campaigned to upgrade the state's standards for milk purity. Laws were passed restricting child labor and establishing juvenile courts. Mary Philbrook, the first woman admitted to the bar in New Jersey, lobbied successfully for a separate juvenile court in Newark. Muckraking author Upton Sinclair founded a utopian socialist community named Helicon Home Colony in Englewood, where he and other intellectuals attempted to create a more perfect society in which women were liberated from the burden of domestic labor. Like earlier utopian experiments in the state, the community proved short-lived.

In stark contrast to the gritty tenements of northern New Jersey and the rough-hewn agricultural colonies in the southern part of the state, captains of industry built lavish estates, often patterned after European country houses, where they lived like landed aristocrats. Many of these estates were located in the Somerset Hills, in and near Morristown, and

in Monmouth and Ocean Counties. Particularly noteworthy examples include Blairsden, the home of investment banker and entrepreneur C. Ledyard Blair in Peapack; Florham, the home of the Twombly and Vanderbilt families in Madison; Shadow Lawn, the Parsons estate in West Long Branch; and Georgian Court, the home of George Jay Gould in Lakewood.

Strong alliances developed between politicians and big businesses. New Jersey's liberal incorporation laws proved a boon to trusts like Standard Oil and U.S. Steel. These corporations brought considerable revenue into the state, but also wielded undue influence over lawmakers at the expense of local interests. After a long stretch of Democratic governors in the years after the Civil War, John Griggs, a Republican, was elected in 1895 in part because of the so-called racetrack scandal, which demonstrated how completely racetrack operators were able to control the state legislature. However, in many ways, the Republicans proved themselves equal to the Democrats in their desire to please big business. Republicans remained ascendant until the election of Woodrow Wilson.

Nevertheless, reformers were actively working to reshape New Jersey politics. One of the first was Mark Fagan, a progressive Republican, elected mayor of Jersey City in 1901. Fagan and his corporate counsel George Record worked to limit utility and transportation franchises, to elect U.S. senators directly instead of by the legislature, and to devise a more equitable tax system. At the local level, Fagan provided services to his constituents that included parks,

N.J. - POLITICS

1928

LILLIAN F. FEICKERT
Candidate for U. S. Senator

A PERSONAL RECORD

As Lillian Ford she was born in Brooklyn, New York, on July 20, 1877. Her direct ancestors came from England in 1622. She came to Plainfield, New Jersey, to live after her marriage in 1902, and has resided in her present home in North Plainfield Township, Somerset County, since 1908. She is an Episcopalian and a member of Grace Church, Plainfield.

She is a member of the W. C. T. U.; the D. A. R.; the Contemporary Club of Newark; the N. J. Historical Society; the N. J. Audubon Society; the National Rose and Iris Societies, and has been President of the New Jersey Women's Republican Club since its organization in 1920. She is also a Trustee of the N. J. Anti-Saloon League.

She was made State Enrollment Chairman of the N. J. Woman Suffrage Association in 1910, and was elected President of that organization in 1912, which office she continued to hold until after the ratification of the 19th Amendment in 1920, when the Suffrage Association disbanded and she organized the N. J. League of Women Voters and served as its Treasurer for a year.

During the World War she was a Vice-Chairman of the N. J. Women's Council of National Defense, and Chairman of the N. J. Suffrage Association Holding Company, which purchased a house near Camp Dix and maintained it as a clubhouse for the enlisted men at the Camp until June 1919. She was also a member of the Red Cross and the National League for Woman's Service.

She was a member of the Board of the New Jersey College for Women for four years, in the formative period of that institution.

She was First Vice-Chairman of the N. J. Republican State Committee from 1920 to 1925, and organized the women of the State for the Republican Party in every campaign during that time. She also acted as Chairman of the New Jersey Branch of the Coolidge Club of America in 1924.

She organized the New Jersey Women's Republican Club in 1920 and has been its President ever since.

Vote for her in the Republican Primary May 15th, 1928

9 Ordered and paid for by Jennie E. Precker, Campaign Manager, Newark, N. J.

Lillian Feickert (1877–1945) led the effort to persuade the state legislature to ratify the Nineteenth Amendment in 1920 and organized the New Jersey Women's Republican Club. Her bid for election to the U.S. Senate in 1928 failed. Source: New Jersey Political Broadsides Collection, Special Collections and University Archives, Rutgers University Libraries.

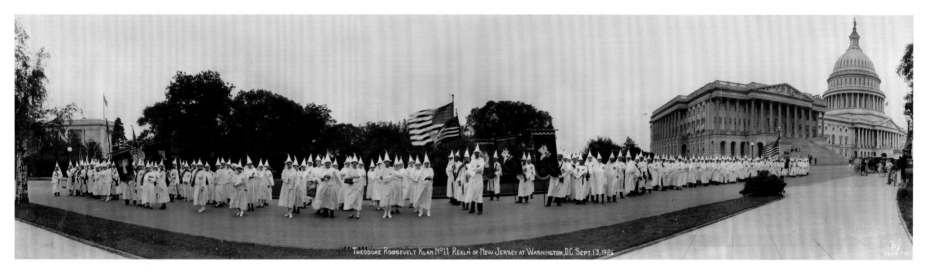

"Theodore Roosevelt Klan No. 11 Realm of New Jersey at Washington, D.C., September 13, 1926." This photograph shows KKK members from New Jersey in a lineup that includes women as well as men. Source: New Jersey Photograph Collection, Special Collections and University Archives, Rutgers University Libraries.

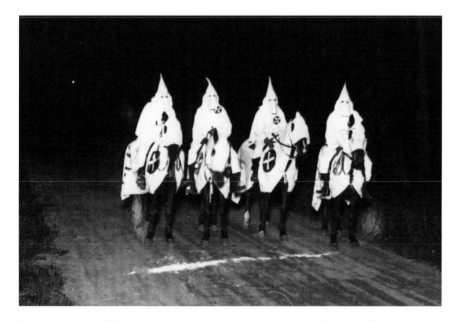

Four hooded Ku Klux Klan members on a New Jersey road, 1920s. The KKK grew rapidly in the North in the 1920s, preaching "100 percent Americanism" and using threats and intimidation against blacks, Catholics, Jews, and immigrants. By the end of the decade, with the reputation of its national leaders questioned, membership declined. Source: Twentieth century 1920–1929 folder. The Newark Public Library.

housing, public baths, and education. He hoped to support these programs by raising taxes on the railroads. Fagan was ultimately unseated by H. Otto Wittpenn, a Democrat who also supported some progressive causes. Implementation of the progressive agenda culminated with the election of Woodrow Wilson.

Only one native-born New Jerseyan, Grover Cleveland, has been elected president of the United States (1885–1889 and 1893–1897). However, Woodrow Wilson lived most of his life in the state, and his political career was shaped by his experiences in New Jersey. Born in Virginia, the son of a Presbyterian minister, he graduated from the College of New Jersey (Princeton University as of 1896) in 1879, worked briefly as a lawyer, completed his graduate studies in political science at Johns Hopkins University, and began a college teaching career that eventually took him back to Princeton. Chosen as president of the university in 1902, Wilson set out

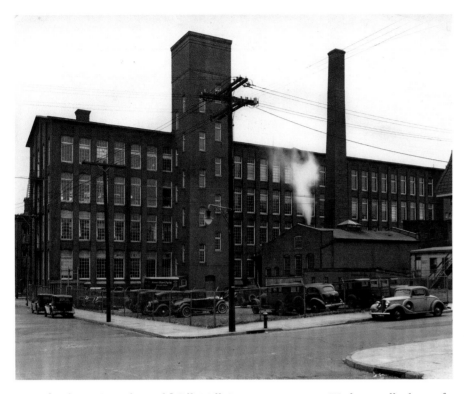

D&W [Doherty & Wadsworth] Silk Mill, Paterson, c. 1930s. Workers walked out of this mill in 1913, and then struck again in following years. Source: Works Progress Administration, New Jersey Writers' Project Photograph Collection, c. 1935–1942, item 138G. New Jersey State Archives, Department of State.

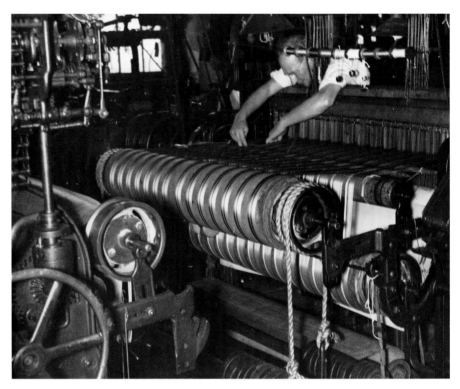

Weaving on a silk loom at D&W [Doherty & Wadsworth] Silk Mills, Paterson, c. 1930s. Source: Works Progress Administration, New Jersey Writers' Project Photograph Collection, c. 1935–1942, item 138E. New Jersey State Archives, Department of State.

to modernize its administration, curriculum, and teaching methods. However, flaws in his leadership style became more apparent over time, and he was increasingly embattled. When given an opportunity to run as the Democratic candidate for governor of New Jersey in 1910, Wilson took it and won. Though nudged into politics by urban Democratic political bosses, he soon proved himself to be independent of their influence and worked to enact a series of political reforms. While in office (1911–1913), Wilson pushed numerous legislative measures to regulate campaign funding, public utilities, and corporations, and to provide worker compensation. In 1912, Wilson ran for president. He benefited from a split in the Republican Party between the incumbent William

Howard Taft and his popular predecessor, Theodore Roosevelt running on the "Bull Moose" (Progressive Party) ticket. Wilson brought his progressive agenda to the White House and was highly effective in his first term.

In 1914, the assassination of Austrian Archduke Franz Ferdinand precipitated the First World War. The conflict soon bogged down in the carnage of trench warfare on the Western Front. At first, Wilson hoped to keep the United States out of the war and to act as a mediator to end the bloodshed; but after Germany began unrestricted submarine warfare, the United States entered the conflict. However, even before soldiers began training at Camp Dix and Camp Merritt, New Jerseyans were involved in the war. Farmers sold livestock,

The Paterson strike of 1913 was the largest and longest in the city's history. When mill owners proposed to double the number of looms assigned to each worker, some 32,000 weavers and dyers walked out and invited organizers from the International Workers of the World (IWW) to help them. The strike attracted national attention, and thousands of supporters attended the "Pageant of the Paterson Strike," conceived by journalist and activist John Reed. But the mill owners were able to outlast the strikers, who returned to work after five months. Source: Program cover art by Robert Edmond Jones (1887–1954). American Labor Museum/Botto House National Landmark, Haledon.

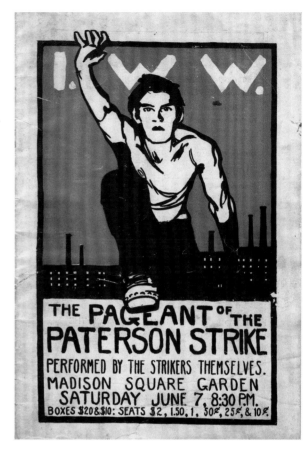

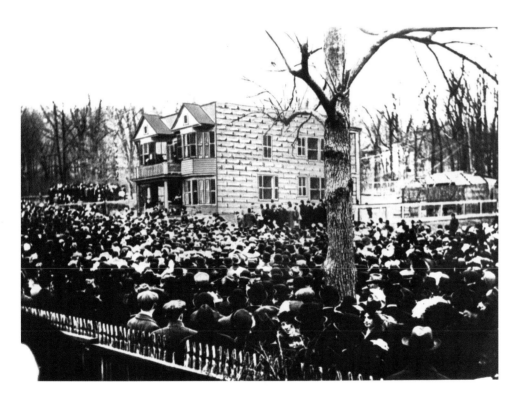

Paterson strikers massed outside the Botto house, 1913. Owned by an Italian family of silk workers and located in a nearby town with a sympathetic socialist mayor, this house became the site of weekly rallies. Today it is a museum. Source: American Labor Museum/Botto House National Landmark, Haledon.

especially horses, to Allied armies; industries retooled to produce war materials; and munitions manufacturers took orders from Allied forces. The state's chemical industry boomed, filling a niche long occupied by German imports. The pharmaceutical industry also flourished, and Merck and Company of Rahway, owned by the German émigré George Merck, grew to prominence.

Initially, New Jersey residents were divided about the war. Many communities had substantial German American populations, including Newark and especially Hoboken, which had served as the American terminus of the Hamburg America steamship line. However, popular opinion quickly shifted toward the Allies, and German Americans faced significant prejudice. Communities

such as German Valley were renamed (as Long Valley), and German Americans living in Hoboken were declared enemy aliens, detained, arrested, and evicted from their homes and businesses. The seizure of German ships and piers paved the way for Hoboken to become the main point of embarkation for the U.S. Expeditionary Force. Ultimately, 2 million soldiers left for the Western Front from Hoboken.

Close to 130,000 New Jerseyans served in the armed forces during the First World War. Their absence created work opportunities for women on the home front. Most New Jersey men served in the 78th and 29th Divisions. They trained at Camp Dix or Camp Merritt and fought with distinction at Saint-Mihiel and in the Meuse-Argonne Offensive. Perhaps the state's most famous casualty was the poet Alfred Joyce Kilmer of New Brunswick, the author of "Trees," who was killed in action in 1918.

In addition to its massive training facilities in New Jersey, the U.S. Army established Camp Little Silver (later Fort Monmouth) in Eatontown, which became the Signal Corps School, noteworthy for training homing pigeons that carried messages between units on the Western Front. Hastily built towns were constructed in the remote Pine Barrens, such as Amatol and Belcoville, which served briefly as shell loading plants. Even small towns had "victory gardens." The war touched all parts of the state.

New Jersey's central role in munitions manufacturing made it a ready target for saboteurs. A cadre of agents organized by Count Johann-Heinrich von

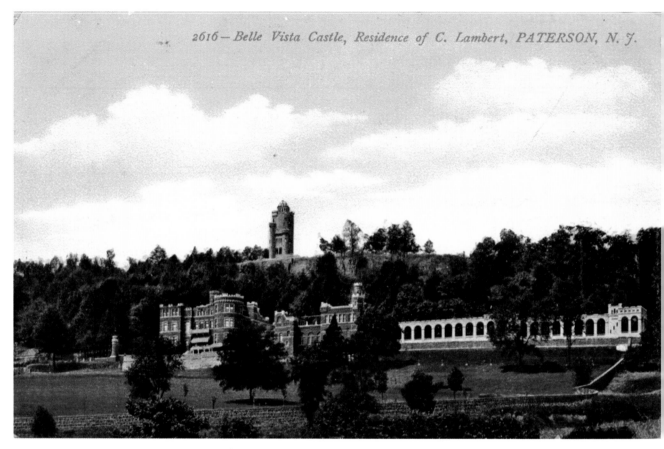

Belle Vista Castle (Lambert Castle), Paterson, c. 1907. The home of wealthy silk manufacturer Catholina Lambert (1834–1923) was built in 1892–1893 on Garrett Mountain overlooking the city. It was filled with Lambert's collection of art acquired in Europe. Lambert's firm suffered financial difficulties after the Paterson strike, and it was liquidated in 1914. Lambert was forced to sell his art collection but continued to live at the castle until his death. The mansion is now the home of the Passaic County Historical Society. Source: New Jersey Postcards Collection, Passaic County, Paterson. Special Collections and University Archives, Rutgers University Libraries.

Part of an open letter from Mayor Mark Fagan (1869–1955) of Jersey City to Governor Franklin Murphy (1846–1920), c. 1902, calling for reform of the tax system, which favored railroads over individual home-owners in a city where the corporations owned one-third of the property. Source: New Jersey Political Broadsides Collection, Special Collections and University Archives, Rutgers University Libraries.

George L. Record (1859–1933), a lawyer and Republican in Jersey City, became involved in progressive reforms while working with Mayor Mark Fagan (1869–1955) to end tax breaks for railroad and utilities corporations and to improve municipal services. Leader of the "New Idea" faction in his party, he worked with Governor Woodrow Wilson, a Democrat, on reform legislation, then supported Theodore Roosevelt in the election of 1912. He never won office himself. Source: Cover of a campaign pamphlet, *Republican Candidate for Governor: George L. Record…Republican Primaries* (Newark, 1916). Special Collections and University Archives, Rutgers University Libraries (SNCLY JK2358.N55 1916r).

Bernstorff, German ambassador to the United States, struck sites up and down the East Coast, including the Black Tom munitions depot in Jersey City and a munitions factory at Kingsland in Bergen County. The destruction at Black Tom in July 1916 was apocalyptic and resulted in damages amounting to $20 million. Accidental explosions also occurred. More than one hundred individuals lost their lives in Sayreville's Morgan Explosion of October 1918. A group of U.S. Coast Guardsmen, stationed in nearby Perth Amboy, responded to the catastrophe and prevented further loss of life by moving a train loaded with TNT out of the plant. Twelve received the Navy Cross for their heroism.

By summer 1918, it was clear that the Allies would win the war. However, the dead and wounded continued to be shipped home. New Jersey was the site of several hospitals treating these convalescent soldiers, including U.S. General Hospital No. 3 in Colonia, which pioneered reconstructive surgery. Returning

Thousands of men and women attended the sixteenth convention of the Anti-Saloon League in Atlantic City, July 6–9, 1915. Source: Panoramic photograph by Thomas Sparrow. Image LC-USZ62–10443, Library of Congress, Prints and Photographs Division, Washington, D.C.

Flyer for Prohibition candidates in Middlesex County, c. 1918. During World War I, temperance activists linked alcohol with a lack of patriotism. One argument was that grain could be better used to feed the troops. The Eighteenth Amendment (Prohibition) had been sent to the states for ratification in December 1917. Source: New Jersey Political Broadsides Collection, Special Collections and University Archives, Rutgers University Libraries.

VOTE THIS WAY FOR DECENCY'S SAKE!

LISTEN!
DOOM OF BOOZE NEAR!

PATRIOTS, PROGRESSIVES, PROHIBITIONISTS,

ATTENTION!

Shall we postpone the Liquor Question until 200,000 men are slain? Our greatest enemy and the strongest ally of Germany is the saloon. The Liquor Traffic is hindering our Government, prolonging the war, by wasting our food, destroying our munitions and man-power. If you would help our boys "go over the top" to win this war, vote this ticket. Forward-looking men will do it.

COUNTY TICKET
NATIONAL PROHIBITION PARTY

Members of Assembly	J. BROGNARD WRIGHT WILLIAM W. SELLERS JOHN R. DUNHAM
Freeholders	CHARLES FRANCIS END DAVID M. MEEKER EDWARD F. R. GOODWIN EMANUEL WILLIAMS WILLIAM P. COMPTON
Sheriff	HOWARD BLOODGOOD
Coroners	JAMES A. GRIMSTEED WILLIAM JOS. KORBONITS

Paid for by the Middlesex County Prohibition Committee.

TIMES JOB PRINT NEW BRUNSWICK, N. J.

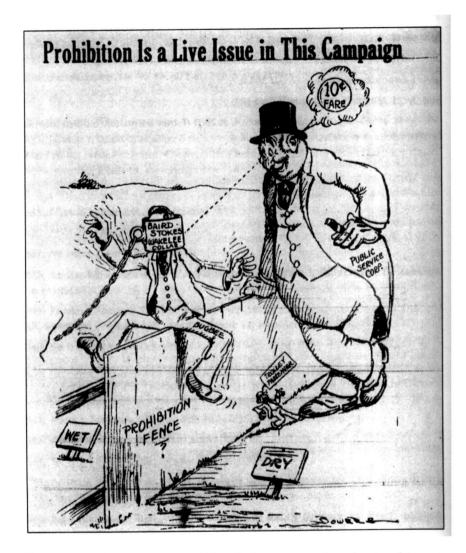

Election campaign cartoon, 1919. Although the necessary three-fourths of the states had ratified the Eighteenth Amendment by January 1919, Prohibition was still an issue in the so-called Applejack campaign that fall in New Jersey, which had not yet ratified the amendment. Democrat Edward Edwards (1863–1931) pledged to keep New Jersey as "wet as the ocean" and won with the support of the state's many immigrants, who were accustomed to drinking beer and wine. Source: *Newark Evening News*, October 17, 1919.

Black Tom explosion, July 30, 1916. The munitions depot on Black Tom Island off Jersey City sent supplies to England and its allies fighting World War I. It was destroyed by a massive explosion that was the work of German saboteurs. Source: Liberty State Park, New Jersey Division of Parks & Forestry.

soldiers unwitting brought with them a new threat, influenza. It began in mid-September 1918, and soon as much as 10 percent of the population was ill. The death rate was high—over 17,000 New Jerseyans lost their lives—and urban cemeteries could not keep up with the number of bodies that needed burial.

At the war's end, President Wilson traveled to Paris to take part in the peace negotiations. He hoped to prevent future conflicts by establishing an international organization, the League of Nations, to maintain world peace. However, the U.S. Senate refused to ratify the Treaty of Versailles or to join the League of Nations, in part because of a clause calling upon League members to defend others from attack. Frustrated, Wilson engaged in a national speaking tour to build popular support for his plan, during which he suffered

Holland America Line piers, Hoboken, c. 1905. Hoboken was a center for trans-Atlantic travel. When the United States entered World War I, it seized foreign ocean liners here and at other ports, and then converted them into troop ships to take soldiers to Europe. Source: Image LC-DIG-det-4a06885, Library of Congress, Prints and Photographs Division, Washington, D.C.

Camp Dix, 1918. Established in 1917 in South Jersey, the facility also served as an embarkation center for troops headed to Europe. Renamed Fort Dix in 1939, it continues to operate as Joint Base McGuire-Dix-Lakehurst. Source: Photograph by Harris & Ewing. Image LC-H261–24846, Library of Congress, Prints and Photographs Division, Washington, D.C.

a debilitating stroke. Consequently, the United States did not formalize peace with the Central Powers until 1921. Interestingly, the joint congressional Knox-Porter Resolution was signed by President Warren G. Harding in Raritan Borough at the home of Senator Joseph S. Frelinghuysen. Harding and Frelinghuysen were playing golf at a nearby country club when a courier delivered the resolution, which was signed with little fanfare. It seemed to signal a return to normalcy.

In the postwar period, women finally secured the right to vote, and Prohibition became the law of the land. Indeed, many women who fought for suffrage were also temperance advocates. Although a small number of female property holders had been able to vote under New Jersey's first state constitution in 1776, this right was later revoked. For nearly 150 years, women fought to regain what had been lost. In 1858, for example, Lucy Stone protested against "taxation without representation" and refused to pay taxes to the city of Orange. Other women wanted to vote in local elections and have a say in school matters. Some were outraged that immigrant men could vote while they could not. Progress was painfully slow. Lillian Feickert provided strong leadership for the New Jersey Woman Suffrage Association in the 1910s. Other leaders in the movement included Alice Paul, who pointed to the inconsistency in President Wilson's calls for democracy overseas. In February 1920, the New Jersey State Senate

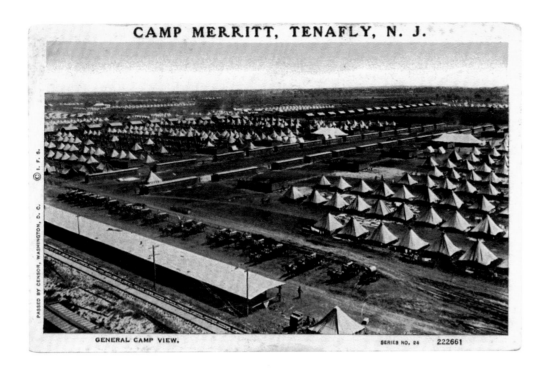

CAMP MERRITT, TENAFLY, N. J.

GENERAL CAMP VIEW.

SERIES NO. 24 222661

View of Camp Merritt, Tenafly. Named for General Wesley Merritt, who fought in Civil War, this facility was built in Bergen County to train soldiers for World War I. It included 1,300 buildings, and more than a million soldiers passed through it. It was decommissioned and dismantled after the war. Source: Postcard by Sackett & Wilhelms Corp., New York and Brooklyn; postmarked January 31, 1918. New Jersey Postcards Collection, Special Collections and University Archives, Rutgers University Libraries.

ratified the Nineteenth Amendment, which was added to the U.S. Constitution six months later, guaranteeing women the right to vote.

Ratification of the Eighteenth Amendment, establishing Prohibition, had already been certified in January 1919, although New Jersey did not ratify it until March 1922, the last state to do so. Neither Republicans nor Democrats supported the act. Indeed, Governor Edward I. Edwards ran on a platform promising to keep New Jersey "as wet as the Atlantic Ocean." Prohibition failed to curtail alcohol consumption and led to the growth of organized crime. Shore resorts increasingly came to be controlled by political bosses, including Atlantic City's Enoch L. (Nucky) Johnson. Soon, rum runners were smuggling booze into inlets up and down the Jersey coast.

Automobiles became more common, and in 1921 the Port Authority of New York and New Jersey was

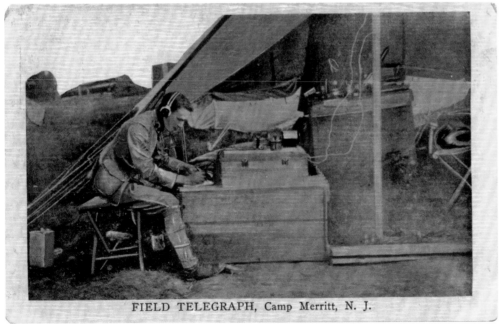

FIELD TELEGRAPH, Camp Merritt, N. J.

Field telegraph, Camp Merritt, Tenafly. Source: Postcard by S. K. Simon, New York. New Jersey Postcards Collection, Special Collections and University Archives, Rutgers University Libraries.

Joseph P. Veit's map and chronology of the World War I battles where he served while in the 78th "Lightning" Division in Europe. Source: R. Veit Collection.

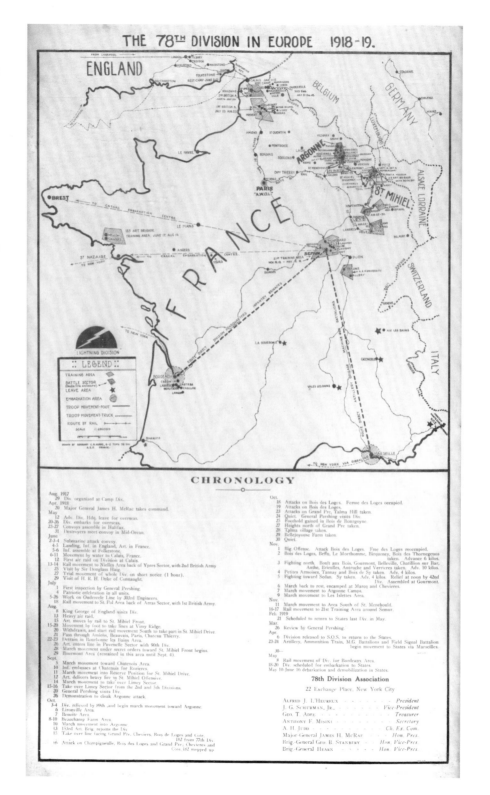

created to facilitate transportation and commerce in the area of the Port of New York. The Holland Tunnel, the George Washington Bridge, the Goethals Bridge, and the Outerbridge Crossing connected New Jersey to New York. Highways, such as Route 1, were vital transportation routes. Always a transportation state, New Jersey was even more deeply integrated into the nation's transportation networks, and the macadam arteries that would carry commuters to the suburbs in the years after World War II were already were expanding.

BIBLIOGRAPHY

For a thorough treatment of this period, see Brian Greenberg, "The Progressive Era," in *New Jersey: A History of the Garden State*, ed. Maxine N. Lurie and Richard Veit (New Brunswick: Rutgers University Press, 2012). New Jersey during World War I is treated in Mark Lender, *One State in Arms: A Short Military History of New Jersey* (Trenton: New Jersey Historical Commission, 1991). Joan Burstyn, *Past and Promise: Lives of New Jersey Women* (Syracuse, N.Y.: Syracuse University Press, 1997), is an excellent source on the struggle for the vote. Alice Paul and her contributions to this fight have been the subject of several recent treatments,

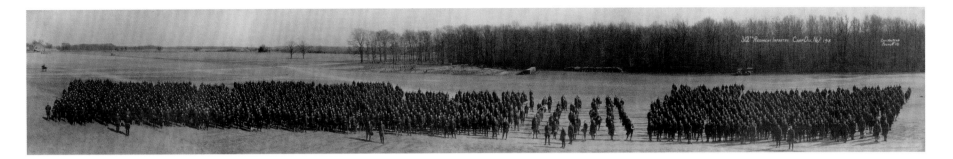

Joseph P. Veit's service unit, the 78th "Lightning" Division, during discharge at Camp Dix. The lineup includes gaps for those who died during the war. Source: R. Veit Collection.

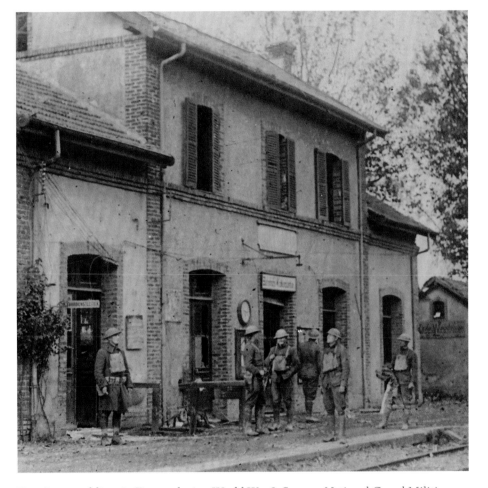

New Jersey soldiers in France during World War I. Source: National Guard Militia Museum of New Jersey, Sea Girt.

including Mary Walton, *A Woman's Crusade: Alice Paul and the Battle for the Ballot* (New York: Palgrave Macmillan, 2010), and J. D. Jahniser and Amelia R. Fry, *Alice Paul: Claiming Power* (New York: Oxford University Press, 2014). New Jersey's governors are closely examined in Michael Birkner, Donald Linky, and Peter Mickulas, eds., *The Governors of New Jersey* (New Brunswick: Rutgers University Press, 2014). The rise of political bosses is examined in Steven Hart's *American Dictators: Frank Hague, Nucky Johnson, and the Perfection of the Urban Political Machine* (New Brunswick: Rutgers University Press, 2013). Douglas Shaw's *Immigration and Ethnicity in New Jersey History* (Trenton: New Jersey Historical Commission, 1994) provides a good introduction to a complex topic. There are also numerous books on specific immigrant groups.

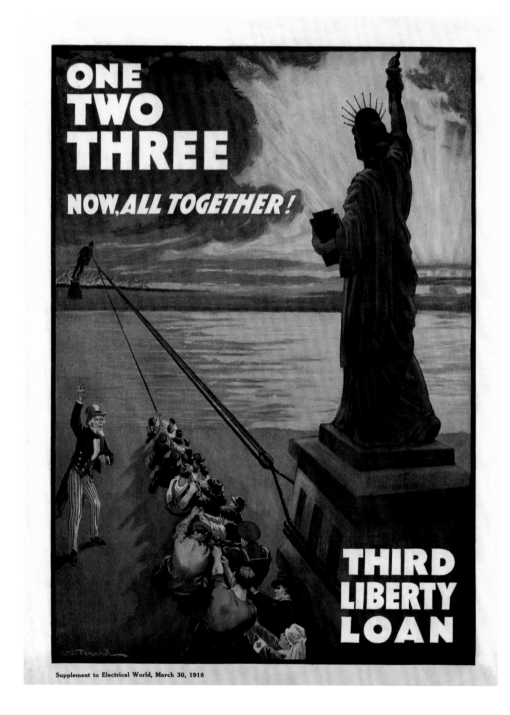

Supplement to Electrical World, March 30, 1918

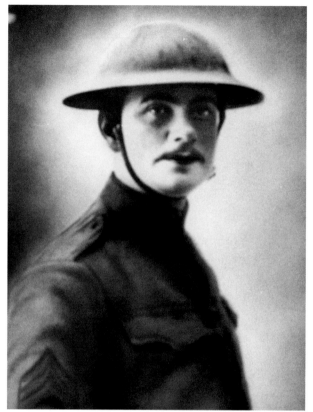

Alfred Joyce Kilmer (1886–1918) in his World War I uniform. Born in New Brunswick, the journalist and poet (best known for "Trees") was killed in action in Europe. Source: New Jersey Portraits Collection, Special Collections and University Archives, Rutgers University Libraries.

The U.S. Treasury issued securities during World War I to help finance the war and build patriotism. In this poster designed by Victor Perard (1870–1957), soldiers and citizens work together to bring down a statue of Kaiser Wilhelm II. Source: Supplement to *Electrical World*, March 30, 1918. World War I Poster Collection, Special Collections and University Archives, Rutgers University Libraries.

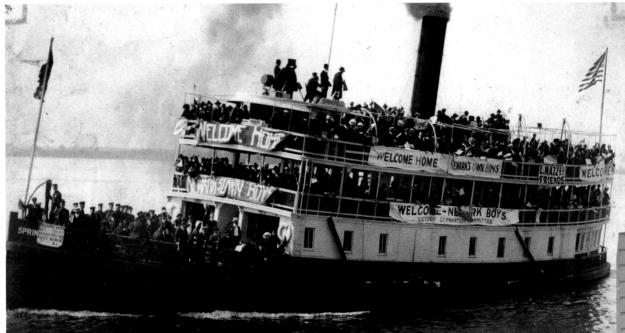

Returning troops arriving in Newark on a ferry festooned with welcome banners, 1919. Source: National Guard Militia Museum of New Jersey, Sea Girt.

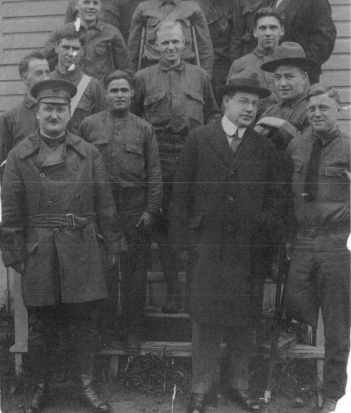

Dr. Fred H. Albee (far left) and Governor Walter Edge (in overcoat) with convalescing soldiers at U.S. General Hospital No. 3, Colonia, Middlesex County, May 13, 1919. Dr. Albee (1876–1945), medical director of the hospital, invented the surgical technique of bone grafting and was a pioneer of physical, psychological, and occupational rehabilitation. According to text attached to the photograph, "With the exception of the officer in the campaign hat in the doorway, all the soldiers are legless men who have crowded out of the 'gym' to get in the picture. Just behind Major Albee stands, at attention, a soldier who is just getting used to walking with an artificial leg without crutch or cane." Source: Twentieth Century 1910–1919 folder, Photo Lab 6014. The Newark Public Library.

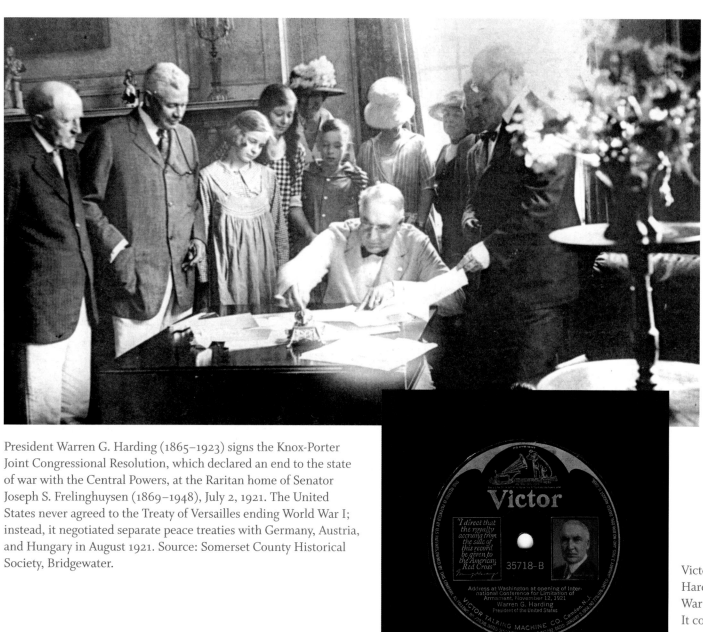

President Warren G. Harding (1865–1923) signs the Knox-Porter Joint Congressional Resolution, which declared an end to the state of war with the Central Powers, at the Raritan home of Senator Joseph S. Frelinghuysen (1869–1948), July 2, 1921. The United States never agreed to the Treaty of Versailles ending World War I; instead, it negotiated separate peace treaties with Germany, Austria, and Hungary in August 1921. Source: Somerset County Historical Society, Bridgewater.

Victor recording of President Warren G. Harding's address at the Ceremony for War Dead held at Hoboken, May 23, 1921. It commemorates the return for burial of 5,212 American soldiers, sailors, marines, and nurses. Royalties from sales of this record were to go to the Red Cross. Source: Hoboken Historical Museum.

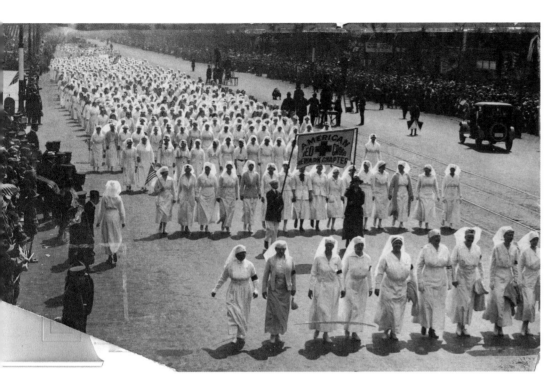

Red Cross nurses marching in Newark in 1918 at the end of World War I. Source: The Newark Public Library.

A South River victim of the influenza pandemic of 1918–1919 was taken to the cemetery in a beer wagon because there was a shortage of hearses. A handwritten note on the back of this photograph says that carpenters worked twenty-four hours a day preparing wooden caskets. It is estimated that this outbreak killed between 50 and 100 million people worldwide, far more than died as a result of World War I. A New Jersey public health report of December 1918, before the epidemic was over, stated that there had been about 225,000 reported cases and 10,090 deaths in the state, most of them in October. Source: Paul A. Schack Collection (MC 675), photographs box 4, folder 15. Special Collections and University Archives, Rutgers University Libraries.

John Cotton Dana (1856–1929) converted the fourth floor of the Newark Public Library into an exhibition space and encouraged local citizens to loan items from their personal collections. The success of the exhibitions he organized led to the founding of the Newark Museum. Source: Rockwell Collection, 1908. The Newark Museum.

When Mabel Smith Douglass (1877–1933) began her campaign for higher education for women, she pointed out that New Jersey was the only state lacking a publicly funded college for women. The New Jersey College for Women opened in 1918 with fifty-four students and Douglass as its founding dean. The college was later renamed for her. Today it is a residential division of Rutgers University. Source: R PHOTO, Portraits, Faculty & Staff, box 4. Special Collections and University Archives, Rutgers University Libraries.

John Cotton Dana (1856–1929), director of the Newark Public Library from 1902 to 1929, believed that libraries should serve the public and reached out to immigrants, children, teachers, and business people. Source: Photograph, c. 1920s. The Newark Museum.

Mail is loaded onto an airplane at Hadley Airfield, South Plainfield, 1920s. The first transcontinental night airmail flight took off from Hadley in July 1925. Closed in 1968, the field is now the location of a shopping mall. Source: South Plainfield Historical Society.

Rosenkrans ferry, Sussex County, 1936. The ferry was started in 1898 and continued to carry traffic across the Delaware River until 1945. Source: New Jersey Division of Parks and Forestry, Bass River State Forest.

Auto shop at the Bordentown School, c. 1930s. The facility eventually included two working farms and more than thirty trade, academic, and residential buildings. Source: Department of Education, Bordentown Manual Training and Industrial School for Colored Youth, Photographs, c. 1930s–1950s, item 25. New Jersey State Archives, Department of State.

A view of the bulkhead of the south tube of the Holland Tunnel under construction, April 7, 1923. The tunnels and bridges constructed in the first half of the twentieth century slowly replaced ferries and opened New Jersey for further development. Source: Image 435226, Photographs of the Construction of the Holland Tunnel, 1919–1927, New Jersey Interstate Bridge & Tunnel Commission. Science, Industry & Business Library, The New York Public Library, Astor, Lenox and Tilden Foundations.

Administration building of the Bordentown School, date unknown. The coeducational school was founded in New Brunswick in 1886 by the Reverend Walter A. Rice, a college-educated former slave who had volunteered with the Union army in the Civil War. The school moved to a 400-acre campus in Bordentown, where, under state sponsorship, it provided academic and vocational courses for the male and female African American students who boarded there. Efforts to integrate the school in compliance with the state constitution of 1947 and federal court decisions failed, and the school closed in 1955. Source: Department of Education, Bordentown Manual Training and Industrial School for Colored Youth, Photographs, c. 1930s–1950s, item 1a. New Jersey State Archives, Department of State.

Employees of the U.S. Radium Corp. in Orange paint glow-in-the-dark numbers on the dials of wristwatches, 1920s. The radium in the paint caused horrific illness and death for many of the young women workers, who were told to lick the brushes to create the tiny numbers. The fate of the "radium girls" led to stronger federal workplace regulations. Source: Argonne National Laboratory, Argonne, Illinois.

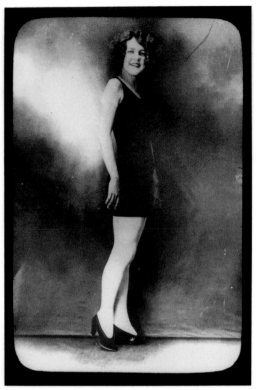

Margaret Gorman of Washington, D.C., was crowned the first Miss America in 1921. The Miss America Pageant originated as a way to bring visitors to Atlantic City after the summer season. Source: Lantern slide collection, 452. Atlantic County Historical Society, Somers Point.

Somerville High School football team, 1919. By the late nineteenth and early twentieth century, team sports were important for high school and college students, as well as those who came to watch. The Somerville team is also of interest because it was integrated. Source: Published with permission of the Somerville Public Library, a branch of the Somerset County Library System.

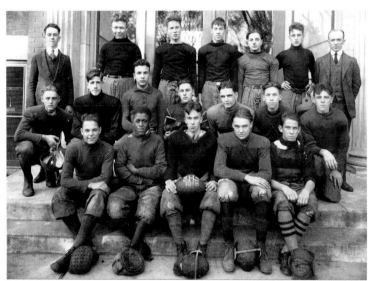

THE STATE HOME FOR FEEBLE MINDED WOMEN, VINELAND, N. J.

State Home for Feeble Minded Women, Vineland. This institution was founded in 1888 and supervised by Dr. Mary J. Dunlap (b. 1853), former director of the Trenton State Hospital. Across the street, a training school for developmentally disabled boys and girls opened a research laboratory in 1906, where Dr. Henry H. Goddard (1866–1957) conducted now discredited studies linking mental incapacity to genetic traits in certain immigrant groups. Source: Colored postcard. R. Veit Collection.

The Great
Depression and
World War II

The Great Depression and World War II transformed New Jersey. The 1920s brought transportation improvements, a booming economy, suffrage for women, and the introduction of Prohibition. Then the Depression shook New Jersey's political and economic foundations. Not until 1941 and America's entry into World War II did the economy return to full steam. By the end of the war, New Jersey was a very different place, with growing suburbs, an increasingly consumer-oriented economy, and advances in health care and technology. A new constitution soon followed. However, New Jersey remained deeply segregated, and its cities, long

centers of cultural life, political power, and manufacturing, were showing signs of decline.

The collapse of the New York stock market in October 1929 hit increasingly urbanized and heavily industrialized New Jersey hard. Banks closed and factories shuttered their doors. The textile mills of Paterson and Passaic laid off thousands of workers. By the early 1930s, employment was flagging and wages were rapidly dropping. Four hundred thousand people, nearly 25 percent of the state's workers, were unemployed by 1932. Some populations suffered more than others. African Americans and the young were particularly hard hit, but even skilled workers and the highly educated could not find jobs.

When the Depression began, Republican Herbert Hoover was president of the United States, and Morgan Larson, also a Republican, was governor of New Jersey. Engineers by training, both men were ill equipped to deal with the deepening crisis. Soon sardonically named Hoovervilles sprang up in the meadows between Newark and Jersey City, where the unemployed farmed and scrimped by. Some young men took to the rails, riding freight trains to other states in search of better opportunities. Many people found themselves with too much time on their hands. In 1930, Charles B. Darrow of Germantown, Pennsylvania, invented an engrossing game, Monopoly, based on his childhood vacations at the Jersey Shore.

Until 1931, there was no state aid to the unemployed, and many families survived on charity. Private institutions provided help where possible. Municipalities

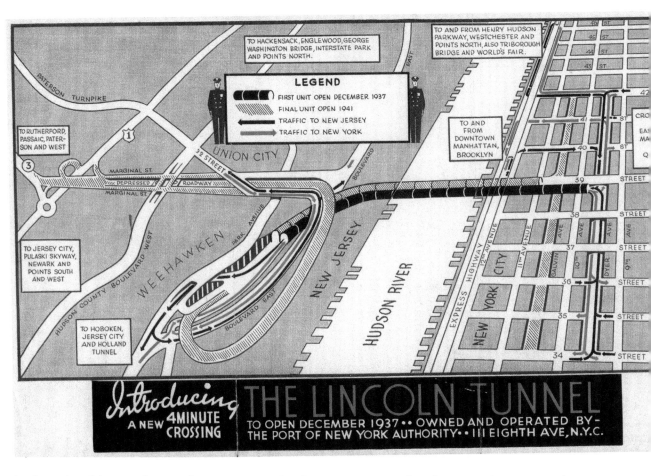

The first tube of the Lincoln Tunnel connecting Weehawken, New Jersey, and Midtown Manhattan opened in 1937. The construction of tunnels and bridges made transportation across the Hudson River faster and cheaper for commuters and commercial vehicles. Source: Courtesy of Peter O. Wacker.

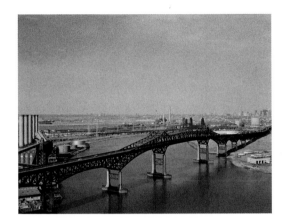

Long-distance view of the Pulaski Skyway's cantilever through truss over the Hackensack River. The movement of troops and supplies during World War I demonstrated the need for an extension of Route 1 from Elizabeth through Newark and Jersey City. The 3.5-mile skyway portion of the route spans the Meadowlands, the Hackensack and Passaic Rivers, and industrial sites in Kearney. It opened to traffic in 1932 and was named after Polish General Casimir Pulaski, who served in the Continental Army during the American Revolution. Source: Historic American Engineering Record Collection, HAER NJ,9-JERCI,10–5, Library of Congress, Prints and Photographs Division, Washington, D.C.

Newark Airport Commissioner Parnell signals the start of TWA's overnight passenger service from Newark to Los Angeles, 1934. Source: Photograph by Doren Print. Newark Airport, 1929–1939 folder. The Newark Public Library.

The town of Grovers Mill commemorated the fiftieth anniversary of the "War of the Worlds" radio broadcast, October 30, 1938, with a plaque created by Thomas Jay Warren (b. 1958). Heightened fears of potential war in Europe led some listeners to believe that Martians had indeed landed at Grovers Mill and were spreading death and destruction on their way to New York. The plaque shows actor/director Orson Welles at a microphone, a space ship, and an alarmed family listening to the broadcast. Photograph by R. Veit.

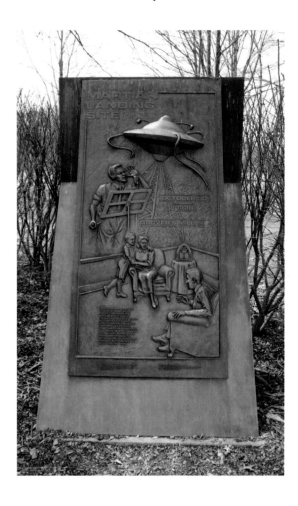

generally lacked sufficient resources to provide support and were often stingy and slow to respond. One of the first formal attempts to put the unemployed to work occurred in November 1930, when Bergen County hired unemployed men to work on road improvement projects. Thousands more applied for work than could be employed. By October 1932, the state's Emergency Relief Administration, created just a year earlier, was assisting 300,000 persons at a cost of $1.2 million per month.

The election of Franklin Roosevelt as president brought hope but not immediate relief. In 1933, within months of his inauguration, Roosevelt created the Federal Emergency Relief Administration (FERA). Under its leadership, states were charged with developing acceptable assistance plans. Ultimately, 30,000 New Jerseyans worked for FERA-funded projects. Roosevelt also sought to bring business, labor, and government together under the National Recovery

Picking up firewood at City Engine Co. No. 14, McWhorter and Vesey Streets, Newark, during the Great Depression. Source: Newark History, 1920–1939 folder. The Newark Public Library.

Administration to regulate prices, wages, and business competition. Roosevelt-era legislation, known collectively as the New Deal, helped many New Jerseyans survive during the darkest hours of the Depression. Some of these programs, most notably Social Security, continue today.

In early 1933, just as Roosevelt was taking office, many banks ran out of money in the face of massive withdrawals. On March 6, two days after his inauguration, Roosevelt declared a bank holiday to give the nation's financial system time to reorganize. Until the strongest banks began to reopen gradually a week or more later, there were serious shortages of cash, so severe that communities such as Newark and Long Branch printed their own emergency scrip, a form of locally valid paper money. Ultimately, more than 140 New Jersey banks folded, taking their depositors' savings with them. On a happier note for many New Jerseyans, Prohibition, which the state had never fully supported, was repealed in 1933.

On the local level, A. Harry Moore, who had served as governor from 1926 to 1929, was reelected to a new term beginning in 1932 (he would serve again from 1938 to 1941, the only governor of New Jersey elected to three nonconsecutive terms). Moore, a Democrat, was an ally of Frank Hague, Jersey City's powerful political

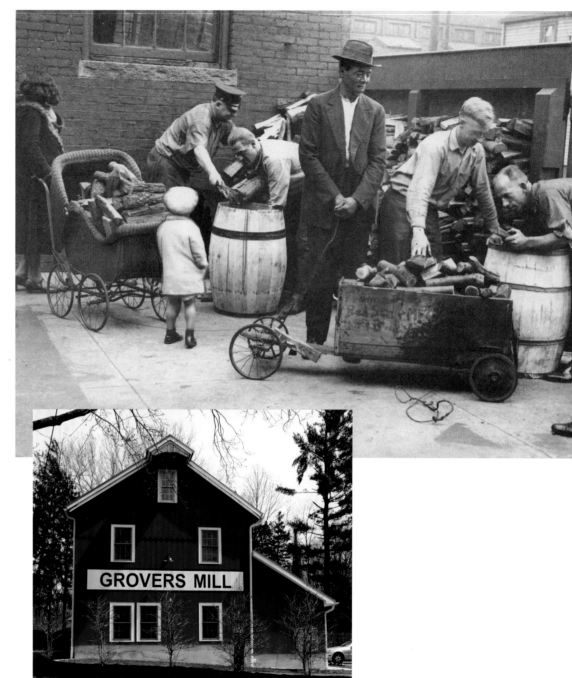

A red barn at Grovers Mill indicates the still rural nature of this small town in 2014. Photograph by R. Veit.

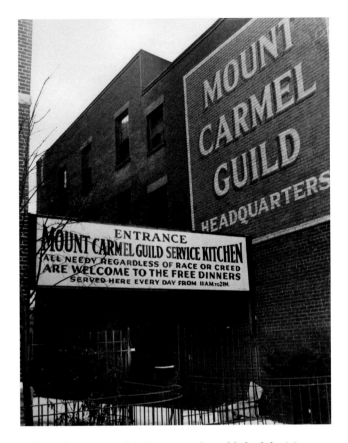

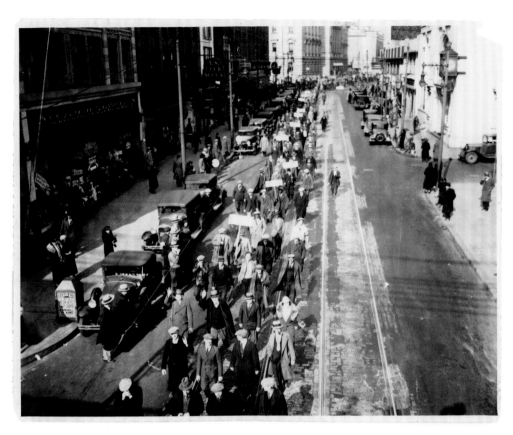

Bishop Thomas J. Walsh (1873–1952) established the Mount Carmel Guild in Newark in 1911 to serve the needy of his Catholic archdiocese. During the Great Depression, the soup kitchen in the basement of Saint Patrick's Pro-Cathedral served more than 1.6 million meals to people of all faiths. Source: Monsignor William Noé Field Archives & Special Collections Center, Seton Hall University, South Orange. Courtesy of the New Jersey Catholic Historical Commission.

March of the Unemployed Union of New Jersey, Camden, 1935. The union lobbied local government officials for housing projects that would give work to the unemployed and provide decent shelter for the homeless. Source: Photograph 92–24. Franklin D. Roosevelt Presidential Library and Museum, Hyde Park, New York.

boss. Hague initially supported Al Smith in the campaign for the Democratic nomination for president; but when Roosevelt was selected, Hague helped him by organizing the largest political rally in the United States up to that time. It occurred in Sea Girt, where the National Guard trained and New Jersey's governors summered, and drew more than 100,000 spectators, many of whom were brought by train from Hudson County. Although Roosevelt disliked Hague, the election year assistance did not go unnoticed, and Hague supporters eventually came to direct many of the employment efforts funded by the federal Works Progress (later Projects) Administration (WPA) in New Jersey. Moreover, Hudson County received funding for Hague's pet projects, including the construction of

Roosevelt Stadium and the expansion of the Jersey City Medical Complex. The hospital, which provided free medical care to city residents, was an important part of Hague's efforts to win the hearts of his constituents. During the 1930s, Hague remained the most potent political force in the state.

In 1934, the last year of his governorship, Harry Moore ran for and won a seat in the U.S. Senate, and Republican Harold Hoffman of South Amboy was elected to the governorship. Under his watch, the state Emergency Relief Administration was forced to close for lack of funding, and full responsibility for relief fell to local governments. The results were often tragic, as municipalities struggled to determine who deserved public relief. In one particularly noteworthy case, Hoboken's stingy and abusive poormaster was killed in a scuffle with an unemployed mason. However, Hoffman is perhaps best remembered for his involvement in the trial of Bruno Richard Hauptmann, the accused kidnapper of Charles Lindbergh Jr., son of the famed pilot.

The child was kidnapped from the Lindberghs' Sourland Mountain home on March 1, 1932, and his body was discovered in nearby Hopewell on May 12. Evidence led to the arrest of Bruno Richard Hauptmann, a German-born carpenter living in the Bronx, followed by a sensational trial in Flemington, his

On April 21, 1936, a group calling itself the Workers' Alliance of New Jersey took over the assembly chambers in Trenton and remained there for eight days. The state Emergency Relief Administration had run out of funds and closed the week before, leaving many families desperate. The self-proclaimed Army of Unoccupation demanded action from the legislature. The crisis ended when the state allocated estate tax revenue for aid. Source: Joseph Bilby Collection.

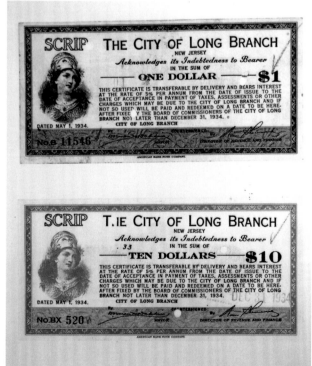

Long Branch City scrip used during the Depression. A number of towns and cities ran out of money and substituted scrip. Source: Local History Room, Long Branch Free Public Library.

Banners at Republican Party headquarters in Newark for candidates Hamilton Fish Kean (U.S. senator), Morgan F. Larsen (governor), and Herbert Hoover and Charles Curtis (U.S. president and vice president), October 1, 1928. Source: Photograph by Belden and Company. Newark History, 1920–1939 folder. The Newark Public Library.

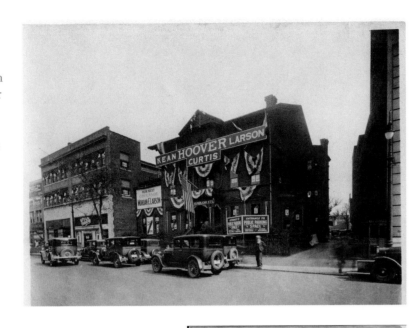

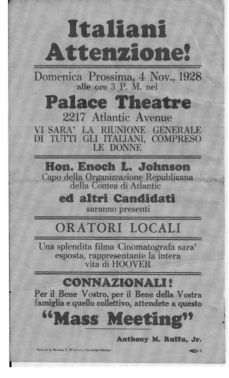

Italian-language notice of a meeting where Enoch L. Johnson, head of the Republican Party in Atlantic County, and candidates would speak on the Sunday before the 1928 election. "Nucky" Johnson (1883–1968) was the political boss of Atlantic City and notorious for his lifestyle and involvement in bootlegging, gambling, and prostitution. He was tried and convicted of tax evasion in 1941. Source: From the Vallozza Family. Courtesy of Karen Schmelzkopf.

conviction, and a sentence of death. Governor Hoffman, convinced that Hauptmann could not have managed the kidnapping alone, stayed his execution and ordered Colonel Herbert Norman Schwartzkopf, first superintendent of the New Jersey State Police, to conduction a further investigation. No new evidence was found.

Organized labor was a major bone of contention between Franklin Roosevelt and Frank Hague. While Roosevelt supported the National Labor Relations Act of 1935, which allowed workers to organize and strike, Hague fought labor unions and their potential threat to business in Hudson County. He particularly aimed unlawful tactics against the Congress of Industrial Organizations, formed in 1935 to represent unskilled laborers. When Norman Thomas visited Jersey City in 1938 to speak as the Socialist Party candidate for president, the police hustled him away and deposited him at the New York ferry. However, Boss Hague also supported Mary Teresa Norton, the first woman Democrat elected to the U.S. Congress without having been preceded by her husband. She had a long and distinguished legislative career.

The ongoing lack of job opportunities during the Depression encouraged students to remain in high school and college longer. The state's teacher colleges extended their curricula from two to three and eventually four years. Teachers themselves, dependent upon municipal budgets, were often paid in scrip. In 1933, the state Emergency Relief Administration opened six junior colleges. Attendance was impressive, with

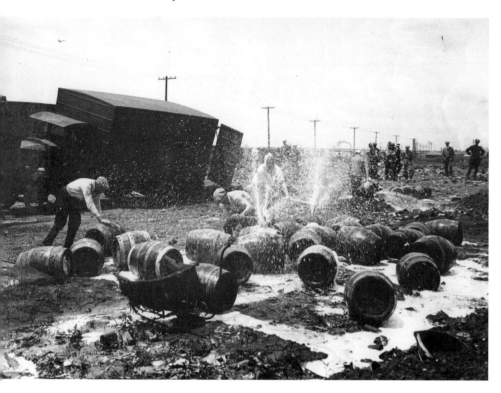

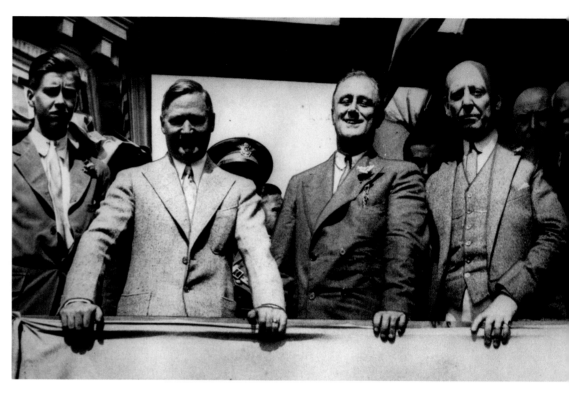

U.S. marshals destroying bootleg beer in the Newark Meadows. Source: Newark History, 1920–1939 folder. The Newark Public Library.

Franklin Delano Roosevelt (1882–1945) launched his national presidential campaign at Sea Girt in August 1932. Jersey City mayor Frank Hague (on FDR's left) had promised to turn out a large crowd, and his ability to do so (and then their votes) gave him political clout during the New Deal. An estimated 100,000 attended. Source: Franklin D. Roosevelt Presidential Library and Museum, Hyde Park, New York.

2,500 young men and women enrolled in the first year. Often they met in high schools; for instance, Monmouth College met in Long Branch High School. The credits students received were deemed emergency credits, which could later be transferred to four-year colleges and universities. Two of the ERA colleges survive today as Union County College and Monmouth University.

Other young people found work and a modest wage through the Civilian Conservation Corps (CCC). The CCC enrolled young men between the ages of eighteen and twenty-five; they were housed, fed, and clothed, often using army surplus materials. Their projects were designed to be "simple work not interfering with normal employment." Stationed at camps across the state, the

CCC improved parks and engaged in forestry projects. At Morristown National Historical Park, archaeologists from the National Park Service, assisted by CCC laborers, carried out extensive excavations to identify the sites of soldiers' huts associated with the Revolutionary War encampments.

Unlike the CCC, the WPA employed both men and women, who lived at home. With a mandate to undertake projects benefiting the public good, the WPA hired more than 100,000 New Jerseyans, including some African Americans, to improve military facilities, drain marshes, and construct schools, parks, boardwalks, post offices, and highways. In 1936, the most extensive archaeological investigation of New Jersey's prehistoric past to date, the Indian Site Survey,

Election flyer put out by the Middlesex County Democratic Committee, c. 1932, urging citizens to vote for Franklin D. Roosevelt. Source: New Jersey Political Broadsides Collection, Special Collections and University Archives, Rutgers University Libraries.

Announcement of the opening of an exhibition of works sponsored by the Works Progress Administration at the Federal Art Gallery in Newark, c. 1936–1939. Source: Poster by Angelo Tartaglia. Image LC-USZC2–5291, Library of Congress, Prints and Photographs Division, Washington, D.C.

began. Associated with the WPA and led by Dorothy Cross, Allan H. Smith, and Nathaniel Knowles, the survey identified and recorded hundreds of prehistoric sites across the state, sampled many of them, and carried out extensive fieldwork at the Abbott Farm.

Other federal programs also contributed to our understanding of New Jersey's past, including the Federal Writers Project, which produced a comprehensive guide to the state. At the same time, historic manuscripts were surveyed and oral histories carried out in immigrant communities. The Historic American Buildings Survey assigned unemployed architects to document the state's architectural heritage through photographs and line drawings, while the Federal Art Project installed dozens of murals, often with historical themes, at post offices.

Aerial Map, 1936–1937. The Federal Art Project of the Works Progress Administration hired hundreds of artists during the Depression to create works for public spaces. Arshile Gorky (1904–1948), an Armenian immigrant known for his abstract paintings, prepared ten large-scale murals for the Art Deco Administration Building at Newark Airport. Only two survive. Source: Oil on canvas, 79 x 123 1/2 in. On extended loan from the collection of the Port Authority of New York & New Jersey (L1.1983.1) at The Newark Museum.

Anti-Hague cartoon, 1929. Joseph Dear, editor of the *Jersey Journal*, originally supported Frank Hague as a reform politician but came to view him as an unprincipled autocrat. In the municipal elections of 1929, the newspaper endorsed the opponents of "King Frank, the Last." Hague survived the challenge, however, and used patronage during the New Deal to provide jobs and to maintain power until he retired in 1947. Source: *Jersey Journal*, April 18, 1929. Jersey City Free Public Library.

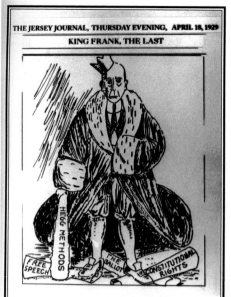

In western Monmouth County, an unusual agricultural-industrial cooperative community was established as part of the federal government's attempt to decentralize industry and enable workers to improve their standard of living through subsistence farming. Jersey Homesteads was the only such planned community intended for urban Jewish garment workers. Led by Benjamin Brown, a Jewish immigrant from Russia, the settlement was seen as a place where Jewish culture could be preserved. Its Bauhaus-style houses were laid out so as to maximize open space. Artist Ben Shahn created a noteworthy mural that still adorns the public elementary school today. In 1945, the community changed its name to Roosevelt to honor the president whose programs made it possible.

Although African Americans faced segregation and discrimination, the New Deal programs provided some employment opportunities. Some gains were also made in terms of political representation. In 1921, Walter G. Alexander of Essex County became the state's first black assemblyman, and in 1936, Democrat Walter Moorehead was elected to the same body.

Frank Hague (1876–1956) accepts the congratulations of citizens upon his election as mayor of Jersey City in 1917. Hague began as a reformer and served as mayor for thirty years, becoming the most famous of New Jersey's political bosses. Source: Jersey City Free Public Library.

Planned in 1931, the Jersey City Medical Center was completed with New Deal funds, and President Franklin Roosevelt attended the 1936 dedication. The large complex included the Margaret Hague Maternity Center, named for Mayor Frank Hague's mother. Source: Drawing for a 1931 brochure. Jersey City Free Public Library.

In 1940, Charles Edison successfully ran for governor of New Jersey. The son of the famous inventor distanced himself from Hague's pernicious influence and began to campaign for a new state constitution. But war in Europe overshadowed these efforts. Already, the rise of fascism in Germany and Italy had inspired some members of New Jersey's large German American population to join the national Friends of New Germany and later the German American Bund. These Nazi sympathizers met at Camp Nordland in Andover, Sussex County, and at Camp Bergwald in Bloomingdale, where they declared loyalty to Adolf Hitler and blamed America's troubles on Jews, African Americans, and socialists. In an attempt to curtail the group's activities, the state legislature passed laws limiting hate speech by pro-Nazi groups. Less formally, Jewish mobsters supported the Minutemen, who disrupted meetings of the Bund. When the United States entered World War II, many Bund leaders were arrested and a few prosecuted.

Civilian Conservation Corp (CCC) workers replacing steps at the Guerin House in Jockey Hollow, Morristown National Historical Park. The CCC provided jobs and training for young men during the Great Depression, and part of their pay was sent home to help their families. Source: Morristown National Historical Park.

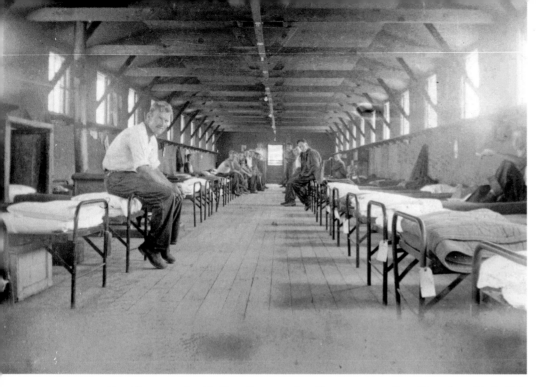

Bunkhouse at the Civilian Conservation Corps camp at Bass River State Park. This facility operated from 1933 until 1942, when the national program was disbanded. Workers were organized and housed in military style, 200 at a time. They worked on roads, bridges, ponds, and facilities in the park. Source: John Nisky Collection, New Jersey Division of Parks and Forestry, Bass River State Forest.

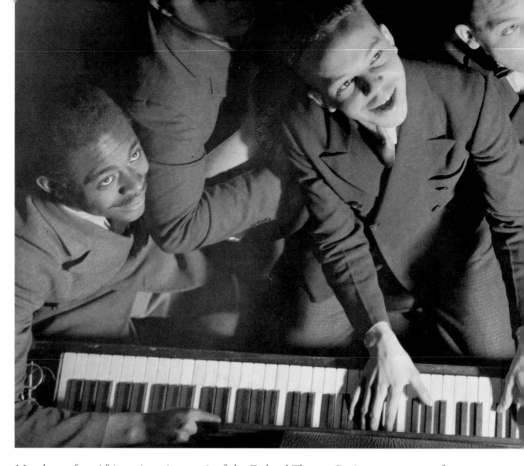

Members of an African American unit of the Federal Theatre Project, an agency of the Works Progress Administration, prepare for a production of *Brother Mose* in Newark, April 8, 1936. Source: Photograph 72115(1). Franklin D. Roosevelt Presidential Library and Museum, Hyde Park, New York.

Civilian Conservation Corp pennant. Source: Photograph by Peter Stemmer. Image courtesy of the New Jersey Division of Parks and Forestry, Bass River State Forest.

Refugees from Europe, including Albert Einstein, Erich Kahler, and Rabbi Joachim Prinz, fled the persecution that was spreading in Europe and resettled in New Jersey. Einstein was invited to become a life member at the newly founded Institute for Advanced Study in Princeton. Indeed, it was from Princeton that he wrote to President Roosevelt warning of the awesome potential of the atomic bomb.

Even before America officially entered World War II, industrial production of military goods had stepped up in New Jersey, creating broader employment opportunities. It seemed the economy was improving. In September 1940, with

Jersey Homesteads (now Roosevelt) was one of the experimental New Deal communities built for refugees of the Great Depression, providing homes and jobs. Jersey Homesteads was unique in that it was planned as an agro-industrial cooperative and established specifically for urban Jewish garment workers, mostly from the Lower East Side of Manhattan. Source: Joseph Bilby Collection.

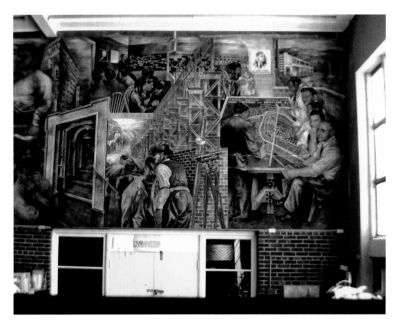

Mural for the Jersey Homesteads (now Roosevelt) elementary school. Ben Shahn (1898–1969) immigrated from Siberia at a young age, studied art, and became known for his social realist paintings. During the Great Depression, he produced public art for several New Deal agencies; in 1936, he was hired to create a mural depicting the founding of Jersey Homesteads. At right, architects lay out homes with garden plots surrounded by woods and farms. The mural can still be viewed in the Roosevelt school. Source: VAGA.

Albert Einstein (1879–1955) in his study at his home in Princeton, c. 1954. Einstein first visited Princeton in 1921, the year he won the Nobel Prize in Physics. Increasingly threatened as a Jewish scientist in Nazi Germany, he immigrated in late 1932 and settled in Princeton in 1933 as a life member of the newly founded Institute for Advanced Study. Einstein supported the Jersey Homesteads project, and his image is included in Ben Shahn's mural. Source: Photograph E-03, 1954. Alan Richards, photographer. From the Shelby White and Leon Levy Archives Center, Institute for Advanced Study, Princeton.

war spreading in Europe, Congress authorized the nation's first peacetime draft. Then, on December 7, 1941, Japan's attack on Pearl Harbor changed everything. The United States was at war. Ultimately, 560,501 New Jerseyans served in uniform, including about 10,000 women. More than 13,000 lost their lives, and 17 were awarded the Medal of Honor. Two of the most famous recipients were Marine Sergeant John Basilone from Raritan Borough and Captain Thomas G. McGuire of Ridgewood. Basilone was decorated for bravery at Guadalcanal.

Brought home to sell war bonds, he volunteered to return to service and was killed on Iwo Jima. McGuire was the second most successful American ace in the Pacific theater of the war. McGuire Air Force base was named after him in 1949. William "Bull" Halsey of Elizabeth was one of the navy's most successful admirals during the war, serving in the Pacific theater.

Women also contributed to the war effort. By the end of the war, Joy Bright Hancock of Wildwood commanded the WAVES (Women Accepted

Children wear a version of the Hitler Youth uniform during exercises at a German American Bund camp in northern New Jersey. Several New Jersey cities had sizable German immigrant populations, among whom were some active supporters of National Socialism. Source: Joseph Bilby Collection.

for Volunteer Emergency Service) and opened up new opportunities for women to participate in the navy. African Americans served with distinction in a segregated military. Many found themselves confined to engineering battalions where they fought the twin foes of prejudice and the Axis powers.

Although the war was fought overseas, its effects were clear in New Jersey. The Coast Guard established foot patrols along the lightly guarded coast, and the Civil Air Patrol and blimps from Naval Air Station Lakehurst searched the coastline for submarines. Sandy Hook's Fort Hancock was improved, and submarine spotting towers were erected at Cape May and elsewhere. Nonetheless, German submarines sank merchantmen and tankers with alarming frequency. Their work was sometimes helped by the bright lights of the boardwalk, which silhouetted ships along the shore.

Fort Dix became the major East Coast training center for over a million draftees. Camp Kilmer was an equally important center for troops departing for Europe. Hudson County's piers were packed with soldiers heading off to war. Boardwalk hotels in Asbury Park and Atlantic City were drafted into service as training centers, and recruits practiced storming

A flyer circulated by the Newark branch of the American League for Peace and Democracy warns against the pro-Nazi activities at the German American Bund's Camp Nordland in northwestern New Jersey. The short-lived league (1937–1939) adopted the slogan "Keep America Out of the War by Keeping War Out of the World." Source: New Jersey Political Broadsides Collection, Special Collections and University Archives, Rutgers University Libraries. Retouched.

In 1927, Charles Lindbergh (1902–1974) became the first pilot to fly nonstop from New York to Paris. He was one of the most celebrated men in the world when he was photographed at Caldwell Airport in the early 1930s. The Curtiss-Wright Propeller Division was located in Caldwell and was one of the largest employers in the area. Source: Caldwell folder. The Newark Public Library.

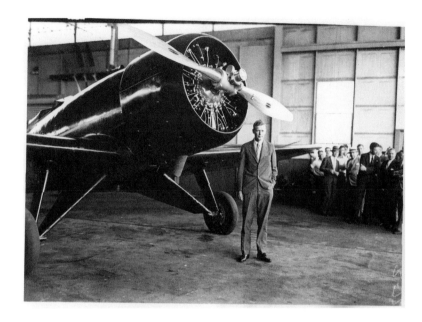

Photograph of Bruno Richard Hauptmann (1899–1936), prisoner 17400, taken on February 16, 1935, three days after he was convicted of the kidnapping and murder of Charles Lindbergh Jr. and sentenced to death. The "trial of the century," held at the Hunterdon County Courthouse in Flemington, attracted enormous publicity. Source: Department of Institutions and Agencies, New Jersey State Prison at Trenton, Inmate File #17400—Bruno Richard Hauptmann, 1934–1965, item 005. New Jersey State Archives, Department of State.

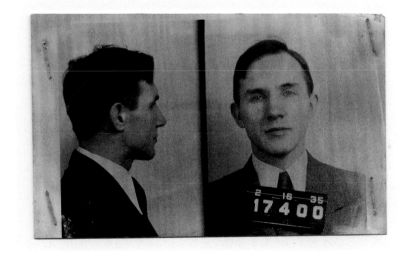

WANTED

INFORMATION AS TO THE WHEREABOUTS OF

CHAS. A. LINDBERGH, Jr.

OF HOPEWELL, N. J.

SON OF COL. CHAS. A. LINDBERGH

World-Famous Aviator

This child was kidnaped from his home in Hopewell, N. J., between 8 and 10 p. m. on Tuesday, March 1, 1932.

DESCRIPTION:

Age, 20 months Hair, blond, curly
Weight, 27 to 30 lbs. Eyes, dark blue
Height, 29 inches Complexion, light
Deep dimple in center of chin
Dressed in one-piece coverall night suit

ADDRESS ALL COMMUNICATIONS TO
COL. H. N. SCHWARZKOPF, TRENTON, N. J., or
COL. CHAS. A. LINDBERGH, HOPEWELL, N. J.

ALL COMMUNICATIONS WILL BE TREATED IN CONFIDENCE

March 11, 1932 COL. H. NORMAN SCHWARZKOPF
 Supt. New Jersey State Police, Trenton, N. J.

Poster circulated by the New Jersey State Police during the search for Charles Lindbergh Jr., March 11, 1932. The toddler had been taken from the family's home in Hopewell. Source: Department of Law & Public Safety, New Jersey State Police, Copies of Evidence Photographs—Trial of Bruno Hauptmann for Kidnapping of Charles A. Lindberg Jr., 1935. New Jersey State Archives, Department of State.

beaches in preparation for action overseas. Fort Monmouth hummed with engineers working on radar and communication devices, and enormous quantities of munitions were stored at Naval Ammunition Depot Earle. Airmen trained at airfields across the state, and in Linden the Eastern Aircraft Division of General Motors turned out thousands of warplanes.

War materials of every sort were produced in the state. Curtiss-Wright built airplane engines and parts in Paterson and Caldwell. The New York Shipbuilding Corporation in Camden turned out vessels ranging from landing craft to aircraft carriers, while Federal Shipbuilding in Kearney produced nearly one-fourth of all U.S. Navy destroyers. Housing for workers was in such short supply that as early as 1940 Congress passed the National Housing for Defense Act; Winfield Park was laid out in 1941 as a separate township on land taken from Linden and Clark. Although plagued by shoddy construction and cost overruns, the community provided housing for workers in the shipyards of Kearney. Following the war, the Winfield

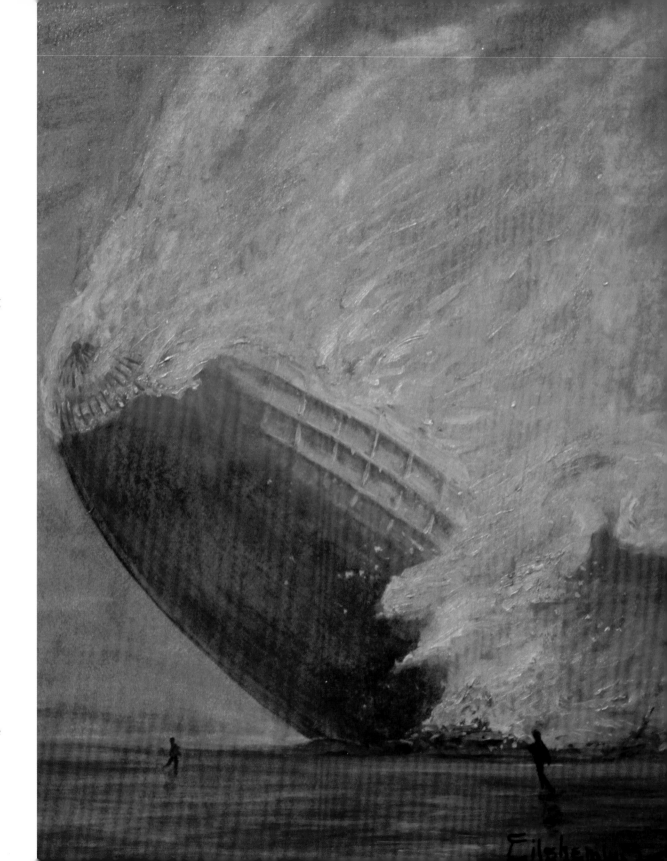

Zeppelin in Flames Over New Jersey, 1937. This painting is based on the May 6, 1937, explosion of the *Hindenburg*, a German dirigible, while mooring at Naval Air Station Lakehurst. The dramatic fire killed thirty-seven and was captured during a live radio broadcast as well as on film. Source: Oil on cardboard, 18 ½ x 15 ½ in., by Louis Eilshemius (1864–1941). Collection of the New Jersey State Museum. Museum Purchase, FA1969.159. Reproduced with permission.

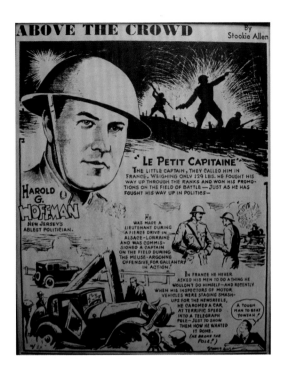

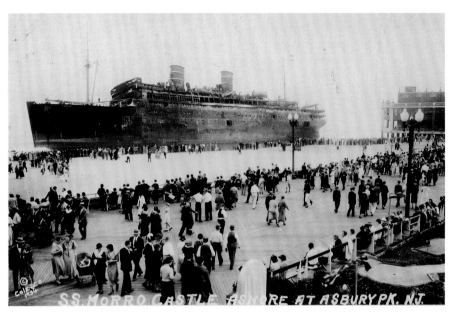

This cartoon lauds the bravery and honesty of Harold G. Hoffman (1896–1954), who was New Jersey's governor during the Lindbergh case. He had doubts about Bruno Hauptmann's guilt and visited him secretly on death row. Shortly before Hoffman's death, it was discovered that he had embezzled funds from the state. Source: Undated cartoon by Benjamin "Stookie" Allen (1903–1971). East Brunswick Museum.

S.S. *Morro Castle* ashore at Asbury Park, 1934. The cruise ship S.S. *Morro Castle* caught fire during a storm in the early morning hours of September 8, 1934, while returning to New York from Havana, Cuba. The power went out, and the crew failed to launch half the lifeboats; 137 passengers and crew died. After the burned wreck drifted ashore at Asbury Park, it became a popular tourist attraction. Source: Photograph by Cole & Co. New Jersey Miscellaneous Photographs, item SS Morro Castle. New Jersey State Archives, Department of State.

Mutual Housing Corporation leased the property from the Federal Housing Authority.

As the war ground on, rationing became widespread. Victory gardens were planted, and scrap metal drives became common. In 1942, Newark became the home of the Office of Dependency Benefits, which mailed out checks to the dependents of servicemen. The office was noteworthy not simply for the volume of mail it sent out each month, but also because it hired without

discrimination. Indeed, federal directives prohibited racial discrimination, and African Americans found ready work in war industries. At the same time, Bahamian and Jamaican farm workers helped fill labor shortages. In 1944, Seabrook Farms, an enormous producer of frozen, canned, and dehydrated foods in Cumberland County, began bringing in Japanese Americans released from West Coast internment camps. Conditions were only moderately better than those at the camps, and the workers continued to face prejudice and discrimination.

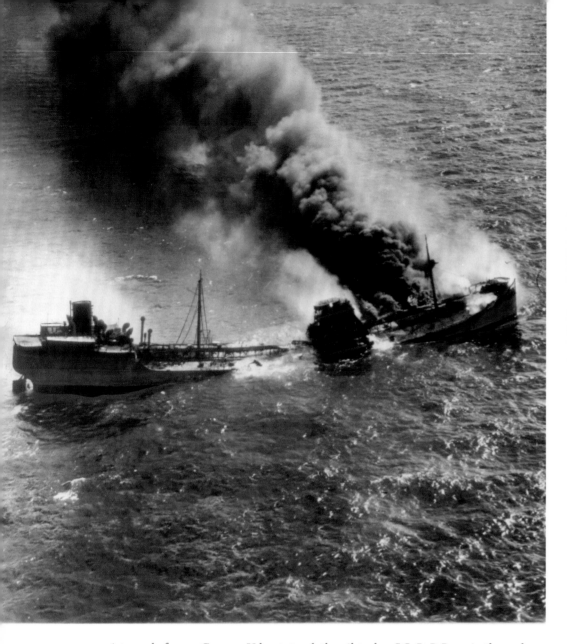

A torpedo from a German U-boat struck the oil tanker S.S. *R. P. Resor* in the early morning of February 27, 1942, about eighteen miles east of Lavallette. Only two of the forty-nine crew members were rescued from the flaming oil that covered the sea. This tanker had been built in 1936 by the Federal Shipbuilding and Drydock Company in Kearny for Standard Oil. German submarines hunted for shipping targets along the New Jersey coast with success in the early years of World War II. Source: Joseph Bilby Collection.

Governor Charles Edison (1890–1969) cutting a ribbon at Bayonne Naval Base Access Road, December 22, 1942. The Bayonne facility was opened by the navy in 1942 as a logistics and repair base connected to transportation networks. Source: Department of Transportation, Photographs Filed by Subject, c. 1920s–1970s, item Bayonne 001. New Jersey State Archives, Department of State.

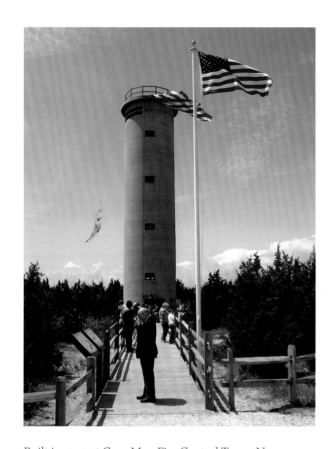

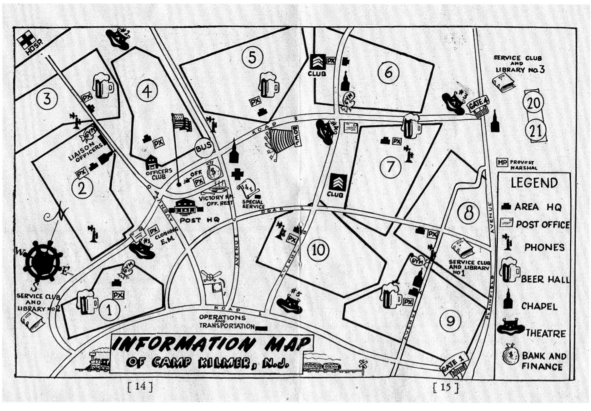

Built in 1942 at Cape May, Fire Control Tower No. 23 was one of fifteen towers designed to detect German submarines and guide the fire of coastal artillery batteries from North Wildwood to Bethany Beach, Delaware. It has been restored and is open to the public. Source: Mid-Atlantic Center for the Arts & Humanities, Cape May.

A soldier's guide to Camp Kilmer, 1946. Constructed in 1942 between Edison and Piscataway, the base named for the poet Joyce Kilmer, a casualty of World War I, processed soldiers on their way to the European front. By 1949, approximately 5 million men and women had passed through. After it closed, most of the land became part of Rutgers University. Source: Special Collections and University Archives, Rutgers University Libraries.

Ultimately, well over 2,000 Japanese worked at Seabrook, a community that lasted into the postwar period.

Women filled jobs formerly held by men in shipyards and factories. By the war's end, hundreds of thousands had worked in war industries. At the same time, college curricula were revamped to focus on engineering and management courses. Classrooms at Princeton and Drew University were filled with naval personnel training to be officers.

When the war ended in August 1945, New Jersey had changed irrevocably. Millions had worked in factories connected with the war, and half a million had served in the military. Wages were high, and there was great concern that a new depression

would begin. Instead, an era of unprecedented prosperity blossomed, based on a consumer economy.

Perhaps most importantly, New Jersey's political scene, long hampered by an antiquated state constitution and ruled by corrupt bosses, was about to be reformed. In the early 1940s, Walter E. Edge and Alfred Driscoll carried on Governor Charles Edison's earlier efforts to restructure the state government and prepare a new constitution. In 1947, a bipartisan constitutional convention met at Rutgers University and was instructed not to alter the boundaries of counties or the basis of representation in the state senate or assembly. The new constitution included many compromises but was a significant improvement over its precursor. The governor's term was increased from three to four years, and governors were permitted to succeed themselves once. The governor was also given greater veto power, and a two-thirds vote of the legislature was required to override a veto instead of the previous simple majority. What had been a byzantine system of agencies was condensed into twenty executive departments. Some of the greatest changes occurred in what had been the state's archaic judicial system. An efficient, well-organized court system, with the chief justice of the supreme court as the administrative head, was developed. Moreover, the new constitution included a bill of rights forbidding discrimination, and, in a nod to pressure from Mary Philbrook and Alice Paul, the word "persons" was substituted for "men" in the document.

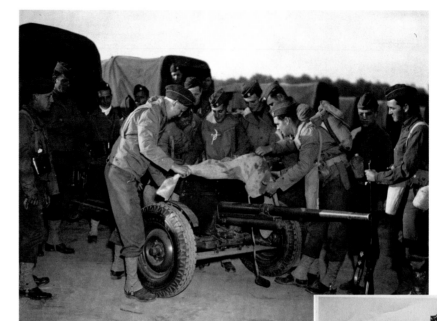

Soldiers of the 165th Field Artillery place a cover over a gun as they leave Fort Dix, May 1941. Source: Department of Defense, New Jersey National Guard, Photograph Collection, c. 1863–1973, item A336. New Jersey State Archives, Department of State.

Destroyer launching at Federal Shipbuilding, Newark, c. 1942. During World War II, New Jersey was a center for the production of ships, planes, military cars and trucks, and munitions. Source: Newark Industries folder, Photo Lab 11, 027. The Newark Public Library.

Lieutenant John Patrick Washington (1908–1943), Catholic chaplain, one of four chaplains who gave their life jackets to others and went down with the U.S.S. *Dorchester*, February 3, 1943. Source: Mass card. Monsignor William Noé Field Archives & Special Collections Center, Seton Hall University, South Orange. Courtesy of the New Jersey Catholic Historical Commission.

The importance of the new constitution cannot be understated. From a state with a weak governor, myriad agencies, and confusing judiciary, New Jersey was transformed into a state with a strong governor, relatively efficient departments, and a well-regulated judiciary. With a strong constitution, a well-established industrial base, growing suburbs, and an expanded automobile-based transportation network, life in New Jersey looked promising indeed.

BIBLIOGRAPHY

Some aspects of New Jersey's history during the Depression and World War II remain understudied. However, the era is receiving more scholarly attention, with a particular focus on crime and social unrest. A good overview is provided by G. Kurt Piehler, "Depression and War," in *New Jersey: History of the Garden State*, ed. Maxine N. Lurie and Richard Veit (New Brunswick: Rutgers University Press,

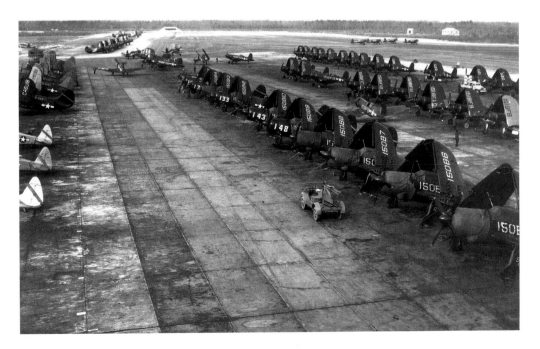

World War II navy planes (Helldivers and Corsairs) on a runway at Naval Air Station Wildwood. This was one of the bases in New Jersey that trained pilots. Source: Naval Air Station Wildwood Aviation Museum; original in the Naval Archives, Washington, D.C.

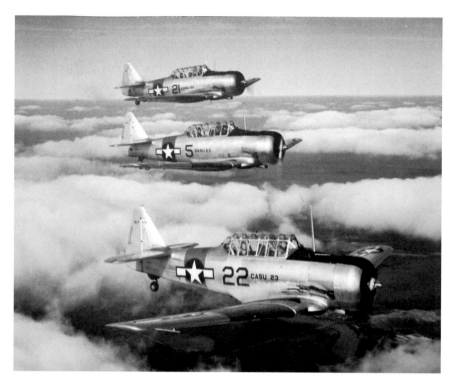

Three navy planes, SNJ advanced trainers, in the air over Cape May during World War II. One of the pilots, Al Timer, later lived in the county. Source: Naval Air Station Wildwood Aviation Museum; original in the Naval Archives, Washington, D.C.

An African American man moving a bomb at Naval Air Station Wildwood. Cooking, nursing, cleaning, and moving bombs were among the few navy jobs available to African Americans during World War II. Source: Naval Air Station Wildwood Aviation Museum; original in the Naval Archives, Washington, D.C.

2012). Important volumes include: Lloyd Gardner, , rev. ed. (New Brunswick: Rutgers University Press, 2012); Holly Metz, (Chicago: Lawrence Hill Books, 2012); Joseph G. Bilby, James Madden, and Harry Ziegler, (Charleston, S.C.: History Press, 2011); Nelson Johnson, (Medford, N.J.: Plexus, 2000); Johnson, (New Brunswick: Rutgers University Press, 2014); Steven Hart, (New York:

The New Press, 2007); and Hart, (New Brunswick: Rutgers University Press, 2013). A solid treatment of a New Jersey town during World War II is provided by Kevin Coyne in (New York: Viking, 2003). Perhaps the best overview of New Jersey's role in World War II is Mark Lender's chapter on the war in his volume (Trenton: New Jersey Historical Commission, 1991).

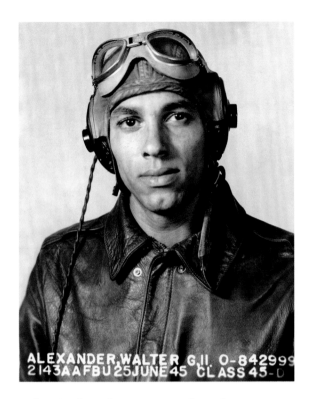

Walter G. Alexander II, Rutgers Class of 1943, was commissioned second lieutenant at Tuskegee Army Air Field, Alabama, in 1945. The war ended before he had a chance to fly in combat. After the war, he was a dentist in Orange, New Jersey. Source: Photograph dated September 28, 1945, Public Relations Office, Tuskegee AAF, Ala. University Archives Biographical Files (R-BIO)—RC 1943. Special Collections and University Archives, Rutgers University Libraries.

Admiral William F. "Bull" Halsey (1888–1959) eating Thanksgiving dinner with the crew of the U.S.S. *New Jersey* (BB62), November 30, 1944. Raised in New Jersey, Halsey commanded the Third Fleet in the Pacific theater of the war and was known for his slogan "Hit hard, hit fast, hit often." Source: U.S. Navy photograph no. 80-G-291498. National Archives and Records Administration, Washington, D.C.

U.S.S. Battleship *New Jersey* (BB62) was built at the Philadelphia Naval Yards and launched in 1942. It saw extensive action in the Pacific during World War II and later also served in Korea and Vietnam. The image here is from 1984, when *New Jersey* was stationed off Lebanon during the civil war there. Its sixteen-inch guns, Turret 1 and Turret 2, could accurately send a five-foot, 2,400-pound projectile twenty-three miles. America's most decorated battleship is now a museum located on the Camden waterfront. Source: Courtesy of Battleship New Jersey.

Sergeant John Basilone (1916–1945), who grew up in Raritan, served in the army and then, during World War II, in the marines. He was awarded the Medal of Honor for heroism at the Battle of Guadalcanal, returned to duty, and was killed in action at Iwo Jima. Source: *Collier's Magazine*, June 24, 1944. New Jersey Portraits Collection, Special Collections and University Archives, Rutgers University Libraries.

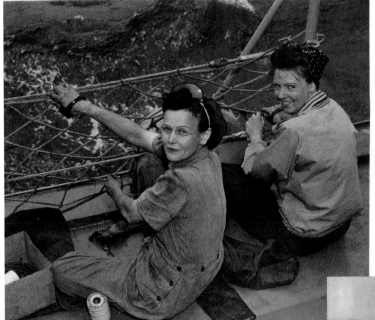

Ruth Mae Moy working on engine parts for American B-25 bombers in the Paterson plant of Wright Aeronautical Corporation, July 31, 1942. The B-25s were used in the Doolittle raid, April 18, 1942, the first American attack on mainland Japan. This American-born Chinese woman had been visiting Canton when it was bombed by Japanese planes in 1938. At the time of this photograph, her "sweetheart" was a pilot in the Chinese Air Force. Source: Joseph Bilby Collection

Women war workers at Federal Shipbuilding in Newark, 1943. During the war, many manufacturing jobs usually held by men were filled by women. Source: Newark History, Twentieth Century World War II 1939–1945 folder. The Newark Public Library.

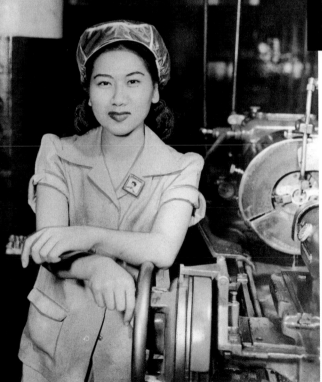

An African American man checking the size and shape of a blade at the Curtiss-Wright Propeller Division, Caldwell, 1942. The need for workers during the war opened manufacturing jobs to minorities. Source: Photograph by Howard Liberman, Office of Emergency Management. Image LC-USE6-D-004357, Library of Congress, Prints and Photographs Division, Washington, D.C.

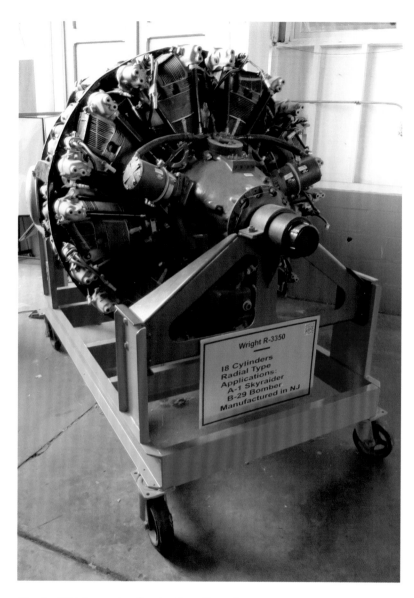

Curtiss-Wright engine for the B-29 Superfortress bomber, built in New Jersey. Source: Courtesy of Dr. Joseph Salvatore, Naval Air Station Wildwood.

"Two Female Air Raid Wardens on Duty." The Japanese bombing of Pearl Harbor raised fears of attack on the American mainland by air or sea. Millions of volunteers worked in local and state civil defense organizations. Source: *Newark Evening News*, April 16, 1942. Newark History, Twentieth Century World War II 1939–1945 folder. The Newark Public Library.

Japanese schoolchildren at Seabrook Farms saluting the American flag, c. 1945. Seabrook Farms processed large quantities of vegetables for the military during the war, and some of its labor needs were met by Japanese Americans released from internment camps in the West. When the war ended, a number of families stayed in South Jersey. Source: Seabrook Educational and Cultural Center.

German prisoners of war (with POW on their pants) working at Mount Pleasant Orchards, Richwood, c. 1944. Farm owner Louis Reuter Sr. stands at the far right; his son Milton Reuter is third from the left. Source: Reuter-Bilewicz Collection, Harrison Township Historical Society, Mullica Hill.

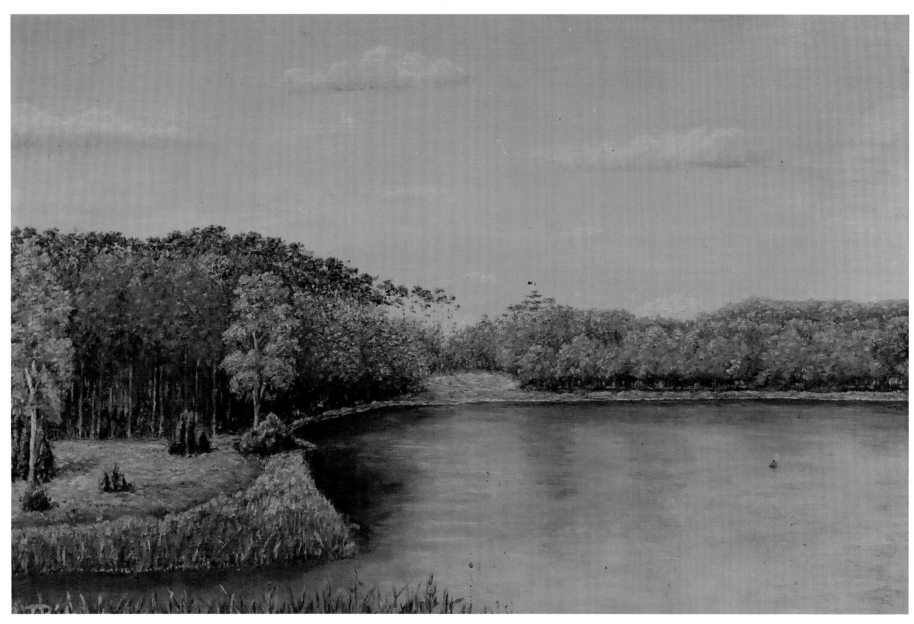

Landscape painting by Otto Rick, a German prisoner of war, given to Charles Roth, on whose farm in Richwood he worked during World War II. The peaceful scene contrasts with the war in Europe, which included the bombing of the home cities of some of the prisoners. Source: Harrison Township Historical Society, Mullica Hill.

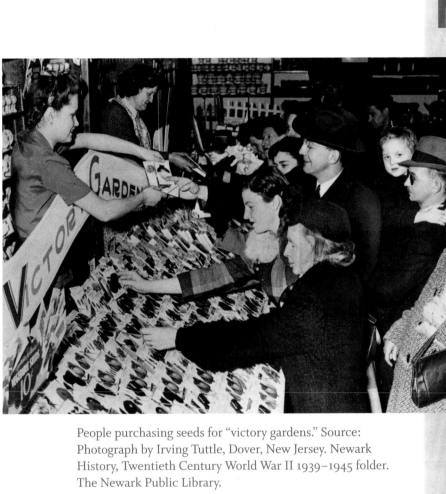

People purchasing seeds for "victory gardens." Source: Photograph by Irving Tuttle, Dover, New Jersey. Newark History, Twentieth Century World War II 1939–1945 folder. The Newark Public Library.

"Plant a Victory Garden: Our Food Is Fighting." The U.S. Office of War Information was created in June 1942 to centralize and control information about the war and to boost patriotism by encouraging people on the home front to participate in the war effort. Source: Poster designed by Robert Gwathmey, c. 1945. Library & Archives, Monmouth County Historical Association, Freehold.

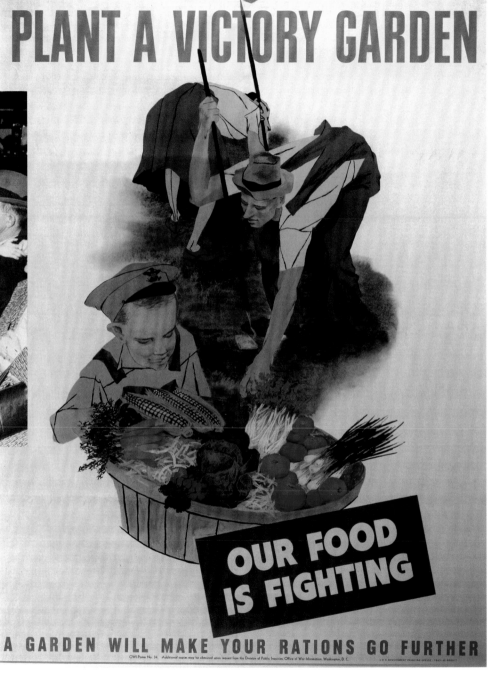

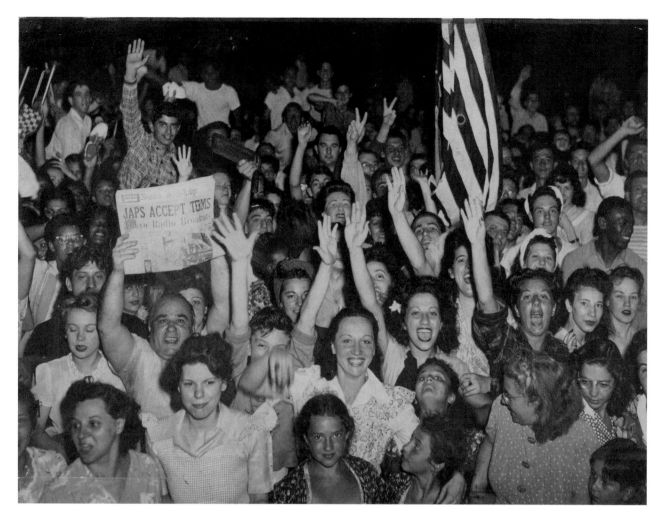

At 4:30 A.M. on August 14, 1945, a crowd at Newark Four Corners celebrated news of the Japanese surrender. Source: Newark History, Twentieth Century c. 1940–1960 folder. The Newark Public Library.

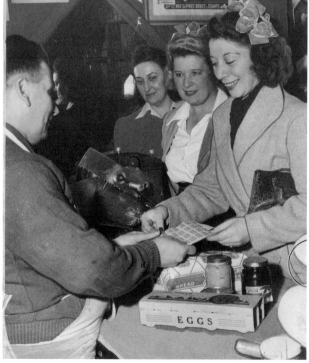

Mrs. Rose Jacobs of Newark, a welder at Federal Shipbuilding, does some grocery shopping with her family's ration coupons. Clothing, gasoline, and other commodities were rationed along with food items. Source: Newark History, Twentieth Century World War II 1939–1945 folder. The Newark Public Library.

VOTE FOR THE YES

New State Constitution

YOUR VOTE IS IMPORTANT
ELECTION DAY ➡ NOV. 7TH

Charles Edison

Paid for by N. J. Committee for Constitutional Revision

United Adv. Corp.

Governor Charles Edison (1890–1969) called for revision of the 1844 state constitution in his inaugural address in 1941. But a referendum on this question failed, as opponents argued it should not be done in the midst of war. Changes were also opposed by Boss Frank Hague, North Jersey cities, and the Catholic Church. Source: Postcard-sized flyer, 6 x 4 in., c. 1942. New Jersey Political Broadsides Collection, Special Collections and University Archives, Rutgers University Libraries.

Governor Alfred E. Driscoll (1902–1975) closing the 1947 New Jersey Constitutional Convention and signing the document. The constitution was then submitted to the voters, who ratified it by a large margin. Source: Special Commissions, Constitutional and Law-Revision Commissions/Conventions, Constitutional Convention of 1947, Photographs and Press Releases, item 648A. New Jersey State Archives, Department of State.

Oliver Randolph (1884–1951), a lawyer from Essex County, was the only African American delegate to the 1947 constitutional convention, where he pushed for the provisions barring discrimination and segregation. Source: Special Commissions, Constitutional and Law-Revision Commissions/Conventions, Constitutional Convention of 1947, Photographs and Press Releases, item 623A. New Jersey State Archives, Department of State.

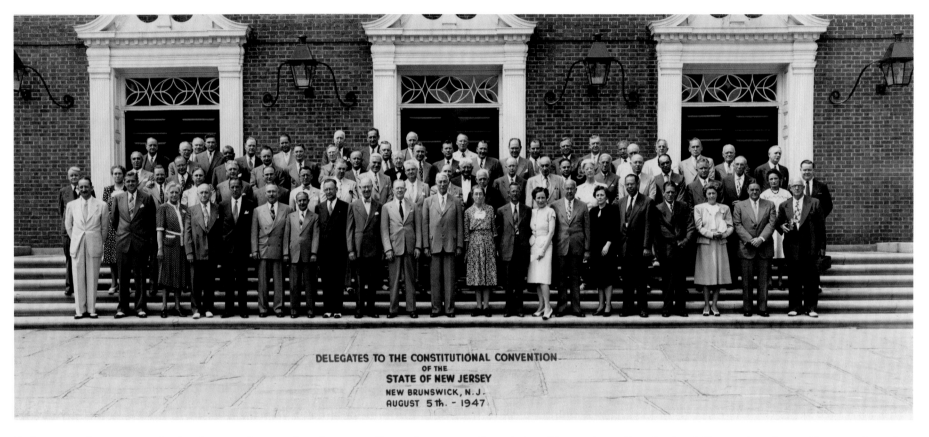

DELEGATES TO THE CONSTITUTIONAL CONVENTION
OF THE
STATE OF NEW JERSEY
NEW BRUNSWICK, N.J.
AUGUST 5th. - 1947

Delegates to the state constitutional convention met from June 12 to September 10, 1947, at the Rutgers University Gymnasium, where they were photographed on August 5, 1947. Source: Special Commissions, Constitutional and Law-Revision Commissions/Conventions, Constitutional Convention of 1947, Photographs and Press Releases, item OV001. New Jersey State Archives, Department of State.

10

Postwar New Jersey

In Bruce Springsteen's song "My Hometown," we hear the plaintive lament of a father watching the decline of his hometown in the postwar period. The bleak view of shuttered stores and closed factories reflects the fate of many of New Jersey's older communities in the decades after World War II. At the beginning of the war, the state's cities, though battered by the Depression, remained important centers of population, industry, and commerce. Urban bosses dominated state politics, and an outdated constitution perpetuated a maze of courts and impeded a governor who was generally subservient to the legislature. Although New Jersey's importance as an agricultural center had long been in decline, suburbs had not yet come to dominate the landscape. A strong network of railroads and streetcars connected urban centers with the suburbs, and industries provided employment for

workers with varying skill levels. Immigration from overseas had slowed. These conditions changed with remarkable rapidity in the postwar decades.

The return of thousands of soldiers, sailors, airmen, WACS, and WAVES from overseas created new pressures in the labor market. In addition, large numbers of African Americans migrated from southern states to the North in the hope of securing employment in the factories of Newark, Trenton, Paterson, and Camden. They found limited employment opportunities, entrenched prejudices, indifferent political representation, and few housing options, all of which eventually created explosive resentments. At the same time, women, a major part of the labor force during the war, were laid off in large numbers. Government programs such as the GI Bill facilitated the transformation of American society by encouraging returning veterans to pursue higher education or start a business. Colleges, which had seen enrollments shrink during the war, were faced with a large influx of new students. Women also increasingly joined the ranks of college students. Exemplifying the challenges faced by educational institutions during this period, Rutgers University put the World War II–era barracks of Camp Kilmer to use as student housing. New Jersey's population also grew by more than 600,000 as a result of the baby boom. Public elementary and high schools struggled to keep pace.

Colleges, both public and private, grew extensively during this period. The number of community colleges increased to nineteen. Seton Hall, a small

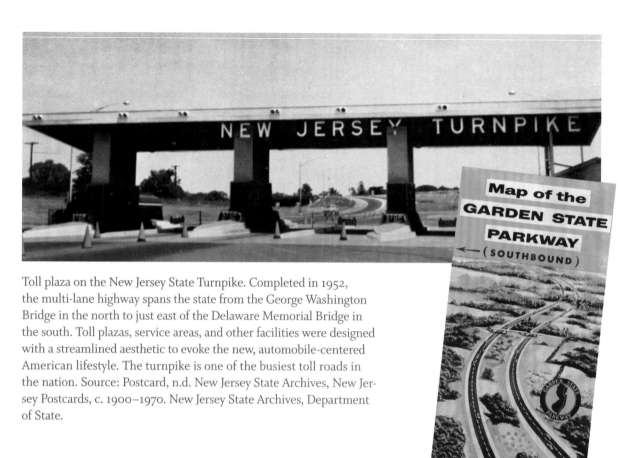

Toll plaza on the New Jersey State Turnpike. Completed in 1952, the multi-lane highway spans the state from the George Washington Bridge in the north to just east of the Delaware Memorial Bridge in the south. Toll plazas, service areas, and other facilities were designed with a streamlined aesthetic to evoke the new, automobile-centered American lifestyle. The turnpike is one of the busiest toll roads in the nation. Source: Postcard, n.d. New Jersey State Archives, New Jersey Postcards, c. 1900–1970. New Jersey State Archives, Department of State.

Garden State Parkway tokens, 1998–2001. The tokens were used to pay tolls from the 1980s until January 1, 2009. Source: New Jersey Turnpike Authority, Garden State Parkway Tokens, 1988–2001. New Jersey State Archives, Department of State.

Map of the Garden State Parkway, Southbound (cover, 2nd edition, 1953?). Most of the Garden State Parkway was constructed in the early 1950s. Running from Cape May in the south to the New York state line, it opened many formerly rural areas to rapid development. Source: Uncatalogued maps, Special Collections and University Archives, Rutgers University Libraries.

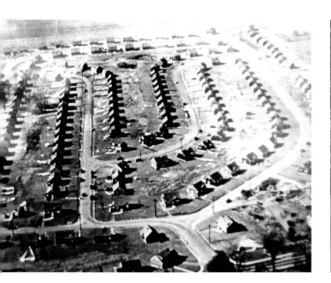

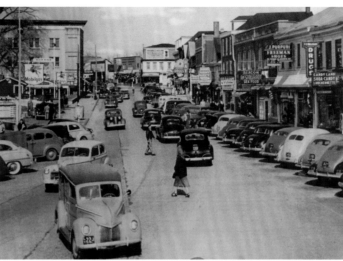

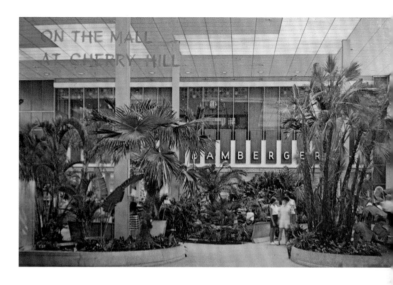

Aerial view of the Geary Park housing development on the site of the former Geary farm in South Plainfield, c. 1951. The construction after World War II of large communities such as this one helped turn New Jersey into the most suburban and most densely populated state in the nation. Source: South Plainfield Historical Society.

Downtown Toms River, c. 1950, with its thriving shopping district. Before the spread of malls, most residents patronized local stores. Source: Ocean County Historical Society, Toms River.

The Cherry Hill Mall, opened in 1961, is credited with being the first indoor shopping center in the eastern United States. With numerous stores and a movie theater, it drew customers away from local town centers. Source: Postcard. Collection of Paul W. Schopp.

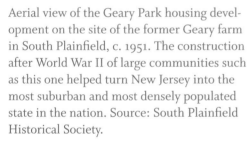

Catholic, all-male institution, became a university that by 2014 had 9,800 male and female students of diverse racial, ethnic, and religious backgrounds. State teachers colleges became comprehensive institutions. For example, the Trenton Normal School, founded in 1855, originally provided a two-year program; in 1996, it became the four-year College of New Jersey and in 2015 had 7,115 students. Most dramatic has been the growth of Rutgers, which was designated The State University in 1945; in 1946, it had 16,084 students in all divisions, including the College for Women (Douglass). In 2015, it offered a law school, medical school, and numerous undergraduate and graduate programs centered in New Brunswick, Newark, and Camden, with an enrollment of 66,000.

In the immediate postwar period, low-cost mortgages and a generally strong economy facilitated out-migration from the cities. New suburbs sprang up in parts of Essex, Union, Somerset, Middlesex, and Camden Counties. Increasingly, middle-class families left the older urban ethnic neighborhoods of their parents for the security, green lawns, and modern amenities promised by suburban housing developments. The decline of American cities, which would come to define the second half of the twentieth century, was exacerbated by redlining, that is, real estate and banking practices that denied African American residents reasonable mortgages and homeowners insurance, forcing them into substandard urban housing. Such conditions in cities like Newark and Camden, coupled with oppressive police tactics, sowed the seeds for future conflict.

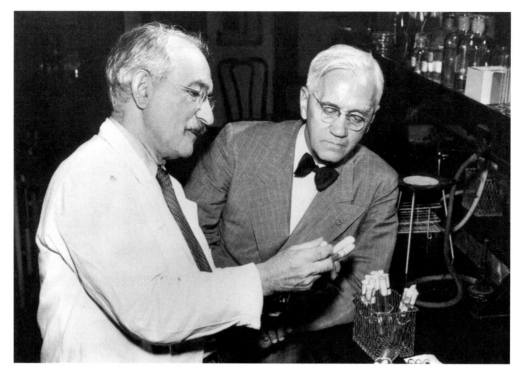

Merck & Co. helped fund the research that led to the discovery of streptomycin at Rutgers University and began producing the drug in 1945. To ensure an adequate supply, Merck and Rutgers shared the patent with a number of companies. Source: Advertisement in *Time* magazine, May 14, 1951. R. Veit Collection. Used with permission of Merck.

Selman Waksman (1888–1973) with Alexander Fleming (1881–1955) in a Rutgers University laboratory. Waksman, a Russian immigrant who graduated from Rutgers College, was a microbiologist and soil scientist. Working with graduate students at Rutgers, he isolated antibiotics from soil samples. The best known of these was streptomycin, used to treat tuberculosis. Fleming had earlier discovered penicillin, the world's first antibiotic, which was developed during and after World War II. Source: Special Collections and University Archives, Rutgers University Libraries.

The Lollipop Motel sign is an example of the mid-twentieth-century Doo Wop architecture that still delights visitors to Wildwood. The brightly colored, neon-lighted designs in this Shore region reflected the optimism and greater wealth and leisure time of the growing middle class. Source: Photograph by Carol Highsmith (1946–), December 10, 2006. Image LC-DIG-highsm-04147, Carol M. Highsmith Archive, Library of Congress, Prints and Photographs Division, Washington, D.C.

Suburban living was intimately linked to changes in transportation. The state's once robust network of railroads and streetcars declined as new highways facilitated commuting by automobile. New Jersey built two major arterial highways in the immediate postwar period, the Garden State Parkway and the New Jersey Turnpike. The Parkway, begun in 1947, runs from Montvale

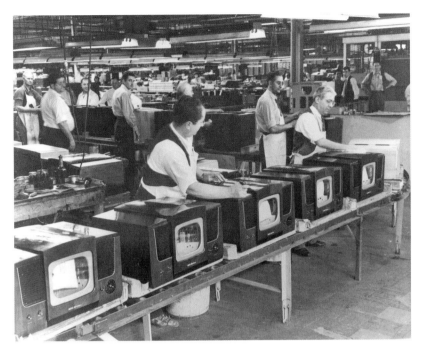

Assembling television sets in Camden, c. 1948. With its acquisition of the Victor Talking Machine Company in 1929, the Radio Corporation of America (RCA) adapted factories in Camden to make radios as well as phonographs and records. Television production began in 1939 and picked up after the war as more families had leisure time and expendable income. The tabletop RCA Victor 8TS30 on this production line had a 52-square-inch screen. Source: Digital image SARNOFF_TV_8ts30production. David Sarnoff Collection, Hagley Museum & Library, Wilmington, Delaware.

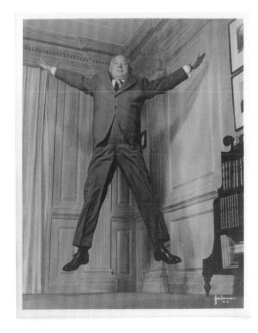

David Sarnoff (1891–1971), first general manager of the Radio Corporation of America (RCA) at its founding in 1919, jumps expansively for photographer Philippe Halsman in 1953. Sarnoff led RCA as it developed electronic communications equipment, including early television, and applied transistors to consumer products. The photograph was taken two years after RCA's research and development facility in Princeton was renamed for Sarnoff. Source: The Sarnoff Collection, The College of New Jersey. Photograph by Philippe Halsman, © Halsman Archive. Reproduced with permission.

Bell Telephone Laboratories at Murray Hill, 1980. Bell Labs, the research arm of the American Telephone and Telegraph Company (AT&T) and Western Electric, was consolidated in New York City in 1925 and later moved to New Jersey. The Murray Hill facility opened in 1941, followed by a second large complex in Holmdel, both designed to foster interactions among the researchers. Before AT&T was forced to split up in 1983, Bell Labs was arguably the most innovative scientific organization in the world. Today the Murray Hill facility is operated by Alcatel-Lucent. Source: Reprinted with permission of Alcatel-Lucent USA Inc.

Project Diana, named for the Roman goddess of the moon, was an attempt to prove the feasibility of radio communication beyond the Earth. A small group of scientists at the U.S. Army Signal Corps Engineering Laboratories, Fort Monmouth, modified a radar antenna and receiver and in January 1946 broadcast a series of signals at the moon. Reflected signals were received about 2.5 seconds later, the time light takes to travel from the Earth to the moon and back. Project Diana was the beginning of radio astronomy for space exploration. Source: U.S. Army.

in the north to Cape May. It was designed for safety and speed, and was carefully landscaped to provide travelers with a pleasing view. The Turnpike Authority was established in 1949, and in 1951 the first section of road opened. Decidedly more utilitarian, the Turnpike runs from Bergen County and the George Washington Bridge south to the Delaware Memorial Bridge and has become one of the most heavily traveled roads in the nation. The Turnpike and Parkway facilitated travel across the state and opened up large areas of the Shore to commuters working in northern New Jersey and New York City.

With the expansion of the highway system and private car ownership, New Jersey's railroads, long a mainstay of the state's economy, went into decline. At

The men who invented the transistor at Bell Telephone Laboratories, 1948. Seated is Dr. William Shockley, who initiated and directed the transistor research program. Standing are Dr. John Bardeen, left, and Dr. Walter H. Brattain, right. In 1956, the three men were awarded the Nobel Prize in Physics for their work. Source: Reprinted with permission of Alcatel-Lucent USA Inc.

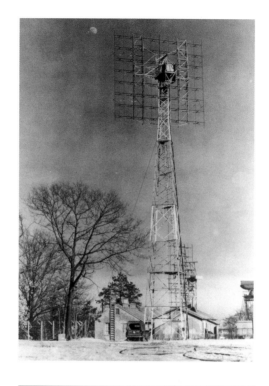

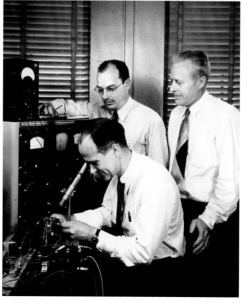

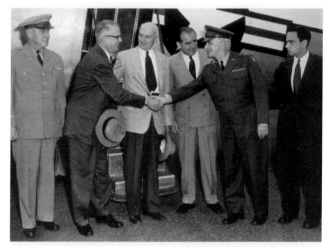

Major General Kirke Lawson, commander of Fort Monmouth, shakes hands with Secretary of the Army Robert Stevens, October 1953, with U.S. Senator Joseph McCarthy (R, Wisconsin) on Lawson's right and McCarthy's chief counsel, Roy Cohn, on his left. McCarthy (1908–1957) claimed that communist spies had infiltrated the U.S. Army Signal Corps Laboratories at Fort Monmouth, and he toured the base to promote his investigation. As a result, the army suspended a number of civilian employees, but no indictments ever resulted. McCarthy's aggressive and abusive attack on personnel of the Signal Corps led to the televised Army-McCarthy hearings in April 1954 and his political downfall. Source: Army Signal Corps.

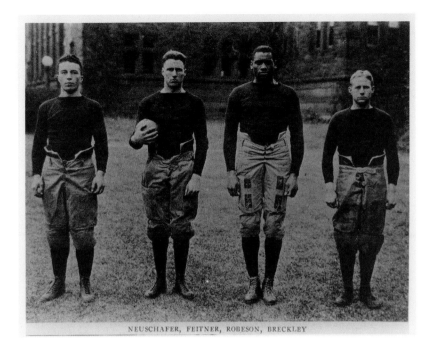

NEUSCHAFER, FEITNER, ROBESON, BRECKLEY

Born in Princeton, Paul Robeson (1898–1976) was one the first African Americans to attend Rutgers, where he excelled academically and in sports (football, track, baseball, and basketball). After graduating in 1919 as class valedictorian, he went on to study law, work as a celebrated actor and singer, and engage in controversial political activism for social justice at home and abroad. Source: Special Collections and University Archives, Rutgers University Libraries.

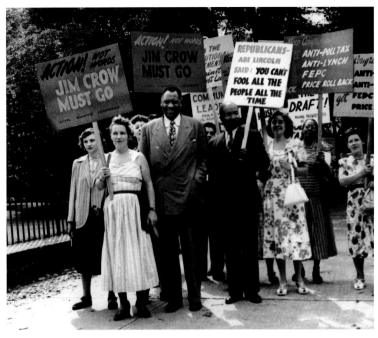

Paul Robeson (1898–1976) with picketers from the National People's Lobby in front of the White House, August 5, 1948. Robeson campaigned tirelessly for labor rights and civil rights, for blacks and others. His criticism of the United States and, for a time, open admiration of the Soviet Union resulted in the revocation of his passport from 1950 to 1958. Source: Image 602337, created by Julius Lazarus. From the Julius Lazarus Archives and Collection (MC 1415), Special Collection and University Archives, © Rutgers University Libraries.

the same time, new bridges, such as the Walt Whitman (opened in 1957) and Betsy Ross (opened in 1976), and the Lincoln Tunnel (the first tube opened in 1937 and the third in 1957) tied New Jerseyans even more closely to Philadelphia and New York. Cities where ferries had long been a fixture of the waterfront, as in Camden, faced new challenges as bridge approach ramps bisected established neighborhoods. New Jersey's highway system continued to expand throughout the 1960s, 1970s, and 1980s: federally subsidized Interstates 80 and 78 opened up northwestern New Jersey to suburban development; the Atlantic City Expressway provided easy access from Philadelphia to the southern Shore; and Interstate 287, a major ring road around New York City, helped create what Howard Gillette has characterized as a wealth belt, an area of exceptionally well-to-do suburbs in Bergen, Passaic, Morris, Somerset, Union, and Middlesex Counties.

The growth of the suburbs seemed unstoppable, and within a generation major companies followed. The development of expansive corporate office parks in Bergen, Morris, and Somerset Counties encouraged more workers to move out of the cities, leaving poorer, often minority workers behind with even fewer employment

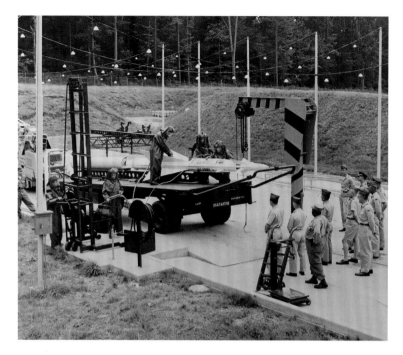

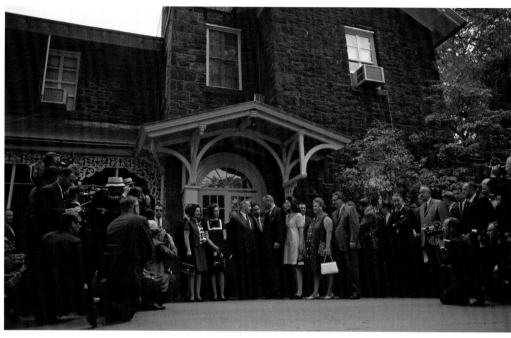

A Nike Ajax missile, c. 1958–1960, being fueled by the 2nd Battalion 65th Air Defense Artillery (probably with the help of members of the National Guard). The Nike was a surface-to-air missile designed to intercept Soviet bombers. There were fourteen Nike missile sites located in New Jersey during the Cold War, active from 1955 to 1974. Those in the north were meant to protect the New York City region, and those in the south, the Philadelphia area. Source: National Guard Militia Museum of New Jersey, Sea Girt.

Glassboro Summit Conference, Hollybush mansion, Glassboro College (now Rowan University), June 23–25, 1967. In a hastily arranged conference, President Lyndon B. Johnson and Soviet Premier Alexei Kosygin discussed the recent Arab-Israeli war, possible peace negotiations in Vietnam, and a halt to the spiraling arms race. The participants—along with Lady Bird and Linda Bird Johnson, Lyudmilla Gvishiana (daughter of Kosygin), and Betty and Governor Richard Hughes—were photographed on June 25 in front of Hollybush, the home of the college president. Source: Photograph by Frank Wolfe, White House Photo Office. Colored photo C5817–26A, LBJ Presidential Library.

options. Poor housing conditions and unemployment contributed to racial unrest. Beginning in the late 1960s, civil disturbances crackled across the state. In what has been characterized as "Revolution '67," Newark's commercial district suffered six days of rioting, sparked by the arrest and beating of an African American cab driver; 26 people died, at least 750 were injured, and property damage climbed into the millions. The continuing frustration of inner-city residents led to riots in Plainfield (1967), Trenton (1968), Asbury Park (1970), and Camden (1971). The damage and fear caused by these disturbances further exacerbated the flight of white residents to the suburbs and the decay of downtown shopping districts. The quality and resources of urban school districts also declined.

Over time, the suburbs moved farther west and south, based in part on the availability of cheap land, low taxes, and promises of employment. Dover

Township, now named Toms River, exemplifies this trend, which can also be seen in the growth of what might be termed the mega-suburbs of Edison, Woodbridge, and Cherry Hill.

Many of the state's traditional industries slumped and ultimately disappeared in the postwar period. Extractive industries such as ceramics, glass, and iron, which had all shaped the history of the state, are examples. The Sayre and Fisher brickworks of Sayreville, although initially benefiting from the postwar construction boom, closed down in 1972 after more than a century in business. The state's terra cotta industry, once the national leader, collapsed as new architectural styles emphasized stainless steel, concrete, and glass. Iron mines and steel mills, which had been brought back to life by the wartime demand for materials, closed. At the same time, high production costs and labor unrest spelled trouble for such major New Jersey firms as Roebling and Campbell and the glass factories of South Jersey. Paterson's mills, which had hummed with war work, closed down or moved south.

The manufacturing economy was increasingly replaced by what historian Lizabeth Cohen has characterized as the "consumers' republic" of the postwar era, when consumption of manufactured goods moved

"Coeducation at Rutgers: A Special Report." Rutgers was among the institutions of higher education that diversified their student bodies in the 1960s and 1970s by admitting female undergraduates. Source: *Rutgers Targum*, December 1, 1969. Special Collections and University Archives, Rutgers University Libraries.

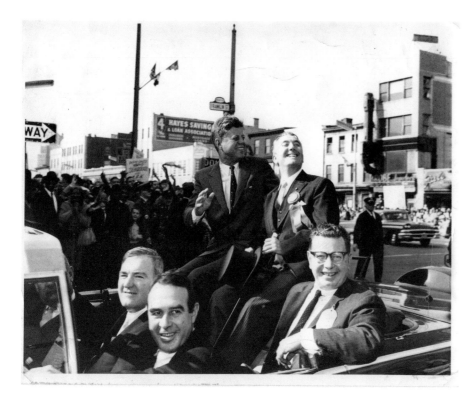

President John F. Kennedy arrived in Newark on October 12, 1962, to deliver a Columbus Day speech. Mid-term elections were just weeks away, and riding with Kennedy were Mayor Hugh Addonizio, Governor Richard Hughes, Senator Harrison A. Williams, and two Democratic candidates for the House of Representatives, Peter W. Rodino Jr. and Cornelius W. Gallagher. The midnight-blue Lincoln convertible was the same one Kennedy was riding in when he was assassinated in Dallas thirteen months later. Source: Newark History, Twentieth Century folder. The Newark Public Library.

Governor Richard J. Hughes (1909–1992; left) and Vice President Hubert Humphrey (1911–1978; center) tour the Kilmer Job Corps Center in Edison. Job Corps, a residential training program for urban youths, was created in 1964 as one of President Lyndon B. Johnson's War on Poverty and Great Society initiatives, which sought to expand economic opportunities for minorities and the poor. Source: Hughes Family Scrapbook, 1965. Monsignor William Noé Field Archives & Special Collections Center, Seton Hall University, South Orange. Courtesy of the New Jersey Catholic Historical Commission.

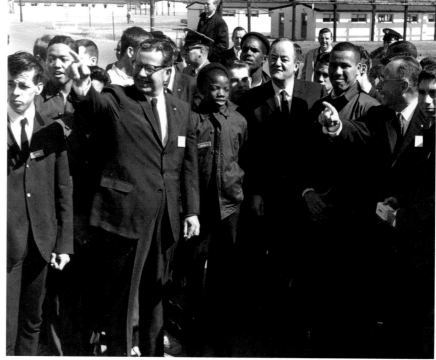

from a luxury option to a civic responsibility, a trend that continues today. Mass consumption supported the new economy, just as work had framed the old. Outdoor shopping centers or strip malls accompanied the new suburban developments and often included supermarkets, hardware stores, and movie theaters. By the 1960s, the indoor shopping mall had developed; Cherry Hill Mall, which opened in 1961, was the first constructed in the eastern United States and became the prototype for large township malls in New Jersey. Malls were important revenue generators for municipalities and successfully competed with downtown businesses.

Postwar New Jersey remained a leader in innovation and technology. Scientists at the U.S. Army Signal Corps laboratories at Fort Monmouth, once known for training wartime message-carrying pigeons, were pioneers in telecommunication. In an early episode in the space race, Fort Monmouth engineers

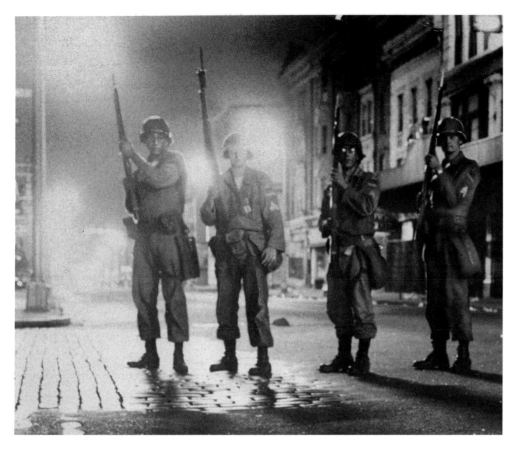

New Jersey National Guardsmen, Newark, 1967. In the 1960s, urban protests exploded in cities across the United States, fueled by anger over racial profiling, housing conditions, and lack of opportunity in education, training, and jobs. In New Jersey, disturbances occurred in Camden, Plainfield, Asbury Park, and other cities. The largest and most devastating was in Newark, where six days of conflict and looting left twenty-six dead and hundreds injured. Source: *Newark Evening News*, July 15, 1967. Newark Riots folder. The Newark Public Library.

Peter W. Rodino Jr. (1909–2005) endorses Kenneth Gibson (1932–) for reelection as mayor of Newark, 1982. Trained as an engineer, Gibson was the first African American elected to run a major Northeast city. He served from 1970 to 1986 and became a spokesman for the country's troubled urban communities. Democrat Rodino represented New Jersey in Congress from 1949 to 1989 and is best known for chairing the House Judiciary Committee when it investigated the political scandal known as Watergate and began the impeachment proceedings leading to the resignation of President Richard Nixon. Source: Campaign broadside. New Jersey Political Broadsides Collection, Special Collections and University Archives, Rutgers University Libraries.

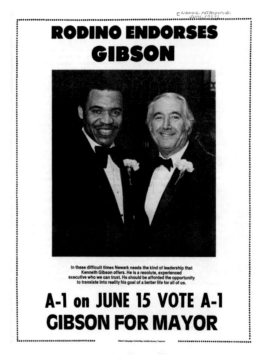

bounced a radar signal off the moon in 1946, proving the feasibility of space communication. They also pioneered a variety of communication devices that revolutionized twentieth-century life. Fort Monmouth was also noteworthy for its diverse workforce. African American servicemen found opportunities for careers in science that were lacking elsewhere. A substantial number of postwar German émigrés and Jewish scientists also found a congenial work environment. Some of them became the target of U.S. Senator Joseph McCarthy's investigations into "un-American activities." The senator's aggressive attempt to discover a Communist spy ring at the laboratory, which he visited in October 1953, played a role in the 1954 Senate hearings that looked into the conflicting accusations of McCarthy and the U.S. Army and ultimately ended McCarthy's career.

Ethel Robinson Lawrence (1926–1994), a long-time civil rights activist in Mount Laurel, asked the town for a zoning variance in 1967 to build low- and moderate-income housing. Its refusal led to landmark state supreme court decisions in 1975 and 1983 declaring exclusionary zoning unconstitutional and requiring communities to take affirmative steps to allow affordable housing. Source: Portrait painted on ceramic tiles by students at the Thomas E. Harrington Middle School, Mount Laurel, 2009. Photograph courtesy of the Mount Laurel Schools.

At Bell Telephone Laboratories, with facilities in Murray Hill, Holmdel, and Middletown, scientists laid the foundation for the modern electronic age. Walter Brattain, John Bardeen, and William Shockley developed the transistor in 1947, and other important research centered on telecommunications, lasers, communication satellites, and solar cells. Microbiologists at Rutgers University, including Selman Waksman and his student Albert Schatz, discovered the antibiotic streptomycin, the first effective treatment for tuberculosis, which garnered Waksman the 1952 Nobel Prize in Physiology or Medicine. Pharmaceutical companies, especially national leaders like Merck and Johnson & Johnson, kept New Jersey's chemical industry strong.

During the Cold War, New Jersey's population was enriched by immigrants, often refugees from postwar Europe. Following the brutal Soviet suppression of the 1956 Hungarian Revolution, thousands of Hungarian

Ethel Lawrence housing development, Mount Laurel. It took more than thirty years for this multi-use, multi-income housing development to be built. Source: Mark Lozier/Fair Share Housing Development.

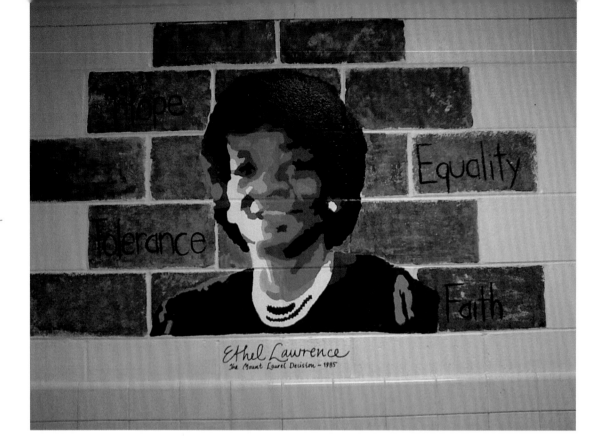

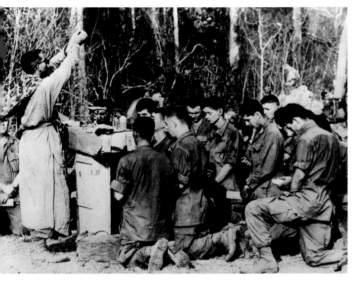

U.S. Army Chaplain (Major) Charles J. Watters (1927–1967) conducting a field mass in Vietnam, November 19, 1967. He died later that day, the result of "friendly fire" from an American bomber. Watters, a Seton Hall University graduate and Catholic priest, was later awarded the Congressional Medal of Honor for having rescued wounded soldiers while under enemy fire. Source: Monsignor William Noé Field Archives & Special Collections Center, Seton Hall University, South Orange. Courtesy of the New Jersey Catholic Historical Commission.

Governor Richard J. Hughes (1909–1992) in South Vietnam, 1967. Hughes was one of twenty-two Americans selected by President Lyndon B. Johnson to observe the conduct of elections there. Source: Hughes Family Papers, box 117. Monsignor William Noé Field Archives & Special Collections Center, Seton Hall University, South Orange. Courtesy of the New Jersey Catholic Historical Commission.

Rutgers University students take over the president's office in Old Queens during a protest against the American invasion of Cambodia, May 4, 1970. Source: Photographs by Bruce Meisterman, 201-283-1466. R-PHOTO Collection, Student Life, Student Activism. Special Collections and University Archives, Rutgers University Libraries.

refugees were temporarily housed at Camp Kilmer; many of them elected to stay on in central New Jersey.

During the Korean War (1950–1953), Fort Dix once again served as a major training facility, and McGuire Air Force Base was the largest military airbase in the world. Civil defense became a priority. Fears about the possibility of a Soviet attack led to the construction of rings of missile bases around New York and Philadelphia. Nine sites in northern New Jersey hosted first Nike and later Ajax missiles designed to destroy Soviet strategic bombers; an additional five batteries were located in southern New Jersey to protect Philadelphia. Air raid shelters and supply depots were also constructed.

New Jersey was briefly on the international stage in 1967, when Soviet Premier Alexei Kosygin and President Lyndon Johnson met on what was seen as neutral turf, the Hollybush mansion on the campus of Glassboro State College (now Rowan University). Although the meeting failed to produce an agreement

on either the Vietnam War or the U.S.-Soviet arms race, it was seen as having a positive tone, sometimes called the "Spirit of Glassboro." The Vietnam War deeply divided New Jerseyans; protests erupted on college campuses across the state. Whether by choice or by draft, large numbers of New Jerseyans served during the conflict, and some 1,563 lost their lives.

Politics in New Jersey remained contentious, with one of the leading issues being taxes. Until the mid-1970s, New Jersey did not have an income or sales tax. Revenues came from fees, excise taxes, and property taxes. However, the rapid growth of government services, exacerbated by the expanding suburbs and by the state's myriad municipalities (then 567, now 565), resulted in the highest property taxes in the nation. The large number of municipalities also seemed to create fertile ground for political corruption, which has proven hard to stamp out.

Suburban growth also increased pressure on the environmental resources of an already densely populated state. As a result, several important environmental battles were fought in New Jersey. Water rights and the availability of fresh drinking water for the state's cities was a major concern in the postwar period. In the early twentieth century, Newark, Paterson, Perth Amboy, and other cities tapped water resources well beyond their municipal boundaries. In the 1960s, major reservoirs were created in northern New Jersey, most notably Spruce Run and Round Valley. In both cases, eminent domain was used to take land in rural agricultural areas.

The Vietnam War Veterans' Memorial in Holmdel was dedicated in May 1995, twenty years after the end of the war. The architect, Hien Nguyen, came to the United States from Vietnam in the last days of the war. Thomas Jay Warren created the group of figures. The perimeter walls are carved with the names of the 1,563 New Jerseyans who died in the war. The associated Vietnam Era Museum and Educational Center preserves photographs and other memorabilia. Source: New Jersey Vietnam Veterans' Memorial Foundation.

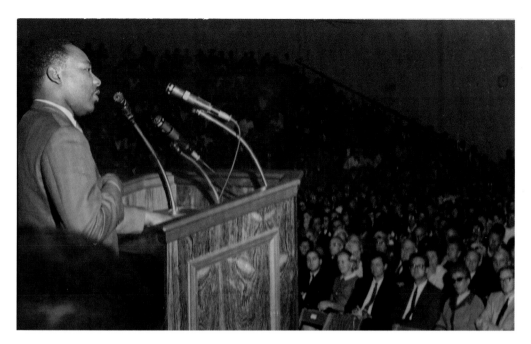

Martin Luther King Jr. (1929–1968) speaking at Monmouth University, October 6, 1966. A Baptist minister, a founding member of the Southern Christian Leadership Conference, and a leader of the civil rights movement, he told the students and the general public here and elsewhere that progress had been made toward ending racial injustice but that much more remained to be done. King was assassinated two years later in Memphis, Tennessee, while trying to support striking sanitation workers. Source: Collection of Professor Hettie Williams.

Demonstrators on the Seton Hall University campus hold signs declaring solidarity with the nonviolent civil rights marchers who were viciously attacked by police in Selma, Alabama, March 7, 1965. Source: Monsignor William Noé Field Archives & Special Collections Center, Seton Hall University, South Orange. Courtesy of the New Jersey Catholic Historical Commission.

Other major environmental battles surrounded the proposed Tocks Island Dam on the Delaware River, a jetport in the midst of the Great Swamp, and perhaps most famously, the integrity of the Pine Barrens. The Tocks Island Dam was proposed by the Army Corps of Engineers to provide clean drinking water to Philadelphia and to create a large recreational area in northeastern Pennsylvania and adjacent portions of New York and New Jersey. A major flood in 1955 increased interest in the project. The dam, if constructed, would have been the largest east of the Mississippi River. The geology of the dam site was problematic, and there was considerable protest against the federal government's condemnation of private lands. Ultimately, the project collapsed. Today, much of the region is a popular national recreation area.

The fights for the Great Swamp and the Pine Barrens are also important chapters in New Jersey's environmental history. The growing population of suburban New Jersey in the postwar period led to interest in building more

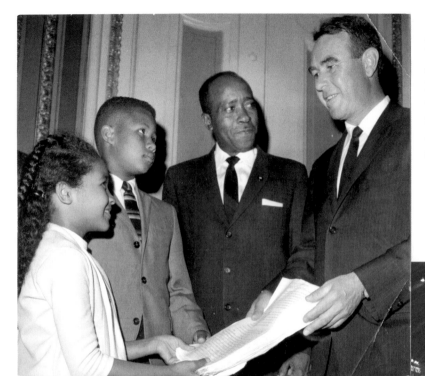

Senator Harrison Williams (1919–2001) accepting a petition from African American residents of Princeton supporting the Civil Rights Act of 1964. Williams was a strong advocate of this legislation to prohibit discrimination on the basis of sex or race in employment and of other measures to protect labor. A Democrat, he represented New Jersey in the House of Representatives from 1953 to 1957 and in the Senate from 1959 to 1982. Caught up in an FBI sting operation, he resigned before being convicted of bribery. Source: Harrison Williams Papers (MC 2), Special Collections and University Archives, Rutgers University Libraries.

Delegates to the Democratic National Convention in Atlantic City were greeted by banner pictures of Presidents Franklin D. Roosevelt, John F. Kennedy, Harry Truman, and Lyndon B. Johnson, and the slogan "Let Us Continue." Source: Photograph by Warren K. Leffler, August 24, 1964. Image LC-DIG-ds-05243, Library of Congress, Prints and Photographs Division, Washington D.C.

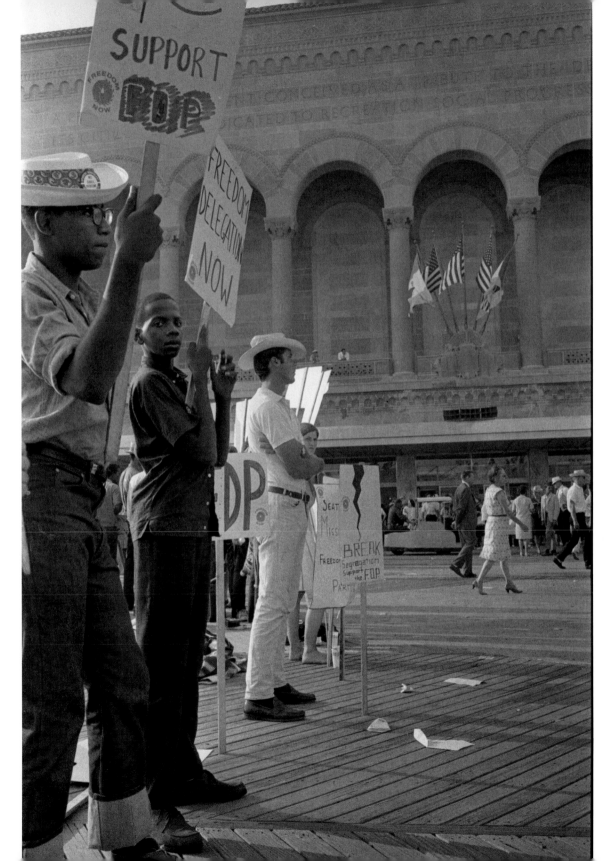

airports. The case of the Great Swamp shows how a determined group of individuals led by a housewife, the indefatigable Helen Fenske, was able to build a coalition to block the Port Authority's designs for a jetport. As a result of their efforts, the Great Swamp National Wildlife Refuge was established in 1966. A second plan for a jetport was proposed for the Pine Barrens, the largest natural aquifer in the world and a rare wildernesses area in the Northeast. Pulitzer Prize–winning author John McPhee introduced readers to this unspoiled area and its residents in *The Pine Barrens* (1968) and helped build support for the region's preservation. Governor Brendan Byrne called the creation of the Pinelands National Reserve the highlight of his career.

Despite these successes, and the more recent Highlands legislation intended to slow suburban sprawl in northwestern New Jersey and to preserve the region's water supply, environmental challenges remain. Moreover, the specter of New Jersey's industrial past haunts the state, which has the sad

African American and white supporters of the Mississippi Freedom Democratic Party (MFDP) demonstrating at the 1964 Democratic National Convention in Atlantic City. The protestors challenged the all-white delegates selected in a state election where blacks were prevented from voting. Although the MFDP failed to gain any seats at this time, the protests energized support for the Voting Rights Act of 1965. Source: Photograph by Warren K. Leffler, August 25, 1964. Image LC-DIG-ds-05244, Library of Congress, Prints and Photographs Division, Washington, D.C.

distinction of being home to more Superfund sites than any other state. The 1980 federal law that addresses these toxic waste sites was drafted in part by former governor James Florio while he was serving as a New Jersey congressman.

Concerns over social inequalities have led to several significant legal decisions. In the so-called Mount Laurel cases of the 1970s and 1980s, the New Jersey Supreme Court declared "exclusionary zoning" illegal and concluded that municipalities must provide lower-income housing. The state Fair Housing Act of 1985 authorized Regional Contribution Agreements, which allow suburban municipalities to fund up to half of their fair share of affordable housing elsewhere, usually in urban areas. Educational reform has also been a priority. In 1985, as a result of *Abbott v. Burke*, special need districts were designated in an effort to ensure that funding for educational opportunities in poor, often urban school districts would be equivalent to that in the wealthier districts in the state. The results of both rulings have been mixed and remain controversial.

A string of popular governors served in the 1970s and 1980s, including Brendan Byrne (Democrat, 1974–1982) and Thomas Kean (Republican, 1982–1990). Although New Jersey is seen as a blue state, neither Republicans nor Democrats have dominated the governorship. In 1994, Republican Christine Todd Whitman, the state's first female governor, narrowly

Dusk view of Atlantic City, c. 1980–2006, showing high-rise casinos behind bulldozed areas before Revel and other casinos were built. Source: Photograph by Carol M. Highsmith (1946–). Image LC-DIG-highsm-15086, Carol M. Highsmith Archive, Library of Congress, Prints and Photographs Division, Washington, D.C.

"Casino Gambling—New Jersey Wins—Vote Yes Nov. 5, 1974." The first referendum to permit casino gambling in New Jersey failed at the polls in November 1974, but a second one limiting it to Atlantic City passed two years later. Gambling was promoted as a way to overcome declining tourism, while also raising tax revenues for the state. The first casino opened in 1978. Source: Plastic bag designed to fit over a door handle. New Jersey Political Broadsides Collection, Special Collections and University Archives, Rutgers University Libraries.

"Citizens for Cahill…Bill Cahill para Gobernador de New Jersey," 1969. This Spanish-language campaign letter declares that William T. Cahill (1912–1996), Republican candidate for governor, is a man whom workers can trust. Elected governor in November 1969 while riding his party's resurgence following Richard Nixon's presidential victory, Cahill served one term. His attempts to solve the budget woes of the state were unsuccessful and unpopular, and indictments for corruption against members of his administration lost him support. His bid for reelection ended with the June 1973 primary. Source: New Jersey Political Broadsides Collection, Special Collections and University Archives, Rutgers University Libraries.

Hungarian refugees being welcomed at Camp Kilmer. In the aftermath of the failed Hungarian Revolution of 1956, immigrants arriving in the United States were processed through this former World War II base. A number remained in the New Brunswick area, where there still is a large population. Source: American Hungarian Foundation, New Brunswick.

defeated incumbent James Florio (1990–1994). James McGreevey, a Democrat (2002–2004), is noteworthy for pushing the Highlands legislation, New Jersey's domestic partner law, and stem cell research. He is perhaps best known for his resignation mid-term, when he announced that he was gay, making him the first openly gay governor in U.S. history. Recent governors include Jon Corzine (2006–2010), a business executive and philanthropist, who served one term, during which he made some progress reforming school funding and worked to eliminate the death penalty. His successor, Republican Chris Christie, has maintained a national profile, while clashing with unions and educators.

On September 11, 2001, terrorists attacked New York City's World Trade Center towers, which were clearly visible from much of northeastern New Jersey. Nearly 800 New Jerseyans lost their lives. Many others participated in the rescue, recovery, and clean-up efforts. Monuments commemorating those lost are found throughout the state.

Today, New Jersey is the most densely populated of the fifty states; it is also one of the wealthiest and most diverse. Although the northwestern and southwestern corners of the state remain rural and largely agricultural, the Census Bureau defines the entire state as urban. Cities and their downtowns have seen some revitalization after a long period of decline. Indeed, young people and retirees are returning to cities nationwide. The same may prove true in New

Governor Thomas Kean Sr. (1935–) and family, c. 1982. Descended from a family with a long history in the state and its politics, Kean served in the assembly for ten years, won the governorship in 1981 by a very narrow margin, and was reelected by a landslide, reflecting his popular appeal and success while in office. Source: Office of the Governor, Office of Public Communications, Photograph Collection, 1950–2006. New Jersey State Archives, Department of State.

UJ ERŐS VEZETŐEMBERT NEW JERSEY ÁLLAM ÉLÉRE!

VÁLASSZUK MEG

TOM KEAN

REPUBLIKÁNUS JELÖLTÜNKET KORMÁNYZÓNAK!

Nyolc évi semmittevés után itt az ideje egy általános tisztogatásnak Trentonban!

ADJUK **TOM KEAN** KEZÉBE AZ ÁLLAM VEZETÉSÉT. SZAVAZZUNK AZ ÖSSZES REPUBLIKÁNUS JELÖLTEKRE. NAGYON FONTOS, HOGY A SZENÁTUS ÉS AZ ÁLLAMI KÉPVISELŐHÁZ IS REPUBLIKÁNUS VEZETÉS ALÁ KERÜLJÖN !

TOM KEAN a legalkalmasabb vezető New Jersey állam problémáinak megoldására. 10 évig szolgált és vezetője volt a Képviselőháznak. Nagyon sokszor, mint „Acting Governor" vezette az állam ügyeit. Eddigi munkásságával kiérdemelte nemcsak a republikánusok, hanem nagyon sok demokrata és pártonkívüliek, valamint az üzleti világ elismerését és bizalmát. **TOM KEAN** mindig szembeszállott a legnehezebb problémákkal is.

New Jersey „ethnic" csoportjaira, az erős családi érzés, az ország szeretete és az Isten-hit jellemző. **TOM KEAN** kormányzó-jelölt tiszteli ezeket az értékeinket.

Ezért a következőket kivánja megvalósitani:

1. Bevezetni a halálos itéletet.
2. Megmenteni a „nemzetiségi" nyedeket.
3. Fenntartani a nemzetiségi iskolákat.
4. Biztositani a nyugdíjasok és betegek tisztességes megélhetését.
5. Ellene van mindenféle uj adóztatásnak.

NEW JERSEY ÖNÉRZETES MAGYAR SZAVAZÓPOLGÁRAI SZÁMÁRA MOST ÚJBÓL ITT AZ ALKALOM, HOGY NECSAK PANASZKODJANAK ROSSZABBULÓ HELYZETÜK MIATT, HANEM SZAVAZATAIKKAL VÁLASSZÁK MEG A REPUBLIKÁNUS JELÖLTEKET !

KÖTELESSÉGÜNK, HOGY NOVEMBER 3-ÁN MINNDNYÁJAN ÉLJÜNK ÁLLAMPOLGÁRI JOGAINKKAL ÉS MENJÜNK EL SZAVAZNI !

Paid for by the Hungarian Committee to elect Tom Kean and the Republican Candidates. Sándor Horváth, Secretary

This Hungarian-language campaign notice supported Thomas Kean Sr. (1935–), the Republican candidate for governor in 1981, as the best leader to clean up Trenton after eight years of "idleness." New Jersey has a long history of campaign literature produced in multiple languages to appeal to its ethnic voters. Kean later titled his autobiography *The Politics of Inclusion*, reflecting his efforts to incorporate diverse people into his political party. Source: New Jersey Political Broadsides Collection, Special Collections and University Archives, Rutgers University Libraries.

Jersey. For instance, Asbury Park and New Brunswick, after years of stagnation, have thriving arts and cultural scenes. Suburban sprawl continues, albeit more slowly, thanks in part to the recession that began in 2008, and there is talk about consolidating municipal services. The state has a highly educated population; however, school districts remain stubbornly segregated. New Jersey is an important destination for new immigrants, especially from Latin America, the Caribbean, China, Korea, India, Pakistan, and Africa. In the words of the late historian John Cunningham, New Jersey remains a "Mirror for America" and a place worth studying.

BIBLIOGRAPHY

Historians looking at the recent history of New Jersey have focused on suburbanization, urban history (particularly the unrest of the late 1960s

William J. Brennan (1906–1997) was the assignment judge in Hudson County from 1949 to 1951, before being appointed to the New Jersey Supreme Court (1951–1956) and then the U.S. Supreme Court, where he served from 1956 to 1990. The historic Hudson County Courthouse was renamed for him. Source: Portrait by Sheldon (Shelly) Fink (1925–2002), fourth-floor courtroom, William J. Brennan Courthouse, Jersey City. Photograph © Mark Ludak.

Distinguished guests at an unidentified Rutgers function. From left to right: Edward Bloustein (1925–1989), president of Rutgers University; former governor Robert Meyner (1908–1990); Governor Brendon Byrne (1924–); and former governor William T. Cahill (1912–1996). Source: Photograph by Victor's Photography of Piscataway, date unknown. New Jersey Portraits Collection, Special Collections and University Archives, Rutgers University Libraries.

and early 1970s), immigration, environmental policy, and political history. A good overview of this period, with a focus on South Jersey, is provided by Howard Gillette Jr., "Suburbanization and the Decline of the Cities: Toward an Uncertain Future," in Maxine N. Lurie and Richard Veit, eds.,

New Jersey: A History of the Garden State (New Brunswick: Rutgers University Press, 2012); see also Gillette, *Camden After the Fall: Decline and Renewal in a Post-Industrial City* (Philadelphia: University of Pennsylvania Press, 2005). Other important volumes that deal with New Jersey

Governor James J. Florio (1937–) with his wife, Lucinda, and granddaughter celebrating Easter on the front lawn of Drumthwacket, the governor's mansion, c. 1990–1994. A Democrat and former congressman, Florio was elected in 1989 but angered voters by raising taxes to cover the state's budget deficits. He narrowly lost reelection four years later. Source: Office of the Governor, Office of Public Communications, Photograph Collection, 1950–2006. New Jersey State Archives, Department of State.

Raised in Bernardsville, Millicent Hammond Fenwick (1910–1992) married, divorced, worked for *Vogue* magazine, and then entered local and state politics. She went on to serve four terms in the U.S. House of Representatives. A moderate Republican, Fenwick was known for her independence, interest in foreign affairs, and advocacy for civil rights. A colorful character, she smoked a pipe and is sometimes said to be the model for Lacey Davenport in the *Doonesbury* comic strip. Source: Millicent Fenwick Congressional Papers (MC 834), box 57, folder 1. Special Collections and University Archives, Rutgers University Libraries.

The success of the Rutgers Civic Education and Community Service Program in placing students in community projects attracted the attention of President William J. Clinton (1946–), who delivered a national policy address on public service at the university's Louis Brown Athletic Center, Piscataway, March 1, 1993. Source: Special Collections and University Archives, Rutgers University Libraries.

Congresswoman Marge Roukema (1929–2014), a liberal Republican from New Jersey's Fifth Congressional District, served eleven terms (1980–2003). Her biggest legislative achievement was the passage of the Family and Medical Leave Act of 1993. Source: Bumper sticker, 1986. New Jersey Political Broadsides Collection, Special Collections and University Archives, Rutgers University Libraries.

Congresswoman Marge **Roukema**

Pd. for by Comm. to Re-Elect Congresswoman Marge Roukema

in this period include: Lizabeth Cohen, *A Consumers' Republic: The Politics of Mass Consumption in Postwar America* (New York: Knopf, 2003); S. Mitra Kalita, *Suburban Sahibs: Three Immigrant Families and Their Passage from India to America* (New Brunswick: Rutgers University Press, 2003); Brad R. Tuttle, *How Newark Became Newark: The Rise, Fall, and Rebirth of an American City* (New Brunswick: Rutgers University Press, 2009); John Whiteclay Chambers II, *Cranbury: A New Jersey Town from the Colonial Era to the Present* (New Brunswick: Rutgers University Press, 2012); Jon Gertner, *The Idea Factory: Bell Labs and the Great Age of American Innovation* (New York: Penguin Books, 2013); and Dan Fagin, *Toms River: A Story of Science and Salvation* (New York: Bantam Books, 2013).

Christine Todd Whitman (1946–) was the first and still the only woman to hold New Jersey's highest office. A Republican elected as the state's fiftieth governor in 1994 and reelected four years later, she resigned before completing her second term to serve as administrator of the federal Environmental Protection Agency. Source: Office of the Governor, Office of Public Communications, Photograph Collection, 1950–2006. New Jersey State Archives, Department of State.

GREEN ACRES '78 VOTE YES

Paid for by
Citizens for Green Acres
300 Mendham Road, Morristown, N.J.

Printed by
Quality Graphics Center
262 W. First Ave., Roselle, N.J.

The Great Swamp National Wildlife Refuge was established in 1960 to preserve the environmentally sensitive area. Source: Map, June 2013. Courtesy of the U.S. Fish and Wildlife Service.

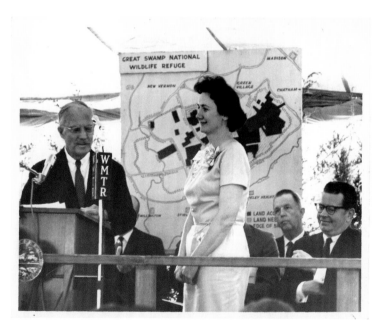

Helen C. Fenske (1923–2007) was a local housewife with no political experience when she led the grassroots fight to prevent the construction of a jetport in the Great Swamp south of Morristown. Source: Photograph by Molly Adams, May 1964. Copyright permission from the New Jersey Conservation Foundation; image from the Friends of the Great Swamp.

"Green Acres '78: Vote Yes." The Department of Environmental Protection's Green Acres Program, created in 1961, authorizes the state to raise money through bonds approved by voters to buy land for conservation and for recreational use. By 2015, over one million acres had been preserved. Source: Bumper sticker, 13 x 3 ½ in., created for Citizens for Green Acres, Morristown, by Quality Graphics Center, Roselle. New Jersey Political Broadsides Collection, Special Collections and University Archives, Rutgers University Libraries. Retouched.

The New Jersey Performing Arts Center (NJPAC) opened in Newark in 1997 as part of an effort to revitalize the city and is now part of a downtown cultural center. Photograph by R. Veit, 2015.

Aerial view of Tocks Island in the Delaware River, date unknown. In 1962, Congress authorized a dam across the Delaware at Tocks Island, six miles upstream of the Delaware Water Gap. The decade-long fight to prevent its construction dramatized the strength of the growing environmental movement in the United States and a changing attitude toward the nation's natural resources. Today the land that would have been flooded is now part of the popular Delaware Water Gap National Recreation Area. Source: Department of Environmental Protection, Division of Parks & Forestry, Photographs Filed by Subject, c. 1930s–1970s, item TocksIsland002. New Jersey State Archives, Department of State.

The deindustrialization of New Jersey's manufacturing centers is symbolized by the implosion of the Campbell Soup Company factory in Camden, November 3, 1991. Much of the company's production had been centered in Camden for more than 100 years. At its height, the factory processed tomatoes and other South Jersey farm products and employed thousands of local workers. Source: Photograph by Ed Hille, *Philadelphia Inquirer*. Special Collections Research Center, Temple University Libraries, Philadelphia.

Empty Sky 9–11 Memorial at Liberty State Park, Jersey City. Designed by Frederic Schwartz and Jessica Jamroz, the twin stainless steel walls point toward the site of the former Twin Towers and record the names of the 749 men and women from New Jersey who died on September 11, 2001, in New York, at the Pentagon, and in Pennsylvania. Photograph by R. Veit.

The Twin Towers of the World Trade Center in New York City burning after the terrorist attack on September 11, 2001, seen from across the Hudson River in Jersey City. Source: Photograph by Timothy Herrick, Jersey City–based writer and journalist; his portfolio/blog is timhrklit.com.

Miss America Beauty Pageant, 1981. This contest started in Atlantic City in 1921 to draw visitors after the summer season. In the 1960s, feminists protested that the pageant was sexist and racist. In following years it attracted a more diverse group of contestants and added a talent performance. The pageant moved to Las Vegas in 2006 but returned to Atlantic City in 2013. Source: Department of Conservation and Economic Development, Photographs Filed by Subject, 1940s–1970s, box 1. New Jersey State Archives, Department of State.

Puerto Rican Day Parade, 1975, in Newark. The community celebrating its culture. Source: Monsignor William Noé Field Archives & Special Collections Center, Seton Hall University, South Orange. Courtesy of the New Jersey Catholic Historical Commission.

Governor James McGreevey (1957–), 2002. The former Democratic mayor of Woodbridge and member of the legislature was elected governor in 2001. He resigned three years later after admitting that he was a "gay American" who had conducted an extramarital affair with a male staff member. Source: Office of the Governor, Office of Public Communications, Photograph Collection, 1950–2006. New Jersey State Archives, Department of State.

From 1892 to 1954, Ellis Island in New York Harbor served as an inspection station for millions of immigrants arriving in the United States; today the main building is a museum run by the National Park Service. Originally only three acres in size, the island was enlarged with twenty-four acres of landfill from the 1890s to 1934. In 1998, the issue of state jurisdiction over the island was resolved by the U.S. Supreme Court, which awarded the original land to New York and the filled-in portion to New Jersey. Source: Photograph by Carol Highsmith (1946–), c. 1980–2006. Image LC-DIG-highsm-13924, Carol Highsmith Archive, Library of Congress, Prints and Photographs Division, Washington, D.C.

Interior of the chapel at Seton Hall University, 1980s. Founded in 1856 to serve as a high school, college, and seminary for male students, the institution grew tremendously after World War II, primarily owing to the GI Bill, which provided free tuition to servicemen. Today Seton Hall is the largest Catholic institution of higher learning in New Jersey. Current students reflect the diversity of the state's population. Source: Monsignor William Noé Field Archives & Special Collections Center, Seton Hall University, South Orange. Courtesy of the New Jersey Catholic Historical Commission.

Sacred Heart Cathedral, Newark. A significant number of Catholic immigrants arrived in New Jersey in the mid-nineteenth century. Today Catholics are the largest religious group in the state, and their cathedral in Newark, dedicated in 1954, is the fifth largest in North America. Source: Watercolor by Jed Leskist, from the cover of the booklet One Hundredth Anniversary of the Archdiocese of Newark, New Jersey, and the Formal Opening of the Cathedral of the Sacred Heart (1954). Monsignor William Noé Field Archives & Special Collections Center, Seton Hall University, South Orange. Courtesy of the New Jersey Catholic Historical Commission.

BAPS Shri Swaminarayan Mandir, Robbinsville. New Jersey's increasingly diverse population has led to the construction of many new places of worship. This extraordinary stone mandir (temple) was undertaken to accommodate the growing Hindu community in the central part of the state. When completed, the mandir will be the largest place of worship in the state. Source: BAPS Swaminarayan Sanstha.

Bruce Springsteen (1949–) and the E Street Band. Springsteen's music reflects his working-class New Jersey origins, and his band's early performances were in Asbury Park at small clubs such as Upstage and The Stone Pony. The Jersey Shore sound, a combination of rock 'n' roll and the blues, developed there. Source: Photograph © Ed Gallucci. Springsteen Archives, Monmouth University, West Long Branch.

Birthday cake in the Capitol rotunda for New Jersey's 300th anniversary. Source: From New Jersey Tercentenary Commission, *The New Jersey Tercentenary, 1664–1964* (Trenton, 1966), 84. Special Collections and University Archives, Rutgers University Libraries (SNCLNJ F134.5.M4).

The New Jersey Tercentenary Historymobile brought 300th birthday exhibitions to locations throughout the state. Source: R. Veit Collection.

New Jersey 350th Anniversary pop-up store in Somerville, 2014. As part of the effort to celebrate the creation of the English colony in 1664, the Main Street New Jersey program arranged for a series of stores to sell New Jersey–themed products. In Somerville, local officials participated in the opening. From left to right: Rob Wilson, Somerville Borough Council; Jane Kabuta, Somerville Borough Council; Patricia Walsh, Somerset County freeholder; Kip Bateman, state senator; Patrick Scaglione (in wheelchair), Somerset County freeholder; Dennis Sullivan (red shirt), Somerville Borough Council; Robert Zaborowski, (former) Somerset County freeholder; Mayor Brian Gallagher; and Tom Mitchell, Somerville Borough Council (holding the red balloon string). Source: Photograph by Beth Anne Macdonald, executive director, Downtown Somerville Alliance.

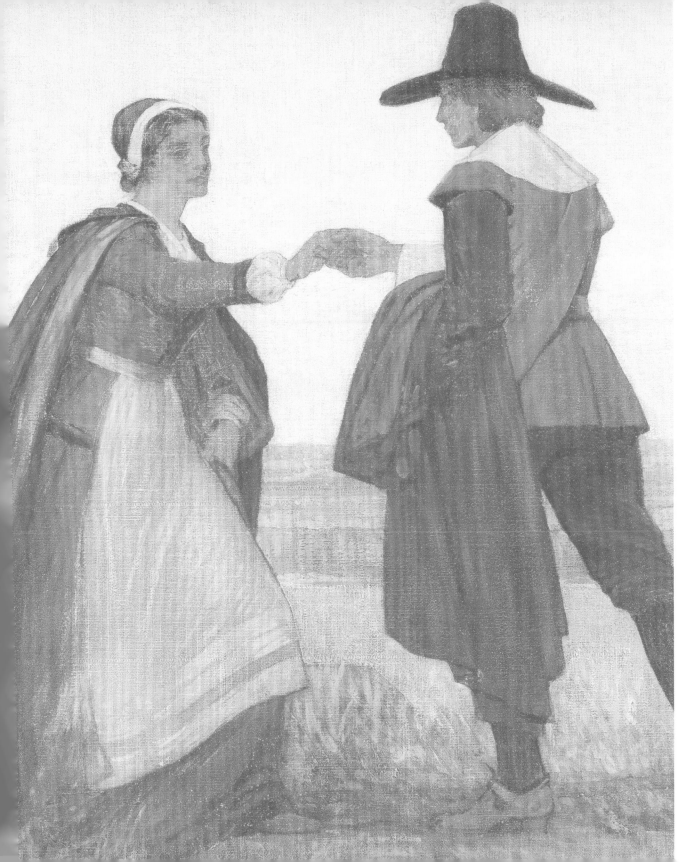

Acknowledgments

FUNDERS

New Jersey Council for the Humanities
New Jersey Historical Commission
Barry Kramer
Robin Suydam
Franklin Mutual Insurance
Anne Moreau Thomas

INSTITUTIONS

American Labor Museum/Botto House National Landmark
American Magic Lantern Theater
American Swedish Historical Museum
Anna C. Scott School, Leonia
Argonne National Laboratories
Ashmolean Museum, Oxford University, UK
The Athenaeum of Philadelphia
Atlantic County Historical Society
BAPS Shri Swaminarayan Mandir
Battleship New Jersey
Bell Labs—Alcatel/Lucent
British Museum
Brooklyn Museum

Acknowledgments

Burlington County Historical Society

The College of New Jersey

Corning Museum of Glass

Cumberland County Historical Society

Doane Academy

Downtown Somerville Alliance

Drew University Archives

East Brunswick Museum

Essex County Courthouse

Fairshare Development (Mount Laurel)

Fort Monmouth/U.S. Army Signal Corps

Franklin D. Roosevelt Presidential Library and Museum

Fraunces Tavern® Museum, New York City

Friends of the Great Swamp

Hackensack Water Works Conservancy

Hagley Museum & Library

Halsman Archive

Harrison Township Historical Society

Haverford College

Historic American Buildings Survey, Library of Congress

Historical Society of Pennsylvania

Historic Cold Spring Village

Hoboken Historical Museum

Hudson County's William J. Brennan Courthouse

Hunter Research, Inc.

J. Paul Getty Museum

Jacobus Vanderveer House and Museum

Jersey City Free Public Library

John Milner Associates, Inc.

LBJ Presidential Library

Liberty Hall Museum, Kean University

Library of Congress

Long Branch Free Public Library

Macculloch Hall Historical Museum

Mariners' Museum, Norfolk, Virginia

McCormick Taylor, Inc.

Merck Archives

Metropolitan Museum of Art, New York City

Mid-Atlantic Center for the Arts & Humanities

Middlesex County Cultural & Heritage Commission

Monmouth County Historical Association

Monmouth University

Monsignor William Noé Field Archives & Special Collections Center, Seton Hall University

Morris County Park Commission

Morristown Library, Morristown and Morris Township Public Library, North Jersey History and Genealogy Center

Morristown National Historical Park

Morven Museum & Garden

Mother Bethel A.M.E. Church, Philadelphia

Mount Laurel Schools

Museum of American Glass, Wheaton Arts and Cultural Center

National Archives and Records Administration

National Guard Militia Museum of New Jersey

National Library of Medicine

National Maritime Museum, Greenwich, London

National Museum of American History, Smithsonian Institution

National Portrait Gallery, London

National Portrait Gallery, Smithsonian Institution

Naval Air Station Wildwood

Neptune Public Library, Archive

New Jersey Catholic Historical Commission

New Jersey Conservation Society

New Jersey Department of Transportation

New Jersey Division of Parks & Forestry

New Jersey Historical Society

New Jersey State Archives

New Jersey State Museum

New Jersey Vietnam Veterans' Memorial Foundation

New-York Historical Society

New York Public Library

Newark Academy

Newark Museum

Newark Public Library, New Jersey Room and Special Collections Division

Northampton County Historical & Genealogical Society

Ocean County Historical Society

Old Barracks Museum, Trenton

Paterson Museum

Peabody Museum, Harvard University

Pennsylvania Academy of the Fine Arts

Perth Amboy Free Public Library

Philadelphia History Museum at the Atwater Kent

Princeton University Archives

Princeton University Art Museum

Rockingham Historic Site

Rutgers University Press

Rutgers University Special Collections & University Archives

Salem County Historical Society

Sam Azeez Museum, Stockton University

Sayreville Historical Society

Seabrook Educational and Cultural Center

Shelby White and Leon Levy Archives Center, Institute for Advanced Study, Princeton

Sisters of Charity of Saint Elizabeth

Somerset County Historical Society

Somerville Public Library

South Plainfield Historical Society

Stevens Institute of Technology Archives and Special Collections, Samuel C. Williams Library

Temple University Archives

Thomas Edison National Historical Park

Union County Clerk's Office

U.S. Fish and Wildlife Service

West Caldwell Historical Society

Yale University Art Museum

INDIVIDUALS

Marlie Wasserman

Allyson Fields

Marilyn Campbell

Anne Hegeman

RUP interns: Krill Abramov, Mohammed Khalil, Sergio A. Rojas, Emily Rosenbach

Warren Adams

Elizabeth Allen

Tom Ankner

Douglas Aumack

Tonya Garcia Badillo

Melissa A. Banks

Judge Peter Bariso

Denise Barricklow

Chris Barton

Marian Bauman

Ronald Becker

John Beekman

Matthew Beland

Steve Bello

Joseph Bilby

Alicia Bjornson

Sean Blinn

William Sauts Netamuxwe Bock

Sara A. Borden

Terry Borton

Beverly Bradway

Justin Breaux

Erich Breyer

Doreen Brown

Michelle Buckley

Jef Buehler

Melanie Bump

Veronica Calder

Ellen Callahan

Stephen Cartwright

Nicholas Ciotola

Julie Cochrane

Jessie Cohen

Andrew Coldren

Cynthia Coritz

Lucy Corvino

Beverly Crifasci

Emily Croll

Thomas D'Amico

Anthony DeCondo

Leonard DeGraff

Robert Delap

Alan Delozier

Ulysses Dietz

Maureen Dorment

Susan Drinan

Oranit Dror-Caplan

John Dyke

Edward Eckert

Jeff Eckert

Joseph Felcone

Sarah Filik

Lisa A. Flick

Thomas Frusciano

Edward Gallucci

Patricia Gandy

Janis Gibson

Rachael Goldberg

Janice Grace

Rosa L. Grier

Sabrina Habieulla

Sarah Hagarty

Andrea Hagy

Irene Halsman

Matthew Hanson

Maggie Harrer

Tim Hart

Rebecca Heiliczer

Evelyn M. Hershey

Timothy Herrick, Dislocations Blog

Carrie Hogan

Karen Hollywood

Sarah Horowitz

Gail Hunton

Paul Israel

Ruth Janson

Margaret Jerrido

Claudia Jew

Jennifer Johns

Lenin Joshi

Stephanie Kalb

Hannah Kendall

Al King

Joseph Klett

Barbara Kowitz

Richard Kuntz

David Kuzma

William LaRosa

Gregory D. Lattanzi

James Lewis

Daniel Linke

Thomas Lisanti

C. Paul Loane

Leah Loscuto

Mark Ludak

Jeffrey Macechak

Alex Magoun

Robert K. Mallalieu

Jenny Martin

Frank McGonigle

Dean Meister

Kiki Michael

Dorothy Miele

John Millar

Diane Miller

Erica Mosner

Sandra Moss

Sr. Noreen Neary

Joanne Nester

Jack Newman

Karl Niederer

Mark Nonestied

Douglas Oxenhorn

Elsalyn Palimisano

Margaret A. Papai

Richard Patterson

William Pavlovsky

Sandy Perry

Acknowledgments

Kay Peterson

Lisa A. Fox Pfeiffer

Jude Pfister

Jessica Phillips

Cristen Piatnochka

Laura Poll

Colin Porther

Joanne Rajoppi

Robin A. Ray

Marie Reynolds

Bernadette Rogoff

Joni Rowe

Joseph Salvatore

Julie Schidler

Chase Schiefer

Karen Schmelzkopf

Paul Schopp

William Schroh, Jr.

Lynsey Sczechowicz

Nadine Sergeijeff

Janet Sheridan

Michael Siegel

Robbi Siegel

Barbara Silber

Jason Slesinski

Alan M. Stahl

Dick Stoothoff

Jessica Stremmel

Sandra L. Tatmen

Steve Tettamanti

Guy Thompson

William R. Truren

Sheila Tshudy

James Turk

Bob Vietrogoski

Peter Wacker

David Webster

Tom Littledeer Weindl

Margaret Westfield

David Whaples

Jack Willard

Hettie Williams

Dianne Wood

Clifford Zink

Melissa Ziobro

Michael Zuckerman

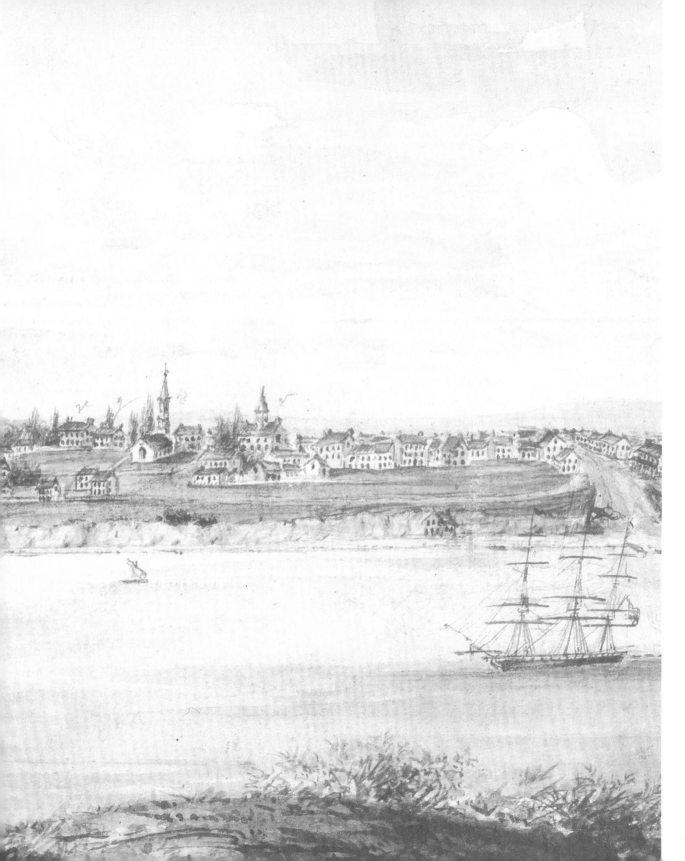

Index

Page numbers in italics refer to illustrations.

About the Authors

Maxine N. Lurie is professor emerita of history at Seton Hall University. She co-edited the *Encyclopedia of New Jersey* and *Mapping New Jersey*, as well as two editions of *A New Jersey Anthology*. She previously collaborated with Richard F. Veit on *New Jersey: A History of the Garden State*.

Richard F. Veit, chair of the department of history and anthropology at Monmouth University, is the author of *Digging New Jersey's Past* and co-author of *New Jersey Cemeteries and Tombstones: History in the Landscape*, as well as co-editor with Maxine N. Lurie of *New Jersey: A History of the Garden State*.

MN

NW